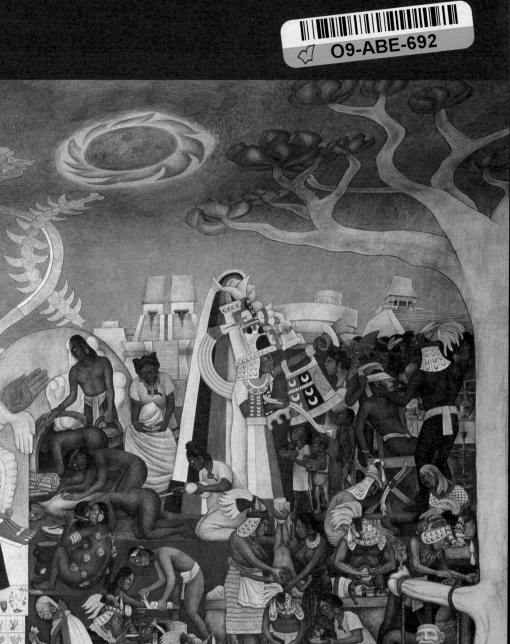

DREAMING WITH HIS EYES OPEN

DREAMING WITH
HIS EYES OPEN

A LIFE OF

DIEGO RIVERA

PATRICK MARNHAM

ALFRED A. KNOPF ❧ NEW YORK 1998

THIS IS A BORZOI BOOK
PUBLISHED BY ALFRED A. KNOPF, INC.

Copyright © 1998 by Patrick Marnham
All rights reserved under International and Pan-American
Copyright Conventions. Published in the United States by Alfred A.
Knopf, Inc., New York, and simultaneously in Canada by
Random House of Canada Limited, Toronto. Distributed by
Random House, Inc., New York.

www.randomhouse.com

Owing to limitations of space, all acknowledgements for
permission to reprint previously published and unpublished
material may be found following the index.

All works of art by Diego Rivera are © Estate of Diego Rivera /
Licensed by VAGA, New York. All works of art by Frida Kahlo
are © Estate of Frida Kahlo / Licensed by VAGA, New York.

Library of Congress Cataloging-in-Publication Data
Marnham, Patrick.
Dreaming with his eyes open : a life of Diego Rivera / Patrick
Marnham. — 1st ed.
p. cm.
ISBN 0-679-43042-3
1. Rivera, Diego, 1886–1957. 2. Painters—Mexico—Biography.
I. Rivera, Diego, 1886–1957. II. Title.
ND259.R5M27 1998
759.972—dc21
[B] 98-6145 CIP

Manufactured in the United States of America
First Edition

Endpapers: *Indian Nativity,* 1953, fresco and mosaic (detail),
Hospital de la Raza, Mexico City

History has the cruel reality of a nightmare and the grandeur of man [consists in his making beautiful works out of the substance of that nightmare . . . it] consists in transforming the nightmare into vision; in freeing ourselves from the shapeless horror of reality by means of creation.

OCTAVIO PAZ, *The Labyrinth of Solitude*

ONTENTS

CONTENTS

Black-and-white illustrations follow page 114.
Colour illustrations follow page 242.

PREFACE

Some of the most perceptive words on Diego Rivera appear in a letter from an Englishman, his assistant Clifford Wight, who was writing in 1933: "I have never known anyone with more perfect poise. And I don't think anyone really knows what his bland smile conceals."

That second sentence haunts the biographer of Rivera, a man whose character stands in extreme contrast to that of his third wife, Frida Kahlo. Kahlo's self-exposure was more or less absolute. Rivera was a master of disguise. He wrote letters infrequently; he once said that he would "rather paint two walls than write a letter." And in conversation he wove a fantastic tapestry of myths about his personal life. Once that is pierced one finds "the bland smile," and silence.

To complicate this fundamental problem there is now an additional distortion, the myth that has been made out of the life of Frida Kahlo. As this has grown up, Rivera has been transformed into a two-dimensional monster, although many people who knew them both well reject this view. Perhaps the best answer to the new, posthumous myth about Rivera is provided by his first wife, Angelina Beloff, who said, many years after he had abandoned her, "He has never been a vicious man, but simply an amoral one. His painting is all he has ever lived for and deeply loved."

The most obviously monstrous aspect of Rivera was his creative energy and the scale on which he expressed it. He stands in an exposed position among the ranks of modern artists. Rivera believed that an artist must be *engagé* and must not withdraw from society. He challenged the modern stereotype of the artist as inarticulate genius. Vlaminck, who inherited Rivera's studio in Paris, wrote that Trotsky had once said to him, "I like your pictures, but you should paint miners and labourers and glorify work," and Vlaminck replied, "A priest once made the same remark to me, but he thought I should use my art to glorify God." In leav-

ing Paris, Rivera relinquished the chance of sharing the conventional, commercial success which awaited Vlaminck. But in following Trotsky's advice, in using his art for political ends and in reinventing the power of the Quattrocento, Rivera acted from conviction. When he died he was not a rich man. Diego Rivera led an unusual life, but it was his painting which gave it grandeur, and I believe that it is in looking at his pictures and at the walls he decorated that the biographer begins to discern something of the truth behind "the bland smile."

§ § §

I WOULD LIKE TO THANK Marika Rivera Phillips, daughter of Diego Rivera and Marevna Vorobev, for the help and encouragement she offered while I was at work on this project. I must also thank Jean-Louis Faure, grandson of Elie Faure, for his sustained interest and sympathy. Martine Courtois, biographer of Elie Faure, was outstandingly generous with her time and expert knowledge and provided me with an invaluable early insight into Rivera's reliability as a raconteur. In Paris I must also thank Jean Kisling, Christina Burrus, Sylvie Buisson, Christian Parisot, Pierre Broué, Jean-Marie Drot, François-Nicolas d'Epoisse, and Véronique and Nicholas Powell, as well as the library staff at the Centre Pompidou and the Musée d'Orsay.

In Mexico I was greatly assisted by, among others, Juan Coronel Rivera, Mariana Yampolsky, Alicia Azuela, Colette Alvarez Bravo, Jorge Ramírez, David Maawad, Alicia Ahumada, Eliazer López Zamorra, Bob Schalkwijk, Marcelle Ramírez, Elena Poniatowska, Manuel Arango, Antonio Garza Aguilar, Yuri Paparous and Francisco Reyes Palma. In New York I was grateful for the advice and good company of Ben Sonnenberg and Dorothy Gallagher, and also to Carla Stellweg, Michelle Stuart, Jennifer Bernstein and the librarians of the New York Public Library and the library of the Museum of Modern Art. Moving still further north I gratefully acknowledge assistance received from Keith Botsford, then in Boston, and from the voice of Nicholas von Hoffman, somewhere out there in the wilds of Maine, as well as the kindness of Linda Spalding, editor of *Brick* in the city of Toronto, and of Dr. John Charlot of the University of Hawaii. In California I would like to thank Ella Wolfe, widow of Bertram Wolfe, Mary Schaeffer and Don Cates, and I note the courtesy and assistance of the staff of the Hoover Institution on War, Revolution and Peace. At the Detroit Institute of Arts, Mary Ann Wilkinson, Associate Curator of Twentieth Century Art, provided me with invaluable help,

and I was most grateful for the time given by Betty Davis, archivist. In Washington, Christopher Hitchens exchanged information for refreshment, and I was advised by Barney Goldstein. Professor Bill Chase of the University of Pittsburgh went out of his way to provide me with very useful guidance. Tom Rosenbaum and Valerie Komor of the Rockefeller Archive Center in Sleepy Hollow, New York, were most helpful, as were Barbara Smith-LaBorde and Linda Ashton of the Harry Ransom Humanities Research Center at the University of Texas at Austin. Finally I must thank Michael Norris, Julian Baker, Lady Selina Hastings and the staff of the London Library in St. James's Square, and pay tribute to the invaluable assistance of Amanda Hopkinson, both in London and in Mexico City.

Without the professionalism and reliability of Mildred Marney of Rowan Script this book might have been delayed. I also acknowledge with gratitude the imaginative insight, steady support and good-humour of Liz Calder of São Paulo.

DREAMING WITH HIS EYES OPEN

A SMALL TOWN IN MEXICO

I N GUANAJUATO, a small town in Mexico, in a house on the Calle de Pocitos, over a hundred years ago, a little boy sat on the stone flags of the courtyard watching a magic fountain.

He had been born in a town where the streets run underground, where pigeons roost in tunnels and trees sprout through air shafts, and where the dead were dug up and carried to the surface and set out in glass cases for public inspection. Among them was a baby girl, dressed in her best lawn gown and clutching her favourite doll. When children died in Guanajuato a hundred years ago, they were dressed up as though for a party and taken to the portrait photographer's studio to be photographed with their mother. When photography reached Mexico, this was one of the first uses people found for it. Then, after the photograph, the family were invited home and all the living children were dressed up and there was a party, with the dead child seated in a place of honour. As she was now, so would they be.

In a city where such wonders were current, where the living disappeared daily into the ground and the dead reposed in daylight, it was little wonder that the family fountain was enchanted. The fountain was placed above a large, semi-circular stone basin, built into the courtyard wall. Water fell into the basin through three lead spouts, each concealed within the open mouth of a stone-carved fish. The three stone fish-heads formed the base of another, smaller basin, set higher up against the wall, which was in its turn supplied with water through the open mouth of a carved hunting dog. The water trickled gently out through this hound's teeth, piped from a spring which rose somewhere on the steep hillside behind the house. The intricacy of the fountain was a celebration of the fact that

in a town which suffered from recurrent drought, this house had a private supply of running water. Yet the magic of the fountain lay not in its water but in that water's reflections.

Sitting on the cool flags beside the basin, the small boy could see the flight of steps leading to the upper levels of the house. On each of the two upper floors, enclosed by iron balustrades, an open gallery ran round the well of the court. Above the second gallery the walls continued to rise towards a central opening which pierced the wooden beams of the roof. And beyond that was the sky. So the small boy, Diego María, could tilt his head back and from his seat on the floor could scrutinise the spiral levels that led to heaven, where his twin brother Carlos lived. "*Volo al cielo Carlos María*" was a refrain in the family. "Carlos María has flown up to heaven." Then Diego María, still in pursuit of his missing twin, could mount the step of the great stone basin and, leaning over the edge, peer down into the clear pool and find himself once more gazing up to the gallery of the first floor and beyond to the second gallery and so deeper down and higher up until he once again reached the sky. And if, with his child's eye, by looking down into the fountain he could see up, so, when he returned to his seat on the floor, he might as well, by looking up, see down. In each case at the final level, the heights of the house led him back to the depths of the sky and to the path down which at any moment, one day, Carlos María might fly back. The small boy had all the time in the world to ponder these matters anxiously once Carlos María had departed and he, for some three years, assumed the privileges of an only child.

"The house of my parents . . . that small marble palace," as Diego described it many years later, was surrounded by a town which was built along a narrow valley on opposing hillsides above a ravine, the houses being crammed together in an astonishing jumble as though riding the waves of a perpetual earthquake. Inside these houses the rooms are assembled on equally obscure principles. The right angle is generally absent. The walls and floors are fitted together like some fantastic, three-dimensional jigsaw. The door lintels are crooked, the ground levels change from room to room, and the volumes, even within a room, are inconstant. The line of a wall sets out from the doorway assuming that it will follow a conventional rectangular path, only for convention to give up the struggle as the wall gives way to the angle of the ceiling beams or is forced off-course by the sharp tilt of a window-sill. One has the impression that each cubic foot of interior space has been fought for; that the houses have been squeezed by some unseen giant hand; and that what is left is the shape they sprang back to when the hand relaxed.

The problem of the interior dimensions of the rooms is carried through the outside walls and repeated on the streets. Warring bands of builders and city planners have clashed all over the city, and you can trace the history of their engagements in the grid plan viewed from Guanajuato's enclosing heights. Here and there patches of order become visible. The nave of a church or the walls of a fortress will shelter a pool of harmony, but it never lasts for long. The pattern dissolves as it spreads out from its source and is overpowered by some conflicting inspiration. Since the floor of the central ravine is wide enough for a road—but not wide enough for a street—someone had the inspired idea of building a road and then roofing it over, so connecting much of the original seventeenth-century town by this subterranean highway. The roof of this tunnel is the floor of the town. It is through the tunnel's air shafts that trees force their way to the earth's surface, their highest branches just reaching the level of the public benches on the plazas above. Around the plazas, the fretwork of buckled alleyways is first, with a rare ingenuity, knitted together, and then, by the walls of its asymmetrical buildings, forced apart. And so the fretwork continues to the town's edge, where the buildings are liberated at last and can rise up in terraces along the sides of the valley, stone construction giving way to more recent brick, and brick to adobe, until, at a certain contour, even the mud walls give out and the crumbling brown earth of the hillside continues up to the crags above.

§ § §

DOWN ONE SUCH STONY HILLSIDE, several folds back from the edge of Guanajuato City, on the evening of the Day of the Dead, 1994, an old man wearing a conspicuous white shirt was slowly picking his path, leading two donkeys, one grey, one black, and followed at some distance by a black dog. He was on his way to the Panteón Nuevo, the municipal graveyard and social centre, which he could see glimmering in the twilight below. He reached a precipitous stretch of tall grass, through which he descended even more slowly. As he drew nearer to the graveyard, faint sounds drifted up: the engine of a bus, radio music, and laughter from a group of policemen huddled together near the car park. Otherwise there was only the wind in the grass; no other noise disturbed the great amphitheatre of hills and fields around. Occasionally on his way down the old man passed solid-looking stone ruins or piles of grey-green shale, all that is now left of some failed silver mine. When he reached the Panteón Nuevo he tethered the donkeys and disappeared into the crowd. The

dog he left free to fend for itself, and it soon wandered off in the direction of the squatters' huts which had started to appear around the graveyard as soon as the first burials took place and an hourly bus service opened up.

The Panteón Nuevo is the graveyard of the future: Guanajuato's development zone, the place where most of the current population of the city will be buried. They have run out of space in the Panteón Municipal, the one where Carlos María was laid in some long-lost grave, so this new arrangement has been set up. At the Panteón Nuevo there is no work for gravediggers. The tombs are located inside three concrete block-houses, laid out back-to-back like barrack huts. The blocks are pierced by five hundred giant pigeon holes, ranged on six levels, each destined to contain one coffin. After some years of tranquil residence, depending on demand, the coffins are removed, unless the catacomb has been purchased *"en perpetuidad."* Most have not. The parallel lines of concrete blocks make a bleak sight on their hilltop, even on the Day of the Dead. Without enclosing walls or living trees, there is nothing to protect the mourners from the emptiness and darkness of the abandoned hillsides. On that evening in 1994 there was the sound of the Rosary being recited in the dusk, but most families stood silent, some hunched and miserable, one group staring at a recently occupied grave as though still hoping that it might yet open and permit death to be reversed. Before another unmarked tomb a father played football with his sons on the flint surface of the ground while the boys' mother stood alone in front of the grave and prayed. These people were not resigned to death. They did not easily let go.

In Guanajuato in 1994 the fiesta of the dead started on October 31, which is sometimes called the day of the *angelitos,* or little angels, the day when families welcome the return of children who have died. I was seated at a café table in the Jardín Unión before a cold Corona Genuina Cerveza de Barril at midday when the doors of the town's infant schools opened and the children poured out, disguised not as angels but as devils, to celebrate this opening of the festival of death. The children's faces were painted death's-head white, they wore long black plastic fingernails, skeleton suits and devils' masks and red devils' horns that flashed, and they carried flashing red devils' tridents or Grim Reaper scythes. Seated before a cold Corona Genuina Cerveza de Barril in the Jardín Unión, I was an easy target. The first little devil to reach me got all the change in my pocket. Then she drove the others off with the point of her trident. For the rest of the day she and her companions rushed round the over-crowded town demanding ransom. The money she gathered was

intended for one of the churches, where it would be used to pay for a temporary altar to welcome the unawaited dead, the returning children of Guanajuato who had no one left to remember them.

On the following day, Todos Santos, All Saints' Day, the gallery by the original municipal cemetery which contains "Las Momias," Guanajuato's famous mummy museum, was doing steady business. The tour seemed particularly popular with courting couples. A notice on the wall of the gallery requested "Silence." The mummies responded to this request. The courting couples were less co-operative. The couples gazed at the mummies and the mummies gazed right back, even the eyeballs and hair being in several cases mummified. Their state is a natural effect of the cemetery's soil, discovered with some excitement in 1865 when, for the first time, space began to run out in the Panteón. A decision was taken to disinter a number of those who had been buried, and the mummies emerged. When the municipal authorities decided to conserve the mummified corpses, they extended the boundaries of Mexico's relationship with death. Over the years the collection has grown so that perhaps one hundred mummies now wait in the glass cases to greet their living visitors. The supply of mummies is constant. After five years all corpses which do not hold burial rights in perpetuity are removed and some will have turned into mummies. The curator is therefore confronted with a steady procession of candidates for his collection. Where he finds subjects whose features or attitudes are sufficiently unusual, he may put them on display instead of having them cremated. There are no moralising reflections engraved on the walls of the gallery, though at one point after turning a corner visitors are confronted with a reproduction of "la Caterina," Posada's famous cartoon of a young lady skeleton subsequently dressed by Diego Rivera in an ostrich-feather hat and a superb full-length white gown. As she is now, so will we be. The thought is just murmured to the visitor, in passing.

Outside the museum on Todos Santos the crowds were beginning to gather in the graveyard from which the mummies had come. It is a small, rather pretty cemetery, shaded by lemon trees, with flowers growing everywhere between the headstones, long-stemmed red or white gladioli and rose bushes, set out as though in a rich man's garden, the tall eucalyptus trees rustling in the wind. In front of the tombs, cut flowers were crowded into grocery tins which, painted green or white, served as pots. Most of the visitors seemed to have chosen geraniums or chrysanthemums, here as elsewhere the traditional flowers of the dead. Along the high walls of the cemetery, perhaps twenty feet high, the coffins are

stacked in columns of seven. The word *perpetuidad* appears much more frequently than it does in the new cemetery, even on some of the simplest graves. There could be no better incentive for paying the extra fee than the mummy museum. Was it, I wondered, a local curse—"May they dig you up for Las Momias!"

On the Day of the Dead families reassemble in Guanajuato, as they do throughout Mexico, to gather round their family graves. In the grave-yard, parallel neighbourhoods spring to life once more. People who may be separated from each other by the width of the city for most of the year dress their graves and call out to each other, neighbours in these walks at least. Around one tomb a family numbering fourteen people aged from about eight to eighty were sitting peacefully, chatting, and eating a picnic. The ladder boys, who could be hired at the cemetery gates, were in brisk demand, their job being to place vases on the stone ledges in front of the higher niches on the wall. A man called out to a boy to carry a pot full of lilies up to a niche which was marked with the name of a woman who had died in 1945. Perched above, on the lip of a black marble vase marked "Lopez," a crow looked down on the ladder boy, then dipped its beak into the vase to drink. Beyond the crow a workman perched at the top of another tall ladder was whitening the dome of a concrete sepulchre.

Some of the graves bore foreign names, Pons or Stephenson, pre-ceded by Spanish Christian names, evidence of some distant immigra-tion. One headstone, in memory of James Pomeroy McGuire, who died in 1959, aged twenty-seven, carried no religious references, but it was marked with the word *perpetuidad* and with the lines from Robert Louis Stevenson beginning, "This be the verse you grave for me." The words were correctly cut in capital letters, though few glancing at the stone would have understood them. There were no cakes on this grave, no photograph, no candles, not even a vase of flowers. It stood beneath a yew.

By the main gates old Indian women were sitting on stools, selling the pots of water which they had filled and carried from some distant tap. It was their grandsons who were carrying the ladders. And on the cob-bled roadway beyond the gates traders had set out their food stalls as they do at the approaches to a football stadium, and a girl was handing out leaflets. I took one. It was printed by a local funeral director and adver-tised discounted "specials." It was Charles Macomb Flandrau who wrote in 1907 that in Mexico death was not just a social occasion, it was above all a commercial opportunity.

The Mexican festival of death is by tradition the greatest fiesta of the year, but in Guanajuato there was no sign of the extravagant details with which it is still marked elsewhere. The dogs in Guanajuato were not muzzled to prevent them from nipping the returning dead. I saw no professional prayer-makers moving among the graves. Nobody carried to the churchyard the bed in which their beloved had died, and the ossuaries were not raided to decorate tombs with the skull and crossbones—an example of the poor being put to work for the rich even after they have entered the grave. But there was no need of these flourishes to emphasise the genuine communion which existed between the living and the dead. In the calendar of the Universal Church, All Saints' is followed by All Souls', when people remember those who died with their sins still to be purged. But in Mexico the two categories have long since been confounded. The Mexicans make no distinction between the saints and the rest of us. A fiesta is not just a feast day, and the Mexican festival of death is not just a commemoration of the dead, it is a reunion with them. There is no authority in Christian teaching for the idea that the souls of dead children return to earth on the day before Todos Santos. But this idea does recall the Aztec custom of dedicating the ninth month of the year to dead infants and the tenth month to dead adults. So in Mexico today the souls of dead children which arrive on midnight on October 31 depart punctually on November 1, to be replaced by the visiting souls of dead adults. These are beliefs, not facts. It is, however, a fact that at midnight on October 31, in my room overlooking the Jardín Unión, the windows blew open with a crash although there was no wind and they had been securely fastened. I began to feel part of the fiesta.

The Aztec festival lasted a month, and in many parts of Mexico Todos Santos is also extended through the whole of the month of November. The Aztecs then went on for a second month, but they did not have Christmas to prepare for. In Mexico even the most extreme enthusiasm for Todos Santos is brought to an end on November 30, the feast of San Andrés. The Mexicans cultivate a great affection for their dead, but they do not want them in the house all year round. It is usual to speak of the Mexican cult of death as reflecting both Christian and Aztec beliefs. But there is, on closer examination, very little which is obviously Christian about it. The Christian faith holds that the grave is the unavoidable path to eternal life, that the life to come is a life of the spirit, and that in the grave we leave everything inessential and outward. Eternity is identified with the immaterial. The Mexican festival of death takes place on church

property and makes use of the furniture of the Christian faith, but there are remarkably few priests in evidence at most of its ceremonies and much of its significance seems to be as much anti-Christian as Christian. The exhumation of the bones, the symbolic offering of food and toys to the dead, the deliberate confusion of the living and the dead are all in harmony with the Aztec belief in the continuous cycle of existence, but they serve only to distract attention from the Christian doctrine of the resurrection of the soul. The Aztec civilisation was among the most sophisticated systems to be invaded and overthrown by Christianity, and the Day of the Dead confirms that it never was entirely overthrown. It was in the Jesuit church in Guanajuato, on the second day of the festival, that I realised the extent to which the Aztecs' original resistance to Cortés is still alive.

It was the time of evening mass and the church was full—though few people were following the service taking place on the altar. Two young women stood among others in the crowd before a black-decked Virgin, saying decades of the Rosary and holding up a tiny baby within the statue's field of vision. They wanted the Virgin to see the baby. Around them children still dressed as devils ran between the pillars of the nave. They were playing devils and lost souls, a game of tag in which the loser is condemned to eternal fire. They were making a game of the mass for the day. Outside the church a crowd of near-worshippers stood waiting in the gloom for mass to end. Through the open doors at the end of the nave they could follow the service, and two old men were on their knees praying, but most of those outside stood talking quietly between the pools of light that escaped through the tall, arched doorway. Among the young women, black and white seemed to be the fashion. Some were in full skeleton costume; others had restricted themselves to black-and-white-striped clothes of a more conventional cut. One young woman, heavily pregnant, was wearing a long, black skirt, a white blouse and a black and white waistcoat. After a moment I realised I was looking at a young, pregnant woman who, in order to join in the town's festive mood, was dressed as an image of death. "The Mexican is a religious being, and his experience of the divine is completely genuine," wrote Paz in *The Labyrinth of Solitude,* "but who is his God?"

Next morning, from the heights around Guanajuato, one could hear the noise of fiesta beating through the streets of the town. It was a blend of distant trumpets, a hint of tambourines, and the bellowing of leather lungs from the violinists singing with the mariachi bands. I had tried to enter the Alhóndiga, once a granary, then a powder magazine, but a

notice outside said that it was closed for reasons of *"fuerza mayor"*—force majeure—in other words, "Fiesta!" It was a wonderful evocation of the power of fiesta in Mexico, *fuerza mayor.* The building was closed because there was no one there to turn the key. There was no point in ordering the staff to work: you can't issue orders against force majeure. Everyone was in the cemetery, having a good time. So I sat outside the Alhóndiga de Granaditas, on a broad and shady stone ledge, among the Indian trinket-sellers who had turned up out of force of habit—an even stronger *fuerza,* it seemed. I was sitting just below the iron hook from which the Spanish suspended the severed head of the Mexican liberator Hidalgo. The cage enclosing his head hung on that hook for ten years. A Mexican dressed in jeans and a cowboy hat came limping up the hill from the direction of the bus station. He was a young man on crutches carrying a light satchel on his back, and he made his way past with the preoccupied air of one who is using his time alone to think deeply about whatever it was he wished to think about. Two and a half paces behind him, his wife had fallen into place, holding their little daughter by the hand, she in a red cardigan and black skirt and the girl in a yellow dress, both as neat as pins for fiesta. The ladies were not talking, although they looked as though they might have been if there had not been the risk of disturbing the man's thoughts. They had not chosen to walk behind; it was just that it was the usual position, a habit the woman had learnt in her father's footsteps when she had been the age her daughter was now. She walked there naturally, even though her husband on his crutches had recently taken to walking so much slower than before. It said quite a lot about their relationship, and about their society, the way they were grouped and the fact that they all seemed quite content about it. It was Wednesday, November 2, the Day of the Dead. I went on sitting on the ledge until a pigeon perched on Hidalgo's hook shat on my jacket, and I thought perhaps it was time to move on.

I reached the Jardín Unión to see the man on crutches limping into the Church of San Diego, the church where Diego Rivera once claimed to have lost his faith at the age of six. Under the trees outside the church, the noise of fiesta was no longer a distant murmur. Beneath my balcony the sound of the mariachis striking up yet again was enough to stir the cold Corona Genuina Cerveza de Barril in its glass. Luisa, who owned this house, had told me that the dictator Porfirio Díaz had once leant on this very same balcony railing and slept in the room I was sleeping in when he came to Guanajuato in 1903. Perhaps this explained why the windows sometimes blew open without a wind. His visit in 1903 was to inaugurate

the Teatro Juárez, the city opera house which stood more or less opposite the dictator's room. It was a triumphant moment for Díaz and for the rulers of the town. The little Teatro had taken thirty years of hard labour and profligate spending to complete.

Díaz loved Guanajuato, which was reputedly one of the most conservative towns in Mexico. It was in Guanajuato that he authorised a triumphal arch to be erected not to his military glory but to the glory of his second wife, the unfortunate Carmelita, who detested the elderly husband she had only married under duress. Carmelita's godfather was very angry about this marriage, and to soothe him Carmelita wrote a letter. "I do not fear that God will punish me," she explained, "for taking this step, as my greatest punishment will be to have children by a man who I do not love; nevertheless I shall respect him and be faithful to him all my life. You have nothing, Godfather, with which to reproach me. . . ."

Díaz visited Guanajuato again in September 1910. It was his last visit and the year of the centenary of the Mexican Revolution. The dictator had just arranged for his seventh re-election, and a new revolution was on the point of breaking out. In Mexico, wrote Paz, "a fiesta . . . does not celebrate an event: it *reproduces* it." And in Mexico in 1910 they celebrated the centenary of the Mexican Revolution by throwing another Mexican Revolution! But Díaz did not anticipate that. He had not read Paz. This time he came to inaugurate the new covered market, which was, and still is, the largest covered area in Guanajuato. Even today a large marble slab fixed to the wall by the entrance to the market records the occasion. The entrance looks like the archway into a mainline railway terminus, and the name of the architect was Ernesto Brunel. At the bottom of the inscription the carver has left a space to record the cost of the project in three different currencies, but each is blank. The Revolution arrived before the governor had finished counting, and after that nobody cared to give credit to an achievement of the *Porfiriato*.

Opposite the market there is a café, and on the day of my visit they had installed a family altar in the entrance hall. On the altar they had placed flowers and corn and fruit and little white sugar cakes each bearing the name in black of someone who was being welcomed back that day. Above the altar a sign read, "You would enjoy yourself more if you gave something for this altar, and so welcomed back all those who have died in Guanajuato." On the kerb outside the café the road-sweeper was sitting with his small son perched between his knees. The boy was propping up his father's long-handled broom and eating something white and sticky, a

treat, a little sugarloaf, shaped like a skull. The boy was eating a shrunken human head.

I walked down the Calle de Santo Niño, the Street of the Holy Child, where the right angles are always awaited, where the perspective is tangible and built into the stones, and eventually came to Pocitos and then to Pocitos 80. Today it is numbered 47. Here a plaque on the wall announces that inside Diego Rivera, *pintor magnífico,* was born. It was the Day of the Dead and the house was closed to the public. But I heard a door bang inside, and the sound of the radio playing, so I knocked and a woman's voice called out and I turned the handle and walked in.

PART ONE

FABLES AND DREAMS

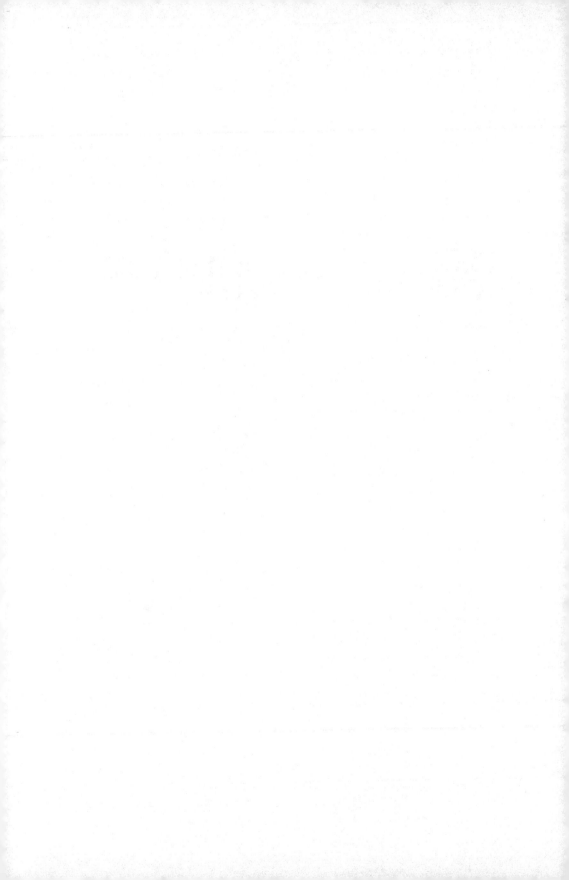

BIRTH OF A FABULIST

Guanajuato 1886–1893

The Mexican tells lies because he delights in fantasy.
OCTAVIO PAZ

THE ARTIST DIEGO RIVERA was born at the age of thirty-four in December 1920 in a small chapel in Italy, just outside the city of Florence. He was standing in front of a fresco by the Renaissance master Masaccio; it was the fresco which depicts the moment when St. Peter finds a gold coin in the mouth of a fish. But he was not looking at the painting. His attention had turned to a muralist's scaffold by his side. It was a wooden pyramid, five ascending platforms, connected by ladders and mounted on wheels. Rivera immediately made a detailed sketch of the platform.

Diego was a Mexican, of Spanish, Indian, African, Italian, Jewish, Russian, and Portuguese descent. Thirty-four years earlier, when the apprentice had been born, he had been christened Diego María de la Concepción Juan Nepomuceno Estanislao de Rivera y Barrientos Acosta y Rodríguez. According to his birth certificate, his name was Rivera Diego María, but in later life Rivera tended to add a new name for each new interviewer. The birth took place on December 8, the feast of the Immaculate Conception, and a day of serious fiesta. The art historian Ramón Favela has examined the baptism certificate held in the ecclesiastical registry at Guanajuato and states that this shows that the *pintor magnífico* was actually born on December 13—in other words, that the very first fact in the life of Diego Rivera, the date of his birth, is a myth. But this seems to be a myth that should never have been propagated. Diego's mother always claimed

that his birth took place on December 8, and his aunt Cesárea also seems to have been under this impression. In fact, the civil document held in the town hall records the birth on December 8, a Wednesday, at 7:30 in the evening.

Rivera's accounts of his early life were frequently dramatic, and his birth was no exception. Not only did it take place on a major feast day, but it was attended by portents, suffering and fatal implications. According to his own account many years later, Diego had nearly died on the day he was born. He had been so weak that the midwife had disposed of him in a dung bucket; his grandmother had then saved his life by killing some pigeons and wrapping him in their entrails. *"Venga, venga, muchachito . . .,"* she crooned to him. This story seems to be the only evidence that Diego was ever anything but perfectly healthy on arrival.

There was, however, a drama taking place in the background. It was in fact not Diego who was dying, but his mother, María del Pilar. Diego proved to be the first of twins. His own delivery caused his mother to haemorrhage, so while fiesta exploded outside the house on Pocitos, inside his poor mother laboured over her second baby. There was a doctor in attendance and a second boy was duly delivered. But María had by that time lost so much blood that she passed into a profound coma; when the doctor tried shortly afterwards to find her pulse, he was unable to do so and pronounced her dead. Don Diego Rivera, her husband, was the more shocked since he had instructed his friend Dr. Arizmendi, a good Freemason like himself, that if a choice had to be made, the life of his wife should be saved and that of his child sacrificed. Since this instruction was in direct conflict with the teaching of the Church, Don Diego would have been able to demonstrate that although his wife was a devout Catholic, her life had only been saved because she was married to a devout anti-clerical. The unexpected turn of events caused Don Diego to despair. He was not much comforted when his late wife's uncle, Evaristo Barrientos, not Catholic but Creole and a spiritualist, arrived and told him that, according to spiritualist orthodoxy, Doña María's mission on earth was evidently terminated and she had by now passed on to superior spiritual circles where she would certainly be contactable in due course. María's sister, Cesárea, and Señora Lola Arizmendi then proceeded to lay out the corpse.

With the wisdom of science, Freemasonry and spiritualism in attendance, Don Diego should have been reconciled to his new situation, but he was not. When old Martha, Doña María's attendant, who had until

then been the sole person preoccupied with welcoming the twins, bent over her "niña María" to bid her farewell and started to cry out that she was alive, it became too much for Don Diego. He had by this time convinced himself that his wife's spirit, following Don Evaristo's postulation, was nearing the end of its journey to the astral spheres. So when the ignorant old woman kissed his wife's cold forehead, imagined she could hear the corpse breathe, and exclaimed, "She can hear me, she can hear me!" Don Diego succumbed to a paroxysm of grief. Seeing that no one believed her, old Martha demanded that the doctor be recalled to carry out "the blister test." To calm the stubborn old lady, Dr. Arizmendi on his return lit a match and placed it just beneath Maria's left heel. To his great surprise a blister formed at once, which, it was universally agreed, would not have been possible had she been dead. It was, therefore, the least-educated of the three people who had examined the body of María who was proved correct. Martha and Cesárea thereupon hurried to the nearby Church of Los Hospitales to thank Our Lady and light candles for this miraculous resurrection on her feast day. Don Evaristo argued that his niece's spirit must have been recalled after setting out on its journey and that she had clearly been allotted some greater task to perform. Dr. Arizmendi concluded that his patient had been suffering from an undiagnosed catalepsy, which he had mistaken for death. Don Diego cancelled his usual order for the large doll which he had presented to his wife on each of her three previous confinements, each of which had resulted in a still-birth. And María made a full recovery.

§ § §

MARÍA DEL PILAR BARRIENTOS, the mother of the painter Diego Rivera, had married her husband, also called Diego Rivera, in 1882, when she was only twenty years old. Their son was fond of recalling in later years that on the eve of his parents' wedding a comet had blazed across the night sky. Since the age of eighteen María had been a teacher in a primary school in Guanajuato, a school founded by her mother in 1878. To this school came a tall, black-bearded powerfully built *profesor normalista,* Don Diego de Rivera. Don Diego was looking for a job, and Doña Nemesia Rodríguez de Valpuesta, María's widowed mother, was delighted to give him one. Neither of her two daughters employed in the school was a qualified teacher. In fact, neither of them had ever been to school themselves, both having been educated by private tutors. María taught music

and grammar, and her younger sister, Cesárea, taught needlework. Don Diego was therefore a significant addition to the staff. Not only was he qualified to teach at the secondary level, he was also the author of a standard textbook on Spanish grammar. In due course he fell in love with the older of his employer's daughters, and on September 8, 1882, María agreed to marry him, although he was fifteen years older than she was. Her intention was to raise a family before resuming her career, which had been interrupted only two years after it had started. Her husband was a man who had tried several careers, but although in possession of considerable ability, he had never really made a success of any of them. All his life Don Diego was noted for his intelligence, his energy and his gift for failure. He had grown up in Guanajuato and in 1862, at the age of fifteen, was already attending the Colegio de la Purísima Concepción, later the University of Guanajuato. He had trained as an industrial chemist; then, after inheriting a family interest in a local silver mine, he had tried to make his fortune as an assayer and prospector. When silver mining came to nothing, he quarried his intellectual inheritance of letters and liberalism instead.

By family tradition, Don Diego's father and grandfather had both been army officers. His grandfather, whose name is not recorded (although Rivera once claimed that he was called the Marqués de la Navarro), had been an Italian adventurer and mercenary who had seen service in the army of the King of Spain. It was said that this Italian officer had been sent to Russia on a diplomatic mission at the end of the eighteenth century. While in Russia he had married a woman called Sforza, but his wife had died in childbirth and he had returned to Spain with their infant son, Anastasio. He spoke to no one about his dead wife but resumed service in the army of Spain, raising a son who by his father's silence acquired the semi-magical status of "child of an unknown mother." In due course Anastasio followed his father into the army of Spain and was, again by family legend, duly ennobled. Despite this distinction, Anastasio decided not to settle in Spain. He emigrated, as his Italian father had done before him, but he did not return to Italy, or to St. Petersburg in search of his mother's family. Instead he went to Mexico and settled in Guanajuato, where he acquired an interest in several silver mines. At the age of sixty-five Anastasio offered his sword to Juárez and fought as a general in the cause of the Republic during the War of Intervention. His father had worked for Spain against Bonapartism and France, and he would do the same. There appears to be very little docu-

mentary evidence to support this account of Diego Rivera's family history, but it is not totally impossible.*

We know that Don Anastasio de la Rivera arrived in Mexico with money because shortly after his arrival he settled in Guanajuato and purchased an interest in the La Asunción silver mine. His partner was Don Tomás de Iriarte, son of the Count of Gálvez. At this time Don Anastasio was a wealthy man, and in 1842 he married Doña Inés de Acosta y Peredo, a beautiful Mexican girl of Portuguese-Jewish descent who, after the death of her father, had been brought up by her uncle, Benito León Acosta, famous in Mexico for his exploits in hot-air balloons. Don Anastasio's speculation in the La Asunción mine took place just before the start of a silver-mining boom, and for some years he made money. But things went disastrously wrong when the mine flooded and then caved in. Overnight Don Anastasio was ruined. In old age he returned to politics and soldiering. The governor of Guanajuato, Manuel Doblado, a friend of Anastasio's, was among the first liberal leaders to rise in 1855 against the country's conservative rulers and in support of Juárez. When the War of Reform broke out in 1858, Governor Doblado and Anastasio Rivera joined the insurrection on the side of liberals. Anastasio is said to have lost his life in that cause, at the age of sixty-five, armed and on horseback.

*If Anastasio joined Juárez in 1858, and if he was aged sixty-five when he joined, then he was born in St. Petersburg in 1793. In 1792, when the Italian Rivera was supposedly dispatched to St. Petersburg, the prime minister of Spain was the twenty-five-year-old Manuel Godoy, the favourite of the forceful Queen Marie Louise. The French Revolutionary Convention had declared its support for any foreign people who rose against their hereditary rulers, and a Spanish diplomatic mission to Catherine mounted against this threat seems a logical possibility. The proceedings of the French Convention certainly caused alarm in Russia and led to a French declaration of war on Spain in 1793.

Having been born in 1793, the Italian General Rivera's son, Anastasio, would have been in the Spanish army by 1820, by which time Spain was passing through a period of liberal and nationalist turmoil. In the succession of insurrections and coups d'état which punctuate Spanish history between 1820 and Anastasio's arrival in Mexico, there would have been ample opportunity for the young officer to distinguish himself. If Anastasio was ennobled by a Spanish ruler, it would have been either by Ferdinand or by his daughter, Queen Isabella II, who came to the throne in 1833. In view of his subsequent career, it seems more likely that Anastasio Rivera would have become "Anastasio de la Rivera" as a follower of the liberal Queen in her struggle with the Carlist absolutists who supported Don Carlos. The first Carlist War ended in 1839, having caused the deaths of an estimated 270,000. This would have been an opportune moment for Anastasio's elevation. Mexico would have been a suitable country for a Spanish liberal general such as Anastasio to turn to for new opportunities. Since 1821, when Mexico finally established its independence from Spain, it had offered a welcome to European adventurers with money to invest.

What else is known about Don Anastasio, foundling, soldier, nobleman, exile, mine-owner, ruined millionaire and liberal insurrectionist? He was, it seems—and the phrase recurs in the painter Diego Rivera's account of his ancestry—a man of "astonishing vigour" or sometimes a man of "fabulous vigour." The evidence for this was that he had married at the age of fifty a girl aged seventeen who duly presented him with a family of nine children. Among them was his oldest son, Diego, the painter's father, born in Guanajuato in 1847. Diego Rivera habitually put his grandparents' achievement the other way round, telling his amanuensis, Gladys March, that "to his wife, Anastasio presented a brood of nine children." In old age this wife, Inés Acosta, thinking of her late husband, is said to have stated that "a boy of twenty could not have made her a more satisfactory lover."

Don Anastasio eventually fell on the field of honour. In 1939, talking to his first biographer, Bertram Wolfe, Diego Rivera made it clear that he supported the conventional account of his grandfather's death, that it had been with his sword in his hand either during the War of Reform in 1858, when he was sixty-five, or during the later War of Intervention, when he would have been eight years older. In saying that Anastasio had died "fighting against the French and the Church," Diego Rivera seemed to be favouring the second date. But by 1945 he had developed an alternative account of Anastasio's death. His grandfather had still fallen on the field of honour, but the field had changed. Anastasio was now struck down by a twenty-year-old housemaid who desired him and who was "driven wild by jealousy of the attentions he continued to lavish on his wife." In her frenzy the girl poisoned the general. This too was a fitting end for a male Rivera, brought down thus in his virile prime, aged only seventy-two, at the hand of a jealous conquest. It is true that when he gave the second version—by poisoning—of his grandfather's death Diego Rivera was himself experiencing considerable difficulties with a demanding and possessive wife.

The problem is that established certainties about the life of Don Anastasio are practically non-existent. Perhaps he was a Spanish liberal, ennobled for his loyal and distinguished service to the progressive Queen Isabella of Spain. Or perhaps he was a Carlist absolutist and antidemocrat, forced into exile by the ignominious defeat the Queen's forces inflicted on the forces of reaction, and looking for easy pickings in the New World. Or maybe he was just an absconding junior officer, briefly in charge of a royal baggage train or a Spanish government treasure chest, who found his way to Mexico by way of Cuba and on the voyage mur-

dered and stole the identity of a nobleman named de la Rivera. When he arrived, the assassin kept well clear of Mexico City and Veracruz—and any likelihood of being recognised—and instead cultivated influential circles in a small town in Mexico. Finally we have only the name of this shadowy figure, his portrait, his approximate age, the strong conviction that he came from Spain, where he was probably born, the near-certainty that he became involved with a silver mine that failed, the fact that he lived in Guanajuato and fathered nine children. Of his wife, Inés Acosta, not much more is known.

There is no clear evidence for Inés's Jewish descent, although it was of some importance to her grandson the painter. Clearly, in bearing nine children to a husband thirty-three years older than herself, Inés was determined to have company in her predictably long widowhood. It is accepted by the Rivera family today that she was the niece of Mexico's first aerial navigator. Benito León Acosta had also been born in Guanajuato and had learnt the art of hot-air ballooning in France and Holland. On returning to his native country, he offered his services and his inflatable apparatus to the Mexican army as a military field observer. This was during the dictatorship of Antonio López de Santa Anna, famous for losing half of Mexico's territory, the lands now known as Texas, Arizona, New Mexico, Colorado, Nevada and California (and part of Utah), but also famous for according his leg a state funeral (after it had been amputated by a French naval gunner who was shelling Veracruz). With regard to the intrepid Benito León Acosta, Santa Anna behaved correctly, appointing him a knight grand cross of the Order of Guadalupe and granting him the official title of *Primer Aeronauta Mexicano*. Rivera later stated that his grandmother Inés was also descended from the rationalist philosopher Uriel Acosta.

All in all, the painter was satisfied with his exotic ancestry. It provided him with a distant memory of wealth, a connection with the European aristocracy of the Conquest, and a ration of military daring, intellectual distinction and Jewish difference. Furthermore, varied as it was, there was no trace in it anywhere of artistic ability. In that matter Rivera was entirely his own creation.

The heritage possessed by Anastasio and Inés was passed on to a character who is not at all mysterious, Don Diego Rivera Acosta, Diego Rivera's father; and in the life of Don Diego the older there are some strong similarities with the legend of General Anastasio de la Rivera. Diego Rivera Acosta, being the oldest of Anastasio's sons and born in 1847, was old enough to fight by his father's side, or perhaps under his

command, in the War of Intervention, since the conflict did not end until
he was aged nineteen. And this, according to his son, he did. In Diego
Rivera's words, he "fought against the French for seven years," starting at
the age of thirteen. Taking both his liberalism and his military prowess
from Anastasio, the teenage Don Diego took part in the final battles
between Juárez and the forces of the Emperor Maximilian and was
present at the fall of Querétaro on May 15, 1867, after which the Emperor
surrendered. Don Diego then witnessed (his father the general by now
being dead, fallen as we have seen on one or other of the fields of honour)
the execution of Maximilian and two of his senior Mexican generals,
which took place on June 19 of the same year.

The shots rang out and the hapless Austrian nobleman crumpled to
his knees. But he needed two coups de grâce before death reached him
and allowed him to accomplish his central role in the archetypal pan-
tomime of pre-modern Mexican politics—the public fusillade. And as
those shots rang out, witnessed or not witnessed by Don Diego, and not
witnessed but immortalised by Edouard Manet, the fantastic retreats and
a hard, bright vein of fact surfaces and pulses through the legend of the
painter Diego Rivera. If all we really know about "General" Anastasio de
la Rivera is his name and his face, his son, Don Diego the older, has a cer-
tain identity. We find him, whether or not returned from the field of hon-
our, an assayer of precious metals in Guanajuato during the five brief
years that remained to Juárez after the execution of Maximilian before he
himself became the only Mexican head of state since independence to die
in the presidential bed, of natural causes, in July 1872. Returning to his
studies, Don Diego qualified and in due course distinguished himself not
as a general, a diplomat or a millionaire mine-owner but as a school-
teacher. At no time does Don Diego seem to have called himself anything
but "Rivera Acosta," although his wife was still signing herself "de
Rivera" in 1900. Diego Rivera later explained that his father had aban-
doned the longer style out of liberal and progressive conviction. Despair-
ing of the reopening of the flooded Asunción mine, Don Diego placed
his small remaining capital in another mine known as La Soledad or
El Durazno Viejo. The job he took at Doña Nemesia Rodríguez de
Valpuesta's primary school was probably suggested to him by his mother,
since she was a friend of Doña Nemesia's, both women having been wid-
owed for some years.

Doña Nemesia was the widow of Juan Barrientos Hernández, a mine
operator who had been born in the Atlantic port of Alvarado. Juan Ba-
rrientos died when his older daughter was aged four, leaving Doña

Nemesia in the care of his brother Evaristo, the spiritualist, and in the care of her own three brothers, Joaquín, Mariano and Feliciano Rodríguez. Because Juan Barrientos had been born in Alvarado, a port noted for its mestizo population, Rivera in later life claimed that he was of partly African descent. Gazing at himself in the mirror as he painted one of his recurring self-portraits, he sometimes accentuated his features in that manner. Rivera's African connections have generally been regarded as another of his inventions. His sister María said that her mother's father had been of Creole cast "with fair skin and fine features." What is certain is that from somewhere in his ancestry Rivera inherited exceptional physical stamina.

Diego Rivera made comparatively few public references to his mother, but it was to her family that he linked one of his most original biographical inventions, and one which cast a new light on several of the more notable events in Mexican and European history in the nineteenth and twentieth centuries. Feliciano Rodríguez, brother of his maternal grandmother Nemesia the schoolmistress, had served as a colonel in the War of Intervention, not on the side of Juárez but among the reactionary forces of the Emperor Maximilian. In the course of time Tío Feliciano had become an admirer and eventually the lover of the Empress Carlotta. If one had to have an uncle on the wrong side in a civil war, it must have been some comfort to Diego that he should at least have seduced the foreign tyrant's wife. On returning to her native Belgium in Europe in 1867 in an attempt to raise support for her beleaguered husband, Carlotta collapsed in the Vatican, thus becoming the only woman known to have spent the night there. The conventional view of history is that next morning she recovered consciousness but not her senses and spent the rest of her life confined to the castle of Bouchout in Belgium, her native land. However, according to Rivera, Carlotta's collapse in the Vatican was caused not by grief but by the fact that she was pregnant. She gave birth secretly to a son who later became General Maxime Weygand, and who was none other than the natural son of Tío Feliciano.

It is of course true that General Weygand was born in Brussels in 1867 "of unknown parentage" and christened Maxime, but his connection with the Empress Carlotta has never amounted to more than speculation. However, any doubts Rivera may have had about the story were dispelled in 1918 when he was staying with Dr. Elie Faure, the leading art historian of his day, near Périgueux in southern France. It was there that a chance but emotional meeting occurred between Diego and Maxime, "his mother's first cousin," rather better known at that time as Marshall Foch's

chief-of-staff. Forgetting the holocaust then taking place in northern France and any plans being laid for the last "Big Push," General Weygand called out: "My little Diego! . . . Come and give me a hug! How is my cousin, your mother? And your aunt Cesárea? And what news can you give me of my good friend, her husband, Ramón Villar García?" This meeting between the French chief-of-staff and his "little Diego" would have made a considerable impression on anyone else present since "Dieguito" was at least twice the general's size. But unfortunately there were no witnesses.

The meeting with General Maxime Weygand is the last performance of the military theme in the legend of Rivera.

The marriage contracted by Rivera's parents, Don Diego Rivera and María del Pilar Barrientos, in 1882 lasted for thirty-nine years, the rest of Don Diego's life. The bridegroom was fifteen years older than his bride, and whereas she, like her mother, was a devout Catholic, he was a notorious Freemason and reputedly the son of a Freemason. Any potential incompatibility was resolved, according to their daughter María, by María del Pilar Barrientos's progressive adoption over the years of most of her husband's opinions. Rivera saw very little of his parents after he left Mexico for sixteen years in 1906 aged nineteen, but in his infrequent references to them it is noticeable that he never made a public criticism of his father and almost never mentioned his mother except in belittling or dismissive terms. This does not seem to have been because he felt that he had been neglected or slighted by his mother; if anything, he found her affection stifling. But it suggests that he denied his true feelings about his mother and may have taken his father's side in the silent confrontation that was the consequence of his parents' incompatibility. In any case, emotional elusiveness was to become a distinguishing feature of Rivera's adult life.

In the early years of his marriage, Don Diego, the frustrated silver miner and outcast from the economic boom that benefited Mexico in the period of Porfirio Díaz's dictatorship, adopted increasingly liberal opinions. At first he continued to teach. Later he secured a position with the state administration of Guanajuato. In 1884 a new state governor was appointed, General Manuel González, a former president of Mexico and one of the most intimate colleagues of Porfirio Díaz himself. González once boasted that he "had killed all the bandits in Guanajuato, except himself"; yet Don Diego's relations with Governor González appear to have been cordial. As the son of Anastasio, who had himself been a friend of Governor Doblado thirty years earlier, Don Diego retained good enough connections to secure an appointment as an inspector of schools.

He was also elected to the municipal council of Guanajuato City; he founded an *escuela normal* for the training of rural schoolteachers; and he became a contributor to, and then in 1887 editor of, *El Demócrata*, Guanajuato's liberal newspaper. During the early years of the *Porfiriato*, liberalism was not necessarily a bar to political advancement. Díaz regarded himself as a liberal, before he became addicted to re-election and the management of foreign interests.

After their marriage Don Diego and María del Pilar lived on the top floor of the house on Pocitos, with a splendid view over the rooftops of the centre of the town to the mountains beyond. There was a grand piano in the drawing room and the house was full of books; they had enough money to keep a little horse carriage and a groom to drive them round the town. They also employed Martha, who lived with them and who was soon counted as one of the family. María del Pilar, according to her son, used to exaggerate Don Diego's age when talking about him, in the hope of making him less attractive to other women. On the death of Doña Nemesia, María del Pilar's sister Cesárea and her aunt Vicenta came to live at Pocitos 80 and the family took over more of the house. Here, for four years, the young couple tried to start a family, and here on three occasions Don Diego consoled his wife with a large doll. And so life continued until the momentous events of December 8, 1886. It was a Wednesday.

So Diego was born. But he made no sound. He was otherwise occupied; he was drawing sustenance. Wrapped in pigeon's entrails or not, he was comfortably installed at the breast of the wet-nurse prudently hired to take the place of the accident-prone María del Pilar. Since twins had not been expected, the wet-nurse, Antonia, a Tarascan Indian, had her work cut out for her during the first twenty-four hours until a second wet-nurse could be found. Was it at this moment that Carlos began to lag imperceptibly behind? Was Diego, taking advantage of his short start, already exercising his mesmeric powers over the breast to hand, causing the distracted Antonia to let down her milk at an uneven rate? When he signed the birth certificate on December 19, Rivera's father, Don Diego, committed an imprecision. He stated that Diego María had no particular distinguishing characteristics. This must have been incorrect. From the earliest photographs, taken when he was about ten months old, where he sits slightly behind Carlos María's left shoulder, thoughtfully sucking his thumb, Diego María has a characteristically alert and watchful air. He is leaning back, at his ease, settled into his woolly jumper and diapers, observing the scene in general and fixing the lens with a calculating eye.

Carlos María, by contrast, is hunched uncomfortably forward. He has an anxious expression, as though wondering from which direction life's next blow will fall. Even the knees and calves of the two infants are in sharp relief, those of Diego paying tribute to the efforts of Antonia, the spindlier shanks of Carlos demonstrating that his nurse, Bernarda, was less well adjusted to the task.

The blow that Carlos was so visibly expecting fell several months later, when Antonia and Bernarda, already rivals in the size and beauty of their sucklings, working in the same nursery, passing their hours off-duty in the same neighbourhood, gossiping with the same gossips, fell in love with the same young man and flew at each other's throats. A violent fight broke out between the two wet-nurses. They were separated by the twins' great-aunt Vicenta, known as Tía Totota, who at once diagnosed a dual case of bile in the milk. She instructed both nurses to withdraw their breasts until passions had cooled. Antonia obeyed and Diego María was denied his milk for several hours. But Bernarda, perhaps anxious to regain lost ground, or worried that her milk was failing, defied orders and suckled Carlos María with her bilious fluid, and poisoned him. According to a different version of Carlos's death, he was visibly frail, his nurse was less bountiful, and to compensate she gave him tainted goat's milk. From this Rivera constructed the Shakespearean theme of deadly sibling rivalry by proxy. The wet-nurses compete in everything; they come to blows over an affair of the heart. Diego's Antonia is sufficiently intelligent and devoted to discipline herself and so saves his life. Carlos's Bernarda is inferior, like him, and poisons her charge through disobedience.

On the death of Carlos, María del Pilar had a nervous breakdown. After the funeral she refused to leave the Panteón Municipal and her husband was obliged to rent a room for her in the cemetery keeper's lodge, where he joined her at night. Rivera was marked by his mother's reaction—"a terrible neurosis"—to his brother's death. "The queen, my mother," he wrote in his autobiography, "was . . . diminutive, almost childlike, with large, innocent eyes—but adult in her extreme nervousness." So Diego experienced the early loss of a brother, whom he could not remember, but he had a clearer memory of his mother's grief and of his own inability to console her, and he learnt that the world of mothers could be irrational, self-absorbed and passionate.

So extreme was María del Pilar's grief that Dr. Arizmendi decided that she would never recover if she was not distracted and suggested that she should attend the university. She chose to study obstetrics. Meanwhile Diego, seated on the floor beside the fountain and feeling abandoned by

his mother, was no longer flourishing. He was handed over to Antonia, who took him off to her village in the mountains. He was apparently sent to the country to be fattened up and cured of rickets. But in his own account he claimed that Antonia was a herbal doctor and magician who allowed him to roam in the forest, where the animals, even snakes and jaguars, became his friends. For the rest of his life he said that he loved Antonia more than he loved his mother and that on his return from the forest his mother complained that he had been changed into "another Diego," a little Indian who spoke to the family parrot in Tarascan instead of Spanish. In fact, since the family album contains photographs of Diego at the ages of two, three and four, all taken in a studio in Guanajuato, his stay in the mountains seems to have been rather less than two years. But whatever its length, the banishment of the surviving twin to the savage paradise of the forest emphasises the epic importance that Rivera accorded to Carlos's death.

What is certain is that Diego Rivera lived in Guanajuato until he was six years old. He grew up in a beautiful house with his mother, two aunts, old Martha, his beloved Antonia and, from the age of four, his sister María. In infancy he was enclosed, adored and fattened by women. They encouraged his masterful personality. Tía Cesárea remembered taking the little boy into a general store full of surprises where he stood in front of a display case full of wonders, clutching a few cents in his hand and shouting desperately, "What do I want? What do I want?" But in his own accounts of that period it is the masculine principle that he chooses to emphasise. While the women fill his head with superstition, his father teaches him to read "by the Froebel method," and this at a time when the Froebel method was, outside Germany, very little known. With the exception of Antonia, who carries him off to her hut in the forest to make him a little Indian, women are given no influential role to play. The little Indian is succeeded by the little Atheist. One day Tía Totota broke Don Diego's rule that Diego should be kept away from priests and took him to the Church of San Diego opposite the Jardín Unión to introduce him to the saints. But Diego insisted that the saints were made of wood and plaster. Then he climbed the altar steps and harangued the crowd of worshippers, warning them to give no more money to the priest and explaining that an old man could not sit on a cloud in the sky since it was in contradiction with the law of gravity. While the ladies in the congregation began to scream and a verger doused him in holy water, the priest came into the church in vestments and declared that the child was Satan incarnate. After a dramatic confrontation the six-year-old Rivera seized the

priest's candlestick and drove him out of the church. Then Tía Totota
took him by the hand and led him home through streets abandoned by
citizens trying to escape from the Devil. The story of the little Atheist
bears a clear resemblance to two episodes from the life of Christ, the
infant Jesus preaching to the elders and Christ driving the moneylenders
from the Temple.

After the little Atheist came the little Scientist, so furious with his
mother for telling him that his unborn sister María would be arriving in
Guanajuato as a parcel at the railway station that he caught a pregnant
mouse "and opened its belly with his scissors in order to see whether
there were small mice inside." Then there was the little Engineer, who
spent hours at the engine depot where the train crews would let him ride
on the footplate, hold the throttle and blow the whistle. And later there
was the little General, whose exercise books contained tactical battle
plans and sketches of fortifications so striking that he was summoned by
Mexico's minister of war before a committee of retired army generals
and, at the age of eleven, enlisted as the youngest soldier in the Mexican
army. As General Hinojoso, the war minister, concludes his searching
cross-examination and bangs his fist on the table, shouting "Damn it,
Diego, you're a born soldier!" we realise that the infant Jesus has given
way to a Mexican version of Leonardo da Vinci. And yet there could well
have been some truth in these legends. Diego certainly had a precocious
fascination for anything mechanical. In an early photograph he holds a
toy railway engine. The women surrounding him gave him two nick-
names, "the Engineer" and "el Chato" (the Wretch). He loved going to
the station to watch the trains from Mexico City pulling in after their long
journey up this branch of the Mexican Central Line. His earliest pre-
served drawings are of railway locomotives, and as the son of one of the
town's leading citizens, he may even have been allowed to play on the
footplate.

In Guanajuato in 1892, the railway station would have been another
magical area for a prodigious child. It would have been more attractive
than a modern airport, more like a space-rocket launching pad. But it was
a rocket pad where a small boy could climb into the rockets and talk to his
friend, the intrepid stoker, whose furnace gave out such an overwhelming
blast of heat and flames. When María del Pilar wished to keep Diego out
of the house on the morning of his sister's birth, she sent him to the sta-
tion, knowing that he would be happy there all day. Today the station, like
the town, has lost some of its urgency, but is otherwise remarkably little
changed. On the edge of town, behind a high crumbling wall, stand two

low platforms. Beyond them stretches the single-track branch line linking the town to Mexico City. There is a low station building with "Jefe de Estación" painted on one door and "Sala de Espera" painted on the other (Room of Hope—"wait" and "hope" are one word in Spanish). A board attached to the wall bears the information that Ciudad Juárez (last stop before El Paso, Texas) is 1,610 kilometres to the north and Mexico City 463 kilometres to the south, and that the altitude above sea level is 2,002 metres. And the prominence given to these calculations shows the lost immensity of the distances they describe.

§ § §

WHEN GENERAL MANUEL GONZÁLEZ died on May 8, 1893, they carried him out of the governor's residence and took him down to Guanajuato Station. On May 9 the body of Guanajuato's last bandit reached the San Lázaro station in Mexico City and was borne in state on a gun carriage through the streets of the capital at the head of a cortege of cavalry and mule-drawn trams. A few months later María del Pilar told Diego that they too were going to the station and getting on a train. She packed up everything in the house, paid off Martha and kissed Tía Cesárea and Tía Totota goodbye. Then María del Pilar and her two children took the train to Mexico City and never came back. Don Diego was away on a tour of inspection at the time, and when he returned it was to find a note from his wife telling him to sell the house and follow; from now on they would not be living in Guanajuato.

It is not clear quite why María del Pilar should have left the town where she had been born on the spur of the moment towards the end of 1893. The authorised version is that Don Diego had become politically unpopular for his liberal views; the change of governor a few months before the family's move supports this. Rivera took the view that his own performance on the altar steps of the Church of San Diego may have been the deciding factor. Another theory is that his mother, having qualified at the university as a midwife, became frustrated by the town's conservative medical establishment. However, none of these reasons explains the abruptness of María del Pilar's departure. The Rivera family claim that it followed "a public attack by the clergy of Guanajuato." But she left like a woman avoiding a bailiff, and it seems likely that by 1893 the protection afforded by General Manuel González to Don Diego had become largely financial. When the governor died, the protection ended. In which case Don Diego's exit had no political significance; he was just

another failed mine-owner, a detail in the statistics of the economic decline of a city which had once produced more than half the world's silver. And perhaps it was just as well that the Rivera family silver mines failed. If they had been productive, Diego Rivera would probably have grown up on a hacienda stocked with debt-bonded slaves; they would have been the only Indians he met, and he would never have ridden up into the hills strapped to the back of a Tarascan wet-nurse, who was seated astride one donkey with the pack donkey following patiently behind.

Y O U N G M E N I N
W A I S T C O A T S

Mexico City 1893–1906

THE TRAIN CARRYING the Riveras away from Guanajuato travelled through a landscape that had been painted many times by Velasco. On his canvasses one sees the ring of volcanoes surrounding the distant city by the lake, and the train winding along the edge of the *barranca,* the line shaded by trees, the track climbing slowly to its destination: the high valley of Mexico where, in Paz's words, "man feels himself suspended between heaven and earth"—and still did in 1893. Occasionally the carriages moved out over a lacework of metal girders that bridged a gulch, so achieving the impossible: flying without wings; or so it must have seemed to a small boy looking down through the carriage window. As the train moved Diego, aged seven, across this wonderland, he could not have realised that everything familiar in his life was being left behind, and that he would never again live in the magical city of Guanajuato.

Shortly after their arrival in Mexico City the Riveras were joined by Don Diego, who found his family in a hotel on the Calle Rosales, where he himself managed to obtain a temporary job as the hotel bookkeeper. Later he was awarded a clerkship in the Department of Public Health. For a man who in his hometown had been able to describe himself, accurately, as an engineer, mine-owner, newspaper editor, city councillor, professor, author, and inspector of state schools, this was a setback. But the clerkship showed that he retained some influence, possibly through the Masonic lodge. And María del Pilar's panic may not have been so ill judged after all. In Guanajuato the new governor closed *El Demócrata* and arrested the staff, and in the years to come liberal newspapers in San Luis Potosí and Guanajuato were regularly suppressed and their journalists

beaten up or murdered by supporters of Porfirio Díaz. But for Don Diego
the departure from Guanajuato marked the end of his hopes for a politi-
cal career, and for the rest of his life the ruined mine-owner remained a
loyal servant of the *Porfiriato*.

This was not at first a rewarding form of devotion. Don Diego was a
newcomer, and what could be discovered about his activities in Guana-
juato would not have been reassuring. The early years in Mexico City
were a difficult period. The boy, Diego, according to his own account, was
undernourished and although the son of a public health official, he suf-
fered from scarlet fever and typhoid. In 1894 his mother became pregnant
and for the first time el Chato was sent out of the house to go to school;
his mother chose the Colegio del Padre Antonio, a private Catholic pri-
mary school. In 1895 she gave birth to another son, Alfonso, but the baby
died after one week. Then, as Don Diego won the confidence of his supe-
riors in the ministry of health and it became clear that he had abandoned
his active support for liberalism and was a competent administrator,
things began to improve. The Riveras found an apartment on the Puente
de Alvarado, then moved to a flat which took up the entire third floor of a
house on the Calle de Porticelli. Don Diego was promoted to the position
of public health inspector, and María del Pilar, who was happier in the
teeming obscurity of Mexico City, built up her midwifery practice and
opened a gynaecological clinic.

Their new home was only one block from the Zócalo, the city's cen-
tral plaza. At that time this enormous open space in front of the presiden-
tial palace still had a beaten-earth surface on which was laid a filigree of
tram lines for the heavy railway-style carriages drawn by a pair of mules.
The horse carriages had to cut their way between these juggernauts;
there was no rule of the road: the drivers just took a bearing across the
distant vistas of the square and plunged in. Collisions were frequent and
popular songs were written about them. Through these dramatic streets
Diego walked to school, a different Catholic school, the Liceo Católico
Hispano-Mexicano, where he later recalled that he had been happier and
had been taught by an intelligent priest. He may also have been a patient
priest. In later years Diego tended to look back on himself as a child
prodigy, but a letter he wrote to Tía Cesárea, dated July 1896, when he
was aged nine, shows indifferent handwriting. He was, however, out-
standing at drawing. By 1895 he had moved on from railway engines to
devils; no saints survive, but there was a solitary cherub, naked except for
helmet and spear with a shield placed to protect his or her sex. This is
what el Chato gave his mother for her saint's day, October 12, when he

was aged nine. Later he executed a pencil sketch of his mother that was so unflatteringly accurate that she destroyed it.

The district they were living in, behind the Palacio Nacional, first on the Calle de Porticelli, then on the Calle de la Merced, was dominated by two enormous markets, occupying a total of forty-nine hectares and thought to be inhabited by approximately three million rats. This crowded daily festival of food, flowers and animal life was the perfect diversion for a small boy, and in his painting many years later Diego would celebrate the colours of the market and the patient attitudes of its vendors. And in old age Rivera would paint one of his greatest frescoes, which shows the pageants of the city's streets in his childhood filled with a fantastic carnival of historical figures and living characters from the *Porfiriato* as they might have appeared in a dream. But the most vivid contemporary pictorial record of the city in which Diego grew up is to be found in the work of the engraver José Guadalupe Posada.

Posada's printing shop was in the same central district in which Rivera spent the greater part of his impressionable years. In later years Diego was to claim that Posada had been "the most important of my teachers." In fact, there is no evidence that the two ever met, but given the boy's fascination with the life of the streets and his love of anything artistic or mechanical, it would have been odd if he had failed to notice Posada's shop, particularly since a printing shop is often open late at night. When other shops were dark and silent, the hypnotic and repetitive noise of the press and the sickly-sweet smell and the heat of the ink would have carried down the empty street. And on many of the countless occasions that he passed the shop, Diego must have noticed the engraver, with his round face, handsome moustache and generous paunch, lounging at his doorway in moments of idleness.

For all his popular success, Posada lived and died in critical obscurity and was buried in a pauper's grave in 1913. His work was only noticed ten years later by the French artist Jean Charlot, who rescued many of his printing blocks when they were on the point of being destroyed. Thanks to Charlot, we can still place much of Rivera's childhood in its popular contemporary context. The illustrator's etchings and engravings were widely distributed on broadsheets or in newspapers or as cheap prints. Posada was not a revolutionary artist; he was a commercial artist capable of executing commissions for "official" art, as in a superb full-page woodcut published just before the Riveras reached Mexico City. It depicted the arrival in the capital of the body of General Manuel González, recumbent in full military uniform, his plumed hat on his stomach, his sumptu-

ously bearded head cradled on a frilly pillow. It is a rare example of
Posada drawing a dead man with his flesh on; he was a specialist in skele-
tons. Posada also made countless studies of a heroic Porfirio Díaz appear-
ing above headlines describing another rigged election as "a landslide
vote." Later, at the appropriate time, Posada would portray the southern
"bandit" Zapata in heroic revolutionary pose.

But his most absorbing work is of the pageant of street life, where he
recorded the violent energy of the Mexican people which would shortly
be unleashed in a revolution. He depicted the everyday horrors encoun-
tered or imagined by impoverished families, brawls between mothers,
mothers-in-law being clubbed over the head with a bottle of *pulque* after a
word out of place, or a woman giving birth to three lizards, amazing
event, and likely to have been a matter of comment in María del Pilar's
waiting-room. Then there were the forty-one homosexuals arrested at a
midnight ball and shipped off to slavery in the Yucatán. The End of the
World, billed for November 14, 1899, at 12:45 a.m., made another superb
subject for Posada, with the sun blazing in the black midnight sky, a
shooting star, an angel with a trumpet, a volcano erupting, a church
tower toppling in an earthquake, forests and houses exploding, and the
populace gathered together to be pelted with molten lava.

There were fires, railway disasters and suicides in Posada's work, a
cyclist squashed by an electric tram, all the life and death of a city that was
joining the industrial age; but there was also the more particular flavour
of Mexican life. There was a female duel with pistols, the combatants
wearing full skirts and high lace collars; there was the Incredible Case of
the Woman Who Split in Two and Turned Herself into a Snake. There
was the pageant of public executions, one of the most popular sideshows
of the day, and there were events which took place near the Rivera home
such as the suicide of the young lady who leapt from the tower of the
Cathedral in May 1899, and the Giant Hailstorm of three o'clock in the
afternoon of April 9, 1904, when flying ice-balls struck people dead in
the street. Posada illustrated a range of cautionary tales likely to impress
even the most intrepid small boy.

Strange events occurred inside the Rivera house as well. After the
death of the baby Alfonso, his body was placed in a coffin lined with
white satin and surrounded with flowers. While friends and relations
attended the customary wake, Diego, aged eight, and his sister María,
aged three, discovered the open coffin, which had been placed out of the
way in an adjoining room, and started to play with the doll-like corpse of
their little brother. A fight broke out and Tía Cesárea rushed in to find

Diego and María tugging the body of Alfonso round the room. It was a Posada cartoon come to life.

If Posada shows the spirited resilience of people surviving difficult times, his work stood out against a background that during the Díaz years became steadily more sombre. It was a time of peace and economic stability which favoured industrial development and eventually enabled Mexico, particularly the northern part of the country, to escape from what was later termed "the Third World." The rail transport system, heavy industry and oil fields were developed and the peso was as solid as the U.S. dollar. Foreign investment flooded in. But the elegance and dynamism of this world, a land of sherbet, tea gowns and silk parasols, of homburgs and high collars, recorded by the photographer Agustín Casasola, were built on a system of social injustice and tyranny. The Díaz tyranny was not a religious one. It was a Republican tyranny with a democratic superstructure, an anti-clerical tyranny, a rationalist demonstration that when it came to injustice, man could, in every way, equal God. Díaz was of mixed blood, half Mixteca Indian from the state of Oaxaca, half Spanish and half illiterate. He had started his career as a progressive army officer and distinguished himself fighting for Juárez. He came to power by leading an armed revolt in 1876, against a lawfully re-elected president, with the battle cry "No presidential re-election." But once Díaz had obtained power he held on to it for thirty-five years. In 1880 he rigged the elections to ensure that his placeman, General Manuel González, became president. Then in 1884 he rewarded González with the governorship of Guanajuato and rigged his own re-election. He had himself proclaimed the victor after rigged elections every four years until he was overthrown by the second Mexican Revolution in 1911. It was after the election of 1892 that Díaz adopted a policy of "scientific government" which gave "economic development and scientific government priority over individual freedom." This decision, one of the most picturesque but also one of the most menacing of Díaz's reign, ushered in the era of the "científicos," a cabinet of savants who followed the teaching of the French sociologist Auguste Comte. The científicos argued that all true knowledge was scientific and depended on the description of observable phenomena. They imposed an intellectual totalitarianism that was directly descended from the Enlightenment and the French Revolution, sharing Rousseau's contempt for the will of the majority. They believed that it was the duty of the wise to impose their wisdom on the brutish masses. It was the worship of "facts" and the rule of science untempered by humanity. As a direct consequence of Díaz's policy of encouraging foreign

investment, and with the blessing of his "scientific" economists, Díaz
reintroduced slave labour into Mexico.

It has been estimated that by the end of Díaz's reign 90 percent of the
country's rural population was landless and risked starvation. At the
same time the boom in foreign investment had created an intense
demand for cheap labour on the cash-crop plantations and vast haciendas
set up to give foreign capital a handsome return. The situation was
described by the North American writer John Kenneth Turner in 1909 in
his book *Barbarous Mexico,* a provocative title which probably accounted
for its failure to appear in a Spanish-language edition until 1955 (when it
was called *Various Agricultural and Industrial Problems*). At a time when the
Porfiriato generally received a good press abroad, Turner set out to give a
fuller picture. He revealed that debt-bondage and outright slavery were
widely practised in the Yucatán on the *henequén* (sisal hemp) farms, where
fifty "*henequén* kings" held about 125,000 slaves on estates that were up to
15 million acres, or 23,000 square miles in extent, each roughly the size of
mainland Scotland or West Virginia. Most of the slaves were Mexican cit-
izens, either Mayan Indians who had formerly owned the land or rebel-
lious Yaqui Indians from Sonora in the north who had been transported
across the country by boat and train. Another centre of slavery was the
Valle Nacional in the state of Oaxaca, where tobacco planters had gained
control of the land by cheating the Chinanteco Indians who had been set-
tled there by Juárez.

Posing as a prospective investor, Turner investigated the methods
used to obtain slaves. He found that when the local supply of illiterate
Indians was exhausted, the planters turned to labour agents, slavers, who
scoured the country on their behalf. The agents paid commission to the
governor, the local administrators, or *jefes políticos,* and the police chiefs of
each state they operated in. Under Díaz, Mexico was governed in three
tiers, the president being the first tier and the state governors forming the
second. The *jefes políticos* answered to the governor of the state and were
given carte blanche, thus forming the third tier of government. The
planters paid the agents and the agents paid the police chiefs. The police
chiefs emptied their jails by deporting convicts into the custody of the
labour agents, and when the supply of convicted criminals ran out they
often arrested people on the street on any pretext, however implausible,
and deported them instead. Another method used by the labour agents
was to induce trusting people to sign enforceable contracts which
promised them high wages when they reached the Valle Nacional
tobacco plantations. Thousands of labourers travelled to the Valle

Nacional willingly, having no idea that they would see none of the money promised, would be unable to communicate with their families once they arrived, and would most probably be dead from exhaustion or disease within two years. The people kidnapped on one pretext or another included skilled craftsmen, industrial workers, teachers and artists.

Turner's book spotlights a number of the hazards of Mexican life scarcely hinted at by Posada, and it has direct relevance to the destiny of Rivera. All his life Rivera was to claim that he had been sent to study in Europe on a state grant by a governor who was a liberal and humane figure, widely loved and respected, and, by the end, an opponent of Porfirio Díaz. This was Teodoro Dehesa, the governor of Veracruz State. Although Governor Dehesa was undoubtedly a more cultivated man than other state governors, he was also one of those most deeply involved in the slave trade. Slaves came to the Valle Nacional from all over Mexico. Turner met slaves who had been deported from San Luis Potosí and from León in the state of Guanajuato. In order to reach the Atlantic coastal areas and the south, where most of the large estates had been established, it was necessary for the slaves to transit Mexico City and then be sent down the rail line to the port of Veracruz. Governor Dehesa was in office for practically the whole of the Porfirian era and was involved in the slave trade from its inception. The cities of Veracruz and Córdoba in Veracruz State were two of the leading suppliers of slave labour to the Valle Nacional, but slavery was also used in Veracruz State itself on the rubber, coffee, sugar cane, tobacco and fruit plantations. Dehesa, whom Rivera was so anxious to depict as an enlightened exception to the general brutality of the regime, was, in fact, just a man of his times. If a direct consequence of the policy of encouraging foreign investment was the reintroduction of slavery into Mexico on a scale that matched that of colonial times, and if practically all the victims of this development were Mexican citizens and most of its beneficiaries were North American or British investors, at least the situation could be "scientifically" justified. As one of the tobacco planters of the Valle Nacional explained to Turner, tobacco grown under the Mexican labour system cost half as much to produce as Cuban tobacco of the same quality. The "scientific economists" were delighted by the balance sheets of the plantations in the Valle Nacional.

Nor was slavery confined to rural areas. The streets of Mexico City were almost as dangerous. Labour agents roamed the capital every day. In 1908 the rudimentary police records showed that 360 boys aged between six and twelve had disappeared on the streets of the city that year and that

some of them had subsequently been traced to the Valle Nacional. This was the equivalent of an entire primary school and has been estimated at over 2 percent of the available male population within that age group. And the records would only have noted a proportion of those whose disappearance had led to a complaint. One labour agent who spoke to Turner identified himself as a personal friend of the governor of Veracruz and as the brother-in-law of Feliz Díaz. Feliz Díaz was the nephew of President Díaz and was the chief of police of Mexico City. The agent said that he paid his brother-in-law ten pesos for every slave taken out of the city. For Feliz Díaz, the celebrated forty-one homosexuals, twenty of them in ball gowns, caught dancing "the Dashing White Sergeant" in November 1891 would have been worth at least 410 pesos ($205, or £51). With patronage like that, the labour agents could operate more or less with impunity. Just occasionally they seized someone who had sufficient luck or influence to escape, but this was rare, and even when a slave had been traced to one of the hundreds of large estates using slaves, it was unusual for him to be rescued. One of the most popular actresses in Mexico died as a slave in the Valle Nacional because the son of a millionaire fell in love with her and the boy's concerned father arranged to have her kidnapped by a labour agent.

The other great paradox of Porfirian society lay in its admiration for everything European. The Díaz regime succeeded that of Juárez and never repudiated Juárez, who remained an official national hero. Juárez had come to power by defeating the interventionist rule of the French puppet emperor, Maximilian of Austria. So Mexico in 1867 asserted its national identity by rejecting Europe. Therefore, it might be supposed that the *Porfiriato* would also be anti-European. In fact, it was a time when everything European was extolled. The regime's founding philosophy came from France. The ports, factories and railways were built by English engineers; as Mexico City was slowly developed, its architects took their ideas from Haussmann and it was eventually vaunted as "the Paris of the Americas." At San Carlos, the national art academy, European art and civilisation, both ancient and modern, were regarded as the model for Mexican artists. The Emperor Maximilian had attempted to re-create an Austrian imperial court in the castle at Chapultepec. Díaz made the castle his presidential palace and continued to adorn it in the same imperial style. He decorated its hallways with ornate malachite vases made in Italy, to a neo-classical design, from Russian material and purchased in France. The chairs in his music room were covered in Aubusson tapestries depicting the fables of La Fontaine. Carmelita's bedroom was furnished with

French imperial chairs and wardrobes encrusted with bronze and marble. When Santiago Rebull, one of Mexico's leading artists, and eventually one of Diego's teachers, who had been a pupil of Ingres, was invited to embellish the walls of the arcade around the presidential garden, he chose to paint them with Grecian bacchantes. Classical mythology was also the chosen theme of the stained-glass windows ordered from France for the presidential stained-glass window gallery. When the Aztecs defeated their enemies in war, they ate them. Perhaps the most Mexican aspect of the era of Porfirio Díaz was this regurgitation of the style of the court of the Emperor Napoleon III forty years after Napoleon had abdicated and retired to die in a house in Chislehurst, Kent.

§ § §

IT WAS IN THIS exuberant, chaotic and occasionally dangerous world that Diego grew up. At the age of nine, when he was still attending a Catholic primary school, he started going to evening classes at the Academia San Carlos. There followed a brief period when his father tried to make him enter the Colegio Militar, the episode which later gave rise to the "young Napoleon" legend; but this false start was due to the fact that Don Diego was trying to provide for the future of his son in a country where 70 percent of the literate population were employed by the state. After a short trial it became clear that Diego would never make a soldier, so his mother had her way and the unhappy boy was allowed to leave the Colegio Militar and attend San Carlos as a full-time student. San Carlos was to dominate his life for the remainder of his childhood and youth. When he started there, he was already capable of the sketch which so upset his mother, but which compares well with Picasso's juvenilia at the same stage, particularly since Rivera was virtually unschooled whereas Picasso was the son of a drawing master. Diego entered San Carlos as a full-time pupil in 1898 at the age of eleven. The move meant that he started his specialist education at an unusually early age. All his life Rivera showed a naïvety in formal argument that verged on childishness; the myths he recounted about his own past are sometimes an example of this, and it may be that the interruption in his general education partly accounted for it, his mind remaining to some extent the unformed mind, with the unshackled imagination, of a child. But it should not be supposed from this that Diego was taught only how to draw and paint at San Carlos. The future artists were also made to study maths, physics, chemistry, natural history, perspective and the human figure. This curriculum,

as Ramón Favela has pointed out, bore all the marks of the *científicos* and their dogma of Comtean positivism.

The ideas of Auguste Comte had first been popularised in Mexico in 1855 by Pedro Contreras Elizalde on his return from studying medicine in Paris. Contreras became minister of justice under Juárez. Shortly afterwards Guanajuato became a centre of Comtean studies when Dr. Gabino Barreda, who had also studied medicine in Paris, was appointed to the chair of medicine, physics and natural history at the university. Many of the supporters of the Juárez regime were Comteans, apart from Contreras. In Mexico City the Escuela Nacional Preparatoria was set up in 1867 with a Comtean curriculum, and Barreda left Guanajuato to become its first director. He was eventually expelled by supporters of Díaz in 1878, but the curriculum remained and influenced the curriculum in San Carlos. Comte taught that progress was desirable and that it occurred in three stages: the theological, the metaphysical and finally the positivist, when man sheds supernatural explanations and confronts objective reality. When the theories of Spencer and Darwin were added to positivism, the *científicos* were able to find a new justification for social hierarchies, as Paz has noted. Inequalities were now explained "not by race or inheritance or religion, but by science." In later life Rivera frequently described his intellectual education, first from his anti-clerical father and then from his Comtean professors, as humanist and atheistic. This was correct, but the teaching was also profoundly authoritarian and intolerant of human weakness. Under Barreda the Escuela Preparatoria produced an intellectual class that was to guide the country not only under Díaz but in the early years of the post-Díaz era. Rivera was exposed to the positivism of these teachers from the age of eleven, but up till then he received a more traditional Catholic education and was more under his mother's than his father's influence. The suggestion that his mother came to adopt most of her husband's ideas is called into question by the fact that Rivera himself always made a strong distinction between the good sense of his father and the irrationality of his mother, as well as by the fact that the relationship between his parents became increasingly hostile as time passed. In going to San Carlos, Diego moved from the maternal to the paternal sphere of influence, abandoned his early Catholicism and adopted the conventional atheism of his peers. But he was doomed to remain a Mexican atheist, which means that he was a religious one.

The artist grew up in the shadow of the conflict that was fought out over the years between his mother and his father, and between his mother and the rest of the world. A few years after the incident when her two

small children had been dragged away from their dead brother, María del Pilar, who signed herself "María Barrientos de Rivera," wrote to her sister, "la Señora Cesárea Barrientos de Villar," in Guanajuato.

December 30, 1900
Dear and unforgettable sister,

How I would have liked to give you my love a thousand times on the eve of the new century in this our house, which will always be your house. But, without any explanation you decided against honouring us with your presence. No doubt you had your reasons. You must have feared feeling uncomfortable and gloomy and unwelcome. In the situation we are in we should not persist in inviting people if it is to oblige them to feel uncomfortable, as you certainly would have felt had you accepted our invitation. . . .

I think by now you must have received the presents which my poor children had prepared to welcome you into our humble home, which will always be your home. Please excuse all the errors they contained. They were just the first attempts they had undertaken on your behalf. . . . But as their mother I beg you to accept them as a completely innocent and sincere demonstration of affection and gratitude. At the same time I beg you both, should I expire, possibly in the near future, not to abandon my children. Always care for them, particularly for poor little María, who is already so unfortunate as to have been born female.

Give all my good wishes and loving thoughts to Canutita and María, and may you all be as happy and fortunate as you have always been (so far).

From your loving sister who wants to see you so much,

María Barrientos de Rivera

P.S. Little Diego celebrated his fourteenth birthday at 6:30 p.m. on the eighth of this month. And his little moustache has started to grow!

In family matters, as in the rest of her life, Diego's mother was overemotional, demanding and unforgiving. Diego saw his mother become increasingly irrational as time passed, and watched while his father struggled to find the patience to support her behaviour despite the humiliations of his own life. Later Diego resolved the contradictions in the family background, and his own anguish at his father's humiliation, by constructing a series of legends about his childhood and about the life he and his father had led in Mexico in the years before the Revolution. In this legend his father had never been a small cog in a repressive machine but a public opponent of it, driven into obscurity because of the threat he posed. And he himself had not been a studious child obsessed with drawing but a precocious military genius who had led a student rebellion.

While his greatest teacher had not been one of the celebrated salon artists of the day but an obscure proletarian engraver whose work presaged the Revolution. The facts were rather different.

Whatever its limitations, Diego seems to have profited greatly from his years of study at San Carlos. He was a docile pupil who worked so hard that by the age of fifteen he had already reached the final level of study. There is a photograph taken in San Carlos in 1902 showing a group of teachers and students assembled with their latest efforts at portraits. Diego is a serious young man, formally dressed in a dark suit and waistcoat, his hair slicked back and parted to the left with no moustache, unlike most of the other students, who are visibly older than he is. It is not always a pleasant experience being two or more years younger than the rest of the class. Diego would initially have been mocked for his youthfulness and resented for his superior ability. In response he would have concentrated even more on his work. A landscape executed in the year of the photograph, 1902, was dedicated by Diego "to my dear master the celebrated painter Don Félix Parra." Favela considers that his childhood love of anything mechanical and the scientific training he received, which included a grounding in architectural geometry, gave him a natural tendency to associate painting technique with scientific theory, and that this led him, starting with the theories of Plato and the golden section, in due course to Cubism. But it would probably have been rash at any time to rely on Diego for a clear exposition of scientific theory. Because of the unformed nature of his intelligence, he rarely separated the reasoning and imaginative powers of his mind. The man who claimed as a child to have filled whole notebooks with tactical battle plans of such brilliance that experienced generals were dazzled was later to spend several years searching for "the Fourth Dimension"; and he kept as a closely guarded secret a construction which he had designed himself and which he was convinced would propel him beyond the visual into some ocular equivalent of the field of gravity. Scientific theory would remain a delightful toy for the whole of his life.

When the time came for Rivera to conjure up the legend of his life, he emphasised that he had been a rebellious student at San Carlos and even claimed at one point to have been expelled for his role in a student strike. He also gave an implausible account of a conversation he had had one day with Posada, and how the self-taught man of the people had said, "There is nothing of value in that Academy . . . except for old Velasco, he *is* a painter, what landscapes! And old Rebull isn't bad . . . and that stubborn old Félix Parra . . . ," and so on. To conclude from this, and from

Rivera's later fabulations, that the docile young student could never have met Posada would be severe. We know that there was some contact between San Carlos and Posada from the fact that José Clemente Orozco, three years older than Rivera and also at San Carlos, spent some time in the engraver's printing shop. But Rivera's peripheral experience of a student rebellion had nothing to do with Posada.

In 1902 Santiago Rebull died and was replaced in the following year as director of painting and drawing by a Spaniard, the Catalan painter Antonio Fabrés-Costa. The new director decided to make his mark by changing the methods used to teach drawing; henceforward students would draw ordinary objects, not just classical busts, and would work in artificial light. The innovations led to objections among the staff and the students, who were already resentful at the appointment of a foreigner, and there was a student rebellion against the "neo-colonialist" policy of the new director. If Rivera was involved in this—the records show that he was suspended for less than three weeks for "disobedience" and "disrespect"—he was certainly not a ringleader. The changes, in any event, seem to have had little effect on his work, which was by then nearing the end of the normal curriculum; he had reached the final year in 1902, aged fifteen. Shortly after the arrival of Fabrés-Costa, Diego took a sabbatical and travelled outside the city to work on landscapes. Four of the paintings he made survive, and two of them more than justify his teacher's confidence: El paseo de los melancólicos and La era, the latter a study in the manner of Velasco, then the most celebrated painter in Mexico, of the walled yard of a large hacienda with a snow-tipped volcano in the background. La era is particularly interesting because it suggests that once he had escaped from the artificially lit, Eurocentric atmosphere of San Carlos, a Mexican subject could inspire him to reach the limits of his technique.

In 1905 Diego returned to San Carlos for his final two years. He was now aged eighteen and was awarded a medal in the competition for the drawing of clothed figures which led to the award of a bursary of twenty pesos a month from the ministry of education. The certificate, dated January 17, was signed by the under-secretary at the ministry on behalf of President Porfirio Díaz, and Diego drew a little treescape sketch on the back of it, a small gesture of independence from a student who had accepted the lucrative burden of state patronage, a burden which he was to bear cheerfully enough for much of his professional life. In the summer of 1906, at the age of nineteen, after eight years of full-time study, Diego Rivera passed out of San Carlos with honours and twenty-six works exhibited in the final show. He was widely recognised as an out-

standing pupil and was recommended by critics and officials to the gover-
nor of Veracruz State for a state bursary to study in Europe.

Diego's bursary was awarded, but it did not take effect until January
1907. In the ensuing six months he was free to enjoy the bohemian life of
Mexico City, untroubled by formal studies or examinations. It was at this
time, as he assured Gladys March, that he lived like a cannibal, joining
some friends who were medical students with access to the medical
school's mortuary, and who were conducting extra-curricular research
into the benefits of a diet of human flesh. Diego claimed that he had
never felt healthier and recommended "the breaded ribs of a young
female." "I discovered that I liked to eat the legs and breasts of women,"
he said. ". . . Best of all, however, I relished women's brains in vinai-
grette." Although it is difficult to disprove this story, there is no trace of
any medical students among the fairly large group of Rivera's known
friends. And Gladys March was, of course, "a young female" at the time
this fragment of Diego's early life emerged from his subconscious and
entered their conversation.

Among Diego's verifiable associates were the young architects, law
students and intellectuals later known as the "Savia Moderna" group.
They included the writers Martín Luis Guzmán and Alfonso Reyes. Both
Guzman and Reyes were to be in Paris or Madrid during some of the
years of Diego's residence in Europe and were to remain in touch with
him for the next fifteen years. Diego's landscape *La barranca de Mixcoac*
was included in an exhibition of avant-garde work in 1906. This was the
first time his work had been put on public display outside the walls of the
Academy. And there was further recognition when he managed to get a
drawing accepted as a cover illustration for the monthly neo-symbolist art
review which gave the group its name. Other illustrators included his
friend Roberto Montenegro and the painter known as "Dr. Atl."

"Dr. Atl" was Gerardo Murillo, a highly influential painter and
slightly sinister political agitator with extreme nationalist views, who had
returned from an extended sojourn in Europe in 1904. Back in Mexico he
adopted the nom de guerre of "Dr. Atl," derived from an Indian word for
water, claiming that he had travelled down all the rivers in Mexico, a sym-
bolic achievement which may have influenced the style of Rivera's subse-
quent mythologising. There is no suggestion that Murillo himself was of
Indian descent; he seems in fact to have been a classic example of Mex-
ico's minority, governing class, the criollos. Diego first heard of Dr. Atl
while he was still a student, since it was Atl who actually led the rebellion
against the innovations imposed on San Carlos by Fabrés-Costa. Atl was

out to cause as much trouble as possible among the Academy students. He was full of the painting he had seen in Europe but at the same time furious that so much influence over the next generation of painters should have been given to a European painter. Atl was a natural guru, an inspirer, an intriguer and a behind-the-scenes operator. But he was above all a Mexican nationalist, and in many ways in the recognisable tradition of the *Porfiriato*. If he had been offered a suitable position in the college's conservative administration he would in all probability have accepted it. He does not seem to have been a liberal or someone who had any ambition to alter the country's social contract. But as his ideas adapted to historical events in the years to come, he was to exert a considerable fascination for the young Rivera. His influence in 1905, when Rivera was still only eighteen, is less certain.

The six months of Mexican *bohème* passed and the time came for Diego to leave Mexico and set out for Spain. Naturally, there is more than one version of his departure. He was to tell Gladys March that he decided to set out for Spain on hearing of Cézanne's death in October 1906, though since Cézanne's work was totally unknown in Mexico it seems unlikely that this would have been announced. Favela has been unable to trace any reference to Cézanne in Mexican literature until 1921, when Rivera himself spoke about Cézanne on his final return from Europe to Mexico. But this does not mean that Atl did not talk of him and circulate his own reproductions of the master's work. What is more to the point is that there is no trace of a Cézannean influence in the work of Rivera for another twelve years.

The legendary account of Diego's departure gave a heroic role to his father, and lives on in the family's version today. Don Diego, who was working both for the public health service and as a part-time bookkeeper for several businesses in Mexico City, was sent on an official tour of inspection through the state of Veracruz, where there had been an outbreak of yellow fever. He took Diego with him to the fever zones so that the boy could paint landscapes and seascapes. On the outward journey they reported to the governor in Jalapa. Left outside the governor's office, Diego started to sketch; the governor came to the door to say goodbye to his visitor, caught sight of Diego's work and signed him up on the spot. "My boy," said Dehesa, "you have great talent. You must go to Europe." Earlier, following the legend, his father had applied for a grant from the governor of Guanajuato, Joaquín Obregón González, but had been turned down by this "dull man who had no interest in art." It seems unlikely that Don Diego would have wasted his time applying to a philis-

tine official for a favour on behalf of his artistic son, particularly since, again according to family legend, Don Diego was remembered in Guanajuato as a liberal opponent of the regime. Furthermore, so far from being uninterested in the arts, Governor Obregón seems to have been quite well disposed to them; virtually his first act on taking office on May 12, 1893, was to commit nearly 250,000 pesos to complete the construction of the municipal theatre, a project which had been dragging on for lack of funds for over twenty years but which, under Governor Obregón, was finished within twelve months. The truth seems to be that although Diego's family connections with the state of Veracruz were tenuous—his mother's father had been born in the fishing port of Alvarado, that was all—he received a Veracruz State bursary because Dehesa, as a noted patron of the arts, visited the final exhibition at the Academia San Carlos, where he was told that one of the graduates displayed outstanding ability. A subsequent journey through Veracruz State certainly did take place. In 1906 Diego made a drawing of the highest mountain in Mexico, the volcanic Pico de Orizaba in the state of Veracruz. The rail line from Veracruz to Mexico City passes through the town of Orizaba, near which is Río Blanco, where the textile mill workers came out on strike at the end of 1906. And this coincidence produced another legend.

Diego claimed that while he was painting the volcano he was swept up in this historic strike and that he "put aside his brushes" and fought with the mill workers. He was sabred by a mounted policeman and then thrown into prison. If this was the case, he was extremely fortunate, since those caught by the police in the initial battle were generally shot, their bodies piled onto railway flat cars and sent down to Veracruz to be thrown into the harbour. They numbered between two hundred and eight hundred. The strikers who were rounded up later were either impressed into the army or hanged. A few strike leaders were sent to prison. Diego may have been in the area when the strike started, but the riot and repression did not take place until early in 1907, when he was in Spain. His "liberal" patron Governor Dehesa was, incidentally, one of those who approved the measures taken against the strikers, and the *jefe político* he put into Orizaba after the strike, Miguel Gómez, came from Córdoba, in Veracruz, where he was noted for his brutal efficiency. Measures against strikes were tightened by Gómez, and any talk of liberalism or strikes was followed by the disappearance and murder of those concerned. This stopped strikes. The English manager of the Río Blanco mill, a man called Hartington, justified the action taken by describing the uprising as "an incipient revolution"; he himself estimated that over six

hundred strikers had been shot. He was extremely proud of the fact that his mill was the most profitable, giving the highest return on investment, in the world.

Apart from the journey to Orizaba, Diego also travelled to Querétaro in 1906, which is on the way to Guanajuato, where he may have gone to say goodbye to his family before leaving for Europe for an unknown length of time. Before his departure he also painted a fine self-portrait of the dreamy young man, without a visible sabre wound, who set out for Spain, leaving behind him the magical surroundings of his birth. For the following fifteen years he was to inhabit a land of reason.

PART TWO

THE LANDS OF REASON

THE EMPTY LANDSCAPE

Spain 1907–1910

I
N HIS AUTOBIOGRAPHY Rivera sketched an arresting self-portrait of the young artist landing in Spain. "I arrived on the sixth of January, 1907," he wrote. "I was twenty years old, over six feet tall and weighed three hundred pounds." Photographs taken at this time show a shambling figure who possessed two dishevelled jackets, his mouth and shoulders drooping in an attitude of settled depression. The photographs do not quite give an impression of three hundred pounds. Shortly after Rivera reached Madrid the beard which he had started in his last days as a student in Mexico, then trimmed off before his departure, made a reappearance. The facial scene-shifts give an impression of youthful unease and a lack of self-confidence. The beard "on" was a statement, "Take me as you find me, here is a man." The beard "off" suggested a retreat into diffidence, a willingness to be led.

From behind the beard, in his more confident moments, Rivera, when setting sail from the port of Veracruz, was a Cortés in reverse, an artistic conquistador of New Spain, crossing the sea to win fame and plunder the wealth of the Old World. The contrast between the two countries was striking. He had left a restless, dynamic society for a country whose economic development was such that his Spanish ship, the *King Alfonso XIII*, an elderly vessel which was to play an essential role in the Rivera family's movements for the next eight years, made its landfall at Corunna on February 2 after a two-week voyage, but then proceeded round to Santander to allow passengers bound for Madrid to disembark. To have travelled the direct route, overland from Corunna, would have taken very much longer. When the Picasso family moved from Málaga to Corunna in 1891, they took a boat via Gibraltar and the coast of Portugal

rather than attempting to cross the peninsula. And for voyagers from Mexico there was only one correct point of entry into this implacable landscape: the rail line to Madrid from Santander. Spain's national railway system was less developed than that of Mexico, but this line was in operation even in winter, looping up through the Cantabrian mountains and across the iron plains of the interior to Valladolid and Segovia.

Provisions for the journey had to be purchased before the train departed, and it was prudent to lay in enough supplies for several days. In the event of a delay, the train passengers climbed down onto the tracks, gathered brushwood, made fires to keep themselves from freezing—there was no heating on the train for those who were not equipped with their own mobile stoves—and negotiated where possible with the local peasants for milk, tomatoes, bread, cheese and poultry. Havelock Ellis was travelling through Spain at the same time as Rivera and he described the conventional manners of a winter rail journey.

By and by, when we have been some hours on our journey, [the man] lifts from the seat in front of him the large, heavy, embroidered wallet—that *alforja* which Sancho Panza was always so anxious to keep well-filled—unwinds it, draws out one of the great flat delicious Spanish loaves and throws it in the woman's lap. Then a dish of stewed meat appears, and the bread is cut into slices which serve as plates for the meat. But before the meal is begun the peasant turns round with a hearty "Gusta?" It is the invitation to share in the feast which every polite Spaniard must make even to strangers who happen to be present, and it is as a matter of course politely refused. . . . Before long the black-leather wine bottle is produced from the wallet, and . . . at its final stage some kind of sweetmeat appears, and small fragments are offered to the foreign *caballero* also. It is not improper to accept this time; and now the leather bottle is handed round . . . it requires some skill to drink from this vessel with grace.

So Rivera, perhaps covering himself with wine and confusion, began to learn about life in Spain on the long, slow journey from Santander to Madrid. When the service was diverted through Salamanca and Avila, the train entered Madrid beneath the walls of the Escorial fortress, one of the most forbidding buildings in the world. Rivera never chose the Escorial as a subject, but he was to prolong the memory of the men who had taken its orders many times in the years to come.

On reaching Madrid, Rivera made his way to an address which he had been given before his departure, the Hotel de Rusia in the Calle Sacra-

mento, where a friend of his from the Academia San Carlos, also on a state bursary, was already installed. The following day Rivera went to the studio of one of Madrid's leading portrait painters, Eduardo Chicharro, carrying an introduction from Gerardo Murillo. As he recalled in his autobiography, "I was a dynamo of energy. As soon as I located Chicharro's studio I set up my easel and started to paint. For days on end I painted from early dawn till past midnight." This habit of working long hours every day, which was confirmed by Chicharro's report, was to last for much of his life.

§ § §

THE SPAIN to which Rivera had come to escape from the isolation of Mexico was itself one of the most isolated parts of Europe. The course of European history had bypassed the peninsula for almost a hundred years, ever since the last of Marshal Soult's grenadiers had limped back across the French frontier in October 1813, harried by Sir Arthur Wellesley's turbulent and undisciplined infantry. Throughout the nineteenth century, with brief liberal interregnums and spasmodic revolts ruthlessly suppressed, Spain dozed under four Habsburgs—one Ferdinand, one Isabella and two Alfonsos. Alfonso XIII was still on the throne at the time of Rivera's arrival. The only time when Spain affected the direction of European history was in 1870, when Bismarck used its vacant throne as the pretext for the Ems telegram, so provoking the Franco-Prussian War and the fall, in Paris, of another Napoleon. The only Spanish city that remained in close touch with the rest of Europe was Barcelona. It was in Barcelona that Picasso, who had passed briefly through Madrid, completed his apprenticeship at the School of Fine Arts from 1897 to 1900. While a student in Barcelona, Picasso acknowledged his drawing master's ability—a rare tribute: he had already, at the age of sixteen, dismissed Murillo as "unconvincing" after a single visit to the Prado—and attributed his master's prowess to the fact that he had studied in Paris. Picasso added, in a letter to a friend, "In Spain we are not stupid. We are just very badly educated." It was to this country that Rivera had been sent to complete his education. Furthermore, during his two-year residence Rivera seems to have visited Barcelona on only one occasion. Madrid, where he passed his final years as a full-time student, was, by contrast, the citadel of Castilian reaction. This Mexican Cortés, in search of the mainstream, had sailed up a backwater. But Rivera nonetheless spent a considerable part of his time

in Spain between 1907 and 1915. For Rivera Spain was at first an introduction, then a haven where he had friends and where he could feel closer to home.

But if Rivera felt more at home in Spain, he was not regarded by the natives as being in any sense Spanish. Europe had scarcely interested itself in Mexico even when its wonders were first laid out on display three hundred years earlier. There are only two clear signs of an artistic interest in Mexico during the seventeenth century—both being religious carvings, one in Liège and the other in Rouen. A third may exist in the cathedral at Amiens. In 1520 the only European artist known to have responded to the splendours of "the Indies," as New Spain was then known, saw a collection of Mexican treasures which had been remitted to the King of Spain and mounted on exhibition in the Hôtel de Ville in Brussels. In awe Albrecht Dürer wrote: "In all the days of my life I have seen nothing which touches my heart so much as these, for among them I have seen wonderfully artistic things and have admired the subtle ingenuity of men in foreign lands. Indeed I do not know how to express my feelings about what I found there." But for all the artist's wonder at the art of the Aztecs, it failed, with the exception of some drawings of Indian figures, to make much impact on his work. There was something in Aztec culture which was not just foreign to Christian civilisation but which caused revulsion. The Aztecs' land of marvels was quickly stigmatised as "barbaric," a judgement which lasted from the Conquest to the arrival of Rivera in Spain.

Under the rule of Porfirio Díaz, and in the wake of the country's determination to follow a European model, Mexico became a more familiar idea, one in which Europe could profitably invest. But although Rivera was intended to become a prominent ornament of that doomed "European" Mexico, he retained "a sense of inferiority . . . a racial feeling . . . the response of men reacting to a tradition of defeat." At no time did Rivera seem to have regarded his period in Europe as a return to what was supposed to have been the land of his grandfather and great-grandfather. Although the Francophile traditions of his Mexican upbringing led him to regard himself as a child of the European Enlightenment, he never ceased to regard himself at the same time as an exile and an outsider.

At the beginning of his exile his newcomer's eye could only have been an advantage. He had the vivid experience of living by himself for the first time, of living abroad, and of living beside the Prado. The Hotel de Rusia was close to the Puerta del Sol, and only a few blocks from one of

the finest collections of painting in the world. For the first time Rivera could see and copy from the original work of El Greco, Velázquez, Zurbarán, Murillo and Goya. Unlike Picasso, Rivera had not been brought up dependent from and surrounded by an art and culture dating back nineteen hundred years. The contrast between the pale imitations available in the Academy of San Carlos and the originals must have been the imaginative equivalent of a blinding light. Many years later Rivera complained that the pictures he had painted during his two-year residence in Spain were "the flattest and most banal" of his life. "The inner qualities of my early works in Mexico," he said, "were gradually strangled by the vulgar Spanish ability to paint." In the mouth of a Mexican patriot, these words have a slightly expected ring. But it was, in any case, to be many years before Rivera's painting acquired the originality to make it immortal. In 1907 and 1908 he was still in the early stages of a very long apprenticeship, and even if his work lost some of its early character, it was acquiring something far more important: a mastery of technique. His teacher, Eduardo Chicharro, aged only thirty-four in 1907, was a noted colourist, a fashionable portrait painter and a highly conventional figure. Rivera's two years of patient labour under this academic guide did for his painting what Picasso's similar labours in Barcelona's School of Fine Arts had done for him. There is, however, one striking contrast in the student work of Rivera and that of Picasso. With the exception of a few horned devils, one heavily armed cherub and a single Virgin's head, there is no religious painting in Rivera's work at all. That Rivera never had to undertake the stock devotional genre painting to which the young Picasso devoted much of his energy is an illustration of the cultural difference between Mexico and Spain in the first decade of the century. Even in Chicharro's studio Rivera never stretched his interest to cover religious subjects, although they were a lucrative field for professional painters. The paintings were, after all, due to be sent to the state governor of an administration that was formally anti-clerical. He painted the outside of more than one church, but he drew the line at the threshold. Nonetheless, there is no sign of a politically or artistically revolutionary spirit in the paintings of the industrious young Mexican. He remained just as conventional a youth as he had been in Mexico City, a child of the lower bourgeoisie on a government grant, struggling to complete his apprentice work and liberate his talent.

Although Rivera had been introduced to Chicharro by his Mexican mentor, Dr. Atl, and although he had been introduced to the Hotel de Rusia by another Mexican friend, he tended, as time passed, to isolate

himself from the Mexican community in Madrid. His hard work did not save him from loneliness, and his early letters home so alarmed his mother that she offered to cross the Atlantic. When he received this offer he was appalled and replied immediately, but to his father, explaining that he was working far too hard to be able to entertain his mother. To this letter his "unhappy mother" eventually responded with wounded dignity, assuring him that he would "never have the displeasure" to set eyes on her again. Diego wrote again to his father, saying that he was still working from the time he got up to the time he went to bed. The truth of this was confirmed by Chicharro, who that year issued a certificate in his pupil's favour. This was addressed to Governor Dehesa and stated that "since Rivera arrived" he had made "astonishing progress," that he possessed "magnificent qualities," and that he was a "tireless worker."

Apart from the instruction provided by Chicharro, Rivera may also have been slightly influenced by the friends he made among Madrid's bohemian and intellectual circles. If the city was an artistic backwater, it was not a desert, and the intellectual life of the capital was nonetheless passionate for being out of fashion. The Hotel de Rusia stood near the Café de Pombo, which had been a celebrated bohemian meeting place since the days of Goya. And there was also the Nuevo Café de Levante, which gave its name to a circle of writers and critics based on "the generation of '98." It was here that Rivera would have met members of that group, which included the Baroja brothers, Ramón Gómez de la Serna and Ramón del Valle-Inclán, who became his friend. According to Havelock Ellis, who enjoyed compiling lists, the most famous living painters in Spain in 1907 were Zuloaga, Sorolla and Anglada Camarasa. But for the generation of '98 these fashionable and celebrated artists represented an academic *"pseudomoderno"* whose time was past. In their place Baroja proposed the neo-traditionalist symbolism of the Parisian painter and critic Maurice Denis. On one celebrated occasion the novelist and poet Valle-Inclán urged a group of avant-garde artists to "go to Toledo and kneel at night-time and by moonlight beneath *The Burial of the Count of Orgaz* in the chapel of Santo Tomé by the divine Greco." Rivera does not seem to have studied this painting until 1911, but he then accorded it such devotion that in 1915 he still had a reproduction of El Greco's *Burial* hanging on the wall of his studio in Paris.

The generation of '98 took its name from Spain's humiliating defeat in the Spanish-American War, when the country lost its last American colony, Cuba. In reaction, the men of '98 considered that the way forward lay backward, that all the greatest painting was in the past, and that a

revival would depend on the inspiration offered by metaphor and symbolism. Since Chicharro's master had been Sorolla, and since Rivera was a malleable and attentive pupil of Chicharro's, this raises a doubt as to his sincerity in identifying himself with the Madrid avant-garde. At one point Valle-Inclán went so far as to launch a public attack on the work of Chicharro while Rivera was still working in his studio. In the authorised version of his life Rivera always emphasises his connection with Valle-Inclán. In the sequence of confirmed facts we know only that the artists continued to study under his then fashionable, later to be slighted, master. Later, long after it had become clear which way the critical cat was going to jump, Rivera described the views of the rebellious "anti-modern" movement as "el Museismo." But at the time, he apparently found nothing absurd in the idea that those dissenting with the artistic establishment should advocate a return to the art of El Greco, whose work had been displayed in Spain's churches and galleries without interruption since the artist's death three hundred years before.

Outside the studio of Chicharro, Rivera was able to visit the Círculo de Bellas Artes, where he could attend life classes; and of course the Prado, where he spent many weeks copying not only the Spanish masters but paintings by Brueghel, Lucas Cranach, Hieronymus Bosch and Joachim Patenir, the last noted for his fantastic studies of scenery around Antwerp in the sixteenth century. It was probably also in the Prado that Rivera first made the acquaintance of a woman who was to have a considerable influence on his life, a young painter named María Gutiérrez Cueto, later known as María Blanchard. She was five years older than he was, born in Santander, but living in Madrid since 1899. And she was to leave for Paris in the following year. María Blanchard was only four feet tall, and a childhood accident had given her the appearance of a hunchback. "But," wrote Rivera many years later, "she was exceptionally intelligent. She had a body like a great spider, hanging slightly to one side, and a wonderfully beautiful head below which her arms ended in the most beautiful hands I have ever seen. She looked like her name [Blanchard], like a Nordic angel of the mediaeval school of Hamburg. Like them she was no vulgar beauty; she was a combination of the flesh and the spirit who went about disguised in the costume of the Englishwoman Abroad. She evoked purity and light." Together Rivera and María Blanchard made a memorable physical contrast. She was to remain close to him for the next fourteen years, to fall in love with him (according to his account at least), and to play a central role in several of the more troubled episodes to come.

From the work Rivera completed in his first year in Madrid there remain only six landscapes, two portraits and one self-portrait. The self-portrait, three feet by two feet, shows him as he wanted to be seen, in contrast to most of his other self-portraits, when he was a little harder on himself. Here we have a young man of romantic appearance, seated at a café table, wearing a dark suit and a tall-crowned, broad-brimmed black felt hat, *à la bohème;* the beard is back, just, he is smoking a curly-stemmed pipe, there is a bottle of beer open on the table in front of him, and he has already consumed half a glass; his head casts a shadow on the wall behind. It is a portrait of the artist brooding alone, as well as a striking impression of a man capable of concealing his true nature. It was not one of the pictures he sent back to Governor Dehesa as evidence of work in progress; nor does he seem ever to have included it in exhibitions at this time. Perhaps he felt embarrassed by the romantic quality of the portrait. Perhaps it was the hat.

But Rivera did not spend the whole of his time in 1907 cooped up in Madrid. Chicharro's studio was intended to turn out general painters, capable of responding to any conventional commission, and to study landscape he would take his pupils on journeys across Spain. In his travels with Chicharro Rivera visited the cities of Valencia, Salamanca, Avila and Toledo. Together they travelled across the regions of Extremadura, Galicia and Murcia, and Oviedo and Santiago de Compostela were also on the itinerary. In later years Rivera recalled that in Castile and elsewhere he would go on long walks across the country in order to make the acquaintance of the peasants, part of his early commitment to agricultural problems and the proletariat. There is no doubt that Rivera was a convivial personality and would have enjoyed the company of those Castilian peasants who could understand his Mexican accent, but it seems clear that his chief purpose in entering the Castilian landscape in 1907 and 1908 was to paint it. It is noticeable that the landscapes he did paint at this time contain no figures. Almost every one is empty. Of his surviving views, painted up to the end of 1908, only three show men at work: one peasant, one bricklayer and one blacksmith.

In May 1907 Chicharro took his pupil with him to Barcelona, where the master was exhibiting at the city's Fifth International Art Exhibition, which opened on May 5. Here Rivera's ambitions suffered a setback when his submission was rejected. But he had the opportunity to see for the first time work by Manet, Renoir and Pissarro—none of which made any immediate impact on his own. Although the Impressionists had had little influence on the school of Madrid, their work was familiar in Barcelona.

The painter Darío de Regoyos y Valdés had "discovered" Monet, Renoir and Sisley in 1890. He had become a close friend of Pissarro and had shown his own work, influenced by Seurat's pointillism, in Barcelona in 1894. Rivera had met de Regoyos in the Nuevo Café de Levante in Madrid, and had also made the acquaintance of two other members of the Barcelona avant-garde, Santiago Rusiñol and Ramón Casas—both painters who had worked and lived in Paris—but the truth is that at this stage of Rivera's development he was still learning from more conventional models. In a letter from Barcelona Rivera said that the new work which had most impressed him was by two English painters, Edward Burne-Jones and Frank Brangwyn, the second being a contemporary who was to play a small but significant part in a much later period of his life. To place Rivera in context, we see in Barcelona a young man excited by his first sight of Burne-Jones and executing symbolist paintings of a conventional character at a time when Impressionism was already thirty-five years old, when Cézanne, who had died seven months earlier, was about to receive a retrospective homage at the Salon d'Automne, and when Picasso, locked in his studio in Paris, was working on an enormous canvas which he at first called *Le Bordel.* One critic who was shown this group of five naked women decided at once that Picasso was exercising a gift for caricature. Ten years later, for its first public exhibition, the picture was renamed *Les Demoiselles d'Avignon,* and later still was described as the foundation of Cubism. Rivera at this point had still not seen his first Cézanne.

After the stimulation and disappointment of Barcelona, Rivera returned to Madrid and resumed his studies with Chicharro. He had been in Spain for only six months when, to escape the fierce heat of Castile in midsummer, the students recrossed the Cantabrian mountains and set out on an extensive tour of the Basque coast. Several landscapes survive from this tour. On the journey Rivera painted a beautiful street scene entitled *Night in Avila,* full of symbolist atmosphere, as well as an exterior of the church at Lequeitio with rhododendrons in bloom. This painting was included in the group sent to Governor Dehesa as part of his first six-monthly tribute. In November there was an exhibition in Chicharro's studio of work by the master's pupils, and for the first time since his arrival eleven months earlier Rivera's paintings were shown to the Spanish public. The show was also noticed by the Madrid critics, one of whom singled him out from the other students and stated that he would become "a great artist." At the same time a Mexican journalist mentioned that Rivera was beginning to win public recognition, but added that he

seemed to do little to keep in touch with other Mexican painters holding state bursaries.

When his bohemian days were long gone, Rivera recalled that he had indulged in such excesses of eating and drinking in Madrid that he had had to restrict himself to a vegetarian diet. But if the company of María Blanchard, the atmosphere of the Café de Pombo, and the intellectual stimulus offered by the two Ramóns were welcome, there is little evidence that he did anything else but work. In his autobiography Rivera claimed that while copying the work of Goya in the Prado he had made a composite from three different originals, later doing the same with El Greco, so that he finished with three pictures. On leaving the city, he presented these to a young man who had acted as his guide and factotum and whose impoverished father was skilled at distressing canvasses. They were subsequently passed off as two Goyas and an El Greco, and "these paintings," he wrote, "now hang in well-known collections, two in the United States and one in Paris." Pending the discovery of Rivera's three fakes, it is worth remembering that he first made this claim just after the 1947 trial of the celebrated "Vermeer forger," Han van Meegeren, whose extraordinary story received worldwide publicity. In fact, it was to be several years before Rivera's work reflected any influence from El Greco or Goya.

In his account of his two years in Spain Rivera tended to inject excitement into what had in truth been a relatively quiet period of his life. He wrote home regularly, usually to his father. He worked on the canvasses which he was obliged to send to Governor Dehesa, and he was interested enough by the Prado and by the commercial possibilities which lapped against the doors of Chicharro's studio, as well as by the problems presented in improving his technique, to be fully absorbed. In 1908 María Blanchard set out for Paris, but for Rivera the year was spent in very much the same way. In the spring he exhibited in the National Exhibition of Fine Art in Madrid, showing three of the Basque country landscapes he had completed during the previous summer. The pictures had already been shown in Chicharro's studio, and they attracted little further attention. He was once again listed among other students as "promising." How it came about that he had no further work to show is not clear. Perhaps he was badly advised; perhaps the previous winter had been a period of consolidation rather than progress. María Blanchard won a bronze medal at the exhibition, a final encouragement before her departure, and Chicharro himself won a gold medal. The exhibition was dominated by

Santiago Rusiñol and Romero de Torres, both of whom won gold medals. Rusiñol was by then as much associated with Granada, which he loved to paint, as with the Barcelona avant-garde, which was already in decline, unable to compete with the magnetic power of Paris. Rivera later explained his lack of success in Madrid in 1908 by the fact that he was a foreigner exhibiting in a Spanish national collection. But the likelihood is that he was quite simply outclassed, and this makes the success of María Blanchard, although five years older than Rivera, all the more notable. The exhibition proved to be fertile ground for the continuing controversy between Valle-Inclán and his symbolist supporters against those who favoured naturalism and Spanish realism.

After the exhibition had closed, Rivera once again travelled outside Madrid, and all the work that remains to us was inspired by the light and buildings of Avila and the surrounding countryside. He showed these paintings in that autumn's studio exhibition, and this time had more success. His work attracted the attention of one of the outstanding younger critics, Ramón Gómez de la Serna, who at the age of twenty had already started to gain a reputation. Another critic stated that Rivera's work showed he had "crossed the line dividing student from painter." For an ambitious young man this was the equivalent of a diploma, and Chicharro himself may well have advised him to move on. Rivera, in any case, added to the tributes which others had offered him by describing to Gladys March a scene which was supposed to have taken place in Chicharro's studio during a visit made by the great Sorolla in person. Struck by *The Forge*, Rivera's study of a blacksmith at work, probably in Madrid, painted after he had completed the Avila series, Sorolla predicted that this student had the talent to become a millionaire. Grabbing Rivera's hands, the great man compared each of his fingers to a chequebook in some powerful foreign currency. Apart from having inspired this encouraging outburst from Sorolla, *The Forge* is notable for being his first full-blooded study of a man at work, one of that "lumpen proletariat, a proletariat in rags" with which Madrid was in those days populated, according to the artist's account.

The last picture Rivera finished before leaving Madrid is an appropriate summary of his time with Chicharro. On a very large canvas, 117 centimetres by 112 centimetres, he painted the portrait of a seated bullfighter, *El picador,* the fruit of his countless hours spent copying in the Prado. The painting monopolised his attention for at least three months and features a realistic detailing which demonstrated exactly how much he had mas-

tered academic skills. But there is something lifeless, immobile, characterless in this mastery. It is unusual among his early paintings in not making one curious as to what he would do next.

On March 7, 1909, Rivera wrote to a friend in Mexico City from Madrid announcing his intention of setting out on a European tour that would take him to Paris, then to Brussels, Munich and Venice, where there were important art exhibitions, and then to Rome. By leaving Spain in the spring of 1909, Rivera missed the uprising that took place in Barcelona in July of that year, provoked by King Alfonso's decision to send conscript soldiers on a punitive expedition to Morocco. Machine-guns, cavalry and artillery were used to reduce the insurgents, and the street fighting lasted a week. In later years Rivera claimed to have witnessed this event; in fact, it passed him by, and although he spent many more months of his life in Spain, he never settled there again. He took the train to San Sebastián that ran on via Bordeaux, Tours and Orléans to Paris, with the apparent intention of returning to Madrid or settling in Italy at the end of his grand tour. His grant was due to run for another two years, but outside the world of Chicharro's studio, the world which had been provided for him by Dr. Atl before he left Mexico, he had few clear ambitions and no settled method for continuing his education as an artist. For Rivera, arriving at the Gare d'Austerlitz, Paris was just a halt on the journey. He still had no preferred style or subject for his art, nor any clear conception of the artist's role. He was waiting to find an influence strong enough to form his plans. Until then "Paris" was mainly the Louvre.

§ § §

ON HIS ARRIVAL in Paris Rivera took a cab along the quays of the Seine to the Boulevard St-Michel, no. 31, then as now the Hôtel de Suez. This hotel was a centre for visiting students from Spain and Latin America. Among those who stayed there that summer were Chicharro himself, who may have arrived with Rivera, and Ramón del Valle-Inclán. Rivera claimed to have travelled up with the latter, though it seems more likely that he made the journey with the former after the studio expedition closed. Soon afterwards Rivera started on the "usual routine" of the art student, copying at the Louvre, painting on the banks of the Seine, viewing exhibitions and attending the free schools of Montparnasse. He claimed that "two great French revolutionary artists, Daumier and Courbet, lit my path as with great torches." Practically no work from this

summer has survived, but judging by the direction his painting was to take in the following two years, any inspiration offered by Daumier and Courbet was ephemeral. Favela has dated a large confident oil of *Notre-Dame de Paris* in the rain to this summer, but there are reasons for thinking that it was actually painted later in the year. Those searching for influences in his work have traced signs of Monet, Pissarro and Turner in this one picture, but Rivera had at this point seen no Turner. Secondly, he had only a short time in Paris. Favela dates his departure for Bruges to September, but there is documentary evidence to show that he was in Bruges in June. He was therefore in Paris for less than two months, and it seems unlikely that he would have soaked up enough of the influence of Monet and mastered the problems of northern light and mist, with only a Paris midsummer, albeit a wet one, to guide him. This is particularly the case since on his arrival in Paris he was far more interested by a very different painter, Pierre Puvis de Chavannes. Just as he had preferred Burne-Jones to the French Impressionists in Barcelona in 1907, so now in Paris two years later he was immediately absorbed in the work of a symbolist. In a letter to a friend in Mexico written from Bruges in November, Rivera summarises his early perceptions of the city and mentions the "strength and nobility" of Manet, Millet, Dupré and Monet, also praising Gauguin and Signac among others. But his main recollection was of Puvis, whose work in the amphitheatre of the Sorbonne and on the walls of the Panthéon had deeply impressed him and would be one of "the unforgettable memories" of his life. Years later Rivera recalled that he had been overawed by Paris on his arrival, that his natural timidity had been increased by "my Mexican-American inferiority complex, my awe before historic Europe and its culture," but if he had one project in his head on coming to Paris it was to study the work of Puvis de Chavannes. In the same letter in which he described his forthcoming "grand tour" Rivera mentioned a scheme drawn up by himself, the Mexican artist Angel Zárraga and another Mexican bursar in Madrid, Roberto Montenegro, to paint the walls of the uncompleted Palacio de Bellas Artes in Mexico City in the manner in which Puvis had decorated the Panthéon. Zárraga had probably been the first to conceive this idea, during a journey he had made to Paris in 1906, work having started on the Palacio in Mexico City in 1904. It is hard to see how Rivera, deeply struck as he was by his first sight of the huge symbolist allegories of Puvis, whose style he was to imitate in at least one portrait later that year, could have simultaneously undertaken a study of northern mist and light in the manner of Claude Monet. While he was staying at the Hôtel Suez, Rivera fell ill, suffering an acute liver

attack, the result of a chronic hepatitis which was to trouble him all his life. Then, towards the end of June, he continued on his scheduled journey, to Brussels. He set out with a Mexican painter of German descent, Enrique Friedmann, and on reaching the Belgian capital they made a detour to Bruges, a Flemish city that was bound to interest Rivera after his encounters with the Flemish masters of the Prado, but also a city which had come to be seen as the capital of symbolism.

On their arrival in Bruges, Friedmann introduced Rivera to a system which would save them hotel charges. They would buy a third-class rail ticket and rest in the station waiting-room, then sleep on a night train. At dawn they would start out on a round of museums and well-known sights where they would paint. One evening they decided to eat at a cheap café before setting off as usual for the station waiting-room. The café they had chosen had a sign outside, "Rooms for Travellers," which attracted the attention of two other young artists who had travelled to Bruges from Paris. One of them was María Blanchard; the other was a Russian friend of hers who was to shape the course of Rivera's life for the next twelve years. She was called Angelina Beloff.

Angelina Belova Petrovna had been born in St. Petersburg in 1879 into a liberal intellectual family. At school she had shown an aptitude for science and had read for a university degree in general science. At the same time she started taking night classes in painting and drawing. She went on to study at the Ecole des Beaux-Arts but was expelled after becoming involved in a student strike. She was eventually readmitted and received a diploma in drawing, after which, with her technical ability, she was naturally drawn to engraving. But she continued to live at home until the death of her parents in 1909. Then, at the age of twenty-nine, funded by a small inheritance, she set out for Paris. She joined the crowd of foreign students at the Matisse Academy, met María Blanchard, who had arrived in the previous year, moved into her new friend's studio to save money, and started to learn Spanish. Her French was already good. When their course closed down for the summer in June, Angelina wanted to go to Brittany, which she had heard about years before, but María Blanchard persuaded her instead to head for Bruges. They spent the afternoon of their arrival painting on the beach at Knokke, and when they got back to the city it was late and they had trouble finding a hotel. "We were tired and they were all so expensive, particularly for María's purse," Angelina wrote in her memoirs. So they decided to stay in one of the rooms of the café. Perhaps María Blanchard knew that Rivera might be in Bruges, per-

haps they had both been given the name of the café as a popular ren-
dezvous. Perhaps Rivera had already seen Angelina in Paris and decided
to follow her to Bruges. In any case, the two parties joined up, continuing
to paint and travel round the region but getting into the habit after a
while of making their plans together. In this romantic northern setting
Rivera, faced with a handsome, gentle, blue-eyed northern woman, seven
years older than himself, slim and fair-haired, with settled ideas on art and
life, fell in love.

Rivera did a lot of work in Bruges, and it was in marked contrast to
his last Spanish paintings. He found a new machine, a steam barge, and
took a trip on the canal towards the Dutch border, painting a windmill
near Damme. But not even the steam barge inspired him to paint its crew
at their novel work. In Bruges, as he later remembered (and as Friedmann
has confirmed), he rose to paint at dawn. His most successful work was
La Maison sur le pont, a study of one of Friedmann's "well-known sights"
of the city. The received symbolist image of Bruges was of "the dead
city," and nothing lives in Rivera's highly atmospheric picture. The water
in the canal is still, the boughs of the trees are bare, the creeper on the
wall of the house is an autumnal red, there are no signs of life behind the
closed windows, the gargoyles look down on the entrance to a dark tun-
nel through which we glimpse another lighted area of water as empty as
the foreground. Another picture Rivera made in Bruges, a charcoal sketch
entitled *Night Scene,* shows the dim outlines of a house and is called
Béguinage à Bruges, possibly a reference to the fact that the name of the
house, Béguinage, the celebrated convent, also means "a passing fancy." It
was dedicated to "Mademoiselle Angelina Beloff as a sign of my affec-
tion" and dated October 9.

As the time slipped by in Bruges, Rivera's plan to move on from Brus-
sels to Munich, Venice and Rome became more and more improbable.
Instead his travels took an unexpected turn when the four friends, speak-
ing either Spanish, which would have left Angelina out of things, or
French, which would have excluded Rivera, found themselves on a small
boat bound for London. How they found this boat, whether it left from
Ostend, Zeebrugge or more likely Antwerp, and why they decided to
board it has never been explained. But it is reasonable to suppose that the
idea was Angelina's. Coming from a Russian liberal background, she had
read Dickens and she was already committed to progressive politics. Both
she and Rivera spoke a little English, having studied it at school. What-
ever the reason, "we made a voyage to England on a small freighter," as

Rivera later put it. "We arrived at the mouth of the River Thames at eight o'clock one lovely, fog-free, summer morning of 1909. Two hours later we disembarked on a London dock."

The impressions which Rivera kept of London filled no more than a page in his autobiography and were confined to those of a politically conscious tourist. Whereas "industrial Madrid consisted of a few small factories . . . the working-class was small and unorganised . . . a proletariat in rags, lacking any initiative for social change," and "most of the common people were . . . thieves . . . shiftless, cunning, picturesque, sorrowful and tragic," in France he had observed people's "reverence for private property. . . . Their attitude to land was positively religious: beside it all ordinary human values disappeared." Now in London he found himself in "a city of the poor." Like a contemporary Westerner arriving in the Third World, he noticed the child prostitution and hungry men and women rummaging through dustbins looking for food. However, even in this extremity the Englishman remained a gentleman. "I never saw an Englishman dip his hand into the waste can until all the women had had their turn." Fortunately, the memoirs of Angelina Beloff provide a more personal account of how the time was spent.

They spent "about one month" in London. Rivera was anxious to study the work of Hogarth, Turner and Blake. He also discovered the collections of classical sculpture and pre-Columbian art in the British Museum. In addition, he was, for the first time in his life, in love and anxious to explain himself. "One day," recalled Angelina Beloff in her memoirs, "standing in one of the innumerable Lyons Corner Houses ('Lions-thee'), Diego in his bad French made another declaration of love, this time directly. I told him . . . I was unsure of my feelings. Then we went to the sculpture room in the British Museum and sat facing a beautiful stone head called, I think, *The Dream,* chatting about life in general. I told him I would think it over."

All thought of Munich and Italy was now forgotten. Rivera had found an objective and was on the point of gaining a point of view: that of Angelina. Together they set out to discover Dickens's London, the hunger and misery and the political demonstrations. They went to Speakers' Corner, "under the marble arches at the park entrances," as Rivera put it, and "listened to all kinds of speakers, from Presbyterian ministers to socialists and anarchists." They went to the docks to watch a meeting of strikers being addressed by their leaders, and in Trafalgar Square they saw a clash between strikers and police which Rivera sketched. Angelina could offer Rivera more than the excitement of being in love; she was part

of a larger world, one which embraced more than the introspection and subjectivity of the art student and which held the promise of great events. In London Rivera, for the first time, noticed the detail of ordinary people's lives—how it was the last man in a police line who had to sweep up the sleeping areas underneath the arches, how food waste had to be tipped into special dustbins to be reused. The poor had become people rather than "shiftless, cunning, picturesque"; the son of the *Porfiriato* was beginning to see the world through someone else's eyes.

When they returned to Bruges Rivera drew and gave to Angelina the *Night Scene,* as a token of his love. "Diego courted me so fervently," wrote Angelina, "that I felt under too much pressure. . . . So I decided to return to Paris, to reflect in peace." On November 2 Rivera was still in Bruges. Shortly afterwards he returned to Paris to hear his fate. "When Diego returned to Paris," wrote Angelina, "I told him I was prepared to become his fiancée and that I thought I would be able to love him." On one side at least, a commitment had been made, for life. In return, and in an unusually frank admission, Rivera wrote, she was "a kind, sensitive, almost unbelievably decent person. . . . For the next ten years I spent in Europe . . . she gave me everything a good woman can give to a man. In return she received from me all the heartache and misery that a man can inflict upon a woman."

In fact, the early years shared by Rivera and Angelina Beloff were happy and even tranquil. Their relationship grew gradually. In 1909 and 1910 they lived at separate addresses, and it seems clear that they were not lovers. As a young man Rivera was modest and unassertive in his relations with women. He never painted a female portrait, with the exception of three childhood sketches, including one of his mother, before he painted his "fiancée." And he does not seem to have been even slightly in love before he fell for Angelina. Nor was he a notably sensual man. Despite the life classes he had attended in Madrid, there are no studies of the nude in his work which can be dated earlier than 1918. He remained for many years after his childhood *"un grand timide"* with a very different reputation and personality from the one he was later to acquire.

On returning to Paris, the foursome of Friedmann, María Blanchard, Rivera and Angelina Beloff broke up. Friedmann returned to the Hôtel Suez, the address at which he had originally met Rivera, but the others took up residence in Montparnasse. María Blanchard moved back into a small studio on the Rue de Vaugirard. Angelina Beloff found a room on the Rue Campagne-Première and studied engraving with an English teacher, while Rivera took a studio on the Rue Bagneux. Rivera's studio

was atelier no. 8. María Blanchard's room was just round the corner; they
were separated only by the bulky premises of the Convent of the Visita-
tion. They both had the same obligation: to send a certain number of can-
vasses back to their benefactors in Spain and Mexico—a source of anxiety,
as Angelina Beloff recalled in her memoirs. Favela notes that Blanchard
was at this point painting like a Fauve but that Rivera was still persisting
with an academic master, a landscape painter and colourist called Victor-
Octave Guillonet, praised at the time by Apollinaire, now quite forgotten,
who had a studio on the Right Bank on the Boulevard de Clichy. With
Angelina's help Rivera executed an etching entitled *Mitin de obreros en los
docks de Londres.* Then he finished *The House on the Bridge* and settled down
to paint a landscape inspired by Turner and Monet. This picture, called *Le
Port de la Tournelle,* was a study of water and mist. But he saw, rather than
the Paris mist which he had in front of him when he painted it, "the trans-
parent blue greys and pink greys of the London mist," and it was inspired
by all "the remembered emotion of London." And it showed men at
work; three of them, on a quay by the river Seine, close to the Halle aux
Vins, unloading barrels of Beaujolais wine from the barges which had car-
ried it up through France. *Le Port de la Tournelle,* later, for a Mexican clien-
tele, rechristened *Notre-Dame de Paris Through the Mist,* has been praised
by Favela and Debroise as a confident work of Post-Impressionism, but it
meant more than that to Rivera. Apart from the pleasure of developing
his technique, it reflected the new hesitant political awareness stimulated
by his relationship with Angelina. It also recorded a spectacular episode in
the history of Paris. The summer of 1909 had been unusually wet, and the
winter of 1909–10 was the wettest for many years. On January 10 the
waters of the Seine began to rise. The river burst its banks on January 21
and a large part of the city had to be evacuated. Rivera's dramatic paint-
ing shows the situation as it must have been in December 1909, just before
the river began to rise above its usual limit. The water has already begun
to flood over the lower quay, although the arches of the Pont de
l'Archevêché are still functioning. Rivera's wine barrels, glistening with
rainwater and lapped by the river, were within a few days to be washed all
over the *quartier.* A photograph of the Pont d'Alma taken at the height of
the flood shows two such wine barrels unable to pass beneath the bridge.
In Rivera's painting a dinghy is tugging at its mooring-line against the cur-
rent. From the Rue Bagneux to this point on the Quai de la Tournelle is a
walk of little more than half an hour through the streets of the Quartier
Latin, which were to be under several feet of water and transformed for
three weeks into a little Venice. At the height of the flood the city was cut

in two and it was practically impossible to pass from one bank of the river to the other. The bridges had turned into dams and were in danger of collapsing from the weight of water. The Métro system and the sewers were flooded, the early electricity and telephone systems were out of order, and an emergency relief centre was set up in the former seminary on the Place St-Sulpice. Drinking water had to be carried in from the countryside, and the giraffe in the zoo in the Jardin des Plantes died of pneumonia. It was mid-February before the waters receded sufficiently to allow the authorities to start clearing up the mass of rubbish and flotsam in the streets and cleaning out the cellars.

Rivera made no mention of the flood in his memoirs, but he was situated just above the flooded areas, and all his friends in Montparnasse were still further away. He and María Blanchard could no longer cross the river to attend classes on the Right Bank, but he was by then working on a third important painting: following *The House on the Bridge* and *Le Port de la Tournelle* he had started a portrait of Angelina in the manner, and with the colours, of Puvis de Chavannes. If the Hôtel de Ville was surrounded by water, he could still study the murals in the Sorbonne and the Panthéon without getting his feet wet. Rivera was to paint Angelina many times; his first study of her shows a reflective, reserved character, gentle but with an underlying strength of character in her face. It is the face of a woman who sees things clearly enough to judge them, but who generally decides to keep her judgements to herself. Whatever it was in Angelina that caused Rivera to fall in love with her, she had become the centre of his life. Once he was accepted he abandoned all thought of Rome or of returning to Spain and took the necessary steps to settle in Paris.

Even in 1910 Rivera used several different addresses in Montparnasse. Angelina remembers that he had a studio "near the Rue de Rennes," but this was in fact on the Rue Bagneux, where María Blanchard would join him for work, and he gave this address to the Mexican Embassy, which was still using it as late as September, when he was invited to join other luminaries and clients of the *Porfiriato* for the centenary celebrations of Mexican independence on September 16. It would have been important for the Embassy to have had his correct address since he had transferred his bursary payments from the consulate in Madrid to the consulate in Paris as soon as he knew that he was going to settle there. But in April 1910 he gave another address to the police, 26 Rue du Départ, which was closer to Angelina. This was a studio he was to occupy in 1912 for a period of seven years. His foreigner's registration card, the internal passport, dated April 12 and bearing his photograph (with beard), states that he had

"arrived in Paris" two days earlier. The date of his arrival is unverifiable, but Rivera would have been careful not to give a false address to the police since they checked regularly on the status of foreign residents and, as a bona fide student on a government bursary, he had no need to avoid them. Chasing art students round the studios and attic bedrooms of Montparnasse ninety years after the event is an exhausting business; the conclusion must be that as he struggled to find his footing as an artist, to make ends meet on a slim grant, and to complete enough work to satisfy Governor Dehesa and his own need to exhibit, Rivera had more than one address.

In March 1910, just after the flood had receded, Rivera managed to get six paintings accepted by the Salon des Indépendants, including *Le Pont de la Tournelle, La Maison sur le pont,* and four other landscapes made in or around Bruges. The Salon had a mixed reputation, and Rivera was not quite certain whether to be elated or discouraged by his immediate success, as he told his father in a letter on April 24. On arriving in Paris, Rivera had been an academic painter, heading towards the lucrative commerce of conventional portraits and landscapes. He was worlds away from the foreign students who flooded into Paris from all over Europe at this time, drawn by the fame of Matisse, and who had to be rebuked by the master (who habitually wore waistcoat and tie) for flooding their canvasses with shapeless masses of colours. In a famous incident in 1908, an exasperated Matisse left the classroom and returned with a classical bust which he instructed his students to draw. "Before you can walk on a tightrope," he said, "you must learn to walk on the ground." That was one piece of advice Rivera did not need. He knew how to walk, but he had yet to learn how to run.

That summer Diego Rivera and Angelina followed her original wishes and went to Brittany, where he made several more paintings that have survived, in particular two portraits of Breton women, one young, one old, done in the Flemish or Spanish realist manner, and a last tribute to symbolism, *El barco demolido,* or *The Wrecked Vessel,* an atmospheric beachscape on a rainy summer day in north Britanny with a north-west wind chasing heavy clouds across the sky and thick bands of light and shade racing across the fields. The drama which he had painted into the water of the river Seine has here been switched to the Breton sky.

But by the end of the summer Rivera was at an impasse. It was nearly four years since he had been in Mexico and he was feeling homesick. He had completed a long academic training but had quite failed to find a style of his own. What could a young painter do when he found he could imi-

tate practically anyone? Rivera's success at the Salon des Indépendants ensured that his grant would be extended for another two years. His problem was that he did not know what to paint. He could do Monet, Goya, Puvis, or the Flemish school, but he could not create something with a life entirely its own. Since arriving in Spain four years earlier, Rivera had learnt a lot about technique. He had studied and copied the masters in the Prado, the Louvre and the Tate Gallery but he had not responded to Cézanne or noticed the significance of the Fauves or of Cubism. He may have sensed that the centre of art had moved to Paris, but he may equally well have decided to settle there for personal reasons. "I had begun to lose my bearings," he wrote later. "Suddenly I felt an overmastering need to see my land and my people."

In this situation the permission he received from Governor Dehesa to return to Mexico for an exhibition of his work, to be mounted as part of the national centenary celebrations, came as a welcome relief. Without waiting for the Embassy party in Paris, Rivera rolled up his canvasses, the fruit of four years' work, in August and set off for Spain. To reach Santander it was not strictly necessary to pass by Madrid—there was a rail junction at Valladolid—but for some reason, perhaps to pick up money or paintings in storage, he dallied over the journey. He wrote to Angelina on the way, from Fuenterrabía, a little village just over the Spanish-French border, on the coast near Irún. He wrote again from Avila, and then on September 10 he wrote her a long letter from Madrid.

"My much loved woman, my beloved wife, my angel," it began, followed by a very lengthy apology for failing to write sooner and complaints about the speed of the post. After comparing Angelina's eyes to the sea, Rivera recounted his recent experience in the Prado. At first he had made for the room containing the work of Velázquez, but to his surprise and disappointment the master's works had left him "cold . . . indifferent . . . sad." Assuming that he was too tired to respond to painting, he had sat down on a bench and found himself surrounded by the works of El Greco, *The Ascension, The Crucifixion, The Descent of the Holy Spirit, The Baptism of Christ*, a *St. Bernard*, a *St. Francis* and a copy of the lower part of *The Burial of the Count of Orgaz* painted by El Greco's daughter.

I was feeling more or less destroyed by my reaction to Velázquez but I looked ahead with my eyes and inside with my spirit, and slowly I began to see ahead, and see the ascension, the ascent, the descent, the crucifixion, and then my spirit saw beyond that and through the symphony of colours and feelings and into the depths which are woven with the mysteries of the paintings of El Greco. So, my wife, in that

moment I realised that my soul was feeling something new. I realised that in truth I had been passing in front of these pictures like an uncomprehending admirer, that I had failed to understand their soul.

El Greco, the most sublime of painters, the greatest in spirit, had been until then unknown to me. . . . Everything that one might feel or desire to feel was there in the pictures of El Greco, whose colours I knew inch by inch but which I did not really know at all. And then, girl, the *Pentecost,* the Descent of the Holy Spirit! I felt a spirit descend on *me* which filled me with the fire of a great beauty, of the highest feelings, from beyond. And I realised that I was understanding El Greco's *Pentecost* because your high spirit had descended on my soul. It was a stronger emotion than I have ever felt before a work of art, unless it was when I stood beside you in front of Rembrandt, in front of Turner, in front of Botticelli and Paolo Uccello and Piero della Francesca, but the feeling was even stronger this time because you were not only beside me, you were within me and because El Greco is perhaps the greatest among all the great. The feeling produced in me by El Greco was so strong that it even showed itself physically and a friend came up and asked me if I was ill. . . .

I will write to you again tomorrow, and the day after tomorrow I board ship early. I kiss your forehead, I kiss your eyes which are the colour of the sea, I kiss your lips which are my lips, I kiss your little hands and the precious little feet of my wife.

<div align="right">Your very own Diego M. Rivera</div>

This letter shows the extent of Rivera's feelings about painting and about Angelina. It also shows a sensitivity to Christian imagery which is surprising in a son of the Comtean Enlightenment. In its humility and intensity of expression it contains all that was best about the painter at the age of twenty-three.

THE FREE REPUBLIC
OF MONTPARNASSE

Mexico 1910–1911
Paris 1911–1914

R IVERA RETURNED to Mexico in October 1910 as one of the pampered favourites of a powerful regime that was in the midst of celebrating its own power, and the work he had accomplished in Europe was intended to be a prominent part of that celebration. The contrast with his obscure status in Paris and Madrid could hardly have been more marked. After landing in Veracruz, he took the train to the state capital in Jalapa to pay his respects to Governor Dehesa and to collect the canvasses he needed for his exhibition. Then he continued by rail to Mexico City, where he arrived on October 7. He was greeted at the station by his family, by members of the Society of Mexican Painters and Sculptors and by the press. In the following day's edition of *El Imparcial* his photograph with beard and moustache appeared. He had until November 20 to prepare for the show which was to be opened at the Academy of San Carlos by Doña Carmelita Díaz, the dictator's wife. No higher compliment could be paid to a returning talent.

Four days after Rivera's arrival in Mexico City, another art exhibition, also held at the Academy, closed, although this one had nothing to do with the centenary celebrations. It had been organised by Gerardo Murillo and was devoted to the work of young Mexican artists associated with the Savia Moderna group, but there was nothing in it by Rivera. The Savia Moderna movement had evolved into a coterie called the "Ateneo de la Juventud" which was notable, under the influence of Murillo, for its opposition to the system of sending talented young painters to Europe. Their exhibition received little attention compared to that given to the

work of Rivera. The Mexican press had been following the foreign bursar's progress and had noted his success at the Paris Salon des Indépendants in March that year, and this may have led to some jealousy. If so, it was not shown publicly, although the Ateneo movement did launch a spirited attack on a third exhibition, which was again part of the official celebrations. This was devoted to Spanish painting and contained work by three of Rivera's Spanish masters: Chicharro, Sorolla and Zuloaga. It would be difficult to think of a more provocative gesture towards Atl and the *mejicanistas* of the Academy than the notion of celebrating one hundred years of Mexican independence from Spain by a demonstration of Spanish neo-colonial, cultural superiority. The failure to predict this reaction, or the blithe indifference to it, was a sign of the extent to which the Díaz regime had lost touch with its subjects.

Years later, when he had become the protégé of the regime which succeeded the *Porfiriato*, Rivera manufactured a fictional account of his life in Mexico in 1910 and 1911. In place of the family meeting at the railway station, witnessed by a newspaper reporter, he described a dramatic sequence of encounters in the house on the Vía Carcuz María where his family, still in the district of the Merced market, were then living. He had failed to warn his mother of his return after an absence of four years, since he wished to "surprise" her. Duly astonished by his reappearance, María del Pilar was just about to throw her arms around him when she was interrupted, as if by magic, by a second reappearance, that of Antonia, his old Indian nurse who appeared at the foot of the stairs having dreamt of Diego's journey and walked through the mountains for eight days to greet him. So, abandoning his mother, Rivera embraced instead his "Indian foster mother, twice as tall and twice as beautiful as my real mother"; the humiliation and betrayal of his mother was a theme to which Rivera was always happy to return. But there was more drama to follow. While his mother and Antonia, face to face in the hall, established a wary alliance, Rivera learnt that his great-aunt Vicenta, Tía Totota, had died less than a week before his arrival. When he went upstairs to his old bedroom, his little dog, Blackie, crept up to him and died happily while licking his hand. By the time his father had returned from the office, Diego himself had fainted beside the corpse of the dog, so completing a tableau of real and simulated death.

Rivera's exhibition was due to open six weeks after his return, but he claimed that, instead of concentrating on the preparations for this important event, he had been plotting to assassinate the president of the Republic, Porfirio Díaz. He had returned to his homeland with a bomb in

his sombrero. While laying his plans, he arranged to have lunch in a restaurant with an opponent of the regime, General Everaro Gonzáles Hernández. Rivera arrived late for the appointment, and when he got there found the general rolling round the floor of the restaurant in agony. He had been poisoned by the secret police and he died in his comrade's arms, leaving instructions that his horse, saddle and pistol be sold to pay his debts. Rivera reflected that he himself had only been saved from poisoning by his late arrival for lunch. But his assassination plot was not to be so easily dissolved. Hearing that Díaz had decided to open his forthcoming exhibition in person, Rivera smuggled explosives into the building in his paintbox on the morning of the inauguration. Then, at the last moment, Díaz cancelled his plans and sent his wife Doña Carmelita in his place, so the attempt was abandoned.

After the exhibition closed, Rivera further claimed that he spent six months in the south of Mexico fighting by the side of the rebel leader Emiliano Zapata and becoming a specialist in the art of blowing up trains without harming the passengers. This claim was well enough established to be repeated in exhibition catalogues published as recently as 1993. And Bertram Wolfe, in the revised edition of his biography published in 1963, wrote that Rivera lost interest in his exhibition when the 1910 insurrection began and went to the southern state of Morelos to be close to Zapata. Wolfe places Rivera's decision to return to Europe in 1911 in the context of his disappointment at the premature ending of the uprising and its failure to develop into a class revolution. "Diego," he wrote, "felt as cheated as the expectant peasants." Rivera himself described how he was dragged from Zapata's side—as we imagine it, in the thick of the fighting—by a friendly government official who warned him that he was about to be charged with treason and sent before a Díaz firing squad. On the run from the Díaz police, Rivera then made his way towards Jalapa to bid farewell to his patron, Governor Teodoro Dehesa, when by chance his path crossed that of a band of revolutionaries led by, of all people, his uncle Carlos Barrientos. Nephew and uncle shook hands warmly. Then the rebels assured Rivera that Dehesa was highly regarded by the revolutionaries and known to be an opponent of reaction. Such was the mutual esteem between the governor of Veracruz and the insurgents surrounding his capital that Rivera acted as a go-between, carrying courteous messages of friendship deferred through the lines. He ended his account of this period of his life by describing a stormy Atlantic crossing during which, with the help of two retired sea captains, he saved the aged Spanish packet, the *Alfonso XIII,* from foundering with the loss of all hands in

mid-ocean. On his earlier voyage Rivera had bellowed his grief into the wind with such force that he had practically been lashed to the mast lest he do himself harm. This time he sat in a saloon awash with sea water, consuming steaks, red snappers and huge crabs plucked from the storm, until the exhausted crew turned to Rivera, handed him whips and a pistol, and sent him down to the hold to supervise the repacking of the shifting cargo. "I held my post until the rolling of the ship subsided and the danger was past," he recalled. If the facts were less dramatic, they help to explain why Rivera later felt obliged to conceal them behind this tumultuous pack of inventions.

In reality Rivera had found Mexico City *en fête* and had thrown himself into events without hesitation. Celebrations had opened on September 1, the whole of the centre of the capital had been redecorated, and twenty thousand guests, many from abroad, were invited to take part in a round of balls, parades, carnivals and other spectacles; even Halley's comet was in attendance to honour the dictator, although not every one took this as a good omen. In the auditorium of the Palacio de Bellas Artes, a superb, multicoloured glass theatre curtain was installed, designed by Dr. Atl and constructed by Tiffany's of New York. The Palacio itself was incomplete. It had been started in 1904 and was always intended to be ready for the centenary, but construction had been halted when the entire marble building began to sink into the marshy subsoil. If anyone had remembered the Emperor Napoleon III's failure to complete the Paris Opera House before his overthrow in 1870, it would have been another bad omen for Porfirio Díaz.

The official opening of Rivera's exhibition was on November 20 and was, again, widely covered in the press. Rivera was described as "a great artist," with a lion's mane of hair and an Abraham Lincoln beard. If he had not, in reality, been plotting to assassinate Díaz, he had at least found the time to get his moustache removed before meeting the dictator's wife. Doña Carmen Romero Rubio de Díaz duly turned up to admire his work and to purchase *Pedro's Share,* a study of a Basque fisherman with his wife, made in 1907 and duly sent back to Governor Dehesa. In real life Rivera's exhibition was a conventional success. The closure date was postponed from December 11 to December 20, and thirteen of the thirty-five paintings on display were sold, five of them to the School of Fine Arts. The etching made in London of a dock workers' meeting was also exhibited. Among the paintings sold were *The House on the Bridge,* which he had worked on in Paris months after returning from Bruges, and *The Wrecked Vessel,* painted in Brittany, as well as the *Portrait of a Breton Girl.* The exhi-

bition earned the artist 4,000 pesos. It was the first time Rivera had been paid a significant sum of money for his work.

Meanwhile, quite unknown to Rivera, another event had been planned for Sunday, November 20, apart from the opening of his exhibition. In the north of Mexico, on the U.S. border, the fugitive liberal politician Francisco Madero had crossed the border and called for an armed insurrection. Opposition to Díaz had been growing steadily during Rivera's four-year absence in Europe. Díaz had encouraged people to think that he would stand down in the 1910 elections, after thirty-three years in power. In the event, he put on the usual performance, banning opposition candidates, and, at the age of eighty, secured his own return to power by decision of a rigged electoral college in October. In June, Francisco Madero, who should have been the opposition presidential candidate, was arrested and imprisoned. But on October 5, just as Rivera was landing in Veracruz, Madero escaped from prison in San Luis Potosí and reached Texas, from where he circulated the Plan of San Luis, which set November 20 as the date for the uprising. On November 13 the police, who had got wind of the date, arrested leading followers of Madero living in Mexico City, and five days later they moved into Puebla, shooting down one of Madero's lieutenants. The result was that when Madero crossed the Rio Grande on November 20 there was no one to meet him and he had to retreat to New Orleans. In Mexico little happened on that day except in the northern state of Chihuahua, where small armed groups rose up. But this was enough, and from then on the first revolution of the twentieth century grew and spread. By February 14, 1911, when Madero crossed the Rio Grande a second time, the Díaz government was facing a major insurrection.

Such were the political events that formed the background to Rivera's visit to Mexico in the winter of 1910–11, and he later claimed that he himself had played an active part in this turning point in his country's history. Favela doubts this and notes that the Mexican press announced Rivera's departure for Madrid on January 3. In fact, Rivera neither left for Europe nor joined the rebellion. A letter written on March 10 from the little town of Amecameca, south of Mexico City, shows that although he was still in Mexico, he was spending his time rather differently.

"My girl," his letter began, "my much-loved girl, my good Angel, darling. I am sending this to Paris, to María [Blanchard]'s address but since I am not sure whether you have left St. Petersburg yet I will send you a short message there as well, just in case." Why should Rivera have delayed his return to Paris after the closing of his exhibition? One reason

was the absence from Paris of its main attraction, Angelina, who was visiting her home in St. Petersburg. Another was a reluctance to leave his homeland after such a short visit; three months was not much time after four years to see his family and renew contact with his friends, particularly when Mexico had given him such a splendid welcome. But his main preoccupation was with his painting. He wanted to discover whether Mexico had any solutions to offer him in his perplexity about the way forward. He had found no equivalent in Europe to the light and colours of Mexico. The critics in Mexico City had been undecided as to whether he was a finished painter or whether his training was still incomplete, but he at least knew the answer. In his letter to Angelina Rivera also mentioned political discussions he had been having with a friend who was one of the Ateneo group, Jesús Acevedo, on the question of national schools of art, which, he told Angelina, is "the subject of much reflection at the moment." In Acevedo's opinion, countries such as Mexico which had only recently joined the mainstream of the Western artistic tradition could not develop a national art of their own. This could only be deliberately created by a group of talented men, or otherwise by a slow distillation of the alien inspiration over a long period of time. Until then artists were forced to join "the European school which is most sympathetic to their individual personality." Rivera added that he thought Acevedo was probably right, "although it seemed rather a sad fact." In his letter to Angelina Rivera also mentioned that, in Acevedo's view, when modern artists deliberately tried to create a national art, they turned to primitive art for the source of their inspiration and so reduced their capacity to respond to their own period. In the course of time Acevedo's analysis was to have a particular significance for Rivera's work.

Much of Rivera's letter to Angelina is concerned with his battle to get back to work. He had found too many distractions in Mexico City, so he had done what he did once before and gone out into the country in search of landscapes. "For the first time I am writing to you in a state of anxiety such as I have not suffered since we were in Brittany last year." It had been in Brittany that Rivera had first sensed that he had lost his bearings, having exhausted symbolism, the style which he had favoured since his arrival in Madrid three years earlier. And it had been in Brittany that Angelina had felt bold enough to tell him for the first time that she had not liked one of his pictures, the *Portrait of a Breton Girl.* "You were quite right to dislike it," he now wrote to her. "Me too. But naturally the gentlemen of the Academy liked it, and they have already hung it." Rivera added, "I just did not want to come back to Paris without having painted

something. . . . I could not stay in town any longer and I did not want to return to you without having two or three things to show you on my return. . . . So I left the city and came to this little village, fearing that I would achieve nothing, that I would lack the strength as I did so often in the city, missing you and lacking my Soul. . . ." The letter makes clear that Rivera trusted Angelina not only for her emotional support but also for her professional judgement. "Your opinions are very intelligent," he wrote, "and your criticism, contrary to what you think, is sensitive and precise." As for the return to landscape, it was already serving its purpose. "I have spent whole days out in the countryside and little by little have felt closer to your Soul. I have felt the need of you all the time and confess that once in the forest, among the great trees that ring the snow-capped peaks, I called your name out loud, as though I had forgotten that you were only inside me. You won't laugh at me, will you?"

The town to which he had come, Amecameca, was easily reached by train from Mexico City, a rail journey of about two hours. It was noted for its piety, and for its views of the Iztaccíhuatl and Popocatépetl volcanoes. A photograph taken in Amecameca in 1907 shows the Mexico City train at the station, the beaten-earth streets, and the fact that in winter at this altitude it was sufficiently cold for everyone outside to be wrapped in ponchos. Another photograph, taken in 1912, the year after Rivera's visit, by a photographer called Guillermo Kahlo, who had formerly undertaken numerous commissions for the Díaz administration, shows that the town was a collection of low buildings lining either side of a single straight street. The only important sites in town were the market, the church and its attached cloister, where the shrine of Christ, Lord of Sacromonte, was to be found. The photographer Kahlo had set up his tripod on the hill behind the town where the graveyard is situated to get a clear view of the plains between Amecameca and the volcanoes. By chance one can see the forests chosen by Rivera for the two large landscapes he painted of Iztaccíhuatl during the several weeks he spent in the area in the background of Kahlo's photograph. He sketched one of these for Angelina in the letter and said that he intended the finished painting to be "as large as *The House on the Bridge*." While still at home Rivera had shown his mother a photograph of Angelina, and María del Pilar had approved, saying that she would make "a good and faithful wife." Now his mother forwarded a postcard from Angelina to Amecameca and Rivera replied in his letter, saying that it was clear that some of his previous letters had not reached her. He added that this was not surprising since "communications with the north of the country are very difficult

due to the political disorders." And that was the only mention he made of the Revolution in the entire letter. It was a cause of concern because it was making it difficult for him to write to his fiancée.

In fact, if Rivera had chosen to involve himself in "the political disorders," it would not have been so difficult. Due south of Amecameca, linked by road and rail, is the town of Cuautla, the communications centre of the state of Morelos, which was under siege by Zapata's forces throughout the period of Rivera's stay in Amecameca. But the tone of the letter makes clear how unlikely it is that he spent any time with the insurgents in Morelos, and how far he was from being, at that time, a revolutionary. In 1911 Rivera was still a young man entirely preoccupied with his painting, as well as being an unprotesting beneficiary of official patronage. If his circle of friends in Mexico City were critical of the Díaz regime, and would almost certainly have voted for the liberal Madero had that been possible, that did not mean that they were supporters of a peasant uprising led by an obscure horseman whose name meant nothing beyond the state of Morelos. In January 1911 in Mexico City, no one had ever heard the cry "Viva Zapata!" Rivera's account of his conversations with Jesús Acevedo shows that, contrary to the opinion of some, he was once again in touch with the Ateneo during his return visit to Mexico. But there was nothing essentially incompatible about the Mexican avant-garde and the Díaz regime. Even Dr. Atl, intransigent opponent of the art establishment, contributed to the centenary celebrations with his glass theatre curtain. And there was a more striking example of the continuity between the *Porfiriato* and the Revolution that supposedly swept it away. On November 13, 1910, an agreement was published between Justo Sierra, Díaz's minister of education, and the Society of Mexican Painters and Sculptors to decorate the auditorium of an important building in the centre of the city, the Escuela Preparatoria. The scheme had been devised by Dr. Atl as part of his project to re-create the great frescoes of the Renaissance in Mexico. Atl had been experimenting with encaustic, a technique suitable for murals, since 1906, and it was he who was sent to discuss possible themes for the decoration of the Escuela Preparatoria with the minister. It was already agreed that the commission should not be awarded by competition but should be a co-operative project in which several members of the Society shared. Nothing came of Justo Sierra's scheme at the time, but a decade later it was to be revived and this time presented as a revolutionary gesture.

When he had finished his landscapes Rivera returned to Mexico City intending to take passage in the last boat of March or the first boat of

April back to Europe. Just as—before his exhibition opened—the most rebellious step he took was to shave off his moustache, so—after the exhibition ended—his sole interest in railway timetables would have been with regard to selecting landscapes. Angelina Beloff recalled that Rivera returned to Europe towards the end of April or early in May. This means that he left Mexico when the Revolution was still an insurrection. In the north, loyalist forces held Ciudad Juárez against the forces of Pancho Villa and Orozco until May 10. In Morelos the government held Cuautla against Zapata until May 19. Rivera therefore took the eccentric decision, for a revolutionary, to return to Europe on a government grant five weeks before the triumph of the Revolution. In fact, right to the end, few people thought that Madero's supporters would be able to overthrow a regime that retained the loyalty of a powerful army and was backed by all of the most powerful countries in the world. It seems that Rivera, like the great majority of Mexicans, assumed that the government would survive. He left the country as he had come, via Jalapa, taking his leave of Governor Dehesa and confident that his state bursary would continue to be paid. His last days in Mexico were not spent in trying to overthrow the regime. They were spent in ensuring that the regime would continue to pay his grant. When he called on Dehesa he was given the required assurance. But on May 25, a few weeks after Rivera's departure, President Díaz resigned; that night he took the train to Veracruz and, accompanied by Doña Carmelita, sailed into exile on the German steamer *Ipiranga,* bound for France, on the following day. Governor Dehesa waved them off from the quay. He himself resigned as governor of the state of Veracruz in June. When Díaz reached Le Havre, Rivera was not far away, enjoying a holiday in Normandy, in the countryside near Dieppe, but he did not return to Mexico to build the Revolution. He had more serious preoccupations of his own.

§ § §

IN THE SPRING OF 1907 Havelock Ellis, who had taken the little mountain railway from Barcelona to Montserrat, in the Catalan mountains, wrote:

I was at first surprised to find that my only companions were two loving young couples. . . . It had not occurred to me that the shrine of Our Lady of Montserrat should be a fitting place for a honeymoon. I had forgotten, what I was soon to realise, that (in Spain) love and religion are two forms of passion that naturally merge into each

other. . . . The little train has arrived, and I follow in the wake of the two young couples . . . to an office where a young man, a lay brother, enters my name and place-of-abode in a book and without further question hands a key to another similarly habited youth, who, with two sheets and a towel over his arm, precedes me to a barrack-like building bearing the name of Santa Teresa de Jesús, unlocks the door of a third-storey room, and leaves me absolutely and in every respect to my own devices for the three days during which Our Lady of Montserrat grants me the hospitality of her lodging.

I look around the little whitewashed cell which for this brief space will be all my own. It is scrupulously clean and neat and furnished with absolute simplicity.

In Ellis's room there were "two little beds, separated from the rest of the cell by a brilliant curtain," a small table, a chair, a basin, an empty water-pot and a candlestick without a candle. He made his bed, and took the jug to fill it from the tap below, and bought a candle at the provision store which supplied the pilgrims with food. In the evening a mist formed around the mountain peaks that overlooked the monastery; light remained on the higher slopes after the terrace he stood on, and the valley below, were plunged in gloom. In the early morning there was the fresh air, the silence and the "immense variety of trees and plants to enjoy, as well as the sound of youthful laughter." It was to Montserrat that Rivera and Angelina came, shortly after his return from Mexico, in the summer of 1911.

In her memoirs Angelina Beloff wrote of how back in Paris in the spring of that year, she waited and waited for Rivera's arrival, having read his letter announcing this for the month of April, and of how she eventually received a telegram from Spain at the end of April or beginning of May saying that he had just disembarked at a small Atlantic port. "So I expected his arrival in Paris from one moment to the next but was disappointed because there happened to be an international painting exhibition on in Spain and he decided to make a detour to see it. . . . I was desperate with anxiety and sadness because I had received no news of him since the telegram. Finally he turned up calmly in Paris, explaining the reason for the delay. What could I say? I was so happy to see him again." "We married," wrote Angelina, "and went to Normandy near Dieppe in the green country, within sound of the sea, a place of flowers, trees and lush meadows. Diego was supposed to be there to paint but he changed his mind and we returned to Paris and then went to Barcelona where we spent a week in the monastery of Montserrat."

Angelina and Rivera were never legally married, but they had

exchanged the promises which enabled her to regard him from then on as her husband. Rivera felt ill at ease trying to paint in Normandy—his eyes were still full of the light of Mexico and his mouth full of Spanish—so he and Angelina decided to restart their honeymoon in a light and landscape that were slightly less unfamiliar to him. The choice of Montserrat must have been made by Rivera rather than by Angelina, who had never been to Spain. Montserrat is a shrine founded on the site of a ninth-century vision of the Virgin and as such, with its carved image of a black Virgin, would have been less exotic to Rivera than it was to his wife. For the Catalans the Mother of God of Montserrat is what the Virgin of Guadalupe is to the Mexicans: a national symbol and a protector.

There was nothing to do at the monastery except walk, paint and, for diversion, attend compline, and after a week they descended halfway down the mountain to the village of Monistrol, where they spent a further two months. Here Rivera painted *pointilliste* landscapes of Montserrat and the surrounding hills, three of which have survived. They are in strong contrast with his symbolist, Flemish and Impressionist styles, and although it is not clear why he should have made this brief diversion into pointillism, he would have been aware that one of the leading pointillists of the day, Paul Signac, was at that time the president of the Salon des Indépendants. In September they were back in Paris, but they did not return directly from Barcelona. The Salon d'Automne opened on the first of October, but Rivera found time to go to Madrid, perhaps to contact friends, perhaps to make sure that his grant had not been misdirected to the Madrid consulate. In any event, Angelina made two etchings in Toledo. Rivera would not have wanted her first visit to Spain to end without a chance to see the work of "perhaps the greatest among all the great," El Greco. Then they took the train to Paris, where Angelina had found a temporary apartment at 52 Avenue du Maine, close to the station of Montparnasse.

The free republic of Montparnasse, which has passed into legend, came into existence by chance; nobody planned its birth or wrote its constitution. Paris had established its pre-eminence among young European artists gradually throughout the nineteenth century. The French state academies, whose task was to lay down the correct rules for painting and sculpture, drew an increasing number of students from all over Europe; the beauty of the city and a booming art market were additional attractions; studios could be erected cheaply; the necessities of life were not expensive; and the Parisians were tolerant of newcomers.

Exhibitors at the Salon exhibition of 1890 included 20 percent of for-

eign artists, and in the same year the U.S. ambassador announced that there were fifteen hundred American art students in Paris that summer. As the numbers increased, the traditional artists' quarter on the hill of Montmartre became overcrowded and was succeeded in popularity by the rustic, empty spaces of Montparnasse on the opposite side of Paris. Here farm buildings that had been surrounded by the expanding city and abandoned could easily be converted into workshops. Small theatres and concert halls were established; cafés and restaurants opened as the population grew. The artists came to set up shop because they were young or poor and could not afford to live in more fashionable districts. Cézanne lived there in 1863, John Singer Sargent in 1875, Gauguin in 1891—by which time Montparnasse was becoming less isolated. In 1903 the critic André Salmon and the poet Paul Fort decided to publicise their joint work, *Verse and Prose,* by throwing a party at the Closerie des Lilas, "the last café on the Boulevard St-Michel and the first café on the Boulevard du Montparnasse." Since it was no more than a pleasant stroll from St-Germain, where the publishing industry was established, the party was a success and the reputation of the new district grew. It became the favourite daily headquarters of the Greek symbolist poet Jean Moréas, who provided the free republic with its Wildean motto, which he repeated to each innocent new arrival: "Always lean heavily on your principles, young man. One day they are bound to give way."

In 1900, when Nietzsche wrote, "I believe only in French culture. . . . Man as artist is at home only in Paris," he was risking a cliché. The German artists, who had evacuated the city in 1870, began to return in 1903. Two years later Pascin, a young Bulgarian-Jewish painter working in Munich, heard about Montparnasse and at once set out to live there. Modigliani heard of Montparnasse from the Chilean artist Ortiz de Zárate while he was working as a student in Venice in 1902. He never forgot Ortiz's enthusiasm, and four years later, when he had finished eight years of training, he abandoned Italy and moved to Montparnasse. Painters started to move into Montparnasse from other parts of Paris. Among the last was Picasso, who got his dealer Daniel Kahnweiler to move him from Montmartre into a splendid apartment and studio on the Boulevard Raspail in the summer of 1912. In the first decade of the twentieth century, practically the whole of the "Ecole de Paris" had formed there, and by 1905 the entire Stein family, led by Gertrude, had moved in. Foujita joined them in 1913 and later recalled, "I arrived in Montparnasse directly from Japan and practically the same night met Modigliani, Soutine, Pascin and Léger." Shortly after that he met Diego Rivera, Ortiz de

Zárate, Chagall, Zadkine, Kisling, Picasso, Juan Gris, Derain, Duchamp and Matisse. There was no shortage of company. Soon after arriving, Foujita made a drawing of Rivera sitting alone at a table in Chez Baty before an omelette and a cup of coffee, wearing a bow tie and an elegant high-crowned hat.

The Ecole des Beaux-Arts admitted women in 1900, which resulted in a further increase in student numbers. Women played an essential role in the life and fame of Montparnasse as muses, comrades, models, as painters and as free spirits. The "liberty" of Montparnasse, perhaps its basic attraction, entailed a freedom to create and speak and write as one wished, but it was also closely related to the sexual liberty of women. This was described variously as "an open society" or as an association of "free souls" noted for their "generosity" and "warmth." Essentially it was an area where the moral conventions of the day did not apply. In 1913 the Dutch Fauvist* Kees van Dongen painted an erotic nude of his wife and exhibited it at the Grand Palais in the Salon d'Automne, where it was promptly seized by the police. When the uproar had died down, rich, fashionable women flocked to Montparnasse to be painted by van Dongen. In the moral battlefield of the early twentieth century, Montparnasse was a liberated area.

Because it was on the growing edge of the city, Montparnasse was a place of flowers and fruit, fig trees and beehives, with windmills still visible beyond the far walls of its large cemetery. Pigs, chickens and goats were frequently kept in its courtyards; there was a silkworm farm near the police station on the Rue Delambre; and in the *cour* of the building beside the one occupied by the Steins on the Rue de Fleurus there was a working dairy complete with cows. Amid this bucolic ease the cafés sprang up and prospered. It was the last great expansion of the Parisian café, an enchanted place where, for the price of a cup of coffee, you could spend the day, demand free notepaper with pen and ink, and eat your way through baskets of free bread knobs. *"Venir au café"* meant, according to Jean Moréas, to arrive at 8:00 a.m. for breakfast and to be there still at 5:00 a.m. on the following day. On the corner of the Boulevard du Montparnasse and the Boulevard Raspail, the heart of the district, two rival cafés were established: the Dôme, which was favoured by the northern and central Europeans, the Germans and the Americans, and on the other

*The word "fauve" (meaning wild beast) was originally applied as a term of abuse to a group of painters who used exceptionally bright colours and exhibited at the Salon d'Automne in 1905.

side the much smaller Rotonde, which had a quiet back room and a south-facing *terrasse*. This led to its nickname "Raspail-Plage" and to its popularity with the Latin American painters and the Spaniards.

Food was cheap in the cafés and in the neighbouring bistros; there was a culture of food in Paris which lasted until 1914, when the outbreak of war cut off supplies. It was the time of the "Club des Cent" (kilos), when beautiful girls were fat and men in their thirties frequently died from overeating. It was a golden age. Two of the Fauvists, Vlaminck and Derain, living up to their name, invented a game which they played with the poet Guillaume Apollinaire. It consisted of eating their way through the menu and starting again from the top. The first to give up paid the bill. On one occasion Vlaminck continued until he had consumed every single dish twice. This was the heyday of embonpoint, the time when a well-nourished girl was *"appétissante à voir"* and when a man without a paunch was a man without authority. What would have happened if these men had been taken to a beach and stripped to their underpants? They would have wobbled around happily, everybody would have roared with laughter, including them, and then, turning their backs on the sea, they would have opened the picnic basket. Rivera had the right physique for this culture, and sometimes late at night he would strip to the waist and wobble around with a full wineglass balanced on his head to amuse the company. When Carco watched Apollinaire at table, he reflected that if the poet ordered any more food his chair would give way. But what did it matter? He had his *"gros pouf d'abord"* to cushion the shock. The painter Marie Laurencin once got "a thrashing" from Apollinaire because she had made a hash of his risotto. Food was the symbol of love. A lack of food meant a lack of love. Indeed it frequently replaced love. *"Pas d'amour maintenant, ma poule. Sers-nous un bon petit repas,"* Apollinaire would say. And so his *"poule"* would prepare another meal, lovingly.

When people were not working, they seem to have been eating; and if they were not eating, then as likely as not they were sitting in a café talking. Years later the sculptor Chana Orloff remembered the Montparnasse of 1910, where he first met Apollinaire, Rivera, Foujita, Picasso and Modigliani. "We were young and it was freedom and cheap. We could spend hours sitting in front of a café-crème warming up. At that time we had magnificent *patrons de café*, who understood our problems." The writer Ilya Ehrenburg remembered in particular "Libion," Victor Libion, who opened the Rotonde in 1911 and who became one of the great figures of Montparnasse. He could never have imagined, wrote Ehrenburg, that his name would feature in the history of art. "He was a fat, good-natured

man who had bought a small café. By pure accident the Rotonde became the headquarters of polyglot eccentrics . . . poets and artists, some of whom were later to become famous. Being an ordinary, average, bourgeois, Libion at first looked askance at his very 'off' clients. I daresay he took us for anarchists. Then he grew used to us and even came to like us." Sometimes Libion would give five francs to a poet or a painter, saying irritably: "Go and find yourself a woman, you've got a mad look in your eyes." At other times he would give Modigliani ten francs for a drawing, and contemporary photographs of his back room show the walls covered in paintings. But he did not really like accepting pictures instead of cash. He regarded this practice as too much of a gamble; he realised that only a small number of his hundreds of artist customers would ever become famous. Still, he could have taken a few chances. His regulars included Léger, Vlaminck, Gleizes and Metzinger, Picasso, Juan Gris, Modigliani, Chagall, Soutine, Zadkine, Kisling, Foujita and Pascin, as well as Diego Rivera.

When Rivera first came to Montparnasse to live with Angelina, he was still an insecure and rather withdrawn figure, as uncertain of himself as he was of his art. And for the first two years after his return from Mexico he remained essentially a traditional artist. In the Salon d'Automne of 1911 he showed the two views of Iztaccíhuatl he had painted in Amecameca that spring. Room 8 of that autumn's Salon contained a famous Cubist room whose pictures were attacked by some of the most notable critics of the day, but the controversy does not appear to have interested Rivera. Whatever work he did that winter he did not consider worth showing in the following spring's Salon des Indépendants, where his contribution was of the Montserrat landscapes he had made the previous summer in Catalonia. When the Salon closed he and Angelina decided once again to spend the summer in Spain. In doing so, they were able to save their rent in Paris by giving notice and moving out of their apartment. Their few possessions were lodged with friends, two Dutch painters, Conrad Kickert and Piet Mondrian. During the previous winter they had changed address, crossing the Avenue du Maine and moving into a studio that was even closer to the railway tracks in a building where the Dutch painters were already living.

In Spain that summer Rivera and Angelina went back to Toledo, where Rivera, for the first time in his life, managed to make paintings that bore an individual style. For most of his life Rivera produced work to order, which is not to say that he was under direction but rather that his art either followed established conventions, as with his portraits, or was

discussed with his patrons before he started work, as with his murals. It is therefore worth asking who at this period in his life Rivera thought he was painting for. Up till 1912 the answer is clear. As a student Rivera painted for his masters, for Velasco and Rebull, later for Chicharro and his patron Dehesa. When he left Madrid his studies continued without a master, but he soon found in Angelina a contemporary and a fellow artist whose views became his reference point and his channel to a wider public. On returning from Mexico, Rivera immediately switched to pointillism, probably hoping to ensure that it would mean that his pictures would be exhibited in the Salon under the presidency of Signac. But sooner or later he would need to find his own clients, and with the paintings he produced in Toledo in 1912 and 1913 we have the first signs that he could offer them something distinctive. Rivera had grown out of the academic mould imposed by his teachers. He had spent two years experimenting with various styles and had covered the Flemish masters, Turner, Impressionism, symbolism and Post-Impressionism. Now he turned back to Spain and—once more in touch with his friends from the Nuevo Café de Levante—he recalled the words of Valle-Inclán and the importance of *The Burial of the Count of Orgaz*. Taking the elongated line of El Greco, Rivera used it to reinterpret some of the themes with something of the humanity of Goya. The resulting mixture was his own, as were the colours in the outstanding painting he produced in Toledo that summer, *Los viejos,* where he portrays with a non-Spanish eye the dry vivacity of that bleakly dignified land. But it is not a dignity that he was prepared to accept entirely on its own terms. There is also in *Los viejos* a hint of what was to follow much later in his career: the satirical response. One of the three old men portrayed has a humorous malice in his glance and a twist to his mouth which suggests that he is about to savour some rather undignified detail of the human condition. This sly touch is quite lacking in the other big canvas he completed in the same style in Toledo, *The Pitcher,* which has the same stillness, archetypal reserve and richly sombre palette, but which lacks the movement and the original character of *Los viejos*. These pictures have frequently been described as "heavily derivative" of El Greco, but it must nonetheless have been an immense relief to Rivera to find that he had at last acquired the beginnings of a distinctive personality. At the age of twenty-five he had grasped the end of a string that would, eight years later, lead him out of the maze.

During the summer of 1912 Rivera and Angelina took a house in Toledo which they shared with another painter from Mexico who was to exercise some influence over Rivera: Angel Zárraga. The house was at 7

Calle del Angel and was to become their summer base for a number of years. That summer in Toledo the three artists abandoned their own brushes and posed for hours on each other's behalf. Rivera painted a portrait of Zárraga, also a follower of El Greco who had recently spent time studying at the Uffizi in Florence and who was at that time of strongly Catholic views. Another painter from Montparnasse who was in Toledo was the Pole, Leopold Gottlieb, and he, in his turn, painted an impressive portrait of Rivera. Gottlieb's *Portrait de Monsieur Rivera* shows a massive seated figure, a young man in a collarless white shirt and buckskin coloured trousers, and was shown in that year's Salon d'Automne. Rivera returned to Paris with a full-length *Portrait of a Spaniard,* again showing something of the influence of El Greco. But this was based on a sketch which he had made of a friend, Hermenegildo Asina, in Madrid in 1907, and was one of the first pictures he had started on his initial arrival in Spain. The original sketch is less marked by El Greco's elongations. This first full summer spent in Toledo was also used by Rivera to make several studies of the city in which he emphasises its resemblance to Guanajuato. But even here he chose views which El Greco himself had painted; the artist searching for a toehold in the future was still clinging to the past.

The vernissage of the Salon d'Automne in 1912 was on October 1, and Rivera and Angelina returned to Paris in the second half of September in time to enter his summer's work for the consideration of the jury. He was by now submitting much more recent work than had previously been the case. In 1911 he had shown the Mexican landscapes made six months earlier. In that spring's Salon he had shown the work finished the previous summer in Catalonia. This time he was sufficiently confident to show canvasses on which the paint was scarcely dry. The jury accepted two: the large full-length *Portrait of a Spaniard* and *The Pitcher,* the less striking of the Spanish thematic studies. Both paintings were two metres tall and, together with Gottlieb's portrait of the artist, which was of an equivalent size, at least ensured Rivera's physical domination of part of the show. The *Portrait of a Spaniard* attracted some critical attention and was noticed in *L'Art Décoratif,* which was all the more pleasing since the decorative arts section was the great success of the 1912 Salon.

On the first day an incident took place which was described by Apollinaire in his habitual report. The opening of the Salon, he wrote, also marked the opening of the Parisian season, "le tout Paris" was there, an elegant crowd which included Debussy and the poet Paul Fort. Among the artists exhibiting were Matisse, Vlaminck and Bonnard, and there were also works by Renoir, Cézanne, Degas, Toulouse-Lautrec and

Fantin-Latour. But it was the Cubists who made the news. The Cubists, noted Apollinaire, were no longer treated with the mockery of earlier years; it was now more a question of straightforward hatred. At the beginning of the year Gleizes and Metzinger, two French painters, had published *Du cubisme,* said to be the manifesto of the movement. But in the Salon d'Automne Cubist works were placed in a poorly lit room, and the artists were not happy about this. Some of them took advantage of the publicity provided by the vernissage to gather round a hostile critic, Louis Vauxcelles, and insult him noisily. When Vauxcelles responded by challenging them to meet him outside, they retired. That month Apollinaire described the Cubists as "the most serious and the most interesting artists of our time," a comment which was likely to have been noted by Rivera since he was living with two of them.

When Rivera and Angelina returned to Paris in September 1912, they moved from the Avenue du Maine to an adjoining building on the same block, still overlooking the railway lines, 26 Rue du Départ; and this was to become their home for the next six years. To start with, they shared it, once again, with Kickert and Mondrian. Piet Mondrian, who was fourteen years older than Rivera, had been living in Amsterdam, where he was painting urban landscapes, until a day in 1911 when he went to see a local exhibition which included some Cubist work by Picasso. He at once moved to Paris, to the Avenue du Maine, and started to paint in the Cubist manner himself. He did this with sufficient confidence to develop his own style and to be accepted as one of the more notable members of the movement. Kickert and a third Dutch painter, Lodewijk Schelfhout, joined Mondrian in his new enthusiasm, and Rivera, who loved to theorise about painting, soon found himself thinking about Cubism. He did not immediately feel tempted to try it himself. Instead, in the winter, he returned to Toledo to finish work on six paintings which he was to exhibit at the fourth exhibition of the "Groupe Libre" held at the Galerie Bernheim-Jeune the following January. This gallery, one of the most prominent in Paris, at that time on the Place de la Madeleine, had launched van Gogh in 1901, and the exhibition was the first held in a private gallery which Rivera had ever been invited to join. Among the works he showed at the Groupe Libre show was the view of Toledo based on the one which El Greco had chosen, and which shows the extent to which even at this late date he remained a relatively traditional painter. But the momentum his work had gained the previous summer had not been lost, as one of the first paintings he completed at his new studio on his return to Paris showed.

The studio at 26 Rue du Départ, which was to be the setting for many of the most significant events in Rivera's life, was in a run-down building, overlooking a courtyard, where Rivera and Angelina occupied the top floor. The large studio window faced north-west and gave a clear view of the dozen or so rail tracks leading into the Gare Montparnasse. This was not a peaceful spot: the smoke and steam from the tracks rose night and day throughout the year. At night the darkness was filled with the noise of trains being marshalled, the eerie whistles announcing departures, the clashing waggons and the sudden explosion of piston blows as a shunting engine moved off. No one who has slept within a mile of a steam-age marshalling yard can ever forget the night-time noise. But for Rivera the activity of the station was a positive attraction. And his excitement is clear from the superb *Portrait of Adolfo Best Maugard* which he executed in his new studio, placing the elegant dandified figure of his friend from Mexico in front of the absorbing new view from his window, over the tracks. The figure of Maugard is directly related to those in *Los viejos,* still clearly seen through the eyes of El Greco, even if Maugard with his Parisian *superbe,* his silver-tipped cane, his fur-trimmed overcoat, his buttoned kid gloves and his spats is some way from the barren summer plains of Castile. Adolfo Best Maugard was a contemporary of Rivera's who had been commissioned by the Madero government to catalogue pre-Columbian Mexican art in European public collections. Rivera showed him standing on an iron-railed foot-bridge, one of the hundreds which crossed railway tracks all over Paris and which were painted standard-issue rust red. By making the background of the portrait the view from his studio window, Rivera gave the impression that the foot-bridge was the balcony of the flat. The deep background is dominated by the enormous orb of the industrial "Great Wheel," which stood 106 metres high, near the Champ-de-Mars, one-third the height of the Eiffel Tower. It was in fact within Rivera's line of vision, but he has increased its height considerably for effect. The wheel is painted in exact detail, with the correct number of gondolas visible and the details of its structural girders shown with technical accuracy, further evidence of his delight at his industrial surroundings. The *Portrait of Adolfo Best Maugard* was perhaps the first outstanding picture Rivera painted. At 2.28 metres high, it is on the scale of a mural and has something of the feel of one, the train moving off the right edge of the canvas giving the sense of an unfinished story. And in placing the fastidious figure of the man about town against this unexpected background, Rivera piques our curiosity: what is he doing there, where is he going next?

The historian Martín Luis Guzmán described visiting Rivera at 26 Rue du Départ at about this time.

Up a narrow, spiral staircase. . . . Then on the third floor a card fixed to the door, handwritten, "Diego M. Rivera—the bell does not work. Knock hard, very hard." Nothing could have been more welcoming than his broad smile flashing with kindness and sincerity. The room was uncomfortable, two old sofas, the bright colours of a *sarape* [blanket] from Saltillo; the work in progress turned to the wall. Through the window the swell of roofs, or of nearby warehouses and workshops, and beyond the constant disturbance, the restlessness, of the trains of the Gare Montparnasse.

There is one detail in this description which intrigues, and which tells one much about the comradeship of the free republic: "the work in progress turned to the wall." Guzmán mentioned this because it was invariably the case, and he knew it was the work in progress because when Rivera discovered who his visitor was, he would have turned it round again to show him. Guzmán was trustworthy, Guzmán was not a painter. But before he opened the door, Rivera checked that his canvas was not on view, just like all the other painters in Montparnasse. Cocteau recalled that "the artists were frightened of each other, and the first time Picasso came with me to visit other painters we could hear the doors being chained up after we had knocked. They were hiding their pictures." Picasso was the most intimidating visitor. Cocteau said that Picasso adopted every new idea he saw and then did it better himself, but Picasso too was wary of being copied and Clive Bell described a visit to his studio to see some water-colours. ". . . He has something of a mania for hiding them and is always on the lookout for spies. Twice during the morning we were interrupted and both times infinite precautions had to be taken before the stranger was admitted."

But in 1913 Rivera had not yet met Picasso. Nor was he sufficiently well known or well established to have attracted Picasso's curiosity. Indeed the first reason why Rivera seems to have been noticed in Montparnasse was for his appearance. Apollinaire was familiar with his remarkable figure sitting on the terrace of the Rotonde with Kisling and Max Jacob. Ehrenburg vividly recalled his "large and heavy, almost savage" looks, as captured in a portrait by Modigliani. And the young Russian painter Marevna, a connoisseur of unusual men, listed his features with an artist's eye and a gourmet's relish and described how children would call out to each other when they saw Rivera in the street.

For Diego Rivera was a real colossus. . . . He wore a beard . . . which fringed his chin in an oval, short and evenly trimmed. The most notable features . . . were the eyes, big, black and set aslant, and the nose which from in front was short, broad and thick at the tip, and in profile was aquiline. He had a wide mouth and sensual lips, like Ehrenburg's, but his teeth were white. A small moustache covered his upper lip and gave him the look of a Saracen or a Moor. His friends referred to him as "the genial cannibal." His hands were small for such a big body; his buttocks were wide. . . . He had flat feet and a walk of his own. To complete the picture he wore a wide-brimmed hat and carried an enormous Mexican walking-stick, which he was apt to brandish.

Apart from painting, Rivera loved more than anything else to talk about painting, and this passion played an important part in his unexpected decision to abandon the style which he had with such patience and so painfully at last developed and chance his luck as a Cubist. At the beginning of 1913 he was still a traditional figurative painter, inspired by, but moving away from, El Greco; by the autumn a complete transformation had taken place and he had turned himself into a Cubist. And once he had started on Cubism he was to paint in no other style for four years. In the winter of 1912 and 1913 Rivera was working on a large canvas of *The Adoration of the Virgin and Child*, the only time he selected a traditional religious theme for a full-scale painting. This work, showing the waning influence of Toledo and Angel Zárraga, was begun in Toledo and finished in Paris. The picture was unusual for several reasons, not least that it was executed in encaustic, an ancient technique in which pigmented wax is spread over the painting surface with hot irons. Delacroix had revived encaustic for his wall paintings in the Chapel of the Holy Angels in the Church of St-Sulpice, not far from Montparnasse, and Rivera had seen it used in Mexico City during his visit in 1911. In his *Adoration of the Virgin* the faceted angles used both for the worshipping figures in the foreground and for the hills and fields of the background suggest that what may have started as a more conventional painting in Toledo, a city studded with religious masterpieces, developed into a more experimental and avant-garde picture in Montparnasse. Once the picture was finished during the summer of 1913, Rivera transformed himself into an exclusively Cubist painter. In his own explanation of this conversion he later wrote: "Everything about the movement fascinated and intrigued me. It was a revolutionary movement, questioning everything that had previously been said and done in art. It held nothing sacred. As the old world would

soon blow itself apart . . . so Cubism broke down forms as they had been seen for centuries and was creating out of the fragments new forms and, ultimately, new worlds." No doubt Rivera's description of his intellectual excitement was sincere. But it failed to explain the timing of his conversion to a movement he had been aware of for two years.

A prime reason for Rivera's interest in Cubism was the failure of the Groupe Libre show at the Galerie Bernheim-Jeune in January 1913 to attract anything like a satisfactory amount of public attention. The modern art market was by this period well established, with skilful dealers, encouraging a succession of "scandals," confident that the hidebound reaction of the French art academies would ensure a satisfactory level of public outrage. In this arena Rivera's painting, however authentic and original, was simply in too familiar a style to compete. Furthermore, with the fall of Madero's regime in February 1913 the artist's government grant came to an end. The Mexican Revolution was now moving into its most violent and turbulent period, which was to last for four years, and Rivera urgently needed an income. He had put aside his brief experiment with pointillism; now he realised that his preferred new style was not capable of winning him the attention that would lead to a contract with a dealer. This, together with his growing interest in the analytical energy of Cubism, a movement which tried to make a science out of painting, made up his mind for him.

On March 19, 1913, at the Salon des Indépendants, Rivera had exhibited his *Portrait of Adolfo Best Maugard* and two pre-Cubist Toledan landscapes, and although they were noticed, usually politely, they attracted nothing like the attention accorded to the man who was painting in the studio directly beneath Rivera's at 26 Rue du Départ. Apollinaire in his opening review wrote that Mondrian's Cubist work *Arbres* would be among the most widely noticed canvasses in the show. And in a subsequent review he returned to Mondrian, judging that the latter had surmounted the influence of Picasso and had protected his own personality to the extent that he was able to offer a different vision of Cubism from the one devised by Braque and Picasso, a view characterised by abstraction and "a sensitive intellectualism." For Rivera, the proximity and success of Mondrian, his own continuing obscurity after a total of six years in Europe and four in Paris, and the calamity of losing his government grant suggest a much simpler and more practical explanation for his conversion to the style of the moment than the one he himself offered. It was Cubism, embraced for commercial reasons, that broke Rivera's conservative cast of mind and led him towards the Revolution; not, as he claimed,

his own growing iconoclasm that led him to Cubism. Rivera always claimed to have been led to Cubism by his revolutionary instincts, by Cézanne and by Picasso. In fact, he reached it despite his deeply conservative instincts, via El Greco and Angelina Beloff. It was she who enabled him to see the world through eyes sufficiently youthful to understand and respond to such contemporaries as Mondrian. There was never any trace of Cubism in Angelina Beloff's own work, but she was unquestionably one of the group of Russian dissidents in exile who were in favour of revolutionary solutions and instinctively sympathetic to novel theories of art. We know this from the comments of their friends.

Early in 1913 Rivera had become more involved, with Beloff's encouragement, in the Russian emigré movement. It was during this period that he met Ilya Ehrenburg, who was to become one of his great friends. At that time, wrote Ehrenburg, Rivera had just started to paint Cubist still lifes.

Both his great talent and a certain excessiveness which characterised him were already in evidence. . . . Shortly before I met him he had married Angelina Belova, a painter from Petersburg with blue eyes, fair hair and a northern reserve. She reminded me far more of the girls I had met at political meetings in Moscow than of those who frequented the Rotonde. Angelina had a strong will and a good disposition; these helped her to bear the riotous Diego's excesses of anger and gaiety with truly angelic patience. Diego used to say: "They made no mistake when they christened her."

Other Mexicans also noticed the importance of the Russian influence. On September 30, 1913, Rivera's friend Alfonso Reyes, who was in Paris, wrote in a letter to Mexico, "Today I had dinner with Diego Rivera—who has just returned from Toledo—and with his Russian wife. It's scandalous. Diego is painting Futurism. And they tell me Zárraga is too. . . . And Zárraga also has a Russian woman at his side. Could the Russians possibly have dispatched an army of Amazons to corrupt Western civilisation?" The answer, of course, was "Yes." The community of exiled Russian revolutionaries in Paris was numerous and influential and included, for brief periods, both Lenin and Trotsky. Trotsky is said to have been a regular chess player in the Rotonde, even if he spent more of his time with anti-militarist French trade unionists than he did with emigré painters. Many of the painters were nonetheless his supporters, and as Rivera saw more of Angelina's circle of political friends, he once again distanced himself from his own compatriots. The *Portrait of Adolfo Best*

Maugard was singled out for hostile comment by Dr. Atl in his review of the 1913 Salon des Indépendants, and Rivera felt misunderstood by his former mentor. That summer, back in Toledo with Angelina, he turned once more to the same subjects: figures in landscapes, and views of the city and its neighbouring hills. But this time he had an up-to-the-minute and more commercial style in which to depict them. He had also managed to fuse his two new worlds, Toledo and Montparnasse, in the same endeavour: Cubist studies of Toledo.

Rivera's decision to switch to Cubism paid off almost immediately. Early in October 1913, just at the time when Alfonso Reyes was writing home about Diego's submission to Russian influence, the art press began to publish rumours of his new style. At that season's Salon d'Automne Rivera showed three Cubist works, including *The Adoration of the Virgin*, which was now rechristened in correct Futurist jargon *Composition, Encaustic Painting*. Cubism remained satisfactorily controversial. The minister of culture, when opening the salon, admired the work of the symbolist Maurice Denis; but on passing the Cubist painting *Bateaux de pêche* by Albert Gleizes remarked that it resembled *"une catastrophe de chemin de fer."* Rivera's *Composition* was noticed and praised and proved to be the artist's entrée into what was later to be termed the first Ecole de Paris. From now on he was a figure to be remarked, and was associated with a circle led by Apollinaire, Delaunay, Léger and by the Cubist theoreticians Gleizes and Metzinger. Many years later Madame Gleizes, in a conversation with Favela, recalled, rather oddly, "a primly dressed and well-mannered" Rivera attending her Sunday salons—confirmation of Rivera's arrival where he wanted to be, among those who were talked about, in the free republic of Montparnasse.

In the winter of 1913 to 1914 Rivera continued to work at his new style, making several portraits, introducing drabber colours and experimenting with "sand painting," collage and pointillist sections in Cubist pictures. He had become friendly with the Japanese artists Foujita and Kawashima and started work on a dual portrait. Foujita was very interested in costume. On the boat from Japan he had worn a solar topee and white ducks. Shortly after arriving in Paris, he kitted himself out as an off-duty London barrister in dark three-piece suit, wing collar, silk tie, fob watch and bowler hat with toothbrush moustache. Then he took to walking round the streets of Montparnasse in Roman costume, short tunic, waist cord, headband and thonged sandals. He still had the moustache. This was the outfit in which Rivera chose to show him in his double portrait, which has now been lost. He himself described the picture as "two heads close to

one another in a colour scheme of greens, blacks, reds and yellows," which owed much to Mondrian. And it was while he was at work on this, early one morning in his studio, that Ortiz de Zárate came to him with a curiously phrased message from Picasso. "He sent me to tell you that if you don't go to see him he's coming to see you." It was the investiture, the confirmation that Rivera was now well enough known to have ignited the curiosity of the man who was already acknowledged as the leader of the modern art movement around the world. And Picasso's phrasing was an amiable reference to his own reputation as a magpie of other people's inspiration, a promise that he would allow Rivera to see what he was doing before he, in his turn, hopped into 26 Rue du Départ. It was a ten-minute walk to the Rue Schoelcher, where Picasso had his studio at 5 bis. Rivera dropped everything, and with the Japanese Roman in tow accompanied Ortiz down the Boulevard Edgar Quinet.

Rivera said that he walked to Picasso's studio feeling like "a good Christian who expects to meet Our Lord." He was not disappointed. The studio was full of excitement, the canvasses stacked up together were "like living parts of an organic world Picasso had created," and even more impressive than when shown by dealers as individual masterpieces. "Will and energy blazed from his round, black eyes," wrote Rivera. "His black, glossy hair was cut short like the hair of a circus strong man," a vivid description of a young painter already at the height of his powers. Picasso was happy to show Rivera everything; it was in fact sensible of him to do so, on occasion. He copied so much that he needed to show that it could be a two-way traffic. When Ortiz and Foujita left, Picasso asked Rivera to stay on for lunch. Then they went back to the Rue du Départ and Rivera showed Picasso everything *he* had done. Picasso took as much pleasure as Rivera in talking about painting, and there was the additional advantage for both men that they could hold their discussions in Spanish. The brief friendship of Picasso was to be of great importance to Rivera. The Spaniard was five years older than he was, but in addition had the immense assurance of a man who knew that he had already won international recognition. In contrast to Rivera's introspection, there was Picasso's warmth and delight in other painters' company, and the energy he devoted to seeking casual human contact. From such contacts he drew many of his ideas. He did not just suck inspiration from other artists' work; he found it with circus performers whom he tracked down for the pleasure of their conversation, and he had time for any number of peripheral activities, such as photography, which had intrigued him since 1901. For a man as isolated as Rivera to find a friendship such as this was a rare

chance. Until he met Picasso he had remained in many ways an uncom-
prehending exile, lost in a hostile environment. But Picasso's friendship
was his key to wider recognition, and in later years Rivera recalled that his
new friend brought all his own friends, such as Max Jacob, Seurat and
Juan Gris, to the Rue du Départ to meet the man known as "the genial
cannibal."

Apart from painting, Rivera had other things in common with
Picasso. They shared a Catholic family background, a hazardous birth
(Picasso was diagnosed as stillborn and only revived when a curious doc-
tor blew cigar smoke into his face), and the abundance of protective
women; Picasso had been surrounded as a child by grandmothers, aunts
and maids. The resulting machismo, the education by priests, supernat-
ural portents (Picasso had vivid memories of a childhood earthquake),
and infantile prodigy made further bonds between them. Years later, in
1939, Rivera made a sly reference to their time of intimacy when he told
his first biographer, Bertram Wolfe, that he had been christened "Diego
María de la Concepción Juan Nepomuceno Estanislao," whereas he had
in fact been christened Diego María. Picasso, on the other hand, had been
christened "Pablo *Diego* José Francisco de Paula *Juan Nepomuceno María de
los Remedios* Crispín Crispiano Santísima Trinidad." But this was not gen-
erally known. When Picasso married Olga Khoklova at the *mairie* of the
seventh arrondissement in July 1918, he declared his full name, less the
names "Diego," "María de los Remedios" and "Crispiano." By the time
Rivera added the names "de la Concepción," "Juan," and "Nepomuceno"
to his own he had grown apart from Picasso, but he liked to recall that
period of quasi-fraternal brotherhood, when they had vied with each
other in describing their outlandish childhoods. Rivera's fantastic tale of
being carried away into the hills by an Indian nurse may have been
inspired by Picasso, who recounted his own experience as a small child at
the hands of the Gypsies. "There was no end to the tricks I learned from
the Gypsies," Picasso would say.

Another link between Rivera and Picasso was their preference for
spending their summers in Spain. Picasso had been retiring to the little
Pyrenean village of Gosol, further along the same Catalan mountain rail-
way line that served Montserrat, since 1906. In Gosol as in Montserrat,
the only forms of entertainment were the religious festivals, and the cen-
tre of religious life was a carved figure of the Virgin and child. And in
Gosol Picasso, like Rivera in Toledo, found himself for some of the time
under the influence of El Greco. But not all their time together was spent
in professional discussions. Both men had a childish taste for practical

jokes. Rivera recalled that sometimes, when he called on Picasso, the latter would hide him in a cupboard before the arrival of "one of our women acquaintances" and would then encourage the unsuspecting visitor to criticise the Mexican, Picasso always being careful to defend him warmly. Rivera may even have accompanied Picasso on his nocturnal expeditions to write up graffiti about Matisse, of whom Picasso was jealous. He would cover the walls with slogans such as *"Matisse rend fou . . . ,"* a reference to the forbidden drink of absinthe, subsequently sold as pastis. Ehrenburg recalls Picasso and Rivera coming into the Rotonde saying that they had just been standing under Apollinaire's window serenading him with a song they had contrived with the refrain "mère de Guillaume Apollinaire," a pun on the words "mother of" and *merde*. Ehrenburg added another detail about Rivera's new friend, which said much for Picasso's domination of the free republic: "I never saw him drunk." Picasso was aged thirty-one at this time and was already starting to abandon Cubism for a more classical style.

Apollinaire also had a kind word for Picasso's new friend, whose work he described as "by no means negligible," but others looked on the new celebrity of this ungainly Mexican giant with a less welcoming eye. The Paris art world has always been a snake pit of envy, treachery and malice, as Rivera was about to discover. Shortly after finishing his Cubist double portrait of Kawashima and Foujita, Rivera had his first one-man show in Paris at the Berthe Weill Gallery. Twenty-five pictures were shown, all in Cubist or near-Cubist style and all painted in the previous twelve months. The exhibition opened on April 21, but what should have been a great day for Rivera was spoiled by the preface to the exhibition catalogue in which an anonymous critic "B." attacked him and belittled everything he was trying to achieve. The preface was in fact written by the gallery's owner in an act of self-destructive mischief, possibly when she was drunk; it had some of the drunken recklessness of a writer blurting out the first phrases which come to mind, and she even managed to misspell the artist's name. Rivera was so upset by it that he decided to withdraw his work from the gallery. He was particularly angry because several of the comments read like a veiled attack on Picasso, which indeed they were. Berthe Weill later confessed that she had used the catalogue as an opportunity to "tease" Picasso a little. In 1902, when he was in trouble, she had been one of the few dealers to support him, but he had subsequently abandoned her for more influential rivals. The vernissage was a fiasco, with Rivera making a furious scene and the gallery closing, an incident which ensured that it was reported at length by Apollinaire.

Fortunately, the quarrel was patched up, the catalogue withdrawn, the gallery reopened, and many of the pictures sold. Today the affair reads like a publicity stunt, but at the time Rivera was genuinely downcast. Alfonso Reyes, who was present at the vernissage, made a shrewd comment when he wrote to a friend, "Poor Diego had his exhibition closed down and has dispensed with the support of this terrible bitch, for the sake of a friend [Picasso] who perhaps sees matters . . . with very different eyes." This was exactly right. Whether or not Picasso had a hand in patching up the quarrel, his own relations with Berthe Weill were completely unaffected and he probably considered the insulting preface par for the Paris course. In any event, he was on sufficiently close terms with the dealer by 1920 to draw her portrait.

There was a hectic atmosphere in Paris in 1914. On March 2 an auction of Cubist work produced higher prices than collectors were paying for Gauguin or van Gogh. The buyers were German dealers, and the top price of 11,500 francs* was paid for Picasso's *Famille de saltimbanques*. This triumph was greeted by the nationalist press as a German plot to destroy French art. Cubism had become *"l'art Boche."* Two weeks later the ultra-nationalist editor of *Le Figaro* was murdered in his office by the wife of a government minister who had been the victim of a defamatory nationalist newspaper campaign. The atmosphere of bellicose hysteria grew worse on July 31 when the Socialist leader and pacifist Jean Jaurès was assassinated in a restaurant in Montmartre. In between these two events Rivera himself played a peripheral role in a duel between the painters Léopold Gottlieb and Moïse Kisling. This epic encounter took place outside the bicycle-racing track at the Parc des Princes, was fought with both pistols and swords, and lasted an hour. Apollinaire, tracking *la vie bohème* for his readers, said that it was fought between an expressionist influenced by van Gogh and Munch (Gottlieb) and a follower of Derain. It was in fact fought by two Poles over an obscure "matter of honour"; Gottlieb had insulted a woman who was being escorted by Kisling. Rivera acted as second for Gottlieb and was required to examine the pistols before shots were exchanged. An eye-witness recalled him "with the dignity of a figure from Velázquez and Mexican to his finger-tips" glancing down the barrels of the pistols before returning them to the president of the duel. The affair ended with both artists sustaining sabre cuts to the face and claiming victory.

*Worth about $11,700 today.

In June it was time for the annual *exode,* a ritual honoured by most of the citizens of the free republic from its inception. Although there were constant rumours of war, none of those departing from the city had any idea that "Montparnasse" as it had been since the first days of the century would never re-form again. Picasso later claimed that he had foreseen the catastrophe and had implored his dealer Daniel Kahnweiler, who was a German subject, to take precautions. If so, Kahnweiler ignored him, for the outbreak of war found him up an Alp in Bavaria. Determined to avoid conscription in a war against France (his wife was French), Kahnweiler fled for Italy, via Switzerland, but he was unable to return to Paris and the contents of his gallery were seized for the duration.

Certainly Apollinaire had no inkling of what lay in store. From mid-June his daily chronicle speculated about the departures for the Midi: Derain and Picasso for Nîmes, Braque for Sorgues. All through the last summer weeks of his civilisation and of his Montparnasse, Apollinaire sang the district's praises; mentioning the terrace of the Rotonde and the preponderance of Germans at the Dôme, or "der Dôme," as it was known. On July 3, five days after the assassination of the Archduke at Sarajevo, he wrote about Berlin, Munich, Düsseldorf and Cologne and noted the way in which those cities patronised and honoured French painting; he noticed the work of "the German sculptor Lehmbruck" and listened to the music of Offenbach at the Bal des Quat'z'Arts. He also noted that Picasso was ignored in Spain and fêted in Germany and Russia, where he was classed as a French painter. His last report appeared on August 1, the day of the French mobilisation. After that nothing, for eighteen months.

Rivera and Angelina had also set out for the south in late June and did not hear the news from Sarajevo until July 14, by which time they were with a party of friends in Majorca. With them were the sculptor Jacques Lipchitz, who was a friend of Modigliani's, and an English painter whom Rivera knew only as "Kenneth." Early in August they sailed back to Barcelona and on Las Ramblas read a newspaper headline saying that Austria had declared war on Russia, an event that took place on August 6. Their reaction was to return to Majorca, where they spent another three months, no doubt hoping, with so many millions of other people, that it would all be over by Christmas.

THE CUBISTS GO TO WAR

Paris 1914–1918

S THE WAR SWEPT into France, Rivera in Majorca painted a series of brightly coloured "tropical" landscapes. He and Angelina had by now been joined by María Blanchard, who had also moved on to Cubism. Rivera later wrote: "On that wonderful, isolated island [we felt] as remote from the conflict on the continent as if we were in the South Seas." The artists and *Parnassois* who had decided to spend the summer in Provence were less isolated from events. Some, like Braque, Derain and Apollinaire, who had got as far as Nice, returned to Paris to enlist early in August. Picasso, a neutral by nationality, stayed in Avignon, brooding about the news that the contents of Kahnweiler's gallery had been sequestered. Meanwhile, just north of Paris, the Battle of the Marne was under way and the French government removed to Bordeaux. In Majorca mobilisation orders arrived for "Kenneth," the English painter, and for a Russian poet and reserve officer who was a member of the party from Paris. Eventually the Riveras' money ran out and he and Angelina took the boat back to Barcelona. Rivera had by now been living off his painting, without a grant, for more than eighteen months. He would normally have exhibited at the Salon d'Automne, but of course it had been cancelled. His means of earning a living in Europe had disappeared overnight. When they arrived in Barcelona, one of the group, a student named Landau, the son of a banker, managed to get funds cabled to the city which he generously shared out. Then Angelina received a commission to paint the Russian imperial arms on the wall of the Russian consulate. A country at war needed to show its arms. It was an unexpected occupation for a revolutionary, but she fulfilled it heroically and was able

to keep them going for a little while longer. Then disaster struck, from a completely unexpected quarter: María del Pilar arrived from Mexico.

In his numerous lukewarm recollections of his mother's behaviour, few were less enthusiastic than Rivera's accounts of María del Pilar's decision to fly to his aid on the outbreak of the Great War in 1914. He later claimed that in order "to pay for a futile trip to Europe," which she made in the company of his sister María, his mother had sold the family's remaining shares in the El Durazno Viejo silver mine in Guanajuato for a fraction of their real value. Rivera also claimed that he and Angelina had been forced to sell everything they owned in order to pay for his mother's and his sister's return tickets. He then gave a further account of faded grandeur being cashed in to save the situation, not silver-mine shares this time but the family title of "marquess." In *My Art, My Life* Rivera recounted that he was able to raise money by revalidating his title in a Spanish court of law and then selling it to a cousin who had decided that it would come in useful. The objection to this story, of course, is that his father was still alive, so the title was not Rivera's to revive or sell. Fortunately, a less imaginative account of the visit to Spain and its termination was given by his sister María in her memoirs. She recalled that when they arrived unexpectedly in Barcelona, Angelina was extremely kind to them and found them lodgings near Las Ramblas in a *pensión* called the Fonda Española, but that her brother, displeased by his mother's arrival, threw a series of "neuro-hepatic" crises which terminated in a blazing row between mother and son. It was "the greatest disappointment in María del Pilar's life" when she realised that she was not a welcome visitor, and she thereupon decided to return to Mexico. Mother and daughter arrived back in Veracruz while the port was still occupied by U.S. Marines, which means that it was before the end of November 1914. The fact that Rivera concocted two fictional accounts of his mother's visit suggests that his real behaviour may have remained on his conscience for some time.

The French government remained in Bordeaux until December, despite the victory on the Marne, which had been won on September 9, and Rivera and Angelina decided that rather than return to Paris, and to a country engaged in a war which would soon be over and about which neither of them felt the least concerned, they would instead spend the winter in Madrid. Accordingly, they moved into a house with María Gutiérrez Blanchard on the edge of the city near the site of the new bullring. Rivera told his first biographer, Bertram Wolfe, that he had attempted to enlist in the French army but was turned down for medical reasons, possibly flat

feet. Other foreign artists enlisted without any problem. The duellist Kisling joined the Foreign Legion on the outbreak of war, as did the Polish-Italian Apollinaire and the Swiss writer Blaise Cendrars. The Norwegian painter Per Krohg joined a ski ambulance corps that was active in the Vosges mountains. In many cases foreign artists joined up to fight for the France which had given them Montparnasse, or because they were naturally belligerent, like Kisling, or because they wanted to prove their patriotism, like Apollinaire, who still felt ashamed of having been arrested in 1911 for his part in a hoax that had connected him with the theft of the Mona Lisa. But none of these motives would have applied to Rivera, and although he may have tried to enlist, and certainly told his friends in Madrid that he intended to do so, he did not really need a medical excuse for changing his plans. Insofar as he had a political or patriotic commitment, it was on the other side of the Atlantic. And his closest group of friends, including Angelina, viewed the war as no more than an important stage in the dissolution of capitalism. "The transformation of the present imperialist war into a civil war is the only effective proletarian slogan, shown by the experience of the Paris commune," wrote Lenin in 1914; and where Russia was concerned, he proved prophetic. Those of Rivera's Russian or socialist friends who were not with Lenin, for war, were pacifists, with Juárez.

In Madrid he and Angelina found that a section of Montparnasse society had formed a community in exile, driven south by the 9:00 p.m. curfew imposed on Paris. Delaunay was in Madrid, as was Marie Laurencin, whose husband was German, and later Foujita and Kawashima arrived, via London. There were also several of Rivera's Mexican friends, including Alfonso Reyes and Jesús Acevedo. Throughout that winter Rivera continued to work at his Cubism, which was becoming increasingly assured. Already, earlier in the year, in Paris, before the world broke up, he had completed an enormous and superb double portrait of Angelina and a friend of hers, a painter from St. Petersburg called Alma Dolores Bastian, which glowed with rich blues and reds. The figures of the women can be seen behind the Cubist faceting like reflections glimpsed in a pool of disturbed water. Now Rivera set to work on portraits of Jésus Acevedo, Martín Luis Guzmán and Ramón Gómez de la Serna.

As the only member of the group equally at home in Madrid and Montparnasse, Rivera quickly became the centre of the exiles' circle, which gathered for regular discussions at the Café de Pombo, his favourite old haunt. Here a "vanguard," founded by Rivera, gathered and issued a "proclamation" that was signed by Lipchitz and Robert and Sonia

Delaunay as well as by Angelina Beloff and María Blanchard. The gather-ing culminated in an exhibition in March 1915 of work by the exiled *Par-nassois,* which served as Madrid's introduction to Cubism. It was not love at first sight. The critics were abusive or indifferent, and the public gath-ered in such crowds at the windows of the gallery that the traffic was blocked. When the exhibition closed, Rivera's portrait of Gómez de la Serna was placed in the gallery window alone. "The portrait," Rivera wrote, "showed the head of a decapitated woman and a sword with a woman's hair on its point. In the foreground was an automatic pistol. Beside it, and in the centre of the canvas, was a man holding a pipe in one hand, in the other a pen with which he was writing a novel. He had the appearance of an anarchistic demon, inciting crime and the general over-throw of order. In this satanic figure everyone recognised the features of Serna, notorious for his opposition to every conventional, religious, moral and political principle." Gómez de la Serna, putting it another way, wrote that the portrait was a "palpable, ample, complete consideration of my humanness turning on its axis." The traffic police asked that this pic-ture be removed from the gallery window, and so, having made his mark on the city where he had spent his last days as a student, Rivera returned to Paris in late March 1915.

On the outbreak of war the president of the Salon d'Automne, forced to cancel his show, found some consolation in the situation. *"Enfin!"* he cried. *"Le cubisme est foutu!"* The German artists and dealers had disap-peared overnight, streaming out of the Gare du Nord on trains routed through Belgium to Cologne while the young Frenchmen mobilised and in uniform were directed to the nearby Gare de l'Est to join their units. The crowds that gathered to cheer them off were shouting, "To Berlin!" Meanwhile in Berlin, German enthusiasm was equally high and public opinion, led by poets and professors, welcomed "the just war" as "a divine blessing and a creative event." This initial excitement had been succeeded in Paris by a period of acute xenophobia. One of the reasons Picasso had no success in his attempts to liberate the paintings seized at Kahnweiler's gallery from the government depot was that they were "Cubist" and therefore "German" and therefore "suspect." Within a few days of the outbreak of war, all those Germans and Austro-Hungarians who had not succeeded in leaving the country were rounded up and interned. Isolated groups of suspicious-looking foreigners were threatened and sometimes attacked and had to be given police protection. Rivera arrived to find a city in which "spies" were discovered every day. Men of his age in civilian clothes were commonly insulted by women who confronted them and

shouted, "To the front!" and even uniformed soldiers garrisoned in Paris were routinely abused as *"embusqués"* (shirkers). On several occasions young foreign men who gathered on the terraces of the cafés on the Boulevard St-Michel attracted hostile crowds who wanted them to be enlisted or taxed. And if Russians or Poles continued to work at their jobs in Paris, they were accused of profiteering. Montparnasse, with its traditionally large foreign community, was generally a haven from these incidents, but the contrast in atmosphere with the city Rivera had left nine months earlier was nonetheless disconcerting. Even in Montparnasse, Picasso, aged thirty-three, was insulted in the street, and Gertrude Stein described how in the winter of 1914 she was walking down the Boulevard Raspail one cold evening with Picasso when "a big cannon crossed the street, the first that any of us had ever seen painted like that; camouflaged. Pablo stopped dead, as if nailed to the ground: 'We're the ones who did that,' he said": an elliptical comment which John Richardson explains as a reference to the resemblance between early camouflage patterns and Cubist painting.

All the artists returning to Paris in 1915 were faced with the same question: how were they to make a living in a city where the art market had collapsed, where the salons had been suspended and several of the major galleries had been closed, where foreign remittances were cut off and where buyers were scarce? In the event, despite these apparently insoluble problems, a solution was quickly found. It was to continue life as before, just as if there were no war being fought at a distance of approximately fifty miles to the north-east of the city. Rivera and Angelina moved back into the studio at 26 Rue du Départ. Schelfhout, Kickert and Mondrian had left for neutral Holland, and like many other artists were not to return until the end of the war, but there was still a sizeable artistic community in residence. Matisse, aged forty-six, was ruled too old for conscription, and Modigliani, who had volunteered, had been turned down on health grounds. He and Soutine became close friends of Rivera's, and with Brancusi and Picasso, Max Jacob and Cocteau, the nucleus of the pre-war republic could be re-formed. The Russian sculptor Chana Orloff later described Paris during the war as "marvellous, though it's shameful to say it. . . . The French government organised a scheme to assist artists and we were given 25 centimes a day and food in the subsidised canteens. It was the ideal life. I could just work on my sculpture night and day without having to worry at all about earning money." Foujita, who had slipped back from Madrid, encouraged by the return of Rivera and Angelina, recalled the canteen organised by

artists in Montparnasse, chez Madame Vassilieff,* which became an important social centre. "In the evening a meal cost 50 centimes. We used to play the guitar and Picasso would mimic us and then leap around, dancing like a toreador." Restaurants were allowed an extra hour during the curfew and had to close by 10:00 p.m., but Marie Vassilieff's studio, down an impasse at 21 Avenue du Maine, was regarded as a private club and could stay open all night. It became even more popular when the French government's aid to artists petered out and anyone allowed in knew they would find a welcome, a cheap meal and the best company in Paris; one large, warm room where the appalling events to the north could be placed in a civilised perspective.

Paris at that time was two cities living side by side within the same walls. Sartre recalled how he, then aged ten, found the period of the war the happiest period of his childhood. "My mother and I were the same age, and we never left each other. She called me her *chevalier servant*, her little man. . . ." Paris was emptied of men, and those that remained, wrote Sartre, were *"dévirilisés"*; it was "a kingdom of mothers." Pierre Drieu La Rochelle noticed the same phenomenon, but from the point of view of a soldier returning from the front. Paris was peace, it was "above all the kingdom of women. The women knew absolutely nothing of that other kingdom at the gates of Paris, that kingdom of bloodthirsty troglodytes, the kingdom of men. . . ." That kingdom was dwelt in and painted by the German soldier Otto Dix, who had volunteered in 1914 with the cry "To Paris!" ringing in his ears and who quickly discovered what "a just war" meant. He fought directly opposite Drieu La Rochelle on the front at Champagne—what Drieu called "the desert of Champagne"—and then in two battles on the Somme. In his diary Otto Dix wrote, "Lice, rats, barbed wire, fleas, grenades, bombs, craters, corpses, blood, schnapps, mice, cats, gas, guns, filth, bullets, mortars, steel, fire, that's what war is. The devil's work. Nothing, but the work of the Devil!" After the second battle of the Somme he said, "You have to have seen Man unleashed to know something of what Man is like." The French soldiers on leave travelled from one kingdom to the other, but they could never make the people of Paris understand what the other place, the kingdom of men, resembled. They arrived in trains like a lawless rabble, making love to passing women in the railway carriages before they even got to the city, and being invited to submit to the rules of a society where they were frequently held in contempt. Private soldiers with first-class

*Marie Vassilieff (b. 1884), Russian painter, arrived in Paris from Smolensk in 1907.

tickets could still be expelled from the leave-train since they were not offi-
cers, which helped to explain why the platforms of the French stations
crowded with men at the end of their leave rang with the cries *"Vive la
Révolution!"* and *"*Long live the Kaiser!*"* (*Vive Guillaume!*).

The gulf between *"poilus et civlots"* became unbridgeable according to
one of the *poilus,* Jean Galtier-Boissière, because of "the grotesque lies" of
the press which turned defeats into victories, minimised massacres and
claimed that the Germans were constantly begging to surrender. The
most hated man at the front, wrote Galtier-Boissière, was not the Kaiser
but President Poincaré. French troops would construct a wooden silhou-
ette of the president of their Republic and hoist it above their lines merely
for the pleasure of seeing it riddled with German bullets. When it was
rumoured that an orang-utan had escaped from a circus on the Champs-
Elysées, scaled the walls of the Elysée Palace, surprised Madame Poin-
caré, a striking brunette of Italian descent, in her deck-chair, seized her by
the waist and carried her up into the branches of a nearby chestnut tree,
the news reached the front within hours, despite the military censorship
which prevented it from being published. The *poilus* christened the ape
"Fritz" and wanted to award it the *médaille militaire.* At Verdun the French
troops were said to have hated the Germans less than they hated the
French gendarmes stationed a short distance behind the lines to arrest
deserters—several of whom, noted Galtier-Boissière, were found
butchered on meat hooks.

Returning from this nightmare, Galtier-Boissière had to deal with the
concierge of his apartment building on the Rue Vaneau, whose son had
been killed, and who pursued him down the street insulting him for being
alive. After a year of fighting in the front line, and while recovering in
Paris from a serious wound, he found that he had to make a detour sev-
eral times a day to avoid this civilian harridan. The war dragged on, and
gradually artists were released from the front, maimed and shocked. But
their suffering did nothing to spread mutual understanding. "Won't it be
frightful," said Picasso one day to Gertrude Stein, "when Braque and
Derain and all the others stretch out their wooden legs and lean back and
tell us about their War." As prices rose, supplies ran out, and there were
growing shortages of shoes, clothes, coal and food, Rivera worked
steadily at Cubism, playing his part in what he was convinced was an
artistic revolution. He later described his frame of mind at this time,
when "the lands of reason" had gone mad. "The horrible and stunning
atmosphere of the catastrophe penetrated deeper and deeper into my
soul. . . . At the same time I was working ferociously on the precise possi-

bilities of general harmony contained within the universe. . . . I worked day and night, sacrificing many hours that could have been devoted to painting." Nonetheless, he painted much faster than he had before. The work which has survived shows that he was completing Cubist pictures at a rate of two a month. Two of his landscapes, finished in Madrid just before he left for Paris, pleased him. One was a view of the monumental new Plaza de Toros; the other was a Cubist construction built around a perspective of the Eiffel Tower. Back in Paris he started once again to concentrate on portraits, sensing that these would attract more attention, not least because several Cubist theorists denied that there could be such a thing as a "Cubist portrait." Having completed portraits of Jesús Acevedo and Ramón Gómez de la Serna in Madrid, he now added Martín Luis Guzmán and Ilya Ehrenburg to his collection. And he then started work with a young female model. When he had finished this picture he called it *Portrait of Madame Marcoussis*, a curious title since the model in question was a twenty-three-year-old Russian painter named Marevna Vorobev.

The fact that Rivera entitled this picture *Portrait of* ——— suggests that he already had a special regard for its subject. With the exception of *Portrait of Angelina Beloff*, painted in 1909, he had never painted the portrait of a named woman. There had been the sketch of his mother drawn in 1896, and there had been the *Portrait of Two Women*, one of them Angelina, painted in 1914. The picture of Marevna was the first in which he chose to distinguish the model. All other studies of women had been called "portrait of a young girl" or "portrait of a woman." But in order to minimise the significance of the event, Rivera also chose to give the portrait a false identity. There was no "Madame Marcoussis." There was, however, a Monsieur Marcoussis, the Polish painter Louis Markus, whose name Apollinaire had changed "to make it sound like a French village." Marcoussis had been the lover of Eva Gouel, until he had made the mistake in 1911 of introducing her to Picasso, since when she had become the mistress, muse and adored, unmarried wife of the Spaniard. In 1915, however, Eva was dying. And Picasso had found refuge where he always found refuge in times of crisis: in the arms of a new woman. In the words of Pierre Daix, "Picasso was an Andalusian of the nineteenth century: any indisposition in a woman who shared his life was a personal injustice to him." So in 1915, while Eva lay in a clinic in Auteuil with a cancer of the throat, Picasso's known refuges included Marevna. Rivera, who was already feeling attracted to Marevna, was jealous of Picasso, and in misnaming her portrait he was teasing Marevna. He knew of how Picasso

had taken Eva from Marcoussis, and was suggesting that Marcoussis would shortly be getting his revenge on Picasso by carrying Marevna off in his turn.

In 1915, in the reduced community of Montparnasse, Rivera became closer to several men he admired, which increased his confidence and diminished his reliance on Angelina and her influence over him. Among them were the politically committed Russians Ehrenburg and Voloshin, but there was also the Italian Modigliani, who was so fascinated by his friend's appearance that he sketched and painted Rivera at least five times; he had made the "Mexican cannibal" one of his first subjects when he abandoned sculpture in 1914. The social life of these painters and their models and admirers was uninhibited. Marevna describes how, under the influence of drink and drugs, Ortiz de Zárate would be overcome with love for his own body, remove his clothes and then "pursue women like a satyr." Modigliani, who was gentler in his violence, would also sometimes remove his clothes at Marie Vassilieff's canteen before "the curious and eager eyes" of his English or American admirers. Then he would display himself, "naked, slim and white, his torso arched," and recite Dante. Marevna recalled an orgy in the cottage that Beatrice Hastings, the South African journalist and artists' muse, had taken in Montmartre; this ended with one guest on his knees praying aloud while attempting to convert Max Jacob to Catholicism, others making love on the floor or in the garden, others arguing about philosophy or singing Russian songs, and Modigliani eventually throwing his hostess through a window. They carried Beatrice Hastings back into the house and laid her on the sofa. "She was wretched, poor woman, with her long, flat breasts daubed with blood." The sculptor Paul Cornet decided that Modigliani must have pressed her between planks.

Apollinaire described how Picasso, on the rebound from Gaby, wooed Irène Lagut, a painter but also a model, who "loved women as a man does." Picasso spent the night beating on her door. "Listen," he said, "open the door. I love you. I adore you. And if you don't let me in, I will kill you . . . with my revolver." Another model, "l'Anglaise" (Beatrice Hastings again), "spent her days naked in my friend's apartment [that is, with Modigliani] and when he went out debauchery went in." In such cases, where a business relationship had been succeeded by something less orderly, the contacts sometimes became mutually destructive. Modigliani's eventual death was commonly attributed to drink and debauchery, although self-neglect and tuberculosis seem to have played a more important part. Two days after Modigliani's death his model,

Jeanne, the mother of his little daughter and heavily pregnant, threw herself from the window of her parents' apartment. Even Beatrice Hastings, a combative and self-assured feminist, eventually killed herself; as did Derain's model, Madeleine Anspach. And the painter Pascin, whose life had been wrecked by his obsession with Lucy Krohg, the artist's wife, eventually cut his throat, slashed his wrists and hanged himself à la portugaise, from the door-knob of his studio.

At that time models could earn between three and five francs an hour, and many of the girls found posing nude a last-minute escape from a life of prostitution. But not all the models were poor, and not all the artists could afford to pay them. Modigliani would sometimes seduce his model in order to avoid paying her, although in the case of Modigliani the word "seduce" is perhaps inappropriate. The nude models of the painter whom Beatrice Hastings once described as "the pale and ravishing villain" gaze back at their immortaliser, expectant and impatient, looking as though they were about to devour him. When Modigliani was not involved with one of his models, he sometimes pursued rich women who would be happy to share his life for a few days while they posed. He once persuaded his dealer's rather fierce wife to pose for him while her husband was away and managed to sell the paintings before her husband returned. But when he fell in love with Beatrice Hastings, who posed for him right through the Battle of the Marne, he refused to let her pose for Kisling. "If a woman poses for *you*," he said, "she gives herself to you."

Occasionally matters got out of hand. Ehrenburg was arrested for wandering in the street at night and sent to a lunatic asylum where he was interned long enough to have his head shaved. The artists were sometimes luckier if they could contact one of the two police inspectors who were also art collectors. Kisling once punched a policeman and broke his jaw. He was arrested but managed to send a message to Commissioner Eugène Descaves, who fined him two paintings. Commissioner Léon Zamaron, who worked at the commissariat on the Rue Delambre, also collected the work of artists active in his *secteur* and died in 1932, leaving a collection of eight hundred paintings, including work by Modigliani, Soutine and Utrillo.

It was at this time that Picasso, the sober leader of this frantic dance, used to hide Rivera behind a door while he encouraged his female visitors to gossip about him. In a photograph taken at a fancy dress ball at about this time, Rivera is shown surrounded by five women. Angelina is the one whose face is hidden by a mask. But whereas Picasso was accustomed to falling in and out of love, and to feeling furious jealousy of each of his

conquests in turn, Rivera continued for the time being to lead a disciplined and continent life. His lack of interest in the nude as a subject may have contributed to this—he painted no nudes at all until 1919—but it seems that he was either very discreet or considered his attachment to Angelina to be exclusive.

Towards the end of 1915, probably in October, Rivera received another unwelcome visit from his mother, once again with his sister María. She had decided on this occasion to separate permanently from his father and settle in Spain, where she planned to practise as a midwife. The resort to flight, started in Guanajuato twenty years earlier, had become a habit with María del Pilar. She left Mexico in September, but because of wartime interruptions to the mail, Rivera never received the letter announcing her imminent arrival, so there was no one to meet her either in Santander or in Madrid. She went to the Mexican consulate, which could do little for her—the staff not having been paid for some time; in Mexico the Revolution had still not emerged from its most chaotic period. Mother and daughter therefore sold all their jewels and managed to raise enough money to continue their journey to Paris, by train, and Rivera was at the Gare d'Austerlitz to greet them with Angelina. Once again they were treated kindly by Angelina and were photographed in the studio on the Rue du Départ with Rivera and Angel Zárraga, sitting on the uncomfortable low chairs in front of the cheap reproduction of a painting by El Greco which Rivera had pinned to the wall. But the visit was a short one. Rivera had no money with which to support them, he was having a difficult enough time supporting himself, and it became clear that María del Pilar's plans would have to be abandoned when she discovered that the Spanish government did not permit foreigners with her qualifications to practise midwifery in Spain. María Rivera had to contact her father, without letting her mother know, and ask for his help. Since he too was unable to pay for their tickets home, Don Diego arranged instead for the Mexican government to repatriate his wife and daughter on the grounds that they had left the country without his consent. The staff at the Madrid legation, who were worried that María del Pilar might refuse to go, therefore summoned her to a meeting without telling her why, and the poor lady found herself being bundled onto the Veracruz boat before she quite understood what was going on. It was her last European incursion and Rivera was not to see his mother again for six years. His father meanwhile had lost his position at the ministry after twenty years of service and was in failing health. He gave lessons as a private tutor in mathematics and accounting until the political situation

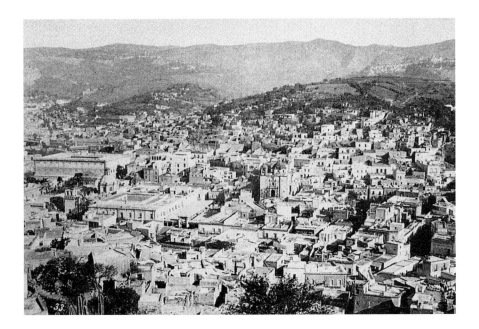

ABOVE: The town of Guanajuato, Mexico, at the end of the nineteenth century
BELOW LEFT: The wedding of Don Diego Rivera and
María del Pilar Barrientos, parents of Diego Rivera, in 1882
BELOW RIGHT: The twins Carlos María and Diego María, aged about one

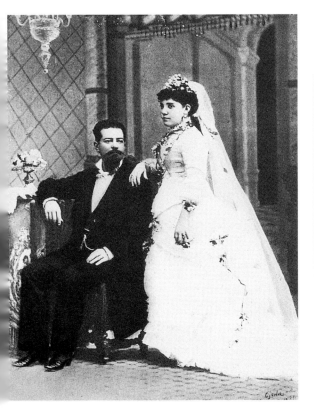

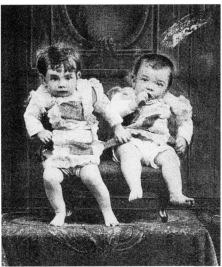

ABOVE LEFT: Porfirio Díaz as a young general in the army of Juárez
ABOVE: Engraving by J. G. Posada of gunman shooting down a rider
LEFT: Díaz, the father of his people, by J. G. Posada, 1910
BELOW: Rivera (rear centre, facing camera) and fellow pupils at the Academy of San Carlos, 1902

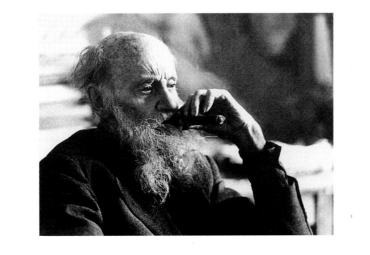

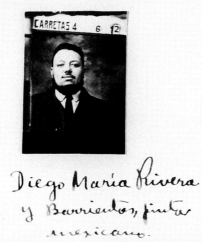

Diego María Rivera
y Barrientos, pintor
mexicano.

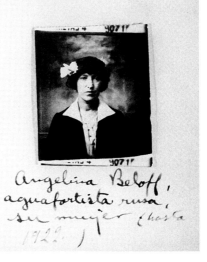

Angelina Beloff,
aguafortista rusa,
su mujer (hasta
1922.)

26

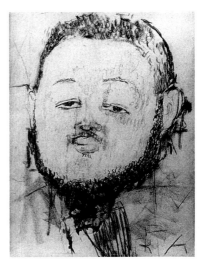

TOP: "Dr Atl," alias Gerardo Murillo,
in old age
ABOVE: Identity card photos of
"Diego María Rivera y Barrientos,
Mexican painter," and "Angelina
Beloff, Russian etcher, his wife,"
probably issued by the Mexican
embassy in Paris
RIGHT: *Portrait of Diego Rivera,* by
Amedeo Modigliani, 1914, ink and
crayon

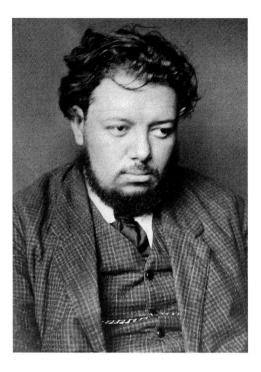

LEFT: Rivera in Paris, c. 1910
BELOW: Marevna's arrival in Paris
in the autumn of 1912
LEFT BOTTOM: Foujita on his way
to Paris, 1913

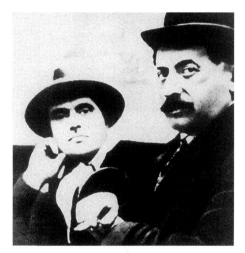

ABOVE: *Portrait of Rivera,*
by Foujita, pencil drawing
RIGHT: Modigliani (left)
with the dealer Basler, 1915
BELOW: Apollinaire in uniform
with head wound, 1916

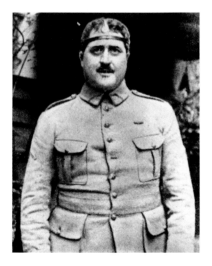

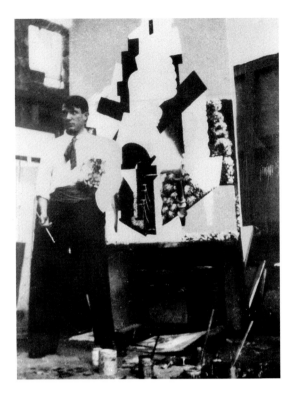

ABOVE: Picasso with his *Seated Man*, 1915
RIGHT: Picasso waiting to join Gaby. In the background of Picasso's sketch, Rivera advances with his Indian club, 1915

ABOVE: Rivera, Modigliani and Ehrenburg, by Marevna, 1916, pencil drawing
RIGHT: Rivera with Marika, aged one, by Marevna, 1921, pencil drawing

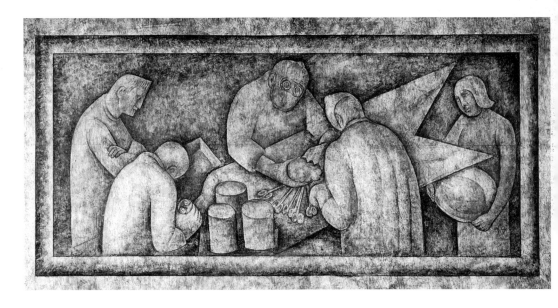

ABOVE: *The Operation,* 1924,
fresco, Ministry of Education
LEFT: Guadalupe Marin, 1921
BELOW: Tina Modotti, by Edward
Weston, 1925

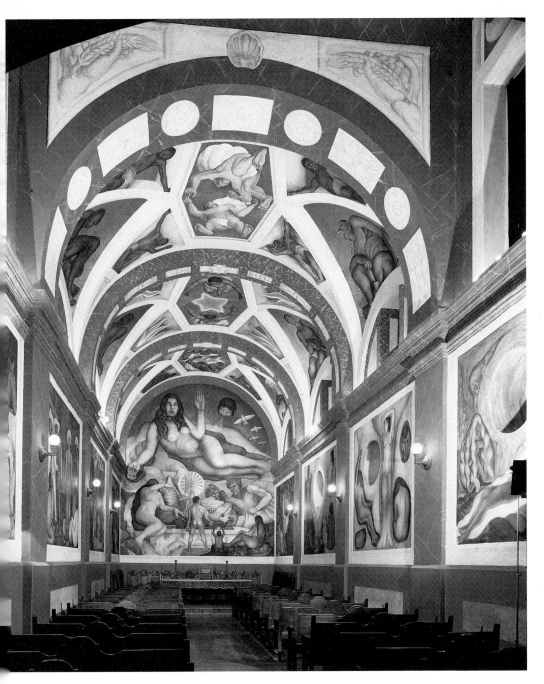

Chapingo Chapel, the nave, 1927

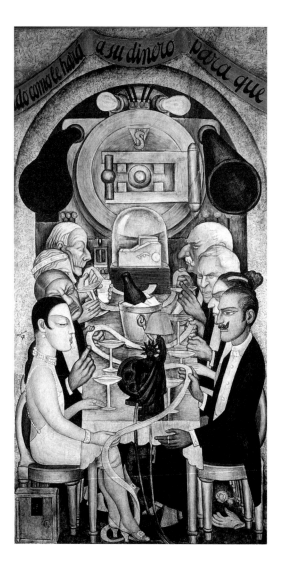

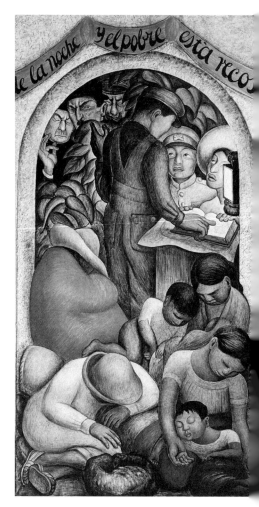

LEFT: *Banquet of the Rich*, 1928, fresco, Ministry of Education
BELOW: *Banquet of the Poor*, 1928, fresco

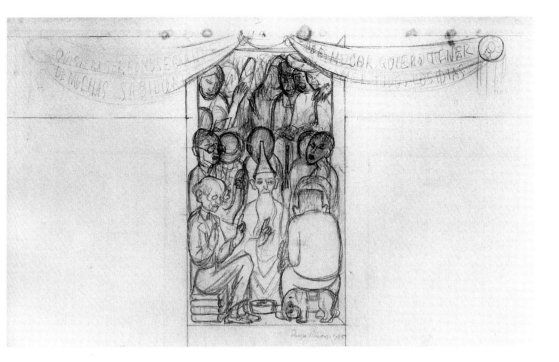

ABOVE: "The Wise Men,"
1928, preliminary sketch
for fresco
RIGHT: Portrait of the
artist as architect, 1928,
fresco, Ministry of
Education

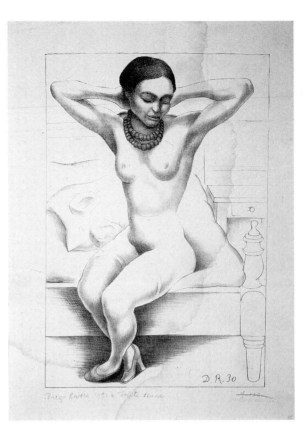

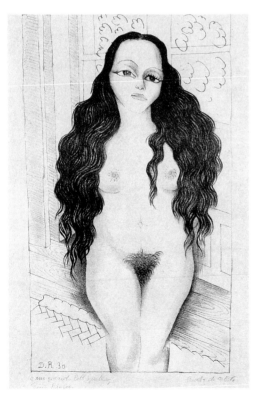

ABOVE: *Nude of Frida*, 1930,
pencil drawing
LEFT: *Nude of Dolores
Olmedo*, 1930, lithograph

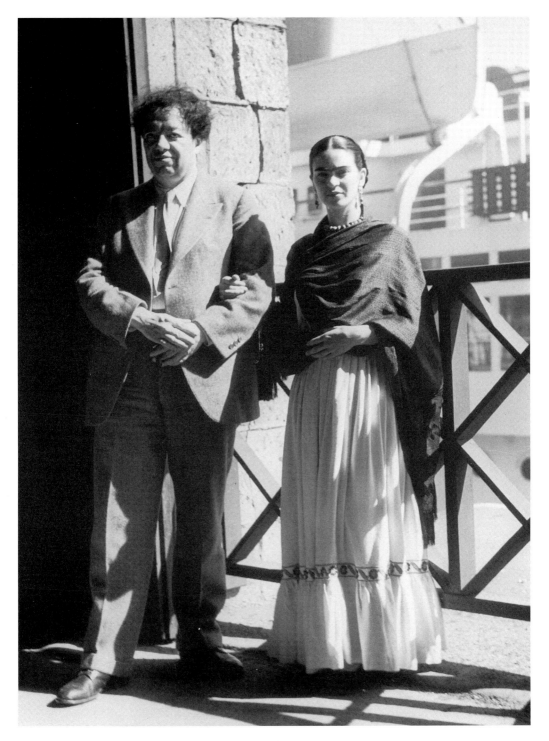

Arrival of Diego and Frida in San Francisco, 1930

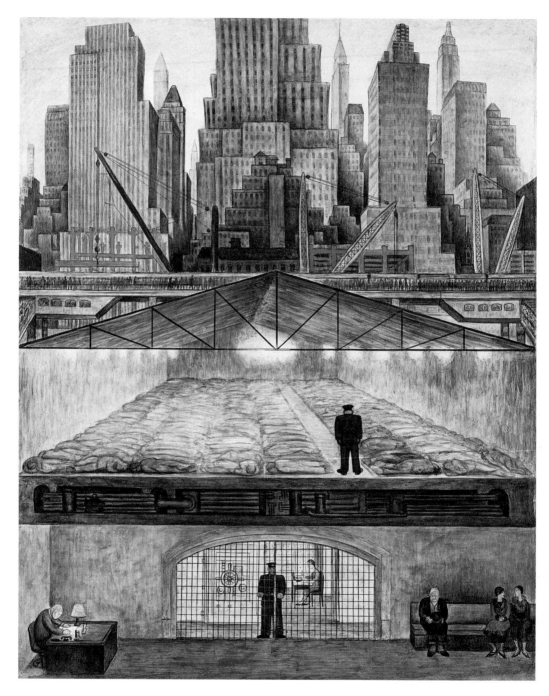

Frozen Assets, 1931, fresco on moveable panel

ABOVE: Portrait of Frida by her father, Guillermo Kahlo, taken after the death of her mother, 1932
RIGHT: Frida and Cristina Kahlo, 1946

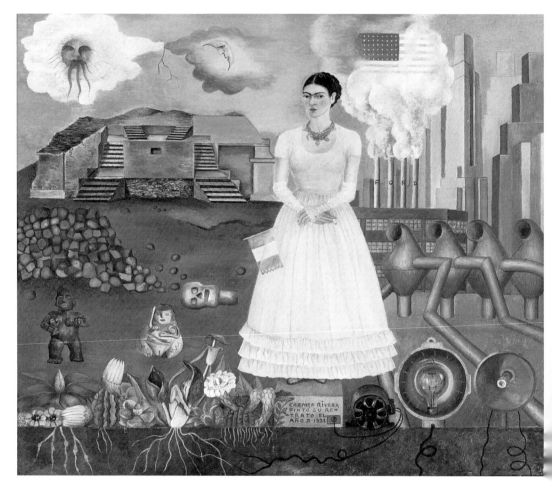

Self-portrait on the border of Mexico and the United States by Frida Kahlo,
1932, oil on metal

Diego Rivera with Frida Kahlo and members of her family, c. 1934.
Cristina Kahlo is at far left.

ABOVE: Frida greeting Trotsky and his wife, Natalia, on their arrival
at Veracruz in 1937
BELOW: *Pan-American Unity,* 1940, fresco, City College of
San Francisco

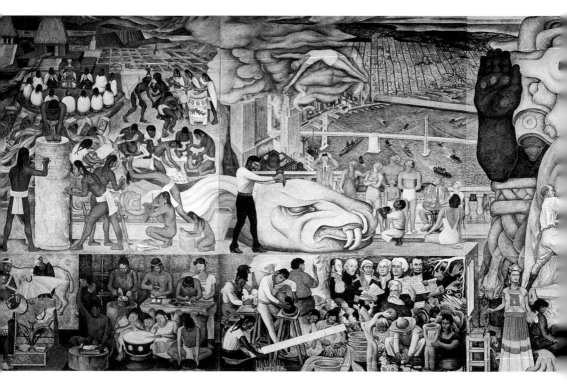

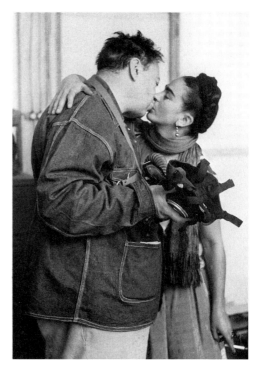

ABOVE LEFT: Rivera, with Paulette Goddard, reaches Los Angeles,
having fled from Mexico, June 1940
ABOVE RIGHT: The second marriage of Rivera and Kahlo, San Francisco,
December 1940

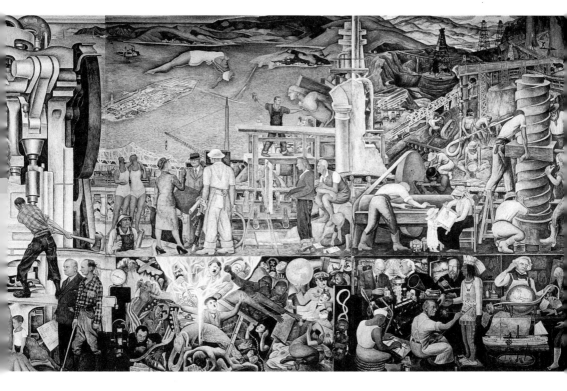

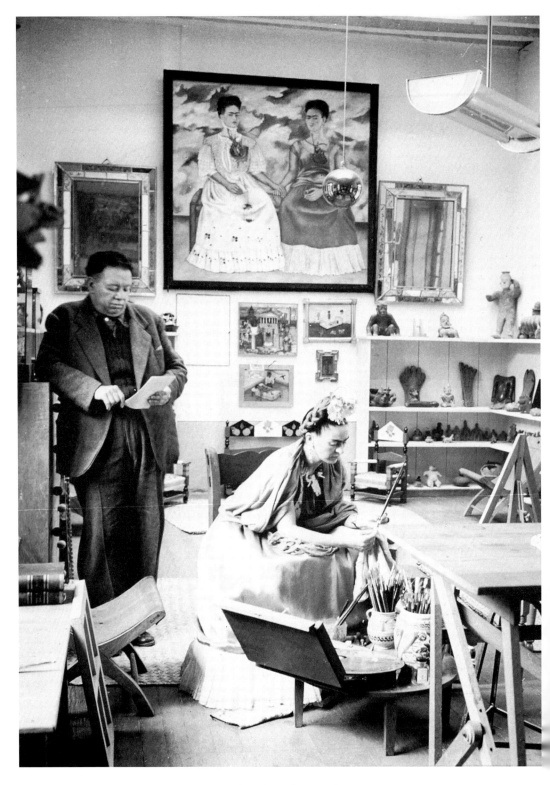

Rivera and Frida in her studio, 1943

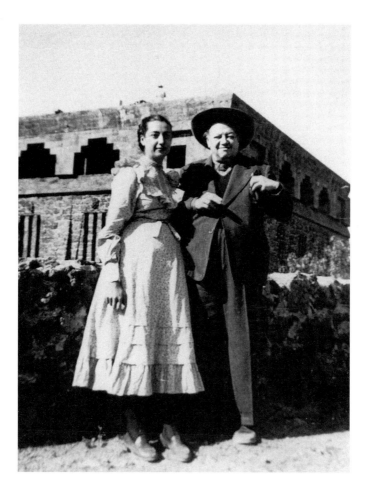

ABOVE: Rivera and his daughter Ruth in 1950, in front of his
house at Anahuacalli, in which he wanted to be buried
BELOW: The house and mausoleum at Anahuacalli

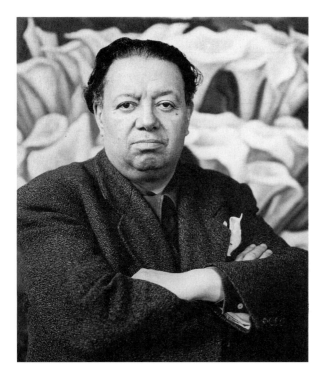

LEFT: Rivera towards the end of his career as a muralist

BELOW: Demonstration against CIA intervention in Guatemala in July 1954, a few days before Frida Kahlo committed suicide

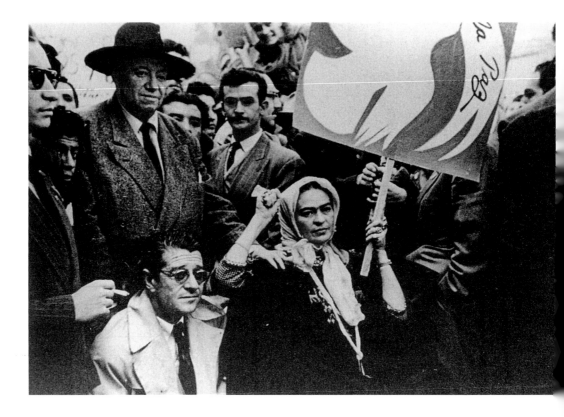

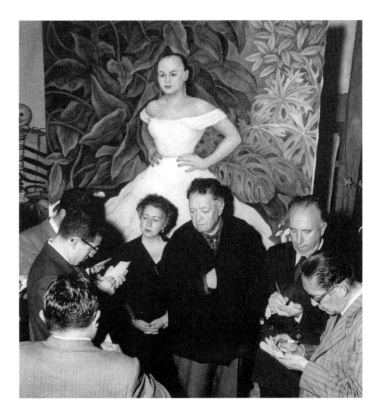

RIGHT: Rivera and his
art dealer, Emma
Hurtado, announce
their marriage, July 1955
BELOW: Rivera painting
an interior of the San
Angel studio in 1954

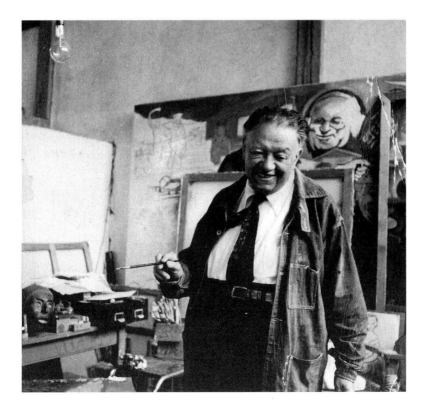

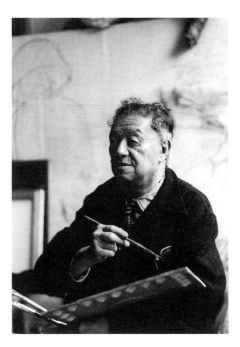

Last pictures of Rivera at work
in his studio, 1957

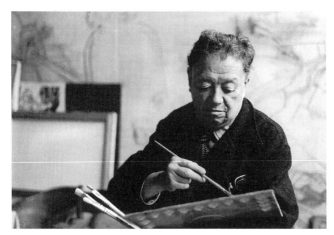

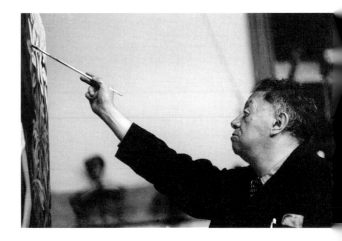

became sufficiently stable for him to be awarded a post on the teaching staff of the national school of business and administration.

For whatever reason, possibly the death of Porfirio Díaz, which took place in Paris in 1915 when the exiled dictator was aged eighty-five, Rivera's attention was sufficiently captured by Mexico that year for him to devote one of his greatest Cubist paintings to a Mexican theme. He eventually called it *Zapatista Landscape* and said that "it showed a Mexican peasant hat hanging over a window box behind a rifle. Executed without any preliminary sketch in my Paris studio, it is probably the most faithful expression of the Mexican mood that I have ever achieved. Picasso visited my studio to see my new paintings . . . he looked and was pleased, and Picasso's approval turned practically the whole of opinion in my favour." The *Zapatista Landscape,* sometimes known as *El guerrillero,* is the first demonstration of Rivera's commitment to progressive politics. The child of the *Porfiriato* was now buried; he would be dug up periodically, but only to undergo cosmetic alterations to his appearance. After *Zapatista Landscape* Rivera, having approved of the Revolution, could claim to be a revolutionary; the influence of Ehrenburg, Angelina and others had taken effect. In the legend which he subsequently constructed to conceal the real facts about his life, *Zapatista Landscape* was one of the few solid pieces of evidence suggesting that Rivera had displayed revolutionary sympathies when the outcome of the uprising in Mexico was still in the balance. But even here there is a problem, since Rivera does not seem to have given the picture any title at all when he first painted it, and without a title its meaning is ambiguous. Max Jacob saw it in 1916 and mistook it for a Picasso, until he was corrected; and nearly a year after he had painted it Rivera was still calling it "my Mexican trophy."

And there is another reason for doubting the extent of Rivera's early revolutionary commitment. In 1915 political developments in Mexico were extremely difficult to follow from a distance. The original uprising had turned into a nine-year carnival of bloodshed. By the time Díaz died in 1915, the man who drove him into exile in 1911, Madero, had himself been overthrown and murdered (in 1913) by one of his own generals, Huerta, who was immediately opposed by four other revolutionary leaders, Carranza, Zapata, Pancho Villa and Orozco. By 1914 Carranza, Zapata and Villa had succeeded in driving Huerta and Orozco into exile, whereupon Villa attacked Carranza, who beat him off while arranging for the murder of Zapata. That left Carranza and his general, Obregón, who fell out, so enabling Obregón to arrange for the murder of Carranza. To simplify matters, one could say that Díaz was exiled by Madero who

was murdered by Huerta who was exiled by Carranza who murdered
Zapata and who was himself murdered by Obregón. The chaotic succes-
sion of events, the mixture of tragedy and farce, made it difficult for cold-
eyed Bolsheviks in Paris to invest the Mexican Revolution with the
appropriate degree of *serieux*. Ehrenburg derided Rivera's enthusiasm for
"the childish anarchism of Mexican shepherds." In any event, Mexican
references in the Cubist work of Rivera are few and far between, and of
subsequent revolutionary references there are none at all.

But "the Mexican trophy" did have a different significance for Rivera;
it led to his first contract with an art dealer, Léonce Rosenberg. Taking
advantage of the absence of Kahnweiler, Rosenberg, a wealthy man who
had previously been a client of Kahnweiler's, set out to make himself the
most important Cubist dealer in the world. He had started to buy pictures
from Picasso, and his decision to add Rivera to his list assured the artist of
a small monthly remittance which could be supplemented by the delivery
of more pictures. The "Mexican trophy" was the first painting by Rivera
that Rosenberg bought. Initially the new arrangement, which was of
great importance to Rivera, worked well. But unfortunately, the painting
which seemed to offer Rivera a bright new future also led to a quarrel
with Picasso, and there seems to be little doubt as to who was in the
wrong.

Towards the end of 1915 Picasso completed work on a large Cubist
canvas which he called *Homme accoudé sur une table* (*Seated Man*). In its
original version this picture bore a close resemblance to the *Zapatista
Landscape*, which had been finished some months earlier in the summer
of 1915. In his biography of Picasso, John Richardson suggests that Rivera
accused Picasso of plagiarism to make "a name for himself," but confirms
that it was Picasso who had committed the theft. Following a complaint
from Rivera, Picasso painted over the central section of his canvas so that
it no longer bore any resemblance to Rivera's painting, but by then the
damage had been done. Marevna recalled hearing of a violent quarrel at
the end of which Rivera threatened to beat Picasso with his great club.
There is also photographic evidence of the ill feeling between the two
friends. In 1915, when he had finished his Mexican landscape, Rivera had
his photograph taken holding his palette, standing proudly to the right of
his painting, wearing dark trousers, a white shirt and a white tie. In a sly
reference to Rivera's naïve pleasure in his achievement Picasso posed for a
self-portrait, a photograph, standing in the same position, wearing the
same clothes, even down to the tie, in front of the very similar first ver-
sion of the *Seated Man*. Later, when he had changed the picture so that the

similarities had disappeared, Picasso posed again in front of the altered picture, but this time dressed quite differently. "Look," he seems to be saying, "I can do it the same as other painters, or I can do it my way, or I can do both at once." It was at this time, in the autumn of 1915, that Picasso made a further reference to the quarrel. He drew a little sketch of himself waiting outside Gaby's window opposite the Montparnasse cemetery on the corner of the Boulevard Raspail and the Boulevard Edgar Quinet. He is hoping for a signal from Gaby and in the corner of the picture one sees that she is making it. Meanwhile, in the background of the sketch the burly but still distant figure of Rivera, Mexican club in hand, is advancing slowly along the cemetery wall. Immediately behind Picasso a stray cur is scratching itself, having just deposited a turd at the foot of the clock. By the time Rivera and his club reach the clock, Picasso will have gone, he will be enjoying himself within, and there will just be the turd to greet the man with the club. The quarrel with Picasso did not end their friendship, but it deprived Rivera of the public support of a powerful ally and weakened him in the battles to come.

In the summer of 1915, after Rivera had finished the Mexican painting, Angelina went to Madrid, possibly to accompany María del Pilar on her journey home, and it was on her return to Paris from this visit that she became pregnant. She had been living with Rivera for four years and had known him for six. She may have been encouraged by his mother and would have had hopes of financial security after the contract with Rosenberg; in any event, she conceived in November 1915. Angelina was universally regarded as Rivera's wife, she wore his wedding ring, many of their friends thought that they were legally married, and he was still emotionally reliant on her. Before he had been offered the Rosenberg contract they had lived mainly on a small allowance Angelina received from St. Petersburg, and her engraving at that time earned more than his painting. Marevna, who lodged with them for a time, recalled the obvious affection between the couple and the "little talk" they used, a mixture of Russian, Spanish and French. She was struck by the sight of this slight, fragile woman addressing the shambling giant as "muchachito, detochka" or "bébé." There was a further reason for Angelina to choose to have a baby: she was increasingly uneasy about Rivera's growing interest in Marevna—who was twelve years younger than she was and six years younger than Diego. When Rivera learned of Angelina's pregnancy he seemed pleased, but he was in fact deeply disturbed.

By 1916 the wartime life of Montparnasse had achieved a certain stability. The first Zeppelin raid on Paris had taken place on January 1, but on

the Carrefour Vavin, at the heart of Montparnasse, every effort was made
to maintain business as usual. An increasing number of artists and *Parnas-
sois* were returning from the war, wounded but capable of resuming their
work. Both Braque and Apollinaire were invalided out in the course of
the year with serious head wounds, both having to be trepanned. Braque
was not fit for work for eighteen months. The poet Blaise Cendrars had
his right arm amputated; André Masson suffered shellshock during the
Battle of Verdun; Fernand Léger was a victim of the poison gas which
had first been used by the Germans during the second Battle of Ypres in
May 1915. Its introduction marked another step towards the destruction
of pre-war standards of civilisation which the Allied armies were quick to
imitate.

A photo-reportage executed by Jean Cocteau on August 12, 1916, illu-
minates the life of Montparnasse in the third summer of the war.
Cocteau had enlisted as a member of the Comte de Beaumont's ambu-
lance unit and was stationed on the Somme. He said that he spent his
time "going from the front to La Rotonde and La Rotonde to the front."
August 12, the forty-second day of the Battle of the Somme, was a day for
La Rotonde and he had brought his mother's camera. Cocteau spent the
time between 12:45 and 4:30 in the afternoon with Picasso, Modigliani and
Kisling. The other member of the group, Rivera, was absent. Cocteau
met his friends outside the Métro and they went to have lunch at Chez
Baty, on the Carrefour Vavin, the meeting point of the Boulevard du
Montparnasse and the Boulevard Raspail. Chez Baty was a bistro that was
favoured as a place of celebration when someone had sold a picture.
Ortiz de Zárate came to the lunch, with Marie Vassilieff, whose canteen
did not open till the evening, then Max Jacob arrived and Picasso. They
were joined by the tall, enigmatic, courteous, slender, uniformed figure
of Henri-Pierre Roché,* his ginger hair hidden by his khaki képi as he
proceeded in his stately manner up the street. Roché had written to
Rivera the day before, offering to buy three of his pictures, and may have
been hoping to see him at the bistro.

This photo-reportage shows the group of people who were among
Rivera's closest friends at that time enjoying themselves together.
Cocteau later explained that Montparnasse was divided into rival bands,
and "our gang" was "Picasso, Modigliani, Rivera, Kisling and me." Mont-
parnasse, he recalled, "was still a little provincial town with grass growing

*Henri-Pierre Roché (1880–1959), aesthete and *bon viveur.* Author of the autobiographical
novel *Jules et Jim.*

between the paving stones. . . . There were only two cafés, we were unaware that a public was waiting for our discoveries. Everything that took place, took place between us. The people of Paris were preoccupied with the War . . . meanwhile the whole revolution of modern art was accomplished at that time, in that little corner of the world. There was no news coverage, no photographers, no journalists. Everything that took place was *entre nous;* there were violent arguments, great hatreds and love-affairs, but it all stayed *entre nous.*"

In the photographs of August 12 Picasso and Max Jacob appear to be on cordial terms, although it is probable that Picasso had not entirely forgiven Jacob for his behaviour at Eva's funeral, six months earlier, when Max turned up drunk and tried to seduce the driver of the hearse. "The burial of Eva was *une triste affaire* and the horseplay of Max Jacob added enormously to the horror of it," wrote Juan Gris to a friend on the western front. Jacob used to go to Montparnasse in order "to sin in a revolting manner," as he himself thoughtfully explained in a letter to Apollinaire when the latter was still in the trenches. At Marie Vassilieff's, "scandalous scenes" took place as Jacob took an increasingly close interest in Swedes or Russians who possessed a nearby bed. At the wedding of the Italian Futurist Severini, Jacob had already exceeded the limits by smashing up one of the wedding presents, a gesso moulding of the Winged Victory of Samothrace before the horrified eyes of the bride and the Italian craftsman who had presented it. "In this gathering of Futurists this old statue makes no sense," shouted Max Jacob as he destroyed it.

But nothing was smashed at lunchtime on August 12. Picasso was wearing the same flat *casquette anglaise* that he had chosen for the second of his self-portraits with the altered version of the *Seated Man,* and Max Jacob was by far the most elegant member of the group. He was in trilby, stiff collar, silk cravat, three-piece suit and spats, although Cocteau himself as painted by Kisling in 1916 was wearing suit, bow tie and spats and probably matched him in elegance. After lunch the party crossed the Carrefour Vavin to the opposite corner of the two boulevards to have coffee at La Rotonde. Roché had left by now; he wrote in his diary that night that the conversation had been "too witty" and had given him a headache. But he was replaced by Kisling and his dog Kouki, a black near-spaniel, and by Paquerette, Picasso's friend of the moment, who was wearing a lorgnette round her neck on a string that reached well below her waist, and an unusual hat that resembled an aviator's leather helmet without the ear pieces. Picasso was sucking a straight-stemmed pipe. The photo-reportage continued on the pavement outside La Rotonde, some

of Cocteau's photographs giving the impression that they may have been intended to illustrate a gangster photo-strip. Picasso is clearly interested by Paquerette, who was working for Poiret, the first couturier to describe himself as an artist and notable for having disinvented the corset. She was later to marry Dr. Raymond Barrieu, who had been Kisling's second in his duel with Gottlieb. In the subsequent photographs two passers-by, Modigliani and André Salmon, joined the plot. So, with his friends at the Carrefour Vavin that day, where was Rivera?

Quite a lot can be discovered about Rivera's life on August 12, 1916, even though he played no part in Cocteau's photo-reportage. That morning—it was a Saturday—he had received Roché's letter and had replied immediately, agreeing to sell him two landscapes for 200 francs each and a small still life for 100 francs. Today's equivalent values would be roughly $400 and $200. "My wife is fine," he added, "everything went well, we have a boy, she thanks you for your kind wishes, as I do." At 1:30 a.m. on August 11, in the hospital of Notre-Dame de Bonsecours near the city walls, Angelina had given birth to Rivera's son. The father's letter of the following day contains several grammatical errors, including a misspelling of Roché's name, which were probably due to the absence in hospital of Angelina. A previous letter, written to Roché on Wednesday, August 2, had said, "I would be very happy to see you tomorrow, with Madame Groult"—Roché's mother—and Rivera signed the letter, naïvely, "Thank you in advance for your visit." That letter, written in Indian ink and in a large looping hand before Angelina set out for the hospital, contains few errors. Roché had been introduced to Rivera by Angel Zárraga, but he was in any case a man who knew everyone. He lived on the Boulevard Arago with his mother and his grandmother, not far from Picasso's studio on the Rue Schoelcher, and was described by Gertrude Stein, whom he had introduced to Picasso, as "a born liaison officer." Despite his uniform, Roché was a classic "*embusqué*": he spent much of the war as secretary to General Maleterre, at the Invalides, because he had been declared unfit for active service on the outbreak of war. He had also been interned for a brief period when war broke out, having been suspected of German sympathies due to his extensive circle of German friends. Roché specialised in *liaisons à trois*. After the war his novel *Jules et Jim* would be based on an episode in his friendship with the writer Franz Hessel. Gertrude Stein praised Roché's beautiful manners and his enthusiasm, and they may have played a part in his decision to meet Rivera on August 3, a week before Angelina's confinement, to buy three of his pic-

tures. There could have been no more welcome present. Roché was a col-
lector on a minor scale and later purchased one of Modigliani's portraits
of Rivera. The sale to Roché was either a breach of Rivera's contract with
Rosenberg or a sale of work Rosenberg had refused. In later years Rosen-
berg said that he had generally paid Rivera "about 250 francs" for each pic-
ture. In any event, Rivera was eager for money; he had taken advantage of
Angelina's absence in the hospital to start an affair with Marevna.

The news did not come as a surprise to Angelina; Rivera had told her
on many occasions that he had fallen in love with Marevna. But she was
shocked by the timing. In her memoirs Angelina wrote, "The boy was
born. . . . Diego seemed very happy and said he wanted more sons. But
while I was still in the clinic a young woman who called herself a friend
and who I had welcomed into my home on the recommendation of
Ehrenburg and the other Russian friends of Diego's took advantage of
my absence to seduce Diego, who had said that he was interested in
launching her as a painter." Marevna wrote, "Here I must avow my peni-
tence: I was caught up in a dangerous game and, instead of avoiding
Rivera because of his wife's pregnancy, I allowed myself to come closer
and closer to the man who frightened and fascinated me." Marevna's
account was published in 1962, five years after Rivera's death, and
Angelina's memoirs appeared in 1986. In his autobiography signed "with
Gladys March," Rivera wrote of the same episode.

Outside the circle of her fellow Russians, Marevna seemed to have no friends in
Paris. Pitying her loneliness, Angelina and I began inviting her to our home. By those
who knew her, Marevna was regarded as a kind of "she-devil," not only because of
her wild beauty but also because of her fits of violence. When she took offence she
did not hesitate to kick or claw whoever she thought had injured her—suddenly
without argument or warning. I found Marevna terribly exciting and one day she
and I became lovers. . . . Inevitably it was an unhappy union, filled with an excruciat-
ing intensity which sapped us both. At last we agreed that it was impossible for us to
live together any longer. . . . During those six stormy months with Marevna, I had
done almost no work.

In fact, Rivera's relationship with Marevna lasted considerably longer, in
episodes, and did not end until 1921. At no time does it seem to have
affected Rivera's work, though he was no doubt left with the impression
that a great deal of time had not been spent in painting. If Rivera never
considered Marevna a serious companion for life, she took their relation-

ship much more seriously and has left an invaluable record of what he was like to be with at this time.

Marevna first saw Rivera in Rosalie's crémerie on the Rue Campagne-Première, a café run by an Italian one-time model who only served people she liked, who felt sorry for hungry artists and filled them with spaghetti, giving them credit or sometimes accepting payment in drawings. At that time Marevna was newly arrived in Montparnasse. She had previously occupied an apartment opposite the La Santé prison, the windows of which gave an unimpeded view of the guillotine which was regularly erected in the street for public executions. The sculptor Ossip Zadkine was attracted to these occasions, and as the blade fell and Marevna fainted he would make passionate love to her. Eventually Marevna became depressed by the sight of La Santé's high stone walls and changed her address. She much preferred Montparnasse and remembered that Rivera had come into Rosalie's "looking like a Moor [an African], wearing a workman's blue overalls . . . and all smeared with paint, especially on the behind, because that is where one wipes one's fingers and brushes, and I liked him at once: I liked his head!"

Before their affair began, Marevna noticed that his clothes were in rags and that when she sat on his knee there was a powerful smell, a mixture of musk, turpentine and linseed oil. She also noticed that he seldom took a bath, the first person to record this widely remarked aspect of the artist. He had very little money, and what he had was managed by Angelina, who was the more practical of the two. He had "prominent eyes which sometimes burst into flame . . . a way of turning pale then red; his nose aquiline in profile and somewhat fleshy in front; his wide mouth with teeth set rather far apart but very white. He wore a moustache and a short beard which covered the lower part of his face. He had beautiful hands, small for his great vigorous body. When he began to speak everybody listened, not only for what he said but for his way of speaking: his hearers hung on his lips." Ehrenburg said, "He was one of those people who do not merely enter a room but somehow fill it at once." He also had one unforgettable characteristic, mentioned by Marevna, Ehrenburg and several other of his friends: he suffered from spectacular fits. He would fall silent, turn pale, his eyes would roll up so that one could see only the whites, and then he would walk around until he found his great Mexican stick, after which he would chase one of his companions round the room and out of the house or set off into the night alone. Ehrenburg recalled that Modigliani would edge towards the

door when a fit started. Rivera would sometimes burble in what was assumed to be Aztec. On one occasion he interrupted Max Voloshin,* who weighed over two hundred pounds, picked him up despite his weight and told him that he was going to bury him head down, Aztec-style, and that he would have a first-class funeral. Sometimes Rivera would collapse, foaming at the mouth. Although Modigliani had the sense to slip out of the room when "the kindly cannibal" started one of his fits, they made a vivid impression on him, and in one of the portraits he drew of Rivera one has the impression that his eyes have rolled up so that only the whites are visible. Ehrenburg remembered that Rivera's skin was yellow and that he would sometimes invite one of his friends to draw something on his arm with the end of a matchstick and the lines immediately stood out in relief. Rivera, in an inspired para-medical diagnosis, told Ehrenburg that the fits, the colour of his skin and the lines standing out were all the result of a fever he had caught in Mexico, and Angelina told Marevna that the fits were the result of a chronic liver condition he could not cure. For Ehrenburg the fits reminded him of how Rivera behaved in life: "He often went for his enemies with his eyes shut."

It is not difficult to see how Rivera became strongly attracted to Marevna. In the studio he shared with Angelina there was "an atmosphere of work and peace," and he needed a change. In a letter written on July 16, 1916, Rivera reproached "Marievnechka" for not writing to him "this month." The things he really wanted to write, he added, "you have known for a long time. Permit me to kiss your hand and your cheek, as I do when you are here; are you going to come soon Marievna?" The letter is rather formal in tone, but it formed part of a clandestine correspondence. "I write to Ilya [Ehrenburg] and you reply to Archipenko,"† Rivera instructed in a postscript. For some time before the birth of his son he had been spending an increasing amount of time out of the studio without asking Angelina to come with him. Marevna was young, loud, wild, exciting—"a badly trained tigress," as Ehrenburg described her, with some moderation considering that Marevna very nearly killed him once by throttling him with a towel until Ehrenburg's face went purple and his throat rattled. With Rivera, Marevna was gentler. She started by washing him, pretending that she had rheumatism and asking him to take her to a

*Maximillian Alexandrovitch Voloshin (1877–1932), Russian poet and friend of Ehrenburg, early supporter of the 1917 Revolution, duly silenced by reality.
†Alexander Archipenko, Russian Cubist sculptor.

Turkish bath.* Gradually Rivera and Marevna started to share their daily lives; Rivera cooking her a *riz à la mexicaine,* rice fried in olive oil with garlic, onions and pepper. "He was very gay," Marevna wrote in *A Life in Two Worlds,* "and I burst out laughing when I saw him screw up a corner of his handkerchief and tickle deep inside his nostrils, one after the other, sneezing violently each time, and explaining, 'It clears my brain, which has been blocked for some time, and it brightens one's ideas.' " Having given Rivera a bath, Marevna set about his wardrobe, which included a system whereby his socks, which were full of holes, were fastened to his longjohns with safety pins. Rivera's first idea was that Marevna should move into his studio on the Rue du Départ while Angelina and the baby stayed in the adjoining apartment, but this was clearly impracticable for the two women and so he tried to split his life between his own studio and Marevna's unheated studio on the Rue Asseline. In the event, Angelina decided, on leaving hospital, that she and Rivera should separate. "I loved Diego," she wrote in her memoirs, "and was terribly unhappy. I was exhausted by feeding my son; I could not look for other food as I had no money and Diego could only give me 100 francs for the essential things for the baby. María Blanchard was a great solace. Her studio was underneath my apartment and there was a little staircase leading from one to the other. So I could get out a little when the baby slept and María looked after it. . . ."

Throughout this turbulent and undignified period Rivera continued to paint, almost always in his studio on the Rue du Départ. Rosenberg later said that Rivera had been "probably the most prolific of all my painters," turning in about five major pictures a month, which would have given him a monthly income of over 1,200 francs. Nonetheless, on September 13 he wrote to Henri-Pierre Roché again, suggesting an appointment and asking when he might come to frame the landscape which Roché had bought from him, an offer which suggests that he was once more short of money. He did a long series of Cubist still lifes that year. Before the birth of the baby he painted a portrait of Angelina pregnant, and then a series of drawings and a Cubist portrait of her feeding their son Diego. Immediately after that he made a Cubist portrait of Marevna and gave her a present of two Siamese kittens to satisfy her maternal instincts and "a pink rubber contraceptive device," estimating

*It was difficult to have a hot bath in the studio anyway; like the great majority of apartments in Paris, it had no running hot water. Running hot water even in a communal bathroom on the landing was considered a great luxury in Paris until well into the 1920s.

that this irresistible combination of gifts would prevent him from becoming a father for the second time.

Rivera's first passion for Marevna lasted for five or six months, after which he found the relationship too exhausting to be continued on a daily basis. In addition, it had shocked many of his friends. Rivera's offence lay not in having two mistresses at the same time but in abandoning Angelina just after she had had her baby. But Rivera did not relinquish Marevna because of social pressure; it was because he found her so time-consuming. There were happy moments. Under Rivera's influence Marevna dropped out of the habit of attending drug-induced orgies, a pastime which had never appealed to Rivera, who preferred to spend the evening drinking and arguing over the wilder artistic and philosophical theories of himself and his friends. And there were other evenings when Marevna and he would sit together after dinner, working by lamplight, or when "with a glass of wine on his head he would shake his great hips and waggle his huge belly. His eyes sparkled and his mouth wore a broad, kindly smile." In Marevna's opinion, Rivera was hydrophobic, so washing him was another high-spirited activity. He would stand hesitating before a basin of soapy water for a long time before she seized his head and plunged it into the water while he made animal noises before abandoning all resistance and letting himself be washed all over like a baby. But on two occasions their passion turned violent: first when Picasso complimented and fondled Marevna in the street and Rivera became jealous and cut Marevna's neck with a clasp knife; later when they were separating and Marevna kissed him and stabbed him in the back of the neck with a knife. Early in 1917 Rivera, while continuing to see Marevna, decided to return to the Rue du Départ and to the more peaceful atmosphere of his life with Angelina. There was in any case a further complication in the form of his new relationship with Madame Zetlin.

Maria Zetlin, also known as "Madame S.," whose full name was Maria Smvelowna-Zetlin, was a Russian poetess who with her husband Mikhail Zetlin held weekly salons for artists and writers at their apartment at 91 Avenue Henri-Martin. She was one of the few patrons who remained in Paris; she enjoyed buying pictures, she enjoyed being courted by their painters, and according to Marevna, who loathed her, she enjoyed sleeping with them. Towards the end of 1916 Rivera had painted a Cubist portrait of Maria Zetlin in gouache which became a study some months later for a larger oil painting, sometimes entitled *Portrait of a Woman* and sometimes called *Portrait of Madame Margherite Lhote*. It was one of the advantages of Cubist portraiture that the same

face could, if necessary, be attributed to different subjects. Rivera was among the painters who regarded a passage through the bedroom of Madame Zetlin as an essential part of his professional activities in those difficult times. Although she seems to have treated artists in the same way that they sometimes treated their models, Rivera was sufficiently moved by his experience with Madame Zetlin to mention it to Marevna while talking in his sleep. At the same time Maria Zetlin became a friend of Angelina's, and in due course she played an active part in persuading Rivera to disentangle himself from Marevna.

During the second part of 1916 Rivera had become steadily better known among followers of Cubist painting. Two exhibitions of his work were held in New York at the Modern Gallery in a collection which assembled work by Cézanne, van Gogh, Picasso, Picabia and Braque. In Paris, among his contemporaries, Rivera had established himself as one of the recognised theorists of Cubism. Matisse, who was never convinced by the arguments for Cubism, nonetheless visited his studio to hear his defence of this revolutionary school, and Rivera was among those who regularly took part in Sunday meetings at Matisse's house. But although Rivera was enjoying a growing success, his position was not universally recognised and he was not included in a large exhibition organised by André Salmon in Paris in July 1916 and baldly entitled "L'Art moderne en France." Rivera's exclusion from this show, which included work by fifty-two artists, among them Marevna, was the more disappointing because of the attention attracted by the first public appearance of *Les Demoiselles d'Avignon,* which had been concealed in Picasso's studio ever since he had finished it nine years earlier.

Now, at this delicate point in his progress, Rivera became involved in a bitter controversy about the nature of Cubism which would eventually help to terminate his career as an artist in Paris. Since its inception, Cubism had attracted a level of critical passion which, as early as 1912, had seemed to Picasso to be getting out of control. Visiting that year's Salon des Indépendants with Braque and Gris, Picasso said, after inspecting the work of recent Cubists such as Gleizes, "I thought it was quite amusing to start with, but I now see it is becoming *horriblement emmerdant* [a real bloody nuisance]." He kept this frank opinion to himself; he was, after all, on the point of achieving fabulously high prices for his Cubist work, which Kahnweiler—who had a gallery full of it—was describing as "the expression of the spiritual life of our age." But irrespective of the views of its creators, Cubism took on a life of its own and became a standard for progressive thinkers of all disciplines.

Much had changed since "Cubism" had simply been the term, probably coined by Matisse, used in art schools before the Great War to describe the work of Picasso and Braque as they began to represent forms first in their geometrical abstractions, then bisected into segments and facets, and then rearranged as cubes. The subsequent controversy can be traced back to the dual origins of the movement, in the work of Picasso and Braque, who exhibited in 1907 and who found their inspiration in both the perspective distortions of late Cézanne and in African art and early Andalusian artefacts. These artists, together with Léger and Gris, were the clients of Kahnweiler, who embroidered their discussions in his *History of Cubism,* written in 1914 and published in 1920. But there was the subsequent and parallel school of Cubism, to which Rivera belonged, based on the theories of Gleizes and Metzinger, whose followers included Lhote, Severini, Lipchitz, María Gutiérrez and Marevna.

In 1911 Metzinger wrote that Cubism was a method which permitted a painter to depict an object from various different viewpoints simultaneously. In 1913 the painter Charles Lacoste wrote that Cubism was the "synthesis" of all the exterior surfaces of an object in one image. The use of the word "synthesis" was unfortunate. In 1914 Kahnweiler seized on the term "synthesis" and borrowed the Kantian opposition of "analysis" and "synthesis" to divide Cubism into "analytical" and "synthetic" schools. Gris then used the term "synthesis" in a different sense, suggesting that an initial period of Cubist "analysis" had been followed by a period when divergent analyses had been "synthesised." Later still, "synthesis" was used to refer to the amalgam of an initial period of simplistic distortion and a secondary period of Cubist "analysis" and fragmentation.

Rivera's contribution to this controversy was entirely original. According to Favela, "Rivera's abstruse theorising during this period related to the problem of the Fourth Dimension and the higher metaphysical realms of plastic consciousness and space. . . . [He] strove to detach multiple colours and volumes from their objects and simultaneously combine their . . . abstract profiles and frontal surfaces into a superphysical plastic dimension." It was at this time that Rivera invented a machine which he called "la Chose" and which he claimed was capable of unlocking "the secret of the Fourth Dimension," a mathematical explanation of Cubism developed by Albert Gleizes. Soutine described this as a "very strange and amusing construction, with mobile planes made of gelatine leaves." According to the artist Gino Severini, Rivera was working on a theory of perspective "according to which the horizontal and vertical planes underwent the same deformation and the object was

enriched by other dimensions." Severini always mentioned Rivera's inter-
est in the theory of "the Fourth Dimension" in respectful terms, although
he admitted that he could not follow Rivera's explanation easily and did
not consider it very convincing. It was of course entirely characteristic of
Rivera to interest himself in an attempt to found a new branch of optics
and to experiment with the possibility of transforming art into a science.
But not everyone was as respectful as Severini.

The extent of the opposition to the theories and painting of Rivera
became evident in March 1917 with the eruption of a scandal that was
almost immediately labelled "l'affaire Rivera." This scandal, which
started with a banal quarrel at a dinner party, eventually led to Rivera's
decision to abandon Cubism and effectively changed the course of the
artist's life. Fortunately for posterity, the affair coincided with the absence
of Picasso from Paris, which meant that Max Jacob recounted all the
details for him in several letters which have survived.

In March 1917 Léonce Rosenberg organised a banquet for twenty-two
guests at the noted restaurant Lapérouse, which stands on the Quai des
Grands-Augustins, near which Rivera had painted his view of Notre-
Dame eight years earlier. The gathering included all the Cubists who
were under contract to Rosenberg, but also Max Jacob and a prominent
young critic, Pierre Reverdy, who held very strong views on "correct" and
"incorrect" Cubism. Reverdy had recently published an article in which
he condemned by implication the theories and the work of Rivera and his
friend André Lhote.* Reverdy's initial interest in Cubism had arisen in the
context of a debate as to whether or not there could be such a thing as
"literary Cubism" or a Cubist portrait. Rivera was regarded by his sup-
porters as one of the leading exponents of the Cubist portrait. Reverdy
argued that such a portrait was an impossibility since a portrait was a like-
ness and Cubism was an attempt to reform or reassemble conventional
likeness. Since most of the art to which the Cubist debate referred had
been sequestered on the outbreak of war, since the same terms were used
like elastic to describe differing concepts, since the debate was conducted
in the social and intellectual vacuum caused by the Great War, and since
so many of those involved in the argument were more notable for their
creative talents than for their powers of analysis, there was ample scope
for violent disagreements after a good dinner. At the restaurant there
were no incidents, but the party then moved on to the Lhotes' apartment,

*André Lhote (1885–1962), French painter and critic who first contributed to the Cubist move-
ment in 1912 and who founded his own art academy in 1922.

where Reverdy, growing over-confident, decided to develop his views on Metzinger's redefinition of Cubism. Since these included the opinion that Lhote and Rivera were not creating original work but were basing their painting on the discoveries of other artists, the discussion soon became heated and matters came to a head when Rivera slapped Reverdy's face. *"Me gifler! moa! moa! moa! c'est la première fois!"* was how Jacob described Reverdy's outraged reaction; then the poet fell on the painter and started to pull his hair. China and glass went flying before they could be separated. Rivera offered an apology which was not accepted, a duel was proposed, and finally Madame Lhote, most upset, insisted that Reverdy be taken away and Rivera be kept in so that they could not continue their discussion on the pavement outside. Reverdy departed shouting the rudest thing he could think of in the heat of the moment, "Mexican!" The incident was closed, but the quarrel had scarcely begun and was to rage in the columns of the art press for months. Reverdy, a hypersensitive and prickly character, fell out with many other people, including Blaise Cendrars, Rosenberg and at one point Max Jacob. He had involved himself in two of the most quarrelsome groups in Paris—the poets and the painters—and he took full advantage of his position. He returned to the attack in the third issue of *Nord-Sud,* published in May, but this time, having little to add to his original criticism, he attempted to ridicule Rivera, whom he described as "a savage Indian," "a cannibal," "human only in appearance," "a monkey" and "a coward." This string of childish insults irritated even Juan Gris, who was supposed to be in Reverdy's camp, and Max Jacob wrote to Picasso saying that Reverdy lived "in a state of eternal rage and distrust."*

One of those who had most to lose from a fundamental split in the ranks of the Cubists was Léonce Rosenberg, and at first the dealer tried to compose the differences developing between his artists. Max Jacob wrote that Rosenberg had sent Gris to reason with Reverdy after the scuffle at the Lhotes' house had transformed a celebration of Cubism into a social disaster. When this did not work, Rosenberg "summoned" Picasso and Rivera to a meeting at his gallery where Picasso agreed to praise Rivera's Cubist paintings in so fulsome a manner that he was suspected by some of being satirical. But nothing sufficed. On June 24 a musical farce, written by Apollinaire, was produced in a small theatre. Entitled *The Teats of Tiresias* and recounting the adventures of a woman who decided to

*In due course Reverdy's solitary nature drove him out of literary and artistic life; in 1919 he went to live near the Abbey of Solesmes and devoted himself to poetry.

behave like a man, it was notable for the appearance of Max Jacob leading the chorus, dressed as a woman, and singing loudly, out of tune. The show closed after one performance, but it contained a passing reference to Cubism and provoked an angry letter to the press. To place this superbly pompous document in context, it should be noted that the letter was written a month after the outbreak of mutinies among French troops in the trenches forty miles to the north had led to the dismissal of the French commander-in-chief and his replacement by the widely popular General Pétain, and it was published in *Le Pays* three days after the arrival of the first U.S. troops in France.

"We, Cubist painters and sculptors all, protest against the deplorable tendency to link our work with certain theatrical or literary fantasies which it is no part of our task to evaluate . . . ," the letter began. It was signed by, among others, Metzinger, Gris, Lhote, Kisling and Severini, as well as Rivera. It at least had the effect of infuriating the author of the piece, Apollinaire, who was just beginning to recover from the head wound which had nearly killed him and who wrote to Reverdy saying that the play's chances of success had been killed off by *"Metzinger, Gris et d'autres culs de cette sorte . . . la bande de pifs qui a envahi le cubisme. . . ."* This squabble marked Rivera's final public appearance as a defender of Cubism. Though it seems Lilliputian today, it caused a considerable stir at the time and was among the circumstances that led Foujita to recall, years later, that Rivera had been "so famous in Paris that it seemed the city was too small for him."

Towards the end of 1917 Rivera started to modify his style for the first time in four years. At the beginning of the year he had finished a large, raunchy Cubist portrait of Marevna, partially unclothed. There followed a demure Cubist portrait of Margherite Lhote, and a series of nine still lifes, all Cubist, and one Cubist view from his studio window. And then, quite without warning, he made a small painting entitled simply *Frutas*. But it is not Cubist, and the only distortion in it is more reminiscent of Cézanne. He followed this with a pencilled sketch of a still life in classical style and then, again quite suddenly, a view of the railway lines outside his studio which bears a closer resemblance to the background of the *Portrait of Adolfo Best Maugard*. He had returned in style to the painter of 1913, and he never painted another Cubist picture for the rest of his life. Rivera left Cubism where he entered it, gazing out of his studio window, and watching his emergence is like watching a man focusing his eyes after an extended period of blurred vision, or recovering his visual memory after a severe spell of amnesia.

Rivera himself linked his break with Cubism to a Pauline conversion he experienced one day as he left the gallery of Léonce Rosenberg. "One beautifully light afternoon in 1917, leaving the famous gallery of my dealer Léonce Rosenberg, I saw a curbside pushcart filled with peaches. Suddenly, my whole being was filled with this commonplace object. I stood there transfixed, my eyes absorbing every detail. With unbelievable force, the texture, forms and colours of the peaches seemed to reach out towards me. I rushed back to my studio and began my experiments that very day." This dramatic story was confirmed by Angelina, who said that the display contained an unusually rich selection of vegetables and fruit for wartime. She remembered that Rivera muttered, "Look at those marvels, and we make such *trivia* and nonsense," referring to the Cubist paintings they had just been admiring in the gallery. Looking back on this turning point, Rivera, in an untypically simple, clear and modest passage, later wrote, "Though I still consider cubism to be the outstanding achievement in plastic art since the Renaissance, I had found it too technical, fixed and restricted for what I wanted to say. The means I was groping for lay beyond it." And Soutine said that Rivera had frequently referred to Cubism as a "passage" or "corridor."

Whether Rivera realised that in replacing Cubism with realism he was making a permanent choice is not certain, but the decision was eventually taken from him by Rosenberg, who was so alarmed that one of his most prominent Cubist artists should have decided to break ranks and treat the movement as a passing phase that he imposed a severe sanction. He would continue to take Rivera's entire output of pictures, but he would show only the Cubism. In other words, Rivera's new work would disappear from public view. To defend his business Rosenberg, later described by Clive Bell as *"assez roublard au fond"* (a wily customer), was transforming Cubism from an adventure into a duty. But Rivera was sufficiently confident of his powers by this time to defy his powerful dealer and follow the interior voice. After all, Picasso had survived the confiscation of most of his work on the outbreak of war and had since returned on occasion to a classical style. And in any case Rivera had little choice. The only way he knew to paint, at this period in his life, was to respond to the demon inside. Nonetheless, the break with Cubism represented both a personal and a professional crisis for him. He was banned by his dealer, the loss of his monthly income was a serious blow, but he was also reviled by many of his colleagues and friends. André Salmon, whose uninspired criticism had long irritated Picasso and Braque, and who had organised the "Art moderne" show in 1916 which had excluded Rivera, now sug-

gested, in a series of articles published in 1918, that Rivera had abandoned Cubism because he was envious of the dominance of Picasso and Braque; and among those who ostracised Rivera in the wake of his rupture with Rosenberg were Braque, Gris, Léger, Lipchitz and Severini. Perhaps some of them were driven by personal reasons. Marevna, after all, once described Rivera's own habit of friendship as "changeable and uncertain."

Rivera left Cubism in the late summer of 1917, at a time when he was back with Angelina and once more living on the Rue du Départ with her and "Dieguito." On August 11, the boy's first birthday, his grandmother María del Pilar sent him an effusive greeting and a photograph* of herself. "To my darling little grandson," wrote María del Pilar in flowery copperplate all round her photograph,

so that when he reaches the age of reason he will know who his grandmother was and with this picture will keep a memory not of the person, who was worth nothing, but of the mother who sacrificed her entire life and her happiness, merely hoping through her maternal love to indulge her dearly beloved but extremely ungrateful son, his father, Don Diego María Rivera y Barrientos, who will never be able to make up to her through filial love for the immense sacrifices and conjugal humiliations which his poor mother suffered in order to save her children from the slightest unpleasantness. If you love your father, my beloved grandson, never and for nobody ever leave his side, because you would destroy his heart. May you always be happy, and may your parents live for many years; these are the heartfelt wishes of your grandmother, who, despite exhausting every resource, in the hope of meeting you and cuddling you, has not been able to get your parents for a whole year to bring you to her side.

María del Pilar inscribed this plaintive and venomous billet-doux to "my first grandson, Miguel Angel Rivera y Beloff," although the boy had in fact been named, as she well knew, Diego María Angel.

But María del Pilar's ungrateful son had too many other things on his mind to be unduly affected by this maternal letter bomb. In leaving Cubism, he had entered a political as well as an artistic void. Cubism was a set of values and a private club as well as an artistic style. In November the political void was filled by an astounding event: the victory of the Bolshevik Revolution. As Lenin had prophesied, "the imperialist war had been transformed into a civil war"; the holocaust had after all been

*Examination of the photograph on the card suggests that Rivera's mother may by this time have been suffering from an untreated thyroid condition.

offered to some purpose, and for revolutionaries the future lay bright ahead. Trotsky, who had been expelled from France on October 30, 1916, was already by October 6, 1917, the chairman of the "Petrograd Soviet," which made a change from the dreary round of what Isaac Deutscher described as "shabby emigré centres such as the Russian library in the avenue des Gobelins, the Club of the Russian emigrés in Montmartre and the Library of Jewish Workers in the rue Ferdinand Duval." In Russia men and women were building the future, and many of their Russian friends came to say goodbye to Rivera and Angelina. Ehrenburg recalled that when he left Paris in 1917 Modigliani warned him that when he got home to his revolution he would find that everyone had been put into prison or shot. "But Rivera was happy for my sake: I was going to see the revolution. He had seen a revolution in Mexico; it was the gayest thing imaginable." Ehrenburg subsequently did not entirely agree with that opinion. Rivera later claimed that he and Modigliani, who had talked far into the night when news of the October Revolution reached Paris, had capped the discussion by applying for Russian visas, but this is unlikely, particularly in the case of Modigliani, who in 1917 was mainly preoccupied with his superb series of nudes, and who once described socialists as "bald-headed parrots." And if, in the winter of 1917, Rivera was impressed by the Russian Revolution, he had no thought of joining it. He was far more concerned with discovering the next step to take in his painting. Furthermore, he had a personal crisis to deal with. His son, Diego, had died on October 28, 1917, at the age of fourteen months.

According to Marevna, the child had been ill and undernourished for weeks and may have suffered from exposure in the unheated rooms on the Rue du Départ. In any event, the baby died, according to Angelina, of bronchopneumonia. "The one thing I have always held against Diego is the way he acted when our one-and-a-half-year-old baby lay sick and dying," wrote Angelina in old age. "From the beginning of the child's illness Diego would stay away from the house for days at a time, cavorting with his friends in the cafés. He kept up this infantile routine even during the last three days and nights of our baby's life. Diego knew that I was keeping a constant vigil over the baby in a last desperate effort to save its life; still he didn't come home at all. When the child finally died Diego, naturally, was the one to have the nervous collapse." Since Marevna too claimed that she saw little of Rivera during the time of his son's illness, it seems that he was, as Angelina claimed, spending the time out of the apartment enjoying himself with his friends. Although he undoubtedly had a normal affection for his son, Rivera also found the presence of a

small, sick child an unbearable distraction from his work, at one time even threatening to throw the baby out the window if it disturbed him. His behaviour at the time of his son's death may be evidence of indifference towards the child and cruelty to Angelina, but it seems equally possible that he was emotionally incapable of responding to demands on his feelings and time. He was not mature enough to deal with anguish and so he simply avoided it. The death of children had marked his own childhood: first the death of his twin brother Carlos María—at almost the same age as his own son—then the death of another brother whose body he and his sister had fought over at the wake. He was to exhibit the same pattern of absence and apparent indifference in the face of the personal anguish of people he loved repeatedly throughout his life. There is a similarity here with Picasso's behaviour; the latter, who also left a trail of emotional wreckage down the years, had been much affected by the death of a beloved sister, Concepción, as a child. She died of diphtheria aged seven, when Picasso was fifteen, and the experience, according to Pierre Daix, haunted him for the rest of his life and meant that from then on he could "no longer bear illness in his circle, neither in his children nor in his friends."

The most careful description of the burial of "Dieguito" comes from the person who was not allowed to attend, Marevna, who followed the funeral cortège at a distance. "Standing behind a tree in the avenue du Maine I watched the hearse and several carriages go slowly by . . . to the Montrouge cemetery. The cold was cruel and biting, but the sun shone to give me courage. At the cemetery Diego was supporting Angelina, who was swathed in veils. I could not help thinking they both looked faintly ridiculous: he, tall and broad and more enormous than ever in his Raglan overcoat; she, small and slim, her tiny feet perched on high heels. . . . I left my flowers with the others beside the little cross inscribed 'Diego Rivera.' "

If the birth of his son had caused something of a split in Rivera's relations with Angelina, the child's death led to their rapprochement. Two pencil sketches which he made of Angelina at this time show her looking tired and sad. They moved out of the studio on the Rue du Départ which they had occupied for the previous seven years and took an apartment in the fifteenth arrondissement, at 6 Rue Desaix. This was away from Marevna, away from the memories of the chilly studio with the empty cot, and away from the distractions of the café life. It was also, for them, the end of Montparnasse.

A MONSTER EMERGES

Paris, Italy 1918–1921

I N THE WINTER of 1918," wrote Angelina, "the Germans were so close to Paris that we could hear the roar of the guns and at night see the red sky along the front. . . . We began to wonder what would happen if the Germans entered Paris. . . . Together with some friends we obtained a pram to help us carry our things away. We bought stout walking shoes. At night we could not sleep for the noise of the battle . . . the whole of Paris was in the streets." In March, having reached a peace agreement with the Bolsheviks, the Germans launched a fierce offensive on the western front. They were closer to Paris than at any time since August 1914. Most of the attacks were carried out by planes and zeppelins. Then, on March 23, eighteen shells fell on the city fired from seventy-five miles away. People became frightened and flocked to the churches. On Good Friday a shell fell on the Eglise St-Gervais near the Hôtel de Ville, killing seventy-five people and wounding ninety. In April the Germans advanced again, recapturing Reims, and the shelling continued nearly every night until the end of July.

For the first time since the outbreak of war Paris was in the front line, and to escape the bombardment many people left the city. Matisse went to Nice. Gris, Modigliani, Ortiz de Zárate, van Dongen and Braque went to Avignon. Montparnasse was no longer so amusing. But Rivera, who might not have been particularly welcome among the exiles of Avignon, and who did not know the south of France well, stayed in Paris. He may have read in the revue *L'Europe Nouvelle,* in an article contributed by Apollinaire on April 6, that Picasso had also decided to stay where he was, on the outskirts of the city in his new studio at Montrouge, where he had gone to escape both the bombs and numerous old girlfriends. The fact

that he and Rivera were no longer neighbours meant that there was even less reason for them to see each other regularly. In place of the friends with whom he had quarrelled Rivera had the compensation of Adam and Ellen Fischer, Danish artists living outside Paris at Arcueil, who knew Angelina and had never met Marevna. Rivera made drawings of both Ellen Fischer and her husband in a different, classical style that resembled the work he had done many years before at San Carlos when he was a student. Throughout the course of 1918 he did at least thirteen portrait drawings in pencil or charcoal in this classical style and then started on a long series of still lifes and interiors. These were drawings, water-colours and oils, and they were all inspired by Cézanne—because, contrary to what he always claimed, it was not Cézanne who led Rivera to Cubism but Cubism that led him to Cézanne. Fifty-seven of Rivera's pictures survive from 1918, twice the annual average of the previous Cubist years, and for most of that year he was doing Cézannes.

In the course of 1918 Rivera settled his accounts both with Cubism and with his former dealer Léonce Rosenberg. During the summer, as the German offensive on the Marne came to a halt, Rivera and Angelina left Paris for a holiday on the French Atlantic coast in the Bay of Arcachon. "We stayed in a village where men gathered pine-resin . . . with our Danish friends Ellen and Adam Fischer . . . ," wrote Angelina later. "André Lhote and Jean Cocteau were living not far away and we used to spend the afternoons together. . . . Lhote and Diego would talk about painting and literature with Cocteau, and I listened, almost always in silence. Cocteau was very proud of his beautiful feet." Before leaving Paris, Rivera had added Cézannean landscapes to his still lifes and interiors. At Arcueil, while visiting the Fischers, he had done an almost Mediterranean street scene, with red tiled roofs and blue-tinted trees. Another, entitled *Woman with Goose*, shows an observation balloon floating above the city, nearly lost in cloud. This is practically the only surviving reference in Rivera's work to the First World War, a remarkable feat of omission. Now, in the light and heat of Arcachon, the outdoor artist came to life. The landscape around Arcachon was partly tropical—there were flowering cacti and mimosa among the sand dunes—and when he first arrived Rivera was greeted by a French exile from Veracruz singing a *jarocho* folksong in an authentic accent. Rivera was delighted by this stimulus and responded with an exotic series of Cézannean cacti and pine forests.

Throughout that summer Rivera, Lhote and Adam Fischer were preparing for an exhibition of post-Cubist or neo-Cézannean work which was to be held at the end of October at the Galerie Eugène Blot in Paris.

In August and September 1918 André Salmon coined the phrase "l'affaire Rivera" to describe the quarrel between the Galerie Blot group and Rosenberg's Cubists, and there was further coverage of the controversy in the press in August and September. By the autumn of 1918 Rivera had been released from his contract with Rosenberg, although the dealer kept all his Cubist work, and he was free to exhibit with Lhote and Fischer. The issues at stake were described by Fischer himself in an article for a Danish paper quoted by Favela. "There are pro-Cubists," wrote Fischer,

and anti-Cubists. . . . [In Paris] a powerful press campaign has been carried on against a certain art dealer who is sitting on a large stock of Cubist art, and who, in order not to damage his business, has made use of a contract he had with a young painter to take his entire production in order, by hiding his pictures, to conceal the fact that he was on the point of abandoning Cubism. . . . Turning Cubism into a dogma became its death sentence. . . . Now that Rivera has been released from his contract he is on the point of executing that death sentence. Of his earlier pictures' Cubist appearance nothing is left. The abstract structure of his pictures is concealed, one feels it but one does not see it. In his portraits and still lifes he has tried . . . to show an optically correct picture while at the same time reproducing the correct dimensions. Construction which had been lost has been found again.

And the master of "construction" was of course Cézanne. The clearest illustration of Fischer's analysis is to be found in the series of pictures which included portraits of Elie Faure; the sculptor Paul Cornet, who was also exhibiting at Blot's; and the engraver Jean Lebedeff. But the finest example is the portrait also executed at this time entitled *The Mathematician*. The preliminary drawing shows a complicated pattern of lines, ellipses, intersections and angles. But the painting is very different, one of Rivera's finest early portraits, powerful, austere and restrained, its simple lines concealing the entangled structure it has grown from; taken together, they are a striking record of how Cubism marked and then served a painter who abandoned it and moved on. In the background two geometrical patterns are displayed, like graffiti pencilled onto the savant's study wall, a ghostly echo of the painter's preliminary calculations. They remind us of Rivera's constant longing for a "scientific art."

The exhibition at the Galerie Blot opened on October 28 and closed on November 19, 1918, a period which encompassed two other momentous events. In the middle of the show the Armistice was signed and the First World War came to an end. Two days before that Guillaume Apollinaire died of Spanish flu in his apartment at 202 Boulevard St-Germain.

The illness was killing two hundred Parisians a day at that time, and Apollinaire had felt the first symptoms six days earlier while sitting in the window of the Café Baty watching a procession of coffins bearing flu victims towards the cemetery of Montparnasse. At Apollinaire's funeral on November 13, Max Jacob put on another bravura performance, appearing to be "transported with mystic joy," according to one mourner, and whispering to another, "From now on *I* will be the leading figure." The funeral of Apollinaire is an appropriate place to let the curtain fall on Rivera's association with the world of Montparnasse. He did not attend it and the event left no trace in his life. Since the last recorded comment on his work by the leading critic in Paris had been that he was one of a *"bande de pifs"* who had invaded Cubism, he may have felt untouched by the death of the man whom he had once serenaded in the company of Picasso. Paris, which had been "a magnet of attraction for so many artists from all over the world," and which had for so long promised so much for Rivera, now turned its back on him. When the show closed at the Galerie Blot, Rivera was to have no more exhibitions in Paris until he left the city for the last time. The hearse jolted along the streets; Picasso, André Salmon and Cocteau followed on; fame and fortune, the world art market and world celebrity beckoned. But not for Rivera. And the capering, grotesque figure of Max Jacob, disputing the mantle of Apollinaire in the dead poet's funeral procession, would eventually symbolise for him the littleness of the world he was about to abandon.

In the new apartment he shared with Angelina on the Rue Desaix, Rivera at first found it easy to work. Twenty-six oils and water-colours have survived from 1918, as well as thirty sketches and drawings, ranging from classical portraits to still lifes and landscapes, all heavily influenced by the man Rivera described as "the grandfather," Cézanne. But as the first exuberance and energy which he had built up for the show at the Galerie Blot, and which were the consequence of his escape from Cubism, wore off, Rivera found that he was back in a familiar situation. He had the technique to paint in several styles with a steadily growing assurance, but he felt at home in none of them. With the marked exception of some of the portraits, none of the pictures he painted in this transitional post-Cubist period shows the same originality as the pre-Cubist *Women at the Well in Toledo* or the *Portrait of Adolfo Best Maugard*. In his perplexity Rivera did what he had done so often before: he rummaged through the past. A portrait of Angelina dated 1918 bears some resemblance to Goya's *Clothed Maja,* and in the following year he undertook several nudes, including one of Marevna, that show the influence of

Renoir. At the same time he painted a series of water-colours of aque-
ducts and industrial chimneys which recall subjects he had last depicted in
1913 when he was on the threshold of Cubism.

While he was searching for the way forward Rivera suffered a creative
block. Only twenty-one paintings were finished in the two years that
remained before his departure from Paris to study in Italy, and one reason
for this was the renewed complications of his personal life. In February
1919, approximately one year after the death of his son by Angelina, his
mistress, Marevna, became pregnant. Rivera never publicly acknowl-
edged his responsibility for the child, Marika, who was born the following
November, but there is no doubt that he resumed his affair with Marevna
towards the end of 1918 or early in 1919, that he offered help to Marevna
during her pregnancy, and that he admitted his responsibility from the
start to Angelina Beloff.

Marevna's account of this period in her memoirs *A Life in Two Worlds*
is coloured by her regret at being subsequently abandoned, and by the
suffering imposed on her daughter by Rivera's ambiguous position. But it
also contains memories of happy times, of bacchic idylls when Rivera
tied her to a tree in the forest of Meudon and lashed her naked thighs
with twigs, or of the time when she spent her meagre wages on buying
him "a khaki American shirt," socks, suspenders, underpants, a tie and a
pair of claret-coloured pyjamas. Towards the end of Marevna's preg-
nancy Rivera, on the advice of the Fischers, rented a cottage at Lagny-sur-
Marne where he could see Marevna well away from Angelina. A battle for
Rivera between the two women now broke out, each bitterly resenting
the other: Angelina, because Marevna had taken advantage of her con-
finement; Marevna, because Angelina now threatened the future of her
own child. According to Marevna, Angelina threatened to commit suicide
if Rivera left her; according to Rivera, he was not certain that Marevna
was carrying his child. It is clear that Rivera was not reliable on the sub-
ject of his relationship with Marevna, and that this lasted much longer
than he admitted and that he was far more heavily involved with her than
he wanted Angelina or subsequently the world to believe. But it is also
clear that he was reluctant to accept his relationship with his daughter
Marika; he felt threatened by a commitment imposed against his wishes.
And the problem was complicated by the behaviour of Picasso, who once
seized Marevna from behind, during her pregnancy, and stroking her
belly told Rivera, "It's not yours. It's mine." Rivera's resentment of chil-
dren was considerable. Apart from Angelina's story that he had talked of
throwing his son out the window, Marevna wrote that when she was

pregnant she sometimes caught him making "fearful grimaces," saying
that the child would probably look like that. His fear of commitment
extended even to superficial relationships. Marevna recalled that while
they were living together in 1919 at the little house at Lagny-sur-Marne,
he persuaded the old landlady, who was dressed like a peasant woman, to
pose for him in the cellar for a portrait in the Flemish style. When he was
painting, Rivera would lose all track of time, and on this occasion he for-
got how long he had made the old lady pose. That night they heard a
groan coming from her room and Marevna went next door to find her
lying on the floor beside her bed. She had fallen off her chamber pot and
lacked the strength to get up. Rivera helped to lift her back into bed and
warned the neighbours, but then decided that she was probably going to
die and insisted on fleeing back into Paris at dawn to escape any further
responsibilities to a model whom he may have literally painted to death.

The other reason for Rivera's refusal to acknowledge Marika was the
deep jealousy aroused in him by her mother's passionate and indepen-
dent nature. He once described Marika as "a child of the Armistice,"
claiming that he had seen her mother dancing with a crowd of Allied sol-
diers on Armistice night. If so, it was nothing to do with their daughter,
who was born twelve months later. Early in 1919 Marevna posed for
Modigliani and it was around this time that she conceived. Rivera's jeal-
ousy had become a game between them. He felt his jealousy as an intol-
erable weakness, and by refusing, in due course, to acknowledge his
daughter, he could turn his weakness into Marevna's weakness and
so make his jealousy into his strength. Marika was the victim of the
struggle.

And all the while, throughout the course of that year, Angelina con-
tinued to fight to get him back, with her repeated threats of suicide. "And
Diego, in his feebleness and cowardice, lent himself to this cruel game."
She was "wicked, so wicked!" wrote Marevna. "Beside her I'm an angel.
She has suffered by her own fault, and it's over: while . . . what has the
future in store for my child and me?" She told Rivera that Angelina "must
take her hooks out of you . . . she's a witch!" At the same time Marevna
suspected that Rivera was telling Angelina that she herself had her hooks
into him. The situation was not likely to bring the best out in a man who
once threatened to kill himself if his mother came to Paris instead of
staying safely in Mexico. Marika had been born in the Baudelocque
maternity hospital on November 13, 1919. Rivera was not in Paris that day,
claiming that he had decided to visit Poitiers, where there was some inter-
esting stained glass. After the child's birth in hospital, which Rivera failed

to pay for, he returned to living with Angelina, where he no doubt found it easier to work. Although he was still fascinated by Marevna, and unable to keep away from her permanently, he never seems to have wanted to settle down to live with her, and the birth of their daughter did nothing to change his mind.

With another child born and abandoned, Rivera in 1920 seemed no nearer to finding the exit from the Cézannean "corridor" that had succeeded the corridor of Cubism. But his devotion to Cézanne, and the post-Cubist interest in "construction" to which the Galerie Blot exhibition had been devoted, had attracted the attention of one of the leading art critics of the day, Dr. Elie Faure. Faure's friendship with Rivera was to be one of the most important in the artist's life, and it is no exaggeration to say that his influence over the painter was decisive.

One seldom finds original abstract theorising in the recorded thoughts of Rivera. The search for the Fourth Dimension and his invention of "la Chose" in 1916 are rare examples. But in the years that remained before his return to Mexico in 1921, Rivera adopted two important new ideas. The first was artistic—his admiration for Cézanne; the second was political—the importance of a public "progressive" art, an art aimed at the people. Whereas there is no reason to suppose that Rivera's decision to submit to the influence of Cézanne came from anyone but himself, the origins of his political conversion are less certain. It has been suggested, by Favela among others, that the Mexican ambassador, Alberto Pani, urged Rivera to return to Mexico in 1918 to undertake government commissions; if so, the artist was unresponsive. However, there was one source which united both these new interests, and that was the published work of Elie Faure. It is not known exactly when Rivera met Faure. His large oil portrait of the critic and military doctor in uniform is dated 1918, but this date has been queried by Faure's biographer Martine Courtois, and the picture has disappeared and can only be seen in reproduction. Nonetheless, it seems clear that the meeting took place in 1918, when Rivera's enthusiasm for Cézanne was still fresh. In 1914 Faure had published a book of essays, *Les Constructeurs,* on artists and writers whose work could be used to point the best way forward, and in the realm of painting he had chosen Cézanne, who had, in his view, attempted to erect a monument on the ruins of nineteenth-century art. Faure's theories and his influence were to be decisive for the life and work of Rivera, who, having emerged from the dead end of Cubism and the cocoon of Montparnasse, was now in urgent need of fresh horizons.

Rivera's portrait of Elie Faure shows him still in the uniform of a mil-

itary doctor, without the medal ribbons to which he was entitled, with his elbow on a table beside a bunch of grapes. Bertram Wolfe wrote that the grapes were there "to suggest grace of spirit and love of Beauty," but Martine Courtois has pointed out that this is "a biographical reference, since Faure's father owned the vineyard of Bellefond-Belcier [St-Emilion Grand Cru] and Faure liked to offer this wine to his friends." At the time of their meeting, Faure, thirteen years older than Rivera, was in his late forties and had started to publish the series of works which were to establish him as the leading art historian and critic of his time. He was a doctor, specialising in anaesthetics and morbid anatomy, and he had a flourishing practice as a fashionable embalmer. Descending from a line of Protestant pastors living in the Dordogne, he had published a novel and had committed himself to a lifelong engagement in radical politics at the time of the Dreyfus Affair. He was also the friend and protector of a large group of painters, although his habit of writing exactly what he thought sometimes strained these friendships. It was possibly Faure's influence that persuaded Rivera in 1919 to attempt his first female nudes, in the style of Renoir. Renoir, a friend of the critic's, was to die at the end of the year shortly after uttering his final imprecations against the new school of untrained painters who considered that "genius sufficed" and that technical accomplishment could be discounted.

From the time of his association with Faure, a permanent new element entered the life of Rivera; from now on he had a political as well as an artistic commitment. Faure was not a member of café society, and the long hours of discussion he shared with Rivera were mainly held in his apartment with its balcony overlooking the Place St-Germain, the Café aux Deux Magots and the busy intersection of the Boulevard St-Germain with the Rue de Rennes, the air being filled at regular intervals with the sound of the abbey bells on the opposite side of the road. Although Faure remained in the army, his front-line service had ended in December 1916 after twenty-two months' uninterrupted duty in an advanced field hospital, during which time he had been repeatedly wounded by shrapnel and blast. The contrast between the influence of this calm, intelligent, courageous and politically committed figure and the world of Rosenberg, Reverdy and Picasso is striking. In his friendship with Faure, Rivera made contact with a level of French society that few foreign artists were able to enter: a world of professional and intellectual distinction, self-confident, open, cultivated and engagé—in a word, "adult." It was a welcome antidote to the frantic chauvinism that coloured the abuse of Reverdy ("Mex-

ican!") and that led Derain and his wife to describe Picasso as *"un petit syphilitique sans talent!"* when talking to Clive Bell.

If Rivera's commitment to the pre-Soviet Marxism of Ehrenburg's circle of exiles is never entirely convincing—in a political discussion late one evening, while Modigliani was identifying the "bald-headed parrots" of socialism, Rivera was arguing that "art needs to swallow a mouthful of barbarity . . . a school of savagery is what is wanted"—his response to the political position of Faure led to an idiosyncratic brand of Marxism which he defended for the rest of his life. In 1919 Rivera met and spent many hours talking to a young Mexican painter, David Alfaro Siqueiros, who had seen action in the Mexican Revolution. As a student at San Carlos ten years after Rivera, Siqueiros had been heavily influenced by Dr. Atl, by then the director of the Academy, who was pursuing his plans for a public art influenced by the Italian Renaissance frescoes which had been under discussion in the last weeks of the *Porfiriato* during Rivera's visit of 1910. That Rivera was able to contribute to this discussion, and help to develop it, was due to the ideas he had received from Faure since their original meeting at the end of 1918. Atl had always wanted a national art—later this became a people's or revolutionary art, whatever that meant in terms of the Mexican Revolution between 1911 and 1918; only in Faure's analysis was it a socialist art. What Atl and Faure had in common was a dedication to fresco and an appreciation of the political potential in the twentieth century of a public art inspired by the Italian Renaissance.

Faure's views were set out in his four-volume *History of Art*, three volumes of which had been published before the outbreak of war. He was revising the final volume, *L'Art moderne*, when he met Rivera although he eventually added a fifth volume, *L'Esprit des formes*, in 1927. Faure divided the history of art into alternating periods dominated by the "individual" or the "collective" genius. He argued that the work of Cézanne and Renoir marked the end of an individual period that had started with the Renaissance, and that a new collective period would be born in the twentieth century. Faure considered that the supreme achievement of the previous collective period had been the mediaeval cathedral, a structure which he did not consider to be of primarily religious significance. For the Protestant Faure, the cathedral was "the house of the people," the market-place, the commercial exchange, the warehouse, the dance floor and the debating chamber of the community which had, by a stupendous co-operative effort, created it, and to the construction of which hundreds of people had contributed anonymously. The true role of the painter in

the collective period, said Faure, was to decorate the buildings thrown up by the genius of the people, as Giotto, the supreme painter of the mediaeval collective period, had decorated the walls of the churches and cathedrals of Tuscany and Umbria.

Faure did not expect the "new cathedrals" to be churches. He envisaged machines, the cinema and steel-framed buildings to be among the probable new "cathedrals" of the new collectivist age. He regarded the arrival of Cubism, with its geometrical references, to be confirmation that architecture was exercising a growing influence over painting. Since architecture was about to resume the importance it had enjoyed in the Middle Ages, the future of painting lay in mural painting, and the most enduring form of that was fresco. Faure had commissioned frescoes for the interior of his own apartment at 147 Boulevard St-Germain, which had been painted on movable panels. From Rivera's point of view, the important thing, according to Faure, was to make a study of Giotto.

Elie Faure had "discovered" Giotto in 1906 and decided that he had not launched the Renaissance, as was usually stated, but that he had ended the Middle Ages. Giotto had humanised Christian art by depicting, in place of symbols, real people with real emotions. He embodied "popular Christianity" while at the same time operating within the guidelines laid down by the Church: that is, that art should edify and console the faithful, that it should proclaim the glories of heaven and convey the message of the Gospels. Painting, according to Pope Gregory the Great, was supposed to serve the illiterate as writing served those who could read. And Bishop Sicardo, in the twelfth century, had ruled that images should not merely be suitable as decorations for a church but should serve to remind the laity "of things past and direct their minds to those of the present and the future." Art would depict the past visions that ordained the future punishments or rewards appropriate for present vice or virtue. Faure's message to Rivera was to study the Italian mediaeval tradition of public art: art as propaganda. He would then be able to play a full role as an artist in the new collectivist age.

Faure was particularly pleased to have a Mexican artist as his disciple since, as Martine Courtois has pointed out, he had placed pre-Columbian Mexican art in the same volume as Giotto—that is, with mediaeval art—and few pre-twentieth-century societies had a more collectivist spirit than that of the Aztecs. Faure's views on pre-Columbian Mexican art were limited by the fact that he had to work from photographic archives and from examples available in Europe, and it is not clear how much help Rivera could have given him since the training at San Carlos when he was there

contained few references to the Aztec period. He must, however, have
seen more of it than Faure, and it is possible that Faure's request to Walter
Pach, in New York in July 1920, for pictures of Yucatecan monuments and
sculptures was the result of his conversations with Rivera. The relation-
ship of Faure and Rivera was an unusually practical application of art
scholarship. Here was a non-practising savant developing his theories, not
merely to impose a subjective pattern on the achievements of the past but
to direct the art of the future. For Faure to find a disciple of this calibre
was a source of enormous satisfaction.

Faure's influence on Rivera was not limited to broad theory, as the oil
painting *The Operation* shows. The artist was introduced to this subject by
Faure, who was probably the anaesthetist acting in the theatre when
Rivera was present. In *L'Esprit des formes,* published in 1927, Faure wrote:

It was while I was watching a surgical operation that I uncovered the secret of "com-
position" which confers nobility on any group where it is present. . . . The group
formed by the surgeon, the patient, his assistants and the onlookers seemed to me to
form a single organism in action. . . . It was the event itself which governed every
dimension and every aspect of the group, the position of arms, hands, shoulders,
heads, none of which could be [altered] without breaking the harmony and rhythm
of the group immediately. Even the direction of the light was arranged so that each
of the actors could see what he had to do.

To illustrate his argument, Faure chose a photograph of a surgical opera-
tion and juxtaposed it with an illustration of Giotto's *Death of St. Francis.*
When Rivera covered the same subject a second time, five years later in a
fresco in Mexico, the influence of Giotto and the "nobility" of the com-
position are evident.

If Faure was able to exercise an opportune and powerful influence on
Rivera, he, in his turn, was deeply impressed. Years later he recalled his
meeting with the painter as an encounter with a "mythomaniac" who
spun wonderful tales of his native land. He thought that Rivera was intel-
ligent, but it was "a monstrous intelligence" such as had flourished in the
Greek archipelago six hundred years before Homer. Since his childhood
Faure had suffered from a horror of the Aztec world and its devotion to
human sacrifice. But as the friendship grew, horror was replaced by
understanding and he took to referring to Rivera, affectionately, as "notre
Aztèque." Years later Faure in a letter to Rivera said, "You will never know
how important for me my meeting with you was. You were all the poetry
of the New World surging up from the unknown before my eyes. As I

grew to know you and understand you I experienced an incredible feeling of liberation. . . ." Rivera was less generous about the help he received from Faure, but his works supply the eloquence which his pen lacked.

As Rivera absorbed Faure's theories he became increasingly isolated from his fellow artists. The drama of Modigliani's death from tubercular meningitis and self-neglect in January 1920 is not recorded in Rivera's memoirs. Furthermore, cut off from his dealer, he was in urgent need of money. Towards the end of 1919 he became friendly with Alberto Pani, the Mexican ambassador to Paris and representative of the Carranza regime, the arrival of which was the first sign of a slow return to stability after the country's destructive years of revolution. Pani was able to assist Rivera by buying *The Mathematician* and by commissioning portraits of both himself and his wife. Pani also helped by sending his son to Rivera to be given painting lessons. And early in 1920 Rivera, who was settled once again with Angelina in their apartment on the Rue Desaix, painted at least seven commissioned portraits, a line of work he was to pursue when he was short of money for the rest of his career. And this was such a time. For though he was living with Angelina, he had fallen in love again, with a woman whose identity is uncertain.

According to Faure's letters, she was married and her husband decided to go to England for a period to enable her to make up her mind. Since Angelina was au courant and since she apparently knew both the husband and the wife involved, it is possible that the object of Rivera's new passion was Ellen Fischer. In any event, the relationship brought Rivera little satisfaction. He had become so unhappy by August 1920 that Faure decided to invite him down to the Dordogne to distract him. Rivera told Faure that Angelina and the husband had decided that the best way to deal with the affair was to tolerate it, so that when it reached a natural conclusion it would not spoil the two couples' friendship. Rivera's response was to talk about his feelings to as many people as would listen, in the hopes of establishing his new relationship. This was one aspect of the situation which pained Angelina; she would also have preferred Rivera to have stopped talking to her about his feelings for her latest rival. Faure's conclusion was that, at heart, Rivera and Angelina still loved each other, *"C'est un bébé monstrueux,"* he wrote to one of the friends of Rivera at this point, *"mais bien sympathique."*

During the weeks he spent with Faure at a rented house called "La Moutine" on the banks of the river Dordogne near St-Antoine-du-Breuih, Rivera, though broken-hearted, was in noisy form. He told Faure of how in Mexico he had once accidentally killed one of his companions,

"and he laughed, he laughed . . . ," wrote Faure, "a delicious imagina-
tion . . . President Wilson's League of Nations is going to have its work
cut out." Later Faure noted that Rivera was still "tortured by love." Faure
tried to effect a recovery by walking the painter about quite hard, hoping
that physical fatigue would prove a distraction. But the husband had
returned from London, the wife had ceased to contact Rivera, and "the
Aztec" was suffering considerably. He had however started to talk of car-
rying out Elie Faure's cherished project and was planning to set out for
Italy in September.

As a further distraction, Rivera set to work on some Dordogne land-
scapes and studies of men and women working in the vineyards, and
Faure drove him all over the region where he had been born. Jean-Pierre
Faure, Elie's younger son, whose portrait Rivera drew, cross-legged and
barefoot on this holiday when he was twenty years old, later recalled that
at "La Moutine" Rivera kept the party amused with fantastic tales of his
childhood in Mexico, even claiming "to have been a train driver at the age
of three." Rivera liked to cross the river to spend some time drinking with
a neighbour on the opposite bank, Monsieur Valade, who would fill his
glass with the command, "Mexican—you will drink!" Jean-Pierre was at
the oars on these expeditions and remembered being alarmed that Rivera
would sooner or later upset the rowing boat "due to his weight and clum-
siness." Despite his discouragement in August, Rivera seems to have
resumed his anonymous affair on returning to Paris in September. Faure
saw Angelina at that time and described her in private correspondence as
"*la pauvre femme* . . . understanding everything and resigned to every-
thing," and while waiting to go to Italy, Rivera seems to have done little to
reassure her. He may have already decided to abandon her, for his plans to
return to Mexico were by now well advanced.

For many years Rivera claimed to have set out for Italy in February
1920 and to have spent seventeen months studying there. "I had had
enough of France," he wrote in his autobiography. Although it was cer-
tainly true that his life in France was becoming increasingly unsatisfying
and complicated, Rivera's journey to Italy lasted much less than seven-
teen months. In February 1920 he was still in Paris. On the morning of the
twenty-first, a Saturday, he visited the Galerie Blot, near the Madeleine,
and found that Cocteau had left him two tickets for a theatre dress
rehearsal that evening. He went to the big post office nearby on the
Boulevard Malesherbes and sent Cocteau a *carte pneumatique,* thanking
him and signing himself "Votre Rivera." As Elie Faure's correspondence
makes clear, he was still in France in July and August, and it was also in

1920 that Faure took Rivera into an operating theatre, probably in the spring or early summer, to work on *The Operation*. At some time in 1920 he shaved off his beard for the last time. Perhaps it went so that he could fit the surgical mask more easily over his face. In November, Rivera had still not departed for Italy. On November 3 he wrote to Alfonso Reyes to thank him for the efforts he was making to obtain a government commission for Rivera and urging him to get money sent soon so that he could fund a journey to Italy before returning to Mexico. It is clear from the letter that Rivera had committed himself to returning to Mexico, that Ambassador Pani had promised him government support when he did so, and that José Vasconcelos, who had been secretary of education in 1915 and was now rector of the National University of Mexico City, was planning to employ Rivera on his return. Eventually the money arrived—it was Alberto Pani who sent it, 2,000 pesos accompanied by a presidential order authorising the journey to Italy—and Rivera set off. Marevna dates his departure as late December in 1920. It was the first time Rivera had visited a new country since arriving in England in 1909, and the first time he had travelled since his journey to Madrid in 1916. He was alone for the first time since he had met Angelina in Bruges. Forgetting his unhappiness in Paris, he set out to work, to study a new craft.

Rivera took the train from the Gare de Lyons to Milan, where he stayed long enough to sketch scenes of street life in winter, café terraces with women in hats, overcoats and muffs. He was struck by the elegance of the women but less attracted by their habit of spitting in public. "In the street, in ships, in hotels, in restaurants. Everybody spat, including the loveliest and most refined ladies . . . the most conspicuous objects [at a banquet] were the gleaming brass cuspidors." When he reached Florence he started work. For Rivera there was the curious sensation during this Italian interlude of completing the journey which he had originally planned when he left Mexico in 1907 to make the European grand tour. It would in fact have been impossible for him to present himself as a qualified fresco artist in Mexico if he had not studied Renaissance fresco. His adventure in Paris with Cubism and the Ecole de Paris had been a diversion that became inevitable when he fell in love with Angelina. Now he found himself copying once more, first in galleries in Florence and then working his way down through Siena, Arezzo, Perugia and Assisi to Rome. He followed an itinerary set out in Faure's *History of Art*. He had not time to see everything, particularly since he spent some days sketching Etruscan tombs and also visited Naples and Sicily. But he still had enough time, he learnt very fast, and it is probable that he subsequently

exaggerated the period he spent in Italy simply because so many of his Mexican contemporaries had spent more time there and he wished to match their knowledge of the Renaissance. And also because in his personal legend it was the time of preparation, the vigil. His studies included lesser-known artists such as Benozzo Gozzoli and Antonello da Messina. What he saw of their work, and particularly of work by Masaccio and Uccello in Florence, by Giotto and Cavallini in Assisi, by Giotto in Padua and by Raphael in Rome, was to turn him into the greatest fresco artist of the century.

Rivera did not spend his whole time looking at frescoes. In Ravenna he was delighted by the Byzantine mosaics in the cupola of Sant' Apollinare. And a surprisingly high proportion of the three hundred drawings he made in Italy show details of the Etruscan funeral vases and tomb paintings that he studied in Tuscany. To find these traces of a pre-Christian civilisation that honoured the dead and built cities for its ancestors must have been reassuring. When D. H. Lawrence visited the same Etruscan sites six years after Rivera, he wrote: "To emerge onto the open, rough, uncultivated plain . . . was like Mexico, on a small scale: in the distance little pyramid-shaped mountains set-down straight upon the level . . . a mounted shepherd galloping round a flock of mixed sheep and goats, looking very small. It was just like Mexico, only much smaller and more human." But it was not only the cult of the dead which attracted Rivera to the Etruscan tombs. Lawrence, who had recently returned from Mexico when he visited Tuscany, wrote of the tomb paintings of Tarquinia: "Still the paintings are fresh and alive, the ochre reds and blacks and blues and blue-greens are curiously alive and harmonious on the creamy yellow walls . . . the dancers on the right wall move with a strange, powerful alertness onwards . . . this sense of vigorous, strong-bodied liveliness is characteristic of the Etruscans." And Lawrence found another Mexican echo in the fact that the body of one of the male dancers was painted red. There was also a direct link with the Mexican Day of the Dead in the Etruscan custom of providing the dead in their tombs with the necessities of life.

What Rivera could not do while travelling through Italy was execute any fresco. But with his love of techniques and craftsmanship he was confident that that would present no problem. The sketch he made of a muralist's scaffold in Florence shows a loving attention to the details of carpentry. "I believe," he had written to Alfonso Reyes before he left, "that I can say without any false modesty or too much pretension that even if I only achieve something small, it will still be interesting." His

experience in Italy, brief though it was, only confirmed his confidence. Once again he could enjoy the privilege of possessing an innocent eye, and it was overwhelming. Just as when he first arrived in Europe and devoured the contents of the Prado, the Louvre, Bruges and the National Gallery, so now for the first time he was exposed to all the wealth and beauty of the Quattrocento. Compared to artists who had grown up in Europe, he saw no clichés. He was left with an even greater desire to return to his native land and endow it with a native art.

After Rome, Rivera visited Naples and Messina in Sicily. Then he returned via the Adriatic coast, stopping at Ravenna, Padua and Venice. Rivera's visit to Italy coincided with a period of violent political struggle. In Ravenna he saw a street demonstration and sketched "a fascist" with a face like a twisted potato, and several of his sketches of the faces on the Ravenna mosaics also have a caricatural line. He had not just absorbed the colours and composition of the Quattrocento, he had also registered its didactic power, and he had every intention of translating this as well. And in Padua he may have noticed something else. Faure had always argued that fresco was the painting of the future because architecture was the art of the future and fresco its adornment. But the Arena Chapel in Padua had been constructed for Giotto to decorate. It was an example of "architecture serving painting," a compliment which Rivera is unlikely to have overlooked. The fact that the chapel's decorations would originally have been intended for a very limited public, since it was a private building, did not deter him at all.

In May 1921 Elie Faure wrote to a friend, "Rivera has returned from Italy, loaded with drawings, loaded with new sensations, loaded with ideas, boiling over with new myths, thin (yes!) and radiant. He says that he will soon be leaving for Mexico, but I don't believe a word of it." There Faure was wrong. Rivera was, as he said, tired of Paris, "that city of idlers," as George Grosz later called it, but he still needed to pluck up his courage to leave. Ehrenburg, who returned to Paris in the spring of 1921, recalled seeing Rivera and Marevna on the terrace of the Dôme after the former's return from Italy, where "he had admired the frescoes of Giotto and Uccello." Rivera asked him how he could get to Russia, but when they met on another occasion said he was returning to Mexico. Ehrenburg lamented how much Montparnasse had changed in four years. The cafés had new owners; the first foreign tourists had arrived, displacing the painters and writers. "Our disordered, semi-pauperised existence . . . had become a fashionable mode of life for people playing at being Bohemians. The Rotonde was living like a *rentier* on its past. . . . No one argued

any more about how to blow-up society or reconcile justice and beauty. . . . The few old regulars were surrounded by cosmopolitan tourists . . . our former turbulence had vanished."

Although Rivera was apparently flirting with the idea of going to Russia—he claimed in his autobiography that he had received an invitation from the Soviet commissar of fine arts—he could never have gone there without money, and his correspondence shows that the only firm offer of patronage was coming from the Mexican government. In May he wrote to Alfonso Reyes predicting that he would be setting out on July 7. The day before he left he visited Marevna to say goodbye. He told her that his father was seriously ill and that he had to leave immediately. "He made passionate love to me for the last time . . . and begged me as a last favour not to come to the station the next day." He promised to send for Marevna and Marika when things improved, but Marevna later reproached herself for failing to make him acknowledge his daughter before he left. "When a love affair is over there is nothing to be done about that; but when one leaves children behind it is one's duty to think of their destiny, their future, even if they're only girls!" Rivera had a very similar conversation with Angelina, telling her that he did not have enough money to pay for her fare to Mexico and promising to send it shortly. The difference was that Angelina believed him. She was resigned to his infidelity and frequent absences, but she loved him, knew that he still loved her, had been the first to recognise his genius, and believed that he still needed her. Angelina took the train with him from the Gare St-Lazare to Le Havre and waved to him as the boat sailed. "The boat left and I was alone," she wrote. "I took the train back to Paris and moved everything into my apartment because Diego had given the studio to a Russian friend, Nora, first wife of Angel Zárraga." Five months later, by which time Rivera was sure he did not need Angelina any more, he did send her a cable inviting her to come and join him. But he did not send her any money. Knowing that she could not respond, he risked nothing.

If Rivera returned to Mexico with his artistic plans set, his political ideas were less formed. He realised that he was entering a "post-revolutionary" situation; he was familiar with the slogans of Lenin and Marx. But his commitment was unformed and more emotional than anything else. The majority of French Socialists had joined Moscow's Third International in December 1920, so forming the Parti Communiste Français, but Rivera seems to have been completely uninterested. Free spirits such as Faure in September 1919 signed a manifesto against Allied intervention in Russia, but Rivera did not. He talked to Ehrenburg about

going to Moscow but again did nothing practical in this direction. On the other hand, he did not react as Otto Dix reacted when the echoes of the final salvoes died away, and men climbed out of the trenches and looked around and found that they had survived. When the German Communists saw Dix's wartime art—*Night Flare,* or *Wounded Soldier: Autumn 1916—Bapaume,* or *Prostitute with Mutilated Soldier*—they supposed that he was a pacifist and invited him to join the party of peace. Dix replied, "Leave *me* in peace. Don't bother me with your ridiculous politics. I would rather go to a brothel." Dix had seen, and he proceeded to show in his painting, how the war had "destroyed the notion of the individual and with him the concept of human dignity," and no one was going to enlist him in any cause, however well intentioned, again. But Dix had not spent the war in Montparnasse.

In July 1921, as the boat moved away from the quay at Le Havre, and Rivera turned from the diminishing figure of the woman who had shared his life for ten years and who would never share it again, and looked towards the west and the future, he had lived exactly half his time and painted almost nothing that would be remembered. His son was dead. He had refused to acknowledge his daughter. He had abandoned two women and most of his friends. The *"bébé monstrueux"* was ready to start work.

PART THREE

REPAINTING THE WORLD

THE BATHERS OF TEHUANTEPEC

Mexico 1921–1922

WHEN DIEGO RIVERA returned to Mexico in July 1921, he re-
entered what was virtually a foreign land. He had left Mexico in the last
weeks of the *Porfiriato*. He came back after ten years to a country that had
been in an almost continuous state of revolution. Madero, the first consti-
tutionally elected leader and the last president to pay Rivera a state grant,
had been overthrown and murdered by a sinister general in wire-rimmed,
blindman's glasses, Huerta, who had attempted to impose a reign of ter-
ror and been driven into exile. The next constitutional leader, General
Venustiano Carranza, attempted in 1917 to introduce the rule of law and
the necessary social and economic changes, but he was unable to control
the quarrelling factions of generals and revolutionary leaders which had
brought him to power. Parts of the country remained in insurrection,
including the state of Morelos, still ruled by Zapata. A general supporting
Carranza, Pablo González, eventually tricked Zapata in April 1919.
González first humiliated one of his own colonels in public. The colonel
then appeared to change sides, invited Zapata to lunch and provided the
legendary rebel leader with a guard of honour. When Zapata inspected
the guard of honour, they shot him. In the following year Carranza,
whose term was drawing to a close, and who was not permitted to seek
re-election, despaired of completing the essential reforms in time and
tried to impose his own candidate as successor. The result was that his
most able general, Alvaro Obregón, led a revolt against Carranza, and
within a few weeks the first post-revolutionary Mexican president had
been assassinated. Fiesta!

The drama, like so many dramas of the Mexican Revolution, was played out on railway trains, and was described by Rivera's friend, the writer Martín Luis Guzmán, in his narrative history *The Ineluctable Death of Venustiano Carranza*. Carranza's fate was emblematic of the fate of his country, and of the political future which was to dominate Mexico for the rest of Rivera's life. Madero, a constitutionalist, had been murdered by a minor tyrant. So when Carranza met the same fate as Madero—death at the hands of an ambitious general—a pattern was set. By the time Rivera returned to Mexico, one year after the death of Carranza, the Revolution had already been betrayed and defeated. But for the next ten years he passed much of his time and devoted most of his energy to the assumption that it was, on the contrary, in the process of being realised.

In Carranza's case, history repeated itself, the first time as farce, the second as tragedy. Once before his destiny had been decided on a train: in 1914, on the Mexico City–Veracruz line, his cautious advance against Pancho Villa was checked by the arrival of a rogue locomotive, dispatched by Pancho Villa to ram Carranza's train. On that occasion the crowd of passengers leaping for their lives was led by General Alvaro Obregón; Carranza remained on board and was injured in the collision when a stuffed eagle, symbol of Mexico, was dislodged from its perch by the force of the impact and fell on his head. Now once again Carranza boarded an official train on the Mexico City–Veracruz line, this time retreating not from Pancho Villa but from his former ally and fellow passenger General Alvaro Obregón. "By the morning of the fifth of May 1920," wrote Guzmán, "the political and military situation of Venustiano Carranza was beyond remedy. A wave of armed discontent, of rebellion and defection, rolling from the remotest fringe of the country had penetrated within the very walls of the presidential suite." Faced with this situation, Carranza gave his remaining officials twenty-four hours to organise a convoy of trains with artillery, cavalry and infantry escort to take the government and the treasury, and the presidential court, and wives and children, down to the coast—a matter of perhaps fifty trains and a brigade of troops. All through his last night in Mexico City his regiments and officials deserted him, and news came in of captains and their men changing sides all over Mexico. The Revolution was only nine years old and already it was back to the point from which it had started.

On the following morning, with rebel detachments flooding into the city, Carranza's convoy began a stately progress out of it, whole trainloads of its defenders, including the entire cavalry detachment, deserting

before, during and after its departure. Every time Carranza was urged to make a decision or to hurry things along, he went twice as slowly as before. He placed his hopes on his destiny, on the presence of friendly forces in Veracruz, and on the slim chance that along the way he would meet reinforcements. He carried with him the contents of the national treasury, four hundred prisoners (those who were his fiercest opponents) in locked cages, and a number of military bands. Among the troops that remained loyal was a detachment of military cadets.

The trains advanced through the heat of a deserted landscape. At night the villages showed no lights. At regular intervals the defending forces had to engage rebel detachments that used artillery to bombard the line and landmines to blow it up. The convoy moved forward by repairing the track ahead and destroying the track behind, because behind them came pursuing convoys of trains, the same trains and in some cases carrying the same troops, which had originally been rostered to form part of Carranza's convoy. During one engagement Don Venustiano Carranza, president of the United States of Mexico, had his horse blown from under him by a hand grenade. The convoy finally ground to a halt at a place where the line passed through a ranch called La Soledad (Solitude), checked not by the enemy attacks but by lack of water for the engines. "Dawn broke on the thirteenth of May. . . . Carranza, and his whole government, and its forces, with the Treasury and Finance Commission, with thousands of officials and employees—some accompanied by their wives and children—were stuck, helpless, on eighteen or twenty trains that could move no further. He was lord of a desolate, hilly shrubland, dry and inhospitable and good only to conceal the danger in which he stood." At this point Carranza's enemies mounted a frontal attack which was heroically repelled by his dwindling forces. At the height of the battle, one of his remaining infantry battalions deserted and Carranza, who was fighting in the front line, gave orders to his servants to start burning his archives. When the attack was repelled, the president decided, after due deliberation, that the moment had come to abandon the train, the prisoners, the wives and children, and indeed everything except the government, the gold bullion and all the ammunition they could carry. He acknowledged that it was a calamity; things had not proceeded at all as they had on the previous occasion when he had retreated along this very railway line.

In the morning Carranza and his generals ate a dignified breakfast. Shortly afterwards another unexpected attack broke up the defending

forces and almost succeeded in reaching the once mobile drawing-room from which Don Venustiano was surveying events. When it had been repelled, the president borrowed a horse and rode into the dusty landscape at the head of a few hundred fugitives, still guarded by the cadets and leaving behind the victorious rebels who were ransacking his train. He was still hoping to reach Veracruz on horseback. But each time he reached a village where help was supposed to be at hand, it was to find that it was either deserted or occupied by rebel troops. After two days Carranza ordered the cadets to leave him. He said that he could no longer expose them to danger when almost his entire army had deserted him, so he overruled their protests, waved them goodbye, and turned towards the north. He was no longer trying to reach Veracruz, one hundred miles to the east; he was now heading for the country to the north of San Luis Potosí, which he believed to be still loyal to the constitution, perhaps five hundred miles distant from the mountains in which he was hiding. On May 20 he continued his leisurely progress. That day the president of Mexico, while riding through Mexico, already accused of pillaging the national treasury, found that he had not enough money to pay for a clean shirt. That night he was guided by a loyal colonel to a remote village where he was told he would be safe. The colonel advised Carranza's men where to stand guard and then disappeared, and by dawn Carranza was dead. The loyal colonel had posted the sentries where they would be of no use and had then led the rebel forces to the village. The president of Mexico was defended at the end by some generals and grooms who had for some reason decided not to take any of the numerous opportunities they had been offered to change sides. General Venustiano Carranza, who had been a senator under Porfirio Díaz, and governor of the northern state of Coahuila under Madero, died in the dark, in a wooden hut, groping for his spectacles with the insults of his enemies, who had the previous week been his troops, ringing in his ears. The regime which succeeded his, under General Alvaro Obregón, identified Carranza as "an opportunist," and this is how he is still described in the official histories of Mexico. There was to be no place for the man who avenged Madero in the pantheon of revolutionary heroes. When Rivera took the train from Veracruz to Mexico City in the year following Carranza's death, he passed through Río Blanco, imaginary scene of his own heroic endeavours on behalf of the Revolution in 1906, and then over the tracks where Carranza's convoy made its last stand. By then it had become a point of touristic interest, and a falsified version of Carranza's death had been officially approved.

§ § §

RIVERA ENTITLED the chapter in his autobiography describing his return to Mexico "I Am Reborn." But if so, it was a rebirth that was almost as traumatic as the original event, for the process lasted twenty-one months. Rivera's contacts in the new government—Alberto Pani, Dr. Atl and David Alfaro Siqueiros—were delighted by the death of Carranza since they all depended on Vasconcelos, and Vasconcelos was a supporter of Obregón. In 1920, when Obregón came to power, one of his first acts was to appoint Vasconcelos rector of the National University, and it was this appointment which allowed him to raise the money to fund Rivera's journey to Italy. In his new post Vasconcelos drew up a highly ambitious and radical programme for national education. He was determined that the post-revolutionary government would abolish illiteracy, which after ten years of civil war had reached levels even higher than under the *Porfiriato*. In 1921 Obregón made Vasconcelos secretary of state in a new ministry of public education with a budget that was more than twice the previous total. Furthermore, the new minister was presented with a brand new ministry, a magnificent building in the classical colonial style, grouped on three levels round three courtyards in the centre of Mexico City. It was started on June 15, 1921, and inaugurated one year later on July 9, 1922, an illustration of the immense energy and organisational dynamism that was unleashed in the early days of the post-revolutionary period. While he was still rector of the university, in May 1921, Vasconcelos was already commissioning public murals. The project had, after all, been under discussion since the early years of the century, Dr. Atl had taken it to an advanced stage in the last months of the *Porfiriato*, and it only remained to change the political message delivered by the murals. Obregón decreed the creation of the new ministry on July 25, 1921, by which time work had already been under way on the building for over a month, and Vasconcelos took up his appointment on October 11 that year. By then Rivera had been in the country for about three months. There had been no one to meet him when he arrived at Veracruz, and when he reached Mexico City it was to find his father was very ill and his mother unable to leave the house. They were living in a smaller apartment, but in the same district as they had been living in when he last visited them ten years earlier.

With his parents in need of support, one of Rivera's first calls was on the rector of the university, and Vasconcelos asked to see examples of his paintings. Rivera showed him a selection of both his Cubist and his post-

Cubist work, but Vasconcelos was not impressed. There was no indication from the style that this artist would make a fresco painter. However, he gave Rivera an appointment in the Department of Fine Arts at the university, which assured him a small salary while Vasconcelos decided what to do with him. The welcome was a disappointment for Rivera, but it was not a setback. Vasconcelos habitually smuggled artists onto his payroll by giving them nominal administrative appointments. While awaiting developments, Rivera undertook a commission for *El Maestro,* the "review of national culture." He designed the cover for the October issue and for the first time in his life drew a hammer and sickle, but the emblems were not crossed together, they were placed on opposite sides of the page. Rivera also painted a portrait of Xavier Guerrero, an artist who was to become one of his first collaborators. His future colleague, and rival mural painter, is shown standing against a wall, but the wall is blank. It is noticeable from the surviving work how little Rivera drew and painted between leaving Paris for Italy and first arriving back in his homeland. In a famous phrase Rivera once wrote, "On my arrival in Mexico I was struck by the inexpressible beauty of that rich and severe, wretched and exuberant land." And he added, "All the colours I saw appeared to be heightened; they were clearer, richer, finer, and more full of light." No doubt this was true—it is a common impression on arriving in Mexico from Europe—but it was to be some time before Rivera's excitement was transferred to his work. It took him months to adapt to a novel situation, something outside his experience: in Jean Charlot's words, "art without an art market." Then, at the end of November, Vasconcelos set off on an official tour of one of the remotest areas of Mexico, the southern Yucatán, and he took with him three of his protégés: the painters Adolfo Best Maugard, Roberto Montenegro and Diego Rivera. For Rivera, who had spent so many years living abroad, the journey was to be a revelation.

The official party reached the capital of the Yucatán, Mérida, on November 27 and were met by "large delegations of Communists and Socialists carrying red banners." There is no evidence that Rivera knew who these people were at the time, but he was being greeted by the victorious heroes and survivors of the bloody uprising on the Yucatán *henequén* plantations (which had finally liberated the slaves sent there under the *Porfiriato*) and was witnessing perhaps the supreme moment of the Revolution. After ten years of bloody struggle the vast crowd of freed men gathered to celebrate their triumph. And Rivera, who had played no part in this victory, drank in their triumph, drew life from it and became a triumphant beneficiary in his turn. The first Socialist governor of the state,

Felipe Carrillo Puerto, led the delegation that greeted Vasconcelos on his arrival. On December 1 and 2 the ministerial party reached Chichén Itzá and Rivera saw the full splendour of what was to become one of his life-time passions: pre-Columbian civilisation. His discussions with Elie Faure, and the reproductions available at that time in Paris, would hardly have prepared him for his first experience of a major pre-Columbian site. It has been suggested that Rivera may have begun to study the Codex Bor-bonicus, an Aztec or early colonial book describing Aztec festivals, in the library of the National Assembly in Paris, but this seems unlikely. There is no trace of Aztec or pre-Columbian inspiration in any of the work dating from his time in Europe, and he never mentioned an interest in it before he met Elie Faure, with the exception of his visit to the British Museum in 1909. In fact, the twenty-one-month gap between Rivera's return to Mex-ico and his first depiction of Indian, let alone pre-Columbian, motifs sug-gests a profound incomprehension of the land he had come to paint. It was only in the Yucatán that he began to understand again, and Vasconce-los could watch Rivera's enthusiasm grow by the day. On his return to Mexico City he made two oil paintings, both entitled *Balcony in Yucatán,* which are in the style of murals. In one, two women and a child sit grouped facing the street in the shade of the room behind the balcony. They are framed by the outside wall of the house and by the stone facing of the window arch and balcony. It is a flat arrangement of immobile forms in which only five colours are used in blocks: the dark flesh tones of the women's arms and faces, the black of the shadowy room, the uniform dimness of their dresses, women and babies all wearing the same single colour, and then the two colours, terracotta and green of the stone and stucco exterior frame. But the scene glows with life, as well as being a witty introduction to the problems and solutions of mural painting, and Vasconcelos was sufficiently encouraged and, according to Jean Charlot, charmed by the artist to award Rivera his first wall.

At the end of 1921 Rivera's father, Don Diego Rivera Acosta, died of cancer in Mexico City. Ten days before he died he was taken to a clinic, and it was during this brief period, just after he had returned from the Yucatán, that Rivera made a final attempt to regain his father's acquain-tance. Rivera was badly affected by his father's death, even though it had been expected for some months, and he barely referred to him again except in mythical or heroic terms. He regarded his father's liberal intel-lect as an essential element in his own upbringing, and even seems to have given Don Diego some of the credit for his own subsequent achieve-ments, something which it never occurred to him to allow his mother. It

was at the time of his father's last illness and death that Rivera sent a telegram to Angelina, inviting her to join him in Mexico. His father had never met Angelina but they had corresponded, and in sending this invitation, Rivera was paying tribute to that remote friendship, and to Angelina's place in his life when his father was still alive. But it was a symbolic tribute. It would have no effect on the future.

Vasconcelos had assigned the first public mural commissions in 1921 to Roberto Montenegro, who had been given the apse of the deconsecrated Church of San Pedro y San Pablo, now converted to the Hall of Free Speech under the revolutionary regime. To Rivera he allocated a wall in the lecture hall of the Escuela Preparatoria, the school at which Rivera and Vasconcelos had both at different times been pupils. Vasconcelos used the Escuela Preparatoria as a proving ground for his muralists, many of whom undertook their first contributions to his programme in various parts of this educational complex, based on an eighteenth-century college which had been extended during the *Porfiriato*. For Rivera his first work was to be very much an experiment. He had an experimental subject, an experimental technique and a team of three highly experimental assistants. Vasconcelos commissioned him to illustrate "a universal theme," so in a room that seated nine hundred people and was used for the performance of musical and poetic recitals, and given a space that included a broad archway, a deep niche, and an organ placed against the wall, Rivera chose "Creation." The result was extraordinary, but not entirely convincing.

Despite all his studies in fresco, Rivera decided to use encaustic, the technique he had employed once before, in Toledo, before embracing Cubism. Encaustic is notoriously difficult to bring off. Pigment is mixed with beeswax and resin, applied and then fixed by the application of heat. Leonardo da Vinci concocted a famous fiasco with encaustic when, in 1497 in the new Hall of Five Hundred, in the Palazzo Vecchio in Florence, his hot wax ran down the walls and melted his paints so that *The Battle of Anghiari* dissolved in streaks onto the floor. Nothing daunted, Rivera began work at the very end of 1921 or early in 1922 and spent twelve months on his first mural, starting with full-scale drawings and teaching himself to paint on a scaffold, without models and within the rigid framework imposed by the existing building. He also learnt how to manage a team, Xavier Guerrero having been joined by Jean Amado de la Cueva and the French muralist Jean Charlot, who found himself appointed by Vasconcelos to the position of national "inspector of drawing" for the occasion. As a first effort the *Anfiteatro Bolívar* mural is remarkable, but its

real significance to the work of Rivera is that it was where he learnt his trade. A muralist working on commission cannot afford too many false starts. He cannot, after a certain time, scrap everything he has done and start again. His patron does not usually have unlimited funds and unlimited time. The artist has to deliver, and as he decides to accept the first part of his uncompleted work he limits the possibilities of the blank wall that remains. He cannot stack a mural, like a failed canvas, at the back of his studio. We can take it that Rivera was dissatisfied with many aspects of *Creation* from the speed with which he developed his technique in the months that followed, but he was working methodically. The formal grouping of the twenty figures on either side of *Creation,* the attitudes of prayer, the heavenward glances, all recall the Byzantine mosaics he had been attracted to in Ravenna, and the inclusion of haloes picked out in gold leaf and figures on clouds suggests the transitional period between mediaeval and Renaissance, rather than the Quattrocento. The most striking thing about *Creation* viewed today is the colours, a superb display which Rivera compared to a rainbow since they are confined by the arch (or arc) of the wall. Similarly, he tried to incorporate the wooden box and tall pipes of the organ into the trunk of the tree of life which fills the central niche. But this was an error of inexperience. The organ has long since been removed, and the hole left behind by the administrative vandals has been filled, in an incongruous substitution, by a plush canopy bearing the arms of the National University.

The organ had been an essential part of Rivera's composition. He had been careful to compliment his patron, Vasconcelos, in claiming a Pythagorean theme for Creation. Vasconcelos had adopted Pythagoras's belief that the key to the universe lay in secret musical harmonies, and Rivera's mural contained the allegorical figure of Music, draped in a goatskin and blowing "double gold pipes." The other figures, of which the standing ones are twelve feet tall, represent the male and female principles of life, the great majority being female in flowing robes. There is nothing strikingly Mexican about Rivera's *Creation* except for one aspect which he emphasised in conversation. "I presented a racial history of Mexico through figures representing all the types that had entered the Mexican bloodstream, from the autochthonous Indian to the present day, half-breed Spanish Indian." Rivera thus anticipated one of the great unstated themes of the political struggle that was to come.

Vasconcelos had originally established his intellectual reputation by demolishing the arguments of Comte; he refuted the idea that all true knowledge was scientific, based on the description of observable phe-

nomena. But his objection to Comte, no doubt partly inspired by his opposition to everything associated with the *Porfiriato,* did not lead him to a more plausible philosophy. And his theory of secret harmonies, at least as illustrated by Rivera in *Creation,* is not persuasive. Even Vasconcelos was not persuaded by the mural; he considered, despite the racial mix, that it was insufficiently "Mexican"—a revealing comment to make of a painting illustrating his own philosophy. And he sent Rivera away on another rural tour, this time to the district of Tehuantepec in the state of Oaxaca.

In his first mural Rivera surrounded the figure of Music with two female figures: one naked, representing Woman; and the other in a red robe, representing Song. Both these figures were modelled by a girl from Guadalajara called Lupe Marin. Rivera has described his first meeting with Lupe as an epic encounter, directed by "the beautiful singer" Concha Michel, and it is one of his finest pieces of imaginative reporting. According to his autobiography, Rivera was working in his studio when the singer called on him.

"Comrade Rivera," she said, "you're a *cabrón.*" "Agreed, comrade," said Rivera. ". . . And you are a *puto,* since you go out with every woman you can." "Correct, comrade," said Rivera. "And what's more you are in love with me, but you know that I am not a *puta* and that I wouldn't leave the brave, stupid and fairly honest man I'm living with to take up with a *cabrón* like you. . . . But I realise that the only thing that can keep us apart is another woman who is handsomer, freer and braver than I am. So I have brought her straight here to see you. . . ." A strange and marvellous-looking creature, nearly six feet tall, appeared. She was black-haired, yet her hair looked more like that of a chestnut mare than a woman's. Her green eyes were so transparent she seemed to be blind. Her face was an Indian's, the mouth with its full, powerful lips open, the corners drooping like those of a tiger . . . her long muscular legs made me think of the legs of a wild filly.

Edward Weston described the same woman as follows. ". . . Tall, proud of bearing, almost haughty, her walk was like a panther's . . . grey-green, dark-circled eyes and skin such as I have never seen but on some Mexican *señoritas.*"

All his life Rivera considered Lupe Marin his ideal of female beauty. That day, as Lupe sat on a draughtsman's bench peeling fruit "with the skill of an ape" and throwing the skins over her shoulder, Rivera started to draw her portrait, again and again, and to make studies of her hands, which "had the beauty of tree roots or eagle's talons." They already knew

that they were fated to become close. When Concha Michel had intro-
duced them, Lupe had looked the artist over. "Is this the great Diego
Rivera?" she had said to her friend. "He looks horrible to me." And Con-
cha had smiled with satisfaction. "Horrible, eh. All right. . . . Nothing can
stop what's going to happen now!" Rivera said that Lupe subsequently
proposed to him in public during a political meeting, and that although
they never married Lupe had taken a proxy to a church to go through a
ceremony that would satisfy her parents. In fact, Rivera married Lupe in
the Church of San Miguel in Guadalajara in a conventional Catholic cere-
mony in June 1922. Lupe came from a family of bourgeois respectability
in Guadalajara; she was one of nine children and she was sufficiently con-
ventional to follow her parents' wishes not only in getting married but in
marrying in church. But the state and the Catholic Church were on the
verge of war and there had been a strong current of anti-clericalism
directing the Revolution since the days of Carranza, who was a Freema-
son. So for Rivera, who was shortly to join the Mexican Communist
Party, his wedding in the Church of San Miguel was another inconvenient
detail which would subsequently be erased from the myth.

Rivera joined the party, holding card no. 992, in the autumn of
1922, allying himself formally with David Alfaro Siqueiros and Xavier
Guerrero. In becoming a Communist barely a year after his return
from Europe, Rivera put himself on a divergent course from the post-
revolutionary establishment, both in its pure, idealistic form, as personi-
fied by Vasconcelos, and in its corrupt, opportunistic form, embodied in
Obregón and most of the successive presidents of Mexico. And even
within the party, Rivera soon put himself into a minority, since he formed
an independent union, the Revolutionary Union of Technical Workers,
Painters and Sculptors, again with Siqueiros and Guerrero, with whom
he was elected in 1923 to the Communist Party's Central Committee. In
due course Rivera was to fall out even with his fellow union founders,
so putting himself into a minority of one, but before then there were to
be several contented years when his patchwork revolutionary identity
was to be of enormous use to him in his painting. By the end of 1922
Rivera, married to Lupe Marín, holding party card no. 992, and in the
process of mastering the art of mural painting, lacked only one element
essential to his imminent achievement. He was to find it on his journey to
Tehuantepec.

When Rivera's first mural, *Creation*, was exhibited to the public in
March 1923, it aroused fierce controversy. Dr. Atl, who was struggling
with his own mural elsewhere in the same building, and who had devel-

oped an alarmingly intense interest in volcanoes, remained ominously quiet. Rivera's fellow muralist Orozco, also at work on another wall, described it as "a peanut": "A peanut is a peanut, even if it encloses the golden section," Orozco observed. To more conservative critics *Creation* was an outrage; a students' movement condemned its ugliness. Neither Vasconcelos nor the artist was entirely satisfied with it, but what it most suffered from was muddle. The muddle resulted from the fact that Rivera was not painting from the heart but was attempting to illustrate another man's ideas. It is not only the symbolism which is quasi-religious in *Creation;* the painting also explores several para-Christian themes. The three cardinal (masculine) virtues of "Faith, Hope and Charity" on the left are balanced on the right by the four (feminine) qualities of "Prudence, Justice, Continence and Strength." The heads of all seven figures are illuminated with haloes in gold leaf. Below them the mysteriously feminine activity of Erotic Poetry, a bug-eyed, frizzy-haired blonde, modelled by Carmen Mondragón, the beautiful but unhinged mistress of Dr. Atl, stares madly out at the artist, as though wondering whether Atl is about to surprise her from behind. The message of this dazzling selection of colours lacks focus, which must have been almost inevitable since it was perpetrated by a man who was still searching for the intellectual mould which would enable him to fuse his visual and his didactic powers. *Creation* is the work of an artist who is using a Christian code of symbols in the service of a mystical set of non-Christian religious beliefs. It was conceived before he had become a Communist and before he had concentrated his own hostility towards Christianity.

Tehuantepec, where Vasconcelos now dispatched him, was a region to which Rivera was to return again and again. In the south-east of Oaxaca State, it is in Indian country, but close to the sea. While there Rivera started to paint *The Bather of Tehuantepec,* a study of an Indian woman, naked from the waist up, washing in a forest stream with a foreground and background of rubbery tropical leaves. In the figure of this Indian we catch the first glimpse of what was finally to become Rivera's style. He was to develop the dominant features of this picture and use them again and again; they are present in work he did in San Francisco in 1940 and in some of his last fresco painting in Mexico City in 1951. Rivera was to make the chunky figure of the Indian woman, the natural simplicity of her gestures, the harmony of fleshy leaves and plump, rounded torso, the fusion of human, mineral and vegetable—of stream, plants and bather—into both his trademark and an emblem of a national Arcadia. In *The Bather of Tehuantepec* in 1923, he first married the simplicity of his

design to the simplicity of the people he was portraying. The subdued colours he chose, the dusky tricolour of creamy waistcloth, dark brown skin and black hair floating over silver blue water and bordered by sombre, grey-green plants, suggest something mysterious, half-lost, the more precious because it can only be dimly perceived.

But the Indian bathers of Tehuantepec did not just give Rivera his style. They unlocked Rivera's response to the beauty of the nude. The visual fusion he achieved in this painting grew from the emotional fusion he experienced in observing the Indian union of sensuality and innocence. The women bathing did not pose for him; they were scarcely aware of his presence. They offered him a central, new subject, the naked female form, merely by following their daily routine of washing, confident and trusting and heedless of strangers, in a forest stream.

The man who had returned to his country determined to endow it with a national art found instead that it was the Indian people of Mexico who were to endow him with a personal vision. And when he arrived back in Mexico City, at the end of his second government-sponsored trip to the hinterland, he incorporated a pattern of rubbery, tropical leaves into the central niche of *Creation*. His first mural had achieved a partially "Mexican character" at last.

A PISTOL ON THE SCAFFOLD

Mexico 1923–1927

Early in March 1923 Licenciado Don José Vasconcelos, the minister of education in the constitutional government of Mexico, received an impudent communication. It was an invitation to attend a party which he himself had already given. The invitation told him that on Tuesday, March 20, the Union of Technical Workers, Painters and Sculptors would be celebrating the completion of the maestro Diego Rivera's mural *Creation* and were inviting the minister, in his capacity as the "intelligent initiator and kindly protector" of the work, to join the festivities. Since Minister Vasconcelos had already inaugurated the mural on March 9, at a ceremony uniting the flower of Mexican culture, the need for a second ceremony was not immediately apparent. But this time the party to celebrate the maestro's work was to be held at the maestro's house, 12 Calle Mixcalco. Admission would cost five pesos, and "in order not to be considered scroungers," even guests of honour were expected to pay.

The party was a success. The Riveras' house had been decorated by the painter's wife in simple style with red floor tiles, wood and leather furniture and straw mats. There were Indian blankets on the walls, alternating with the few Cubist pictures which Rivera had not sent to Rosenberg. And the bumptiousness of Rivera's invitation would have reassured Vasconcelos that at least the artist was not discouraged by the sometimes derisive comments made about his first attempt at mural art. Ever since President Obregón had inaugurated the new ministry building in July 1922, Vasconcelos, impressed by the early stages of *Creation*, had made it clear that he regarded Rivera as the key member of the muralists' team. In his speech at the inauguration the minister had singled out "our great

artist Diego Rivera" as the one who would decorate the walls of the building which was to be the intellectual centre of a national revival. From this ministry Vasconcelos would control the entire national teaching system, from elementary school to university. From here he would publish all the approved literary and technical texts, regenerate national culture and promote a new spirit of participation in the field of ideas. The ministry building was to be "a work carved in stone, a moral organisation, vast and complex with spacious rooms in which to hold free discussions under high ceilings, where ideas could expand without hindrance." The mural decorations were to be a permanent inspiration for these discussions; in Vasconcelos's philosophy, art, the life of the spirit, did not merely symbolise progress, it initiated it. For Vasconcelos the ministry was the key to the future and the murals were the key to the ministry.

As the national mural project got under way, the artists argued over which technique to adopt. Rivera took the view that encaustic lasted longer. Others argued for fresco and attempted to translate from *Il libro dell'arte,* a fourteenth-century treatise by Cennino Cennini on mural techniques, which proved to be of little help. On February 18 Guerrero, de la Cueva and Charlot, Rivera's three assistants from the National Preparatory School, had moved over to the ministry of education to start work on the new project. They had met the master plasterer and had started to mix pigments. None of them had ever worked in true fresco before, but they were confident since it was reputed to be a much easier technique than encaustic. Ahead of them lay over 1,500 square metres of blank wall and years of toil; after all, it had taken Rivera over fifteen months to complete the 150 square metres of *Creation*. The maestro joined them on March 23, three days after the party. He had personally signed the contract with the ministry and was to be in sole charge of the works. The decorations were to be paid at eight pesos a square metre, and from this sum Rivera had to pay his three assistants, the plasterer, a second plasterer and five labourers. The project ran into trouble from the start.

Rivera realised that it would take far too long to employ encaustic for the walls of the ministry and switched to fresco; but not knowing enough about fresco, he began to despair. All his life he had been struggling to unite a style, a theme and a patron. To be frustrated by a technical difficulty when he had so many ideas in his head was too much to bear. Charlot recalled that late one evening when he was leaving his work in the adjoining courtyard, he passed Rivera's scaffold and noticed that "it was shaking as though an earthquake was about to start. Peering up through the darkness I saw the obscure mass of the painter. He was sobbing

uncontrollably, and furiously erasing his entire day's work with a little trowel, like a small boy in a rage flattening his sandcastle. Guerrero witnessed similar scenes in those first feverish days." Charlot and Guerrero realised that a solution would have to be found or Rivera would have a nervous breakdown and the whole project would be threatened. Then Guerrero recalled that his father, a house painter, had developed a stucco technique which seemed similar to those used by the Aztecs in the temples of Teotihuacán, where it had lasted sixteen hundred years. The method consisted in laying a coat of mortar and covering it with a mixture of gesso and powdered marble. Guerrero experimented with the mixture for some time before finding a formula which seemed to work, and Rivera not only accepted his assistant's solution but capitalised on it. Shortly after he started to use the new method, the Mexican press carried sensational news: Diego Rivera had "rediscovered one of the ancient secrets of the Aztecs!" *El Universal Illustrado* stated on June 19 that Rivera was now using the same process to decorate the walls of the ministry of education as the Aztecs had used at Teotihuacán. It would have been uncharacteristic of Rivera to deny this sensational achievement. But in fact, not only had Rivera not discovered "the Aztec secret," but the inclusion of nopal, the fermented juice of cactus leaves, as a paint binder was a mistake. The organic matter in the juice decomposed, leaving blotchy stains. According to Desmond Rochfort, the use of nopal juice partly explains the poor condition today of some of the early murals. Rivera eventually abandoned Guerrero's mixture when further experiments led him back to traditional fresco formulae.

The work started with an application of rough plaster which had sufficient "grip" to stay on the stone or rubble wall. Onto this Rivera drew the cartoon of his picture, the broad outlines, sometimes in freehand, sometimes tracing from a full-size cartoon he had already drawn on paper; he would normally use charcoal for this outline drawing. Once the outline of the whole work had been transferred to the wall, the second coat of plaster would be added. This was a smooth coat which could only be painted on while it was damp (*fresco*), so it was applied in sections, each sufficient for a day's work. Once it was on, Rivera started a race against the clock. He first redrew the cartoon onto it, this time more carefully, but joining it up with the original where the lines reached the edge of the second coat, so that the drawing linked up with those parts of the first coat that remained uncovered. He then had to complete the day's painting before the plaster dried, bearing in mind that all the colours used would eventually dry lighter than when they were applied, and remem-

bering also that as the day wore on and the plaster started to dry, the degree to which the colours lightened would alter; this was particularly important if they were to be matched to colours that had been applied at a different time on the previous day. A fresco painter has to be able to work with certainty at great speed. He has to be able to recalculate as he works, he must have the panache and confidence to impose his will on a team, some of whom will be blocking out areas of colour under his direction as he works on the finer detail. Once the plaster dries, nothing can be done to alter the result, except to cut it away and start again, because as the pigments mixed with lime water or plain water soak into the crystalline plaster, a chemical reaction takes place and the colours become inseparable from the wall, which is why fresco is such a permanent form of painting. If Rivera went too slowly, then areas of plaster he was intending to paint dried out too much and became unusable. They had to be cut away and a fresh coat applied and time was lost, sometimes as much as half a day. Or if he worked faster than he expected, then he ran out of fresh plaster and had to wait until a new coat had been added and had "taken" sufficiently to be worked on. Any plaster unused at the end of the day was hacked off and reapplied before the next session. Rivera had to become expert at judging how much plaster he would need for the next period of work, and he had to train a plasterer to be sufficiently skilled and flexible to serve him. No form of painting is more demanding of the artist's capacity for organisation and technical skill. In the words of Hugh Honour and John Fleming, fresco "sets a premium on the virtuosity of the master." And it might be added that no form of painting is more likely to develop an artist's dictatorial and egotistical qualities. Rivera's scaffold became a small workshop, a production line on three levels, on which the great bulk of the genius-foreman moved around, creating, reflecting, altering, criticising and ordering, as the clock ticked and the humidity seeped out of the damp mass in front of him. Jean Charlot did a little sketch of him at this time which shows the three-hundred-pound maestro, hooked onto the side of his scaffold, like King Kong ascending a skyscraper. But as King Kong worked his way round the ground-floor walls of the Court of Labour, he taught himself the craft of fresco; and one can follow his progress by the quality of his results.

He started with the theme that was still on his easel in Tehuantepec, with the bathers and weavers and dyers of the native idyll, and it is notable how much less assured he is at first in handling it than he had been in the original oil painting. But the style is soon translated without strain; the chunky, dark figures of the Indians, with their unselfconscious

grace, begin to move through the elements of their idealised landscape, washing, waiting, watching, when they are not toiling, and the colours, often thin and monotone in the first walls, are sometimes triumphantly judged, particularly the blue dyes of the weavers' spools, the luminous purpley-white dresses of the women approaching the underground well, and the explosive orange bonfires surmounting the pyramids that link the doorways leading to the elevator well.

It was a point of some pride with Rivera that he and his assistants were paid like house painters—which is what in Marxist terms they were—that is, by pesos per square metre. The rate of eight pesos* a square metre was the going rate in the decorating trade at that time. Rivera took 33 percent; Guerrero, his chief assistant, took 17 percent; de la Cueva and Charlot were each allocated 10 percent; the master plasterer took 7½ percent; and so on down to the junior labourer, who was paid 3 percent, or twenty-four centavos per square metre. The difference, of course, was that house painters would have worked in smaller teams. No one could have lived off the rates Rivera had negotiated with the ministry, not even he alone; but in his case it was of little importance since he had his easel painting to fall back on, although he had temporarily abandoned this.

Although his time was largely devoted to the frescoes, Rivera also managed to continue directing the Sindicato (the Union), now renamed the Revolutionary Union of Technical Workers, Painters and Sculptors, and to developing its philosophy, whose chief architect was Siqueiros. The third founding member, Guerrero, seems to have been as self-effacing in the committee room as he was on the scaffold.† The Sindicato's manifesto, when it eventually appeared in 1924, proclaimed that its members were opposed to "aestheticism, ivory towers and long-haired exquisites! Art will don overalls, climb the scaffold, engage in collective action, reassert its craftsmanship, take sides in the class struggle." Artists were "workers with their hands like plasterers, stone-cutters and glaziers, they would clarify with their paintings the working-class consciousness and would join the working class in building the workers' world." "The Union," proclaimed the manifesto, "directs itself to the native races,

*There were eleven pesos to a pound at the time; the equivalent value today would be £3.50 (or $2.30) a square metre.
†Wolfe, repeating a harsh judgement, said that Guerrero was known by his political comrades as "the Parrot" because he was never heard to utter an original observation. Guerrero, a full-blooded Indian, spent his life as a Communist Party organiser, member of the Executive Committee and illustrator of party literature.

humiliated for centuries; to the soldiers made into hangmen by their offi-
cers; to the workers and peasants scourged by the rich; and to the intellec-
tuals who do not flatter the bourgeoisie." In conversation Rivera now
described Cubism as "the art of a declining bourgeois society, and there-
fore a decadent art." The Sindicato, on the other hand, would wipe out
"bourgeois individualism, it repudiated so-called easel painting and every
kind of art favoured by ultra-intellectual circles, because it is aristocratic,
and we praise monumental art in all its forms, because it is public prop-
erty. . . . The creators of beauty must do their best to produce ideological
works of art for the people, art must no longer be the expression of indi-
vidual satisfaction . . . but should aim to become a fighting, educative art
for all." But as he painted a fighting, educative art on the walls of the min-
istry and made himself the apostle of collective action and the enemy of
bourgeois individualism, Rivera was drawn into one of the fundamental
contradictions which were to confront him throughout his political life.
On this first occasion it involved his relationship with his assistants, his fel-
low "creators of beauty" and brother manual workers. Jean Charlot
recorded the situation as it developed.

While Rivera worked his way round the Court of Labour, Charlot
and de la Cueva were working in the second courtyard, the Court of Fies-
tas, under Rivera's overall direction. They too were decorating the north
wall but outward in a westerly direction, just as Rivera was working out-
ward in an easterly one. So the two teams, which had started side by side,
were steadily separating until, when three sides of the linked rectangles
had been covered, they would start to converge and would eventually
unite somewhere on the south wall. Charlot and de la Cueva hoped that,
provided they could work roughly as fast as Rivera and Guerrero, they
would cover roughly half the walls of the ground floor. But even if he
worked faster, it would be some time before Rivera rejoined them, and
they would have had time to cover several sections each. They had reck-
oned without the ruthlessness of the maestro and the acumen of the ex-
client of Léonce Rosenberg.

On May 21 Charlot noted that he had started work on the cartoon of
Los cargadores (*The Stevedores*). He finished the fresco on May 31. On June
25 Charlot started working on his second wall, but on July 9 he and
Amado interrupted their work because of a disagreement with Rivera,
whom they suspected of refusing to guarantee their continued role in the
work. By demanding that they spend some of their time carrying out sub-
sidiary painting of his frescoes, Rivera was preventing them from concen-
trating on their own. Furthermore, Rivera was working much faster. In

July he completed the last of twenty-five frescoes in the Court of Labour, but instead of carrying on along the south wall of the Court of Fiestas, he jumped to the west wall, thus blocking Charlot and de la Cueva from carrying on with their own sequence and developing their own style through the adjoining panels. Rivera had finished one decoration of the ground floor of the Court of Labour, including the elevator foyer on the north wall, where he had twice imposed the hammer and sickle, much to the annoyance of Vasconcelos. He had also started work on the first of eleven panels of the south stairway, a sequence that would rise to the third floor and demanded the stylistic harmony of one artist. Now, instead of proceeding methodically towards the rendezvous somewhere in the Court of Fiestas, he was threatening to monopolise that too. And his technique was improving as he worked. On the south staircase and the west wall of the Court of Fiestas he had abandoned the evil-smelling nopal-juice mixture developed by Guerrero, having at last discovered a satisfactory recipe for traditional *buen fresco.* The lime used in the plaster was now woodburnt and purified, so that it was free from ammoniates and nitrates, and shipped to him in rubber sacks. It was mixed with ground marble dust instead of sand, and he had also purified his pigments.

Charlot decided that if Rivera did not give way, he and Amado would withdraw from the project. On July 16 there was another confrontation. Rivera apparently gave in and Charlot was able to finish his second wall, *The Dance of the Ribbons,* three days later and to assist Amado, who had only been able to start work on his first panel on July 20. Two weeks later, on August 2, Charlot had finished his third fresco, *The Washerwomen.* Charlot and de la Cueva were then ready to start work on the four central panels of the south wall, but on August 6 Rivera told them that they would no longer be employed to paint their own frescoes. They demanded a meeting with Vasconcelos, who saw them on the following day and agreed that they should continue, but once again Rivera sabotaged the agreement, and Charlot's diary notes "difficulties with Diego" on the following three days. On August 11 he wrote, "Are we going to go into work?" and on August 16 Charlot left the ministry of education and went to the Escuela Preparatoria to work as assistant to David Alfaro Siqueiros, who had received a state commission to paint frescoes on the gloomy little staircase of the Colegio Chico.

In the meantime Charlot kept looking for an opportunity to secure his own wall, and in September he applied for permission to paint in the deconsecrated Church of San Pedro y San Pablo, which had been renamed the Hall of Free Speech and which was the site of the first spon-

sored murals in Vasconcelos's programme. The day after his application, on September 12, Vasconcelos refused permission and sent him back to Rivera, who had decided to allow him to paint his own frescoes at the ministry, but limiting his subject to the coats of arms of the thirty-one states of Mexico. And even this was to be done under the master's direction. It had taken Rivera less than six months to take control of the entire project of decorating the ministry of education, and to subjugate and then humiliate his fellow "creators of beauty." But he was not finished with them even then. According to Charlot, Rivera continued to behave in a domineering fashion. Charlot's diary for October contains such comments as "Diego exceeds his authority," or "Diego insupportable." The situation for Charlot, who had already completed a fresco in the Escuela Preparatoria and who had served as an artillery officer in Flanders, was difficult enough, but de la Cueva, who was Mexican, found it impossible. On October 16 he walked off the job for good. Rivera refused to pay him the money outstanding on the grounds that he had left two of the coats of arms unfinished. De la Cueva could afford to laugh at this response since he had found a new patron in the governor of Jalisco State, José Guadalupe Zuno, who had offered him walls to paint in Guadalajara. But for Charlot, a foreigner without contacts or patrons, there was no alternative but to swallow his pride and continue to carry out menial tasks for his fellow revolutionary. As he worked on the monotonous and uninspiring copies of the official heraldry of a foreign country, he could hear the masons in the courtyard below him chipping off one of his three completed frescoes, *The Dance of the Ribbons.* The master had decided to repaint it himself.

Rivera's justification for his ruthless and apparently destructive behaviour in the collective project to decorate the ministry of education was quite simple: he would be judged by results. The only "collective" that can produce an artistic masterpiece is a collective directed by a master, and that is what Rivera transformed the revolutionary collective of manual workers and technicians into: a technical team assisting a master fresco painter. Rivera was able to dominate and then dispose of his colleagues because it was he who had signed the contract with the ministry. But that was merely a legal pretext, an opening shot in the brief struggle to occupy the undecorated walls. It was his enormous confidence and energy that carried the day, backed by the authority that went with his greater age and experience, but above all by the justification of his talent. It is a tribute to Charlot's intelligence and character that, despite the treatment he suffered, he remained an admirer of Rivera's achievement. For

Charlot, Rivera was the finest example of the artist as tireless artisan rather than introverted genius. From the start of the ministry of education project, Charlot realised what Rivera was capable of. The whole of the nopal-juice sequence in the Court of Labour is marked by a primitive force and imagination that show how far Rivera had already gone in endowing his country with a new national art, something utterly different from the exhausted academicism of his youthful masters, Parra, Rebull and even Velasco. Rivera's early work is derivative, in particular of Giotto, but it is derivative and original at the same time; one can watch a young artist taking something from the past and turning it into a weapon with which to build the future.

Rivera called the patio the Court of Labour because his paintings showed weavers, dyers, cane harvesters, silver miners, peasants, factory workers and foundry workers. Compared to his later work, the figures are sketchily drawn and static, the perspectives are flat and two-dimensional, and the colours are muted and monotonous. But enough of his passion is communicated, enough of his new conception of his native land is manifest, to make the Court of Labour a success. The miners entering the silver mine are bowed with exhaustion as they go to work half-naked. The overseer in his high, black sombrero, black waistcoat and silver watch chain, pistol at his hip, looking down at the peons who strain to lift the sack at his feet, is a figure whose cruelty might have come straight out of the pages of *Barbarous Mexico*. The men and women stand in the foreground; behind them the parched hills rise to the distant white walls of an isolated village. But there is something about the landscape that reminds one immediately of a Tuscan hill-town. This is the Mexican Revolution as it might have been painted by a pupil of one of the masters of the Quattrocento. In *The Embrace* the mediaeval halo has become the brim of a straw sombrero, while the ochre and black blanket worn by one of the peasants calls to mind the Galilean fisherman waiting to have his feet washed by Christ: and the gestures in *The Embrace* are based on the meeting of Joachim and Anne in Giotto's decoration of the Scrovegni Chapel in Padua. In the finest of all the frescoes in the Court of Labour, *The Liberation of the Peon*, we see a peasant who has been stripped, bound and flayed, being freed by armed horsemen, while in the distance the white-walled hacienda belonging to the man who committed this crime is burning. The hacienda is exactly the same sort of ranch, the peon is exactly the same sort of man—even the mountains on the horizon are the same sort of mountains—that Rivera last reproduced in 1904, under the influence of Velasco, when he painted the romantic landscape entitled

The Threshing Floor. But the artist's viewpoint has changed with his patrons: he is no longer inside the walls of the hacienda, looking out. Instead he is setting the hacienda alight; he is committing arson on the bourgeois Mexico of his childhood.

The Liberation of the Peon gets its pathetic force from the helplessness of the victim and the gentleness with which his rescuers are treating him. It might as well be *The Laying-Out of Christ,* again from the Scrovegni Chapel, the insurgents bent over the peon with the solicitude of apostles, their arms encircling the body and offering the same support. In the adjoining panel, called *The Rural Schoolteacher,* Rivera showed the future life of the hacienda. While the men till the land, guarded by a horseman with a rifle, a woman sits on the ground with a large book open on her lap, surrounded by her pupils, who include children, old people and labourers. The humble attention shown by the adult pupils, sitting cross-legged on the ground beside their children, learning their letters, suggests some of the artist's affection for his subjects. Even as Rivera was painting this panel, Vasconcelos's staff, working in the rooms around it, were organising the new rural schools which were intended to make every Mexican literate within a generation. No other painting in the series achieved the same harmony of artist, patron and settings; it plays the same role as a devotional painting on the wall of a church—everyone working in the ministry could have identified with it and drawn encouragement from it. It symbolised and strengthened their secular faith. Each time they passed it and silently approved, they said a secular prayer.

However, Rivera had by this time begun to express a more dogmatic faith. In July 1923, having completed the Court of Labour, he moved on to the west wall of the Court of Fiestas and gathered the four central panels of the new wall together in one new theme. He called it *The May Day Meeting.* The picture, stretched around and across the three large doorways and their linking walls, was the first example of his ability to execute crowd scenes. It is complex, animated and humorous, and every figure in it is alive. Liberated by the absence of fermented nopal juice, the colours have begun to glow; the dominant colour throughout the four panels is a beautiful, soft burnt umber, found on the skirts of the Indian woman and the cloth belts of the peons, but most obviously on the political banners and standards that fly above the heads of the multitude. The vast assembly is painted as though from the back of the crowd; it is in fact two meetings with two speakers, one industrial, one agricultural, but united under the central banner, which has been unrolled by two little boys placed as though standing on one of the door lintels. Their banner reads in large

black capitals on a red background, "True civilisation will be found in the harmony of man with the land and the harmony of men with each other." Another banner reads, "Peace, land, freedom and schools for the oppressed people"; the scene was inspired by the enormous gathering which had greeted the arrival of Vasconcelos and Rivera in Mérida in 1921. "The land belongs to everyone," reads another banner, "like the air, the water, the light and heat of the sun," and just above this message is the hammer and sickle. Again Vasconcelos failed to voice his objection, but by then he had other problems on his mind.

The Mexican Revolution, which had ended officially in 1920 with the assassination of Carranza and the subsequent elections which had brought Obregón to power, had by 1923 degenerated into a thinly disguised military oligarchy. With certain exceptions, such as Vasconcelos's educational and cultural programme, the authorised organisation of the labour movement and limited land reform, the revolutionary agenda was already dead on the branch. Despite its immense initial promise and its success in liberating hundreds of thousands of agricultural slaves, the final result was barely positive. The old wealth of the *Porfiriato* had been succeeded by the new wealth of the retired revolutionary generals and their protégés; as one all-powerful bureaucracy was banished, another was smoothly installed. Rivera's growing commitment to Marxism was a logical response to this development, but it created a gulf between him and the minister. Vasconcelos was neither a Marxist nor an ideological revolutionary; he was a visionary idealist who in 1923, despite his considerable political skills, was experiencing increasing difficulty. And the fiercest criticism his policies attracted was a consequence of public hostility to the murals programme.

The protests had started very soon after the work began in the Escuela Preparatoria. The school had a tradition of protest and was popular among the wealthier and more reactionary families of Mexico City. For these dissidents the post-revolutionary artists had become the new establishment. The students first ridiculed and then physically attacked the murals in the open courtyard of the Escuela Preparatoria, and the artists, some armed with pistols, fought back. Then Rivera's murals in the ministry of education came under attack. In one of the earlier frescoes in the Court of Labour, showing the miner being searched by a guard, Rivera had incorporated a verse from a poem by Gutiérrez Cruz urging miners to use the metal they dug up to make daggers rather than coins. This reference to violent struggle had drawn public protests, and Vascon-

celos had instructed Rivera to erase the offending lines, which he did. But outside the walls of the ministry the level of political violence rose. On July 20 Pancho Villa, who had retired from politics to lead a comfortable life in Durango, was assassinated by "prominent" members of the community of Hidalgo del Parral while he drove through the streets of the town in his open Dodge car. It was clear that a powerful member of Obregón's administration had authorised Villa's death—exactly why has never been established, although the United States recognised the Obregón regime on August 31, six weeks after the killing. The death of Villa and the support offered by the United States initiated a struggle for the presidential succession between Obregón, who favoured a trusted ally, Plutarco Elías Calles, and a former ally, General Adolfo de la Huerta. Huerta's supporters were manoeuvred into joining a military rebellion in December 1923 and were eventually defeated by forces loyal to Obregón the following March. In January 1924 Felipe Carillo Puerto, Socialist governor of the Yucatán, was assassinated by Huertistas, and shortly afterwards a senator supporting Huerta was murdered. At this point Vasconcelos, whose budget had been cut and who was sickened by the growing level of political violence, offered his resignation. He was not allowed to resign, so, throughout the first part of 1924, press and student attacks on the murals increased. They were said to be a caricature of Mexico, and Rivera was criticised for making people "look like monkeys." "The monkeys" (or caricatures) became the slang name for his paintings, and many of those supporting Plutarco Elías Calles, the future president, demanded that the new regime's first act should be to "scrub the monkeys off the walls." In June the attacks redoubled; students presented Vasconcelos with a petition to stop the mural programme, and work by Orozco and Siqueiros in the Escuela Preparatoria was damaged. Rivera was more fortunate since his first mural, *Creation,* in the Escuela Preparatoria was in a room that was habitually locked, and the entrance to the ministry of education was guarded. After a series of student riots Vasconcelos agreed to suspend the programme, and on July 3 his resignation was accepted. Vasconcelos never returned to power. He had been a force in the land for nine years, and his career as a minister had lasted for four; during that time he, more than any other individual, had attempted to realise the ideals of the Mexican Revolution. His mural programme became world-famous, and his achievements as an education minister were widely acknowledged. But his philosophy had been proved wrong. Clearly the "key" to the Mexican part of the universe and to the govern-

ing of its population was not musical and artistic harmony. Vasconcelos left office a much-mocked figure. Curiously enough, his departure had no effect at all on the career of his celebrated protégé, Diego Rivera.

The fall of the man to whom he owed everything that he had achieved since his return to Mexico merely became Rivera's second chance to demonstrate his own increasing political skill. Vasconcelos was hounded out of office as the protector of what had become a highly unpopular group of artists. The muralists and their works were under physical attack from a well-organised and ultra-conservative group of students who were the mouthpiece for the most reactionary forces in post-revolutionary Mexican society. Led by Siqueiros and by the Revolutionary Union of Technical Workers, Artists and Sculptors, supported by the Communist Party, by socialist groups and even by the solitary and unpredictable figure of Orozco, the artists defended themselves energetically. Yet Rivera, although a leader of both the Union and the Mexican Communist Party, and the chief target of the students' wrath, refused to join in the general condemnation of the students. He first described their vandalism as "a minor incident" and then resigned from the Union. He thus managed to distance himself from the defensive reaction to the students' protest movement—he could afford to do so since his murals inside the ministry were well protected—and at the same time he managed to keep painting. When he signed his contract he had also been appointed "head of the Department of Plastic Art." This appointment had not been cancelled when the mural programme was cancelled, and he was therefore able to claim that his continued work on the frescoes formed part of his official duties and that he was bound to continue. Alone among the muralists, he ploughed on. The new minister of education was a nonentity called Puig Casauranc, and Rivera made sure that he was soon on friendly terms with his new boss. The scaffolds in the courtyards of the ministry were now the only ones that had not been dismantled, and "Rivera at work on his scaffold" became a popular diversion among visitors to Mexico City. As Rivera's political posture became more adroit he adopted less flexible clothing. It was at this point that he began to paint in military costume: khaki drills with high brown boots and a military stetson. And he sometimes wore a pistol and holster while painting. When Foujita visited Mexico in 1933, he found that stories of the pistol had become legend: "I was told that he fired a gun into the air while standing on his scaffold," Foujita wrote. "When asked why he said it was to frighten off hostile journalists."

Among those who came to watch was the novelist D. H. Lawrence. He and his travelling companion, the North American writer Witter Bynner, were sitting in Mexico City in a café called the Monotes (the Big Monkeys) owned by the muralist Orozco's brother, when they met a young painter who introduced himself as a pupil of Rivera and who offered to take them to see the painter at work. Bynner described the sight that met the visitors' eyes.

We have long remembered the companionable ardour with which the painters were developing their frescoes. As far as we could observe, there was none of the friction among some of them which has developed since. Where could one meet a jollier, heartier giant than Rivera, looking to me . . . like a mudhead or rough, half-formed, primeval being, grown Olympian? And what a joy to watch the delicate workmanship of his big hands.

Another of those watching Rivera was the woman who was to break up his marriage, an Italian-American actress from Los Angeles called Tina Modotti.

Tina Modotti first came to Mexico in 1922 to bury her estranged husband. She discovered an immediate sympathy with the land and its people and in 1923 she came again, this time with the photographer Edward Weston, with whom she had started an affair. She quickly became famous as the model in Weston's photographs and also began to make a reputation as a photographer in her own right. Tina Modotti became acquainted with the muralists, and when Weston opened the first Mexican exhibition of his own work in 1923, the event was attended by Rivera and Guadalupe. Rivera was immediately attracted to Tina, but she was at that time still in love with Weston. However, she started modelling for some of Rivera's assistants, including Jean Charlot and Pablo O'Higgins, who had also come from California to study under Rivera. Seeing the success she was enjoying, Rivera decided to flatter her differently; instead of asking her to model for him, he developed an interest in her photography, in which at that time she had very little confidence. Rivera wanted a photographer to work with him on the relatively uncomplicated task of recording progress on the ministry of education murals at different stages of the work. He asked her to do this, she agreed, and the result was that she came down to watch him at work on the scaffold regularly. Tina Modotti also took some pictures of campesinos reading *El Machete*, the Sindicato's newspaper, on the streets. One of her finest early photographs

shows four straw sombreros bent over a single copy; it looks posed but is quite likely to have been reportage. At five centavos (one-sixth of the average daily wage), the price of the workers' paper was too much for the workers to buy their own copies. But the paper, illustrated with woodcuts by Guerrero and Siqueiros, was a superb production. Bertram Wolfe, by this time officially an expatriate teacher (unofficially a Communist Party international organiser) in Mexico, noted that its masthead was sixteen and a half inches long and described it as "vast, bright and gory." The paper was dated by the years of the Revolution: 1924 was "Year IV." Rivera's signed editorials in *El Machete* won him a reputation for a short while, and mainly among the expatriate community, as "the Lenin of Mexico," as Edward Weston noted in his diary. This was a flattering description since, according to Wolfe, Rivera's knowledge of Lenin's work was limited to a few slogans.

A sort of political Montparnasse now began to form in Mexico City. It was an international society including many talented people drawn there by mutual enthusiasm for the great social experiment that was believed to be under way in a country where a socialist revolution could be picturesque as well as earnest. For many of the "Internationalists" Mexico was a country where revolution could turn to carnival, and where atrocious events could take place in lovely scenery. Rivera and Lupe became two of the leading figures in this society, their house the one to which everyone wanted an invitation. Distracted by his fame, his success and his social celebrity, Rivera remained publicly unaffected by the death of his mother in 1923, an event which he never mentioned either to his first biographer, Wolfe, or in his autobiography. In 1924 Lupe gave birth to their first child, a girl, also called Lupe but always known as "Pico," and there are photographs of Rivera gazing at the baby with conventional enthusiasm. With Orozco and Siqueiros dismissed from their walls, and the Revolutionary Union of Technical Workers, Painters and Sculptors dissolved, Rivera celebrated New Year's Eve, 1923, without reservations among the *Internacionalistas* at the house shared by Tina Modotti and Edward Weston. Lupe, a formidable cook, was in charge of preparing the traditional food. Earlier in the month Plutarco Elías Calles had been inaugurated as president, and guests on the roof terrace of Tina's house could hear the rumble of distant artillery fire as the battle between the president's troops and the forces supporting Huerta continued outside the capital. For Rivera it was a reminder of how far he had come since the last time he had heard guns, in Paris in the spring of 1918.

Although with hindsight it is possible to see that the Mexican Revolution was already a failure by 1924, this was not how it appeared to its supporters at the time. While the members of the junta were quietly lining their pockets and allocating each other enormous ranches confiscated from the old bourgeoisie, the public activities of the regime were apparently more disinterested. The role of the labour movement in thickening this smokescreen was invaluable. In these circumstances, and particularly if one was an idealistic foreigner, it was possible to believe sincerely in the Mexican Revolution. For a start, it was so colourful.

Bynner described the eruption of the May Day procession into Mexico City's central Zócalo on May Day, 1923. The official political struggle at that time was still between "governmental and capitalistic interests," and as part of this charade the May Day procession was produced with all the panache of a Latin production of the march through Red Square. Government offices were closed, despite the protests in the right-wing press, but schools were kept open so that the children could listen to a reading of an official text left behind by Vasconcelos on the significance of this proletarian fiesta. "All shops were closed," wrote Bynner,

. . . the colours and flags of the workers were everywhere. It was a red flag with a stripe of black running crosswise . . . black was a concession to anarchist sentiments still flickering among the workers . . . even peddlers had red flags on their packs. . . . With a band blaring at its head the mile-long procession swung into the Zócalo. . . . Group after group came by . . . beside all the expected unions there were icemen, seamstresses, bartenders, bullfighters and even gravediggers. . . . A peasants union carried banners, "We have suffered enough" [and] "Bourgeoisie, shave your heads and get ready for the guillotine." . . . Constantly along the route [they] broke into the International.

Then, as D. H. Lawrence's wife Frieda stood up in her open car squealing with excitement and brandishing her parasol, the Red Russian flag with its gold hammer and sickle was hoisted by a group of revolutionary artists on the flagpole above the cathedral while intruders rang its bells. It was a most terrific display, and the most terrific charade, as a horrified Lawrence pointed out at the time.

For another, less enchanted, view of the early, post-revolutionary years in Mexico City there is the account left by the Spanish novelist and Republican sympathiser Vicente Blasco Ibáñez. Ibáñez was struck by the way in which men wore pistols and cartridge belts in Mexico rather as, in

other countries, they wore suspenders and watch chains. He was also amazed by the number of generals the country had produced during the Revolution. "There are generals created by Carranza, generals promoted by Villa, generals manufactured by Zapata and even the generals promoted by Feliz Díaz, the police chief and nephew of the dictator Porfirio Díaz, who are just waiting their turn to replace the generals installed by Obregón." Blasco noted that after a military exchange between two of these groups an order came from Mexico City to shoot all the generals on the losing side. This order was executed but it could not be applied to one of the most audacious of the rebels, who was a civilian. Two telegrams were then received from Mexico City. The first promoted the prisoner to the rank of general, and the second conveyed a reminder to shoot him. "These generals are invariably young, they are proud of their humble origins and their socialism and they never wear military uniforms, indeed many of them have never owned one. The only sign of their rank is a little gilt eagle worn in the buttonhole of their lapel or pinned to the front of their fedoras. And the other sign is the size and originality of the revolvers which they wear beneath their waistcoats. Strolling about the city one sometimes comes across a gun battle between two of these generals. They blaze away until their ammunition runs out or one of them is dead and the idea of arresting the survivor occurs to no one."

Although he was not an idealistic foreigner, Rivera did not have the benefit of hindsight either, and there is no reason to suppose that his newly discovered revolutionary fervour of 1923 and 1924 was anything but genuine. Nonetheless, his resignation from the relaunched Revolutionary Union of Technical Workers, Painters and Sculptors was announced in El Machete in September 1924, and shortly afterwards he shed another commitment.

In April 1925 Bertram Wolfe decided that it would be a good idea if Rivera were to leave the Communist Party. Wolfe had joined the Mexican party and been elected to its Central Committee, where he sat with Rivera and had noticed the effect the painter's chaotic and powerful imagination had on Committee deliberations. Unconsciously choosing the same word as Elie Faure, Wolfe described Rivera as "a monster of fertility" whose verbal "picture-making power" overwhelmed the inexperienced and often naïve minds of other party members. Wolfe did not specify what direction these flights of fantasy took, but there was a rich choice available. Rivera could have recounted his imaginary exploits blowing up trains with Zapata, or told tales of the street fighting he had not joined in at Río Blanco or Barcelona, or explained how he had outma-

noeuvred Trotsky at chess, or improvised on his hours of imaginary con-
versations with Posada.

But it was not just the distractions that Wolfe disapproved of.
"Nobody on the Committee seemed to know anything about the eco-
nomic and political realities of the land, nor . . . did anybody seem to
care," wrote Wolfe.

Diego had no need for such study. . . . He had a feeling for trends, developments,
directions, elaborating them more directly and logically than reality did, not trou-
bling to check with the facts, building them into pictures as complete and rich and
detailed as any he ever spread on walls. Occasionally these fantasies were right, fore-
seeing developments for long periods ahead . . . but most of the time he would be
just as completely, overwhelmingly wrong. . . . When his fantasy elaborated things
in the wrong direction, the Committee, swayed by his eloquent verisimilitude, was
so far wrong that they might as well have been laying plans for work in another
country or on another planet.

Wolfe himself was under pressure at that time from the newly appointed
Soviet ambassador to Mexico, Stanislav Pestkovsky. Furthermore, he had
the authority to throw Rivera out of the party. Moscow, somewhat
ineptly, used North American comrades to issue its instructions to the
Mexican party, and Wolfe had returned from the October 1924 Comintern
conference with plenary powers. His wife, Ella, was working as a cypher
clerk at the Soviet legation, and the Soviet ambassador was pouring funds
into the embryonic Mexican Communist organisation. Wolfe managed
"to get Rivera to agree to resign" on the grounds that he had far more
important work to do for the cause than waste his time at Central Com-
mittee meetings. No doubt after his departure it was much easier for
Wolfe to concentrate the Committee's minds on more practical matters,
but he never explained why it was that he did not merely persuade Rivera
to resign from the Committee rather than from the party. In that way the
Communist Party would have continued to benefit from Rivera's
immense prestige without being confused by his super-fertile imagina-
tion. It seems that Wolfe either considered that Rivera was too unreliable
and undisciplined to be allowed to remain even a rank-and-file member of
the party, or that his work as a propagandist was more effective if he did
not hold a party card. But it is also clear that Rivera was offended by
Wolfe's intervention and may have decided that if he was not wanted on
the Central Committee he would not remain within the party at all.
There is some support for the last explanation in the fact that Rivera's res-

ignation was only temporary and that he rejoined the party, and the Central Committee, in July 1926, a year after Wolfe's expulsion from Mexico and departure for the United States. Wolfe never realised the offence his removal of Rivera had caused, or the fact that, whatever his status at that time in the international Communist movement, he remained, in the Mexican analysis, another suspect gringo, throwing his weight around, south of the border.

Throughout 1924 Rivera worked at completing the ground floor of the Court of Fiestas. In the Court of Labour he had moved up to the first floor. He was also still at work on the staircase of the ministry. In the Court of Fiestas he covered most of the south wall with another series of connected panels showing a crowd of peasants, this time gathered not for a meeting but for the redistribution of land. And in the corners of the court he blocked out two of his most confident murals. The first showed the market on the Day of the Dead with crowds drinking *pulque* and buying sugar skulls and hot food; and beside it, in *The Burning of the Judases*, he showed the Easter Day crowds stoning, by tradition, the huge papier-mâché figures of a general, a politician and a priest. These "Judases" explode above their heads as they are in reality hollow dummies stuffed with fireworks. For the first time the reverent note which has dominated his work in the ministry of education disappears. These two frescoes do not show a suffering people and include few Indians. This is simply the street life of Mexico on a day of fiesta; there is no piety in these paintings; they are mildly satirical but mainly remarkable for their high spirits. But placed beside the cosmopolitan, secular bustle of the *Day of the Dead—City Fiesta* there are two very different pictures dedicated to the same feast. They are both night-time scenes showing Indian celebrations. One portrays family altars in a mountain village with candles, arches of flowers and garlands, food and leaves. The other shows an Indian family gathered round a dinner table which has been laid with dishes to welcome the returning dead. These two studies are of a simplicity and unity of purpose which make the city fiestas look decadent. And yet in the middle of the city crowds we see Rivera's head, alert and watchful, passing the *pulque* seller's stall, gazing back at his audience, an unexpected comment on the ambiguity of his own position. Faced with a priest in a cassock, Rivera stuffed him full of fireworks and blew him up; but confronted with the trusting devotion of the Indians honouring their dead or kneeling at the doors of a church, he was content to record it without comment.

Secure in his new arrangement with Minister Puig Casauranc, and reassured that his "monkeys" were not after all to be "scrubbed off the

wall," Rivera now moved up the staircase in the Court of Labour and started work on the second floor. On the staircase the project originally planned with Vasconcelos was well under way. An ascending frieze showing a panorama of Mexico began at "ground-floor sea level" and was intended to end on the second floor with volcanic peaks. In a moment of depression about the student protests, as he worked up the first flight of stairs, Rivera had painted the words "Pearls Before Swine" onto the prow of a boat. He now removed this message and began work in an entirely different style on the three walls directly above his first frescoes in the building.

Whereas on the ground floor of the two courts Rivera had depicted his country as it had been in the times of oppression and as it was presently, here on the first floor he intended to show the future. This is the didactic work of a Communist: Rivera is imposing a pattern on Mexico; this is the country as it must, scientifically, be. The Marxist historian as prophet has issued his decree.

The result is a magnificent series of small panels in grisaille, a new style for Rivera, which he adopted in response to the fussy architectural details of the three open sides of the first-floor galleries. The technique of grisaille, grey on grey, used in fresco is intended to imitate bas-relief, and according to Florence Arquin, Rivera may have got the idea from studying the continuous frieze of Trajan's Column during his visit to Rome. Since the future was to be governed by the rational intellect, Rivera chose to illustrate "intellectual ideas." Yet the effect of these symbolic paintings is far more that of a declaration of faith. Studying them today, one feels like an archaeologist who has opened a pyramid and finds that he can decipher the past. The figures in the grisaille frescoes have the immobility of graven images, but their lack of life adds to the impression of immortality. And the absence of colour, the monochrome, the lack of variation, confirms the certainty of the message. One has the impression that anything so understated must need no emphasis. There is no appeal to be made against the ruling of the land surveyor as he registers the decision reached by means of his optical aid. Elie Faure and his brother Jean-Louis reappear in their surgical masks, setting right the defects of nature at the centre of their eternally golden section. X-rays are shown with a radium arc and a photographic plate, seeing where the human eye fails, and nobody looking at the wire coils, generator and flying sparks of the "electrical machine" would have connected it with an instrument of torture. In *Work* two seated figures, posed reverently, receive a hammer and sickle from a woman who has the calm demeanour of an angel in some secular

annunciation. The astronomers stoop over their calculations, a pathologist peers into his microscope, and the spectator knows that whatever it is they are searching for will inevitably, sooner or later, be revealed. If you want to know why a man became a Communist in 1924, here is the answer. You wonder how this church converted its members, and you realise that you are in the process of undergoing the same experience. Writing at the impressionable age of twenty-four, the Marxist art historian Anthony Blunt happily paid tribute to this ability. Rivera "does not merely attack the present system, but sets forth the principles of a positive solution for its evils. All his paintings are conscious expositions of Communism," wrote Blunt. ". . . The ultimate object of the paintings is always propaganda . . . to expound the lesson of Communism, just as that of the mediaeval artist was to expound the lesson of Christianity. . . . If mediaeval art was the Bible of the Illiterate, Rivera's frescoes are the *Kapital* of the Illiterate."

In November 1924 Rivera, freed from his work with the Union, started an entirely new project: the decoration of the National Agricultural School buildings, which had been installed on a former hacienda just outside Mexico City at Chapingo. The fact that Rivera was able to capture and hold on to another major mural project while he was still in the midst of the largest single scheme in the country is a tribute to his considerable ambition but also to his exceptional imaginative and physical energy, a creative capacity that can be properly described at this period of his life as "monstrous." For Rivera was now working simultaneously on two of his life's most important achievements. In Chapingo he had been given an entrance foyer, a staircase, an upstairs lobby and an entire chapel, formerly the family and estate chapel of the hacienda and built on a scale that offered fourteen major fresco panels. Rivera started to travel out to Chapingo from the city, by train, three days a week. The agricultural college had moved into its new quarters in May 1924, and Rivera had been given the commission by the director, Marte Gómez. The motto of the school, which Rivera painted at the head of the entrance stairway, was "Here we teach the exploitation of the earth, not of man," and Gómez wanted the paintings to inspire and commemorate the distribution of land among the campesinos, many of whom came to the school to learn the new techniques required now that they were in charge of the work rather than just raising cash crops as serfs.

Rivera claimed that the building he was now working in was of special interest since between 1880 and 1884 it had been the country residence of Manuel González while he was president of Mexico and before he

became governor of Guanajuato. It was, and still is, a handsome white-walled mansion built round a stone-paved courtyard. Originally it had been used by the Jesuits as a self-sufficient convent with its own land; when the Society of Jesus was expelled from Mexico in the eighteenth century it passed into private hands and became a *pulque* farm. In his frescoes at the entrance and stairway of what is now the Administration Building of Chapingo University, Rivera showed some of the history of the estate and so began to illustrate the history of Mexico for the first time in an exact and detailed way. He was still inspired by the Renaissance, and in particular by the frescoes of Ambrogio Lorenzetti in the Town Hall in Siena with their themes of peaceful and war-ravaged cities. His work on the staircase at Chapingo was direct, even naïve, but also colourful and effective given its relatively uncomplicated message. In *Dividing the Land* he showed the peasants gathering to listen to a dark-skinned revolutionary bureaucrat, an Indian commissar, as he explains to them how an estate will be shared out between them, while the grim-faced, white-skinned former owners sit in dejected silence. In *Bad Government* the bodies of peasants dangle from trees, soldiers in motor cars shoot at unarmed field workers, and huts go up in flames. Opposite is *Good Government,* in which agriculture and industry are set out, side by side, in a well-planned landscape; men drive mules before the plough or rest in the shade of trees; and in the background, where the mountains reach the sea, the tides and currents are regulated by the walls of a port designed to export the common wealth which will be shared by all. It is rather like an illustrated picture book on economics for children, and by Rivera's standards marked a creative interlude. For the decoration of the chapel, political developments were to provide him with fresh inspiration.

The Calles regime had wasted no time in launching its own revolutionary programme. The "revolutionary" status of the oligarchy was the only means it had of distinguishing itself from the previous, reactionary oligarchy of the Díaz regime. Deprived of their standing as revolutionaries, the leaders of Mexico would have been revealed for what they were: another military cabal. But revolutionaries need a revolution. This presented a problem for Calles since "the forces of reaction," in the form of Díaz's supporters and clients, had long since been dispersed and there were no well-organised and identifiable opponents of the Revolution. Even the United States had agreed to recognise the administration, so depriving the Revolution of the invaluable "enemy without." This left Calles with the problem of land reform. The redistribution of land was

the most urgent and loudly demanded part of the government's pro-
gramme; indeed for millions of Mexicans it was the only reform they had
been fighting for. The Indians who had made the Revolution thought
nothing of walking barefoot and in rags for thirty miles and eating
nothing for twelve hours in order to attend a meeting where they were
harangued on the importance and imminence of the government's land
distribution programme by a retired revolutionary general who had
already appropriated hundreds of thousands of acres on his own account.
Such was the power of the revolutionary rhetoric that the speakers fre-
quently managed to convince even themselves of their own sincerity. The
campesinos trusted these generals because in their simpler world a truth
once expressed became a fact; words had that power, they made yearning
concrete. And they trusted their leaders because they had no choice. The
generals who promised them land reform and stole the land at the same
time were the only leaders since the death of Zapata that the Revolution
had given them. The Revolution had already become a system for trans-
ferring immense wealth and privileges from one small group to another
but the campesinos, the people of the Revolution, were not yet prepared
to admit that. Calles instituted a further programme of distribution; but
to distract attention from the programme's limitations, and from the
grants which state governors were making to their principal supporters,
so well described in Guzmán's masterpiece *The Shadow of the Chief,* Calles
needed something a little more dramatic. So he decided to re-create an
earlier phase of the revolutionary struggle. The Revolution would go to
war again, but this time Mexico would make war on the Mexican Church.

Plutarco Elías Calles's declaration of war on his own countrymen's
church was one of the first acts of his presidency. Calles, who was
rumoured to have worked as a bartender in his youth, had become a pros-
perous businessman under the *Porfiriato.* At the age of thirty-three, when
the Revolution broke, he was sufficiently shrewd to see which side was
going to win. As a successful son of the *Porfiriato,* he had anti-clericalism
in his veins, and was, like most other revolutionary leaders, a Freemason.
Once in power, he appointed brother Masons as his ministers of war and
the interior and he activated the anti-Catholic clauses of the 1917 constitu-
tion. The labour minister, a gangster called Luis Morones, who was also
leader of the powerful CROM union federation and whose American sec-
retary, Mary Doherty, was a friend of Tina Modotti's, opened the assault
on the Church in February 1925 by launching a schismatic "National
Church" which attempted to install its own parish priests. The governor
of the state of Tabasco, Garrido Canabal, ordered all the priests in his

state to marry; while in Mexico City to celebrate the feast day of General
Joaquín Amaro, the minister of war, his fellow officers and masons requi-
sitioned the Church of San Joaquín and threw a surprise party for the gen-
eral where they served a banquet on the altar, broke open the tabernacle,
brewed coffee in the chalices and dipped consecrated hosts in the coffee.
In July 1926 Plutarco Elías Calles passed "the Calles law," which forbade
priests to wear clerical dress and ordered all priests to register with the
ministry of the interior.

At this stage the Mexican hierarchy gave up trying to negotiate with
the government and ordered all the churches in the country to be closed
and the clergy to leave their parishes and withdraw into the towns. At first
government ministers were delighted by this response, claiming that it
went beyond what they themselves had demanded of the Church; in fact,
it turned out to be a decisive move. All over Mexico the peasants rose up
in arms, refusing to accept the loss of their churches. The leaders of the
"Revolution," who held religion in contempt and who were so skilful in
managing the lethal and mercurial cabals of Mexico City, had little con-
tact with the Mexican people and had no idea of the extent to which the
campesinos were devoted to their churches. As the priests departed, the
peasants crowded to take communion at their last mass and then set out
to destroy anything they could associate with the government which had
deprived them of the spiritual centre of their lives. Undirected by the
Catholic hierarchy, which had preached non-violent resistance, and
joined by only a few dozen priests, a spontaneous movement proclaimed
its own leader "Christ the King," and so became known as the *Cristeros.*
Like the revolutionary horsemen who had ridden with Zapata crying
"Land and Freedom," the *Cristeros* rode under the banner of the Virgin of
Guadalupe; although it is true that their battle cry, *"Viva Cristo el Rey!"*
(Long live Christ the King!), was rather different.

Rivera found himself instinctively in sympathy with the anti-clerical
initiative of the new government. His family came from a similar back-
ground to that of Plutarco Elías Calles: he too had been trained in the
Comtean *scientífico* tradition, and his father had been a Mason during the
Porfiriato; for the first time he enjoyed a heartfelt and lifelong sympathy
with the aims of the revolutionary regime. At one stroke he could usurp
the past, replace a Christian iconography and commit a deicide. The war
on the Church also gave him a magnificent new theme to paint, which
stood in strong contrast to land reform. While the Masonic and military
hierarchy of Mexico City took to holding regular meetings in the Cathe-
dral, whose bells were now silent for non-secular purposes, Rivera found

that at Chapingo he had a building at his disposal which he could redeco-
rate in a style that would be entirely acceptable to his patrons. He did not
even have to apply for a church; the chapel of the former Jesuit convent at
Chapingo, with its apse, reredos and 150 square metres of walls, was
already allocated to him. He was perfectly placed to commit the most
superb and permanent blasphemy of the Mexican Revolution.

The ingenuity of Rivera's blasphemy is due to the way in which, in
the chapel at Chapingo, he adapted the techniques of Renaissance devo-
tional art to the desecration of a religious building and its transformation
into a place of anti-religious devotion. He was inspired by Michelangelo's
decoration of the Sistine Chapel; although the space decorated in Rome
was three times larger, he faced for the first time the same problems of
painting ceilings and vaulted bays. In the Chapingo Chapel, which has fre-
quently been described as Rivera's masterpiece, he came closest to re-
creating the mediaeval function of religious art: art as an instrument of
conversion, the highest form of propaganda. To paraphrase Bishop
Sicardo's twelfth-century definition of the purposes of religious art,
Rivera's images in Chapingo were not only decoration, they were
intended to remind the people of their past, to direct their conduct in the
present, and to describe their future. If, in the Middle Ages, the past was
evoked in legends and visions, the present was divided into virtuous and
vicious behaviour, and the future contained punishments and rewards, in
Rivera's art the same pattern was applied but the visions were moved
from the past to the future since the system he was advocating was
Utopian rather than Arcadian.

You enter the chapel by the narthex, the area that had been a railed
portico in the early church, reserved for women, penitents and the
unbaptised, and here on the ceiling Rivera painted a five-pointed red star
with hands holding a hammer and sickle; this performed the function of
a crucifix outside a church: it described the function of the building in one
powerful symbol. Down the left or western wall (the chapel is not aligned
to the east) he painted a series of five panels showing "Social Revolution."
This starts with El propagandista, or The Birth of Class Consciousness, and
ends with The Triumph of the Revolution. On the opposite side of the nave
he showed a similar series on "Natural Evolution" which starts with The
Blood of the Revolutionary Martyrs Fertilising the Earth and ends with The
Abundant Earth; among other subjects it shows volcanic subterranean
forces, the process of vegetable and human gestation, and nature's fruit-
fulness. Both series terminate on the north wall, at the end of the nave,
behind the site of the absent altar. Here a huge mural is dedicated to The

Liberated Earth with Natural Forces Controlled by Man; a mighty female nude, gazing down the nave, raises her left hand in a gesture of quasi-episcopal blessing.

The story told by Rivera in the Chapingo Chapel is that through the revolutionary process, man learns to control first society and then existence; that all aspects of consciousness are subject to rational analysis; and that through socialism, mankind achieves its highest potential. You can buy the message or not; the force of the painting remains undiminished either way. The series includes a number of historical or near-contemporary reportages of social conditions—miners at work, a labour organiser addressing workers, a mounted European employer with an armed Mexican guard lashing campesinos with his riding crop—but it also includes a new style of apocalyptic study featuring the female nude. The deeper message of Chapingo is not about politics, it is about sex. And in particular it is a heartfelt tribute to the sexual harmony that had flowered between Rivera and Lupe. In all Rivera painted seventeen female and two male nudes in the chapel, some innocent, some erotic and one quite alarming, the vast superhuman figure, like some profane God the Mother, with flowing locks, green eyes, strapping thighs, knotty hands and swelling, pregnant belly, thrusting aside her rib cage and breasts, that dominates the entire interior from its reclining position on the end wall. This was inspired by what Rivera described as "the gorgeous nudity of Lupe" his once again pregnant wife. In Lupe's carnal proficiency, Rivera had discovered a new source of inspiration. From now on sex would provide him with much of his creative energy. But he used several other models for the smaller figures, and in particular he used Tina Modotti, with whom he had started an affair.

One of the most luxuriant of the nudes occupies the greater part of a panel entitled *The Earth Enslaved, or The Forces of Reaction.* This shows a naked female surrounded by three tyrannical figures: a greedy, pot-bellied capitalist, a grotesque soldier and a sly, becassocked and lubricious priest. This was another new departure. Rivera's work on the ground floor and first floors of the education ministry included no attacks on the clergy (except for one carnival maquette), and the few references to the religious practices of the people are neutral or mildly sympathetic. But the gross and avaricious priest was from now on to become a regular theme. The introduction of this hypocrite into the former chapel of a Jesuit convent, together with the sumptuous breasts, burning phalluses and multiple references to sexuality, fertility and carnal delight, were for Rivera one of the most stimulating and rewarding aspects of this exuberant project. His

relations with the religious culture of Mexico and his personal religious sense were not straightforward, but their anti-Christian aspect was never again given a more forceful expression than in the murals he painted in the Chapingo Chapel in 1926 and 1927. In Chapingo he took an Aztec's revenge on Cortés and the missionaries, turning a Christian place of worship into a pre-Christian temple of pantheism.

Referring to his childhood, Rivera told his biographer, "Around my soul my father, who was a liberal and anticlerical, drew a line; that was off limits to the pious ones. Until I was six years old I had never been inside a house of worship." And he added that when his great-aunt Vicenta first took him to the Church of San Diego in Guanajuato "my revulsion was so great that I still get a sick feeling in my stomach when I recall it." Since Rivera had been baptised, a ceremony held in church for which his presence was essential, this claim is literally untrue. Furthermore, if his father had been such a bigoted anti-clerical, he would hardly have allowed his son to be baptised, nor would Don Diego have allowed the boy subsequently to be sent to at least two Catholic schools in Mexico City. The incident in the Church of San Diego is clearly an invention; it is far more likely that Rivera held such passionately anti-clerical feelings precisely because he had, for a part of his childhood, been brought up as a Catholic. That is also why he had such a talent for blasphemy, piety and blasphemy being opposite sides of the same coin. The blasphemer does not deny God; he defies God. He is saying, "So where's the thunderbolt?" Rivera's apocryphal childhood performance in Guanajuato in the church of his patron saint is a striking example. The little Atheist is possessed by a secular but holy rage. From the steps of the altar he abuses the worshippers, he denies the existence of cherubim, he explains the nature of clouds and the theory of precipitation; then, having been identified as Satan, he drives the congregation, the verger and even the priest out of the building. And no thunderbolt falls. It is probable that the imagined emotion expressed in this memorable passage was genuinely felt when, as a sceptical adult, Rivera was painting the walls of the chapel at Chapingo. It was then that he proved to the satisfaction of that part of himself which entertained any doubts on the matter that there was no God. And although it is true that no thunderbolt fell on the painter's head, he did, while painting his stupendous blasphemies on the walls of Chapingo in 1927, for the only time in his life, fall off his scaffold. If the thunderbolt failed to descend, the floor rose to meet him, and the head injuries he suffered knocked him unconscious. He was carried home and Lupe reluctantly put him to bed with an ice pack until the doctor told her that he had

a fractured skull. Thereafter she was obliged to take his condition more seriously. But his three months' convalescence was still interrupted by violent marital arguments, during which he would leap out of bed, seize his great club and chase Lupe round the house. The other ironical coincidence that attended his work at Chapingo was that even as he painted the panel entitled *El agitador,* or *The Underground Organisation of the Agrarian Movement,* a real revolutionary and clandestine movement was being organised in Mexico among the peasants who worked outside the walls of the chapel. But it was dedicated to the destruction of every atheist and humanist ideal advocated in Rivera's frescoes. Rivera was well aware of the situation and even made two pen-and-ink drawings of the ambushing and "interrogation" of the *Cristeros.* But he ignored this contradiction, blithely. And so took a step away from reality and towards the political dreamland where he was to execute so much of his future work.

TO MOSCOW AND BACK

Mexico and Moscow 1927–1929

THE MARRIAGE OF Diego Rivera and Guadalupe Marin had been conceived within the walls of the National Preparatory School and had survived the quadrangles at the ground- and first-floor levels of the ministry of education. It emerged slightly battered from the lobby and entrance stairwell of the National Agricultural School at Chapingo, but was eventually sunk by the flood of energy uncorked by the artist in the chapel. Guadalupe Marin, who was a considerable personality in her own right, was in the habit, when Rivera was working in Mexico City, of bringing his lunch—the famous "hot lunch"—down to the scaffold on which he was perched. This not only kept her in touch with her husband and reminded him of how fortunate he was to be married to her; it also limited his opportunities with other women. But the situation changed when Rivera set off day after day for Chapingo, leaving his wife at home in the company of their infant daughter. Rivera described the situation in his autobiography: "Lupe was a beautiful, spirited animal, but her jealousy and possessiveness gave our life together a wearying, hectic intensity. And I, unfortunately, was not a faithful husband. I was always encountering women too desirable to resist. The quarrels over these infidelities were carried over into quarrels over everything else. Frightful scenes marked our life together." Wolfe observed several of these eruptions, including one when Lupe, at a party, set about both her husband and a Cuban girl with whom Rivera was having an affair. Later that night Lupe came hammering at Wolfe's door, begging to be let in and saying that Rivera had been dragging her round the house by the hair. Next morning Lupe went not to her lawyer but to the Monte de Piedad, the national pawnshop in the Zócalo, where she bought Rivera a "big, beautiful revolver" as a peace

offering. On another occasion Rivera claimed that his wife had caught him making love to her sister, a story repeated by Wolfe. Lupe, however, who had five sisters, indignantly denied this story, which she attributed to her husband's bragging. For Lupe the event which made Diego's behaviour beyond bearing was his affair with Tina Modotti. Lupe was an independent woman who was eventually to follow a successful career as a writer and fashion designer, and was proud of the fact that her husband found her so attractive and had painted her so often and so prominently. Between 1922, when they met, and 1927, when they separated, she frequently occupied the foreground of his art as well as his life. It was when Rivera found an alternative muse for his work in Chapingo, placing Tina on a twin pedestal in the chapel, that Lupe felt "deeply injured and deceived." Modotti was not only a friend of hers but had also taken advantage of her second pregnancy, which Lupe regarded as a treacherous act. Furthermore, because her rival was so well known, it was a particularly public humiliation.

Tina Modotti had very quickly gained a reputation in Mexico City as a femme fatale. From the start she was famous as the beautiful model in the celebrated photographs which Weston exhibited. Soon afterwards Tina began to take other lovers. She considered herself Mexican, because Mexico reminded her of Italy and her Spanish was so good that she was able to pass as Mexican. The sensation created by Weston's photographs of her encouraged gossip and boasting, and though she had many affairs, even more were invented on her behalf. In his memoirs Vasconcelos, who never claimed to have had an affair with Tina, described her as "sculptural and depraved" with a figure that was "almost perfectly and eminently sensual. We all knew her body because she served as an unpaid model for [Weston] and her bewitching nudes were fought over. Her legend was a dark one. . . ." Vasconcelos made Tina sound even more irresistible than she actually was, and no doubt did much to darken her legend, but Rivera had no need of gossip to feed his interest. After employing Tina to photograph his murals in the ministry of education, Rivera blew hot and cold, standing Tina and Weston up for a dinner party, testing a wooden walkway which Weston built off his balcony on the grounds that if it was safe for him it was safe for anyone, and praising Tina's photography in a magazine review. At the end of 1925 Rivera started to draw Tina in a preliminary study for Chapingo, working at first from Weston's photographs and then persuading her to pose for him. Their affair started in 1926 and lasted a year, and during this period Rivera painted Tina at least five times for the Chapingo murals, using her as a model for *The Earth Enslaved,* for

Germination and for the superb *Virgin Earth,* which is on a high panel directly opposite the vast figure already modelled by Lupe. "The legend of Weston and Tina" had attracted many devotees in the heyday of that relationship. They were reputed to be a golden couple, sharing their talent and their liberation and managing to give each other love and support without restricting each other's freedom to grow and change—the ideal relationship in revolutionary Mexico. The reality was different, with Weston increasingly jealous and unhappy about Tina's conquests and Tina unhappy about the unhappiness she was causing him and uncertain of a future without him. But until Weston's departure from Mexico, and the couple's public separation at the end of 1926, many of the international community continued to believe in the legend.

In his own affair with Tina, which overlapped with Weston's last months in Mexico, Rivera was living out the fantasy life of many of the men in his circle. He too, after Weston, had secured both Tina's services as a model and her undivided attention. In his studies of this celebrated muse Rivera was saying, "You have seen what a photographer made of her beauty; now see what a painter can do." But something turned sour between them at the end of the relationship. Although Rivera remained on friendly terms with Tina for several years to come, she did not feel the same tenderness for him as she felt either for Weston, to whom she wrote love letters even after his final departure, or for Rivera's successor, Xavier Guerrero. Tina Modotti once light-heartedly described her profession as "men," and it seems there was an element of trophy-collecting on both sides in the liaison she formed with Rivera. But the consequences were more permanent than the relationship.

Lupe was distraught for a time; then she divorced Rivera and, on the rebound, married a rather fragile poet who shortly afterwards mutilated himself and his son before committing suicide. It seems that progressive society in Mexico City was considerably less liberated than artistic society in Paris. The avant-garde in both cities held "bourgeois morality" in equal contempt, but the artists acted out of high spirits and eccentricity whereas the views of the progressives were based, as always, on principle. When principle proved inadequate there was no question of abandoning it, but the strain showed. Rivera's affair with Tina Modotti lasted from the end of 1926, when she was posing for him in Chapingo, until June 1927, when Rivera confessed to his wife after the birth of Ruth, their second child, that the rumours about himself and Tina were true. At that point Guadalupe wrote Tina "a really nasty letter" and Tina decided to end the

affair.* Almost at once Tina fell in love with Xavier Guerrero, and in August Rivera set off for an official visit to the Soviet Union. He had rejoined the Communist Party twelve months before, and the work at Chapingo was finished. Guadalupe was left to look after their two children on very little money, and as his train drew out of the central railway station in Mexico City she speeded him on his way with her final blessing: "Go to hell with your big-breasted girls." "That," explained Rivera, "was what she called Russian women."

<div align="center">§ § §</div>

RIVERA'S JOURNEY to Moscow took him abroad for ten months, and it was for him one of the most frustrating periods of his life, a political and professional disaster. In his memoirs he allowed his imagination free rein, describing how on his way to Moscow he had witnessed a nocturnal ceremony in the forest of Grunewald near Berlin where he spied on President Paul von Hindenburg, dressed as the war god, Wotan, and seated on a throne, being carried by Druids at the head of a procession of eminent chemists, philosophers and mathematicians. Behind Hindenburg came another throne on which sat Marshall Ludendorff, dressed as the thunder god, Thor. "For several hours the elite of Berlin chanted and howled prayers and rites from out of Germany's barbaric past," wrote Rivera. "Here was proof . . . of the failure of two thousand years of Roman, Greek and European civilisation." Later Rivera attended a meeting of the German Communist Party which was addressed for two hours by Adolf Hitler. Rivera noted that "a weird magnetic current flowed" between Hitler and the German Communists, many of whom were converted. The Mexican, on the other hand, "had to be restrained" by German comrades from assassinating the "funny little man" with a pistol shot. When at last he arrived in the Soviet Union, it was to find that his visit coincided with the expulsion of Leon Trotsky and the beginning of Stalin's persecution of the intellectuals and the "opposition of the left."

What Rivera did not mention in his memoirs is that, whether or not he saw von Hindenburg being carried around dressed up as a pagan god, he did, before passing through Berlin, go to Paris. The costs of his trip to Moscow were paid by the Soviet government, but only from the Russian

*The chronology does not support the story that it was Tina who pushed Rivera off the Chapingo scaffold, angry that he had informed his wife about their affair.

border; he had to plan and pay for the rest of the trip himself, with a sub-
sidy from the coffers of the Mexican party. In these circumstances it is not
strange that he chose to travel via Paris, where Rosenberg still held a large
stock of his paintings, but it is surprising that, before leaving Mexico, he
denied any intention of going to Paris. "I hate the town and everything it
stands for. It's the last place in the world I want to go," he told Walter
Pach. He then set off for Paris, where he spent one day and a night and
visited Elie Faure, who had just acquired, and was delighted with, one of
Soutine's six paintings, entitled *Beef Carcass*. Faure considered that his
new Soutine was up to the standards of the Rembrandt which had
inspired it. But if Faure had not written of his pleasure in showing the
painting to Rivera, we would have no trace of this phantom return to the
city where Rivera had spent so many of the most important years of his
life. He still had many friends in Paris; he would only have had to drop in
to the Rotonde to have seen several of them. Life in Montparnasse went
on much as before. The main difference was that there was more money
around. Rivera's old friend Roché was on the point of negotiating the sale
of Modigliani's *Portrait of Diego Rivera* for 150,000 francs. Picasso had
returned from Cannes just before Rivera's arrival, obsessed with his new
model, Marie-Thérèse, with whom he was having an affair. Kisling was
still there, as were Marie Vassilieff, Foujita, Conrad Kickert, Vlaminck and
Matisse. Marevna was there too, Marika was now seven years old, and
Angelina was still living in their old apartment on the Rue Desaix. But
Rivera, who had just left another wife and two more children, did not
choose to visit the women he had abandoned six years earlier. After one
night in Paris he set off for Russia, via Berlin, leaving Angelina and
Marevna in ignorance of his passage, and he never in his life returned to
the city of his apprenticeship.

Rivera's arrival in Moscow to celebrate the tenth anniversary of the
October Revolution once again coincided with the death of that revolu-
tion, its demise this time being marked by the triumph of Stalin. While in
Moscow Rivera made a famous series of forty-five sketches and water-
colours known as "the May Day Sketches," which were in fact started on
November 7, 1927, when he was given an honoured place on the review-
ing stand in Red Square to watch the anniversary procession of the Fall of
the Winter Palace. Even as Rivera was watching what were the death
throes of the Russian Revolution and the birth of a totalitarian state,
Trotsky was fleeing from his office in the Kremlin and taking refuge in the
house of one of his remaining supporters. The long columns of idealists
made their way across the square beneath the sea of red banners—the

Red Army cavalry, followed by the motorised infantry, wave after wave of caps and anonymous faces—and Rivera's pencil never stopped; he gazed down approvingly for three hours as the future wound its way across the ice that stretched beneath the snow. "The marching mass was dark, compact, rhythmically united, elastic. It had the floating motion of a snake but it was more awesome than any serpent I could imagine," he recalled twenty-five years later. Rivera spent so long transfixed by the spectacle that a few days later he was confined to the Hotel Bristol in central Moscow with a severe cold.

By November 24 Rivera was well enough to sign a contract offered by Commissar Lunacharsky, director of education and fine arts, to paint a fresco on the walls of the Red Army Officers' Club. This contract was never put into effect. Shortly after signing it, Rivera was again taken to hospital, this time with pneumonia, and he remained there until the end of December. Trotsky's expulsion, secretly, at night, on the mail train to Tashkent took place on January 17, and by then Moscow had become the capital of a different country. Foreigners were no longer welcome and were forbidden to travel around the Soviet Union without special permission. Any sign of dissent from the official line in any area whatsoever was repressed or punished. The horde of international supporters of the world Communist movement, who had been attracted to Moscow by the anniversary celebrations, had become an embarrassment. And Rivera's contract for the Red Army Officers' Club had become a dead letter. But it was to be some weeks before the painter realised what had happened. When Stalin addressed the Mexican comrades who had gathered at the Central Committee building, Rivera sat in the front row and sketched him. Rivera's subsequent account of this occasion, written when he was trying to regain admission to the Mexican Communist Party, is a masterpiece of unintentional humour, but it was also probably an accurate reflection of his attitude to the supreme leader at that time. Stalin, by Rivera's account, also generated "a magnetic current," although, unlike Hitler's, it was not "weird." Stalin invited his audience to manifest their disapproval of what he said, but perhaps not unexpectedly, none of them did. Rivera's explanation was that they were too busy applauding him enthusiastically. Stalin then answered questions "with the clarity and logic of Jaurès"; he gave an impression of tremendous but controlled strength and appeared to grow taller as he spoke. Stalin opened his speech with the hope that anyone disagreeing with what he said would speak out frankly, and ended it by threatening dissidents with the secret police, the GPU. Rivera noticed nothing odd about that.

The curious thing is that although Rivera's subsequent attitude to Stalin was abject, when he was in Moscow and in Stalin's power he showed a much more combative spirit. On his arrival in Moscow Rivera had been hailed as a major figure of world Communism. He was appointed "master of monumental painting" by the Moscow School of Fine Arts, and he undertook a series of lectures in his rough-and-ready Russian, remembered from his life on the Rue du Départ. Then, as Rivera began to realise that the authorities in Moscow had no intention of giving him a wall after all, he started to join in the fierce arguments taking place in Moscow's political and artistic circles. Rivera found that the barons of Moscow art were either the Socialist Realists, who had succeeded the academic authorities of the tsarist era, or the leaders of the Moscow modernist school, who had continued to experiment with the ideas developed in Paris during the war; and he was equally out of sympathy with both. He therefore decided to support the Union of Former Icon Painters, whose craftsmanship he greatly admired and who were being persecuted as propagators of ignorant counter-revolutionary superstition. At the same time he wrote a critical letter to the dissident review *Revolution and Culture,* the official journal of the Association of Russian Revolutionary Artists, and boldly signed the manifesto of the dissident "October" group of artists, who were attempting to defend Trotsky's view that the spirit of October 1917 had been perverted by party apparatchiks. In the new atmosphere of xenophobia and suspicion, Rivera's position in Moscow soon became untenable. His hosts therefore invited him to return to Mexico to "assist the Mexican Communist Party's presidential election campaign." The invitation to return came in April 1928 from the Latin American secretariat of the Comintern, and Rivera left the Hotel Bristol so suddenly that he broke several appointments and said farewell to none of his Moscow friends.

In Moscow Rivera had seen the birth of something tremendous, and it had rejected him. It is possible that in involving himself in Moscow politics, in pushing his luck and supporting threatened artists such as the icon painters and the October group, Rivera was deliberately trying to discover the limits of the relationship which it was possible for an artist to have with Communism. His expulsion from Moscow provided him with the answer. But whatever his reasons, the circumstances of his expulsion were entirely to his credit. In the system powered by the brutal force of the Red Square parade, which had so impressed him, and which he had wanted to transform into a fresco on the walls of the Red Army Officers' Club, there was no room for individual artistic creation. The Soviet

painter could no more follow his individual genius than one of the Soviet guardsmen could march out of step. If he was to continue to paint as he wished, Rivera realised that he would have to challenge the party's authority in Mexico, but at first he was careful to conceal the extent of his defeat. He told a UPI correspondent on April 17, just before he left, that he would be returning in the autumn to start work on his state commission in the Officers' Club. The reality was that he had accomplished almost no painting during his journey to Moscow; he had wasted nine months. On the other hand, he had met a fellow guest at the Hotel Bristol who was to be a great deal more use to him in the future than Stalin would ever be. This was a young North American art history student called Alfred Barr to whom Rivera showed his album of Tina Modotti's photographs of the frescoes in the ministry of education. Together Rivera and Barr went on an icon-hunting expedition intending to add to Barr's collection. And Barr even bought a drawing by Rivera of Soviet workers laying a rail track; he paid thirty roubles. Shortly after his return to New York, Barr was appointed the first director of MoMA, the Museum of Modern Art.

§ § §

RIVERA REGAINED Mexico on June 14, 1928, and soon found himself enjoying his new bachelor status. For almost the first time since he left Spain in 1909, he had no emotional commitments and was free to deploy his powerful attractions to women without hindrance. It made no difference that he was at this period in his life filthy as well as gross, if we are to believe Lupe, who said that when they lived together he "hardly ever" bathed. Women flocked to meet him. During his absence in Moscow Rivera had become an international celebrity and he was inclined to take advantage of it. His interest in the nude had been non-existent during his marriage to Angelina. The "clothed maja" of 1918, which depicted her, has no "naked" equivalent. It was Marevna who first awakened this interest, which became fully developed during the course of his marriage to Lupe Marin. She was his only real muse and she was never to lose her powerful physical fascination for him. Once they had separated, Rivera sought inspiration elsewhere. Tina Modotti was no longer interested, but there was no shortage of alternatives. He happily discovered what Kenneth Clark described as

the fatal flaw in the whole respectable edifice of the academic nude . . . the relationship between the painter and his model. No doubt an artist can achieve a greater

degree of detachment than the profane might suppose. But does this not involve a certain . . . dimness of response? . . . As a matter of history . . . painting the nude usually ended in fornication.

Capitalising on his fame, Rivera seduced a stream of young women, including several from the United States, who came to study his work or act as his assistants. Many of these visitors succumbed to the flattery of being invited to pose for Rivera, who was adept at taking advantage of the intimacy of his studio.

Earlier, immediately after his return, Rivera had finished his massive series of frescoes in the ministry of education. In Mexico he had established a virtual monopoly in the field of official fresco; one by one his fellow artists had been excluded. Orozco, Siqueiros, Guerrero, Charlot, had either renounced mural painting or gone abroad in search of new commissions. Rivera was now the sole purveyor of official art, enjoying the same privileges as a state painter in a totalitarian regime, but with the difference that the cynical Mexican regime was happy to let him paint what he wanted. The corrupt years of the *Maximato,* the presidencies of Plutarco Elías Calles and the three puppet presidents who succeeded him and whom he dominated for ten years until 1934, proved to be fruitful ones for Rivera. Exhibitions of his easel painting and drawings were held in private galleries in San Francisco and New York, he was able to sell a growing number of pictures to North American collectors, and no one objected when he recycled ideas on canvas which were closely related to themes in his murals. He developed his regular line in flower pictures and studies of Indian children, which were particularly popular with tourists; his years in Chicharro's studio, learning the business of pleasing patrons, were now paying off. And this enabled him to invest quantities of time and energy in the mural work, which was generally very badly paid. Rivera needed the additional money for Guadalupe and their two young children, and although she complained that he never sent her enough, he did support her, as well as continuing to send money to Marevna on an occasional basis.

In 1926, at the time of his readmission to the Mexican Communist Party, Rivera had started work on the second floor of the Court of Fiestas, completing two walls with a sequence of sixteen panels entitled *The Singing of the Ballad.* Above the panels a red streamer with black lettering runs the length of both walls, carrying the words of the ballad, which has a revolutionary theme. The great majority of the characters are Indian campesinos, and the ballad ends with scenes of conventional social

virtue: women sowing, children writing and men ploughing. The silver bridle on the horse of a revolutionary guard is juxtaposed with the primitive loudspeaker of an early wireless set which is relaying the words of the ballad to the nation. But in the middle of the sequence Rivera once again shows capitalists obsessed with profits and engaged in joyless orgies. Once again Rivera reproduces the authentic note of conviction. In the contrast between the disciplined virtue of the revolutionary workers, in harmony with nature, and the epicene figures of the capitalists, dissipated with greed and idleness, there is evidence of what might be described as a para-religious faith. In the panel entitled *Wall Street Banquet* Rivera showed millionaires poring over the stock-market ticker tape which snakes between their champagne glasses, his work suggesting something of the spirit of George Grosz. The seated plutocrats include John D. Rockefeller, Henry Ford and J. P. Morgan, two of whom were subsequently to become his patrons. In the adjoining panel, *The Savants,* he attacked his former Mexican patrons. A group of Comtean luminaries are shown cogitating, gesturing weakly, strumming on a lyre or dozing on a pile of leather-bound volumes written by Comte, Herbert Spencer, Darwin and John Stuart Mill. Worse, a hunched figure with his back to the artist, seated on an ivory elephant, holding a quill pen which he is about to dip into an inkwell shaped like a spittoon, has the aspect and protruding ears of José Vasconcelos, the man who constructed the building in which the fresco is displayed, unleashed the artist and authorised him to decorate its walls. The inclusion of Vasconcelos was a sly response to an earlier episode, an attack on Rivera in which the former minister accused his protégé of covering the walls with "pictures of criminals." Now, on his return from Moscow, Rivera set out to complete the final sequence of the series, but for the first time the work is of uneven quality.

The frescoes Rivera executed in 1928 on the second floor of the Court of Labour show clear signs of a flagging inspiration. Here he executed, round three sides, twenty-three small fresco panels, the majority of them grisaille, the rest being portraits of four Mexican revolutionary martyrs and the remaining six emblematic references to the arts and sciences; there is also a selection of vegetable or social themes. The colours alone in this section stand out, glowing reds and browns and smoky-greeny blues, but the only fine panel, a portrait of the dead Zapata in red shroud, reminiscent of the risen Christ, closely resembles a similar study already on the wall at Chapingo. In the adjoining Court of the Fiestas there remained one wall, the south wall, and here he rallied. But although the work is visually superb, it is politically repetitive. The artist is once again

in full song, but the propagandist's needle has got stuck. The sequence has to act as an introduction to *The Singing of the Ballad,* so it shows the revolutionary struggle that precedes the establishment of the socialist order already illustrated, but the revolutionary struggle was a theme he had successfully dealt with in 1923, on the ground floor of the ministry and at Chapingo in 1926. Rivera managed to find several new angles, but the overall result suggests that some of the passion had been drained by his Moscow experience. However, in two of the central panels, entitled *Who Wants to Eat Must Work* and *Death of the Capitalist,* there is renewed inspiration. In the first, a society lady is being handed a broom by an armed, booted and bandoliered female revolutionary, while a bourgeois artist named "de Sodoma" wearing asses' ears and a pink suit is offering his bottom to a blue-overalled worker, who is booting it in response. The artist's lyre, palette, quill, spectacles and rose bloom have fallen to the ground, together with his copy of *"Ulises* by Jean Joyce." The high-spirited expression of the worker wearing the boot is in striking contrast to the stern righteousness of the revolutionaries who dominate the panel. And in *Death of the Capitalist* a disarmed and wounded rancher, his blood-stained face a sickly, dying shade of green, is slumped on his office safe. The gringo rancher's face is so porcine as to be scarcely human. And here Rivera achieves a much stronger resemblance to Grosz, suggesting that he may have seen an exhibition of Grosz's work in the Prussian Academy in Berlin in 1927, when he was en route to Moscow.

The ingenuity of the composition of *Death of the Capitalist* lies in the fact that when Rivera faced this panel for the first time, he noticed that in the bottom left-hand corner of the wall there was a brass light switch. In the fresco that switch becomes the keyhole of the capitalist's safe. On the safe Rivera slumped the capitalist with his back on the edge of the fresco, leaning against the real pillar that frames the panel. The subsequent arrangement of armed workers and disarmed overseers and lackeys falls easily into place. Rivera frequently faced the problem of the existing light switch in his ministry of education panels. On the ground floor the brass plates obtrude into the landscapes or interiors of his frescoes. Towards the middle of the series the light switch is disguised as a bench end or part of an ammunition box or fuse box. By 1928 a light switch has become the departure point of the entire composition.

In his disappointment which followed his dismissal, Vasconcelos rejected Rivera's achievement and argued that "the economic transformations" taking place in society were supposed to have produced "great popular art," but that the artistic achievement remained incomplete, both

socially and artistically, "for lack of a religious spirit." But in this Vas-
concelos was surely wrong. Rivera's frescoes in the ministry of education
are religious art as well as social art. They are inspired by faith: they juxta-
pose good and evil; they propose a remedy for social ills; they promise
redemption.

In November 1928, five months after returning from Moscow, Rivera
signed off on the building to whose decoration he had devoted nearly six
years of his life and where he had accomplished much of his greatest
work, by finishing the staircase. The decoration of the staircase had faith-
fully followed the original topographical plan. It started on the ground-
floor lobby at sea level and rose to the second-floor landing, where it
depicted the volcanic peaks of the Mexican highlands. But again there
was a surprise in the final panel. Here, placed at the summit of his own
achievement, was a self-portrait of the artist: Rivera as architect, Rivera in
para-military khaki and stetson, poring over a blueprint while builders fol-
low his designs. It was based on a celebrated photograph by Edward
Weston; in choosing this image for his wall, Rivera was incidentally erect-
ing a memorial to his brief success in depriving the photographer of his
mistress. And in one of the panels in the final sequence in the Court of
Fiestas, *Insurrection*—sometimes called *In the Arsenal* or *The Distribution of
Arms*—Rivera painted a portrait of Modotti herself, but this time wearing
the red shirt and severe black skirt of a Communist nun. The central fig-
ure in this panel is another red-shirted nun, who is handing out rifles to
the risen workers. This second revolutionary was modelled by a young
Communist friend of Modotti's named Frida Kahlo.

As he completed his work in the ministry Rivera took a seven-month
break from frescoes and dedicated himself, for the first time since his
return to Mexico, to full-time politics. Throughout the winter of 1928–29
he helped to organise the presidential campaign of the Communist candi-
date. He was also one of the leaders of a Communist front organisation,
the Anti-Imperialist League of the Americas, which opposed U.S. policy
and supported the uprising in Nicaragua led by Augusto César Sandino.
In January 1929 Rivera was elected president of another Communist front
organisation, the Workers' and Farmers' Bloc. But events during the rest
of the year were to follow an unexpected course which would culminate
in September with Rivera's expulsion from the Communist Party. It was
an agitated and confusing nine months in Mexican politics, but even more
so in the personal and political life of Diego Rivera.

The crisis began, in the Mexican tradition, with an act of violence. On
the evening of January 10, 1929, Julio Antonio Mella, a charismatic Cuban

revolutionary who had been attempting to organise a coup to overthrow the right-wing Cuban regime led by General Gerardo Machado, was gunned down on a dark street while he was walking with his lover, inevitably Tina Modotti, towards the apartment they shared in the Zamora Building in central Mexico City. According to reports reaching the Mexican Communist Party, Mella had been threatened with death by Cuban government agents. But the Mexican police attempted to implicate Tina Modotti in the crime. Rivera played a leading part in her defence, mounting an independent, parallel enquiry, making his own sketch map of the murder scene, blocking the clumsy attempts made by the detectives to frame her, and appealing to influential friends of Tina's, including the mayor of Mexico City, to come to her assistance. As a result of the efforts made by her friends, Tina was cleared of any involvement in the murder after a ludicrous but humiliating five-day investigation. Her reputation was blackened. Her private papers were published. Throughout this process Rivera did his best to protect her. Photographs of his presence by her side at the police reconstruction of the crime show the familiar vast figure, made even larger by his lofty stetson, dominating the night-time street. At the funeral of Mella, Rivera marched at the head of the Communist delegation.

The accepted version of Mella's death follows the contemporary party analysis. He was assassinated by Cuban government agents, assisted by the Mexican police. But the truth may have had more to do with the internal politics of the Mexican Communist Party than with the paranoia of General Machado. With Bertram Wolfe's departure for the United States in 1925, the Mexican Communist Party had reverted to a more idiosyncratic method of conducting its business and was soon, in the view of Moscow, out of control. Rivera's return to the Central Committee in 1926 did little to raise its level of consistency or discipline. But Mexico, with its turbulent history, its volatile and impoverished population, its failed revolution and its lengthy and porous border with the United States, was a key area for the Communist International's plans to organise world revolution. So in July 1927 the Comintern dispatched one of its most resourceful, unscrupulous and violent agents to Mexico to bring the Mexican party back into line. He was travelling under the alias of Enea Sormenti, but his real name, which remained a secret for many years, was Vittorio Vidali.

Vittorio Vidali had been born in 1900 in Trieste, and after the Great War had served his apprenticeship as a street fighter and become one of the founders of the Italian Communist Party. Expelled from Italy as a Red

terrorist, he was trained in Moscow and adopted the cover of an official of International Red Aid, a front organisation which claimed to be a humanitarian group dedicated to protecting the interests of the world's political prisoners. He ended his life as a member of the Italian Senate and a member of the Italian party's Central Committee. On arriving in Mexico in 1927, Vidali became a member of the Mexican party's Central Committee. He also started to work with Mexican Red Aid, where he immediately encountered Tina Modotti and Julio Antonio Mella. It seems clear that, shortly after he met her, Vidali became obsessed with Tina Modotti, who was his compatriot as well as his comrade. Vidali quickly organised Tina's transferal from membership of various front organisations to full membership of the party, and he promoted her to de facto leadership of Mexican Red Aid. Throughout his years undercover in Mexico, Vidali seems to have had two clear objectives which he pursued with his customary ruthless energy: the first was to fulfil his original mission of purging and redirecting the Mexican party; the second was to dominate, abduct and possess Tina Modotti. It took him two and a half years to achieve these two objectives. In 1927 Tina responded to his initial interest and encouragement by taking a rare photograph of Vidali. It shows a sinister figure casting a menacing shadow against a sunlit wall. Vidali is dressed in a black suit, dark shirt and black trilby with the brim turned down so that his eyes are hidden. He has a pencil moustache, and if he were to withdraw his right hand from his pocket one would expect it to be holding a gun.

When Vidali arrived in Mexico, Tina was still conducting her affair with another member of the Central Committee, the fresco painter Xavier Guerrero, with whom she had fallen in love after her brief involvement with Rivera. By December Vidali had got rid of Guerrero by persuading the Central Committee to send him to Moscow for three years' training at the Lenin School. Tina promised to remain loyal to Guerrero, but six months after his departure she began a secret affair, this time with Julio Antonio Mella. Vidali seemed to be back to square one, but throughout 1928 he continued to cultivate Tina, offering help to her brother, encouraging her to become an effective public speaker and authorising her to take up a very public position as a member of the Communist Party. In the absence of the silent and cautious Guerrero, Tina's apartment in the Zamora Building in central Mexico City became what Margaret Hook has described as "a radical salon" for progressive circles and an obligatory port of call for visiting sympathisers. From Moscow Guerrero wrote to her in alarm, warning her not to let her apartment be used

for "drunken parties" and reminding her that the party's enemies were watching her closely, looking for scandal. "Do not in any way draw attention to your home," he pleaded. But with Vidali's approval the parties continued, and in May he arranged for her to launch a public attack on the Mussolini government for having turned Italy into "one vast prison and cemetery," a speech which ensured that she was blacklisted by the Italian Embassy. At several public meetings Tina was accompanied on the platform by Diego Rivera, who had returned from Moscow in June. For the first time Vidali was able to assess Rivera's influence on the Central Committee.

In July 1928 Vidali left for Moscow in the company of Rafael Carrillo, the Mexican party's general-secretary, to attend the Sixth Congress of the Comintern. On their way through New York, Carrillo called on Bertram Wolfe and showed him photographs taken by Tina Modotti of Rivera's latest panel in the ministry of education. It was the picture variously known as *Insurrection, In the Arsenal* or *The Distribution of Arms*. Rivera, too, had been attending Tina's soirées and had met a young lawyer there called Alejandro Gómez Arias, who was accompanied by his former girl-friend, the twenty-one-year-old Frida Kahlo. It was in fact in Tina's apartment that Rivera found the cast for *Insurrection*. On examining the reproduction, Wolfe was struck by the central figure of Frida, so much so that he said to Carrillo, "Diego has a new girl." But the dramatic tension in this picture is provided by the closely grouped heads on the right. For just as Vidali had been watching and evaluating Rivera, so the painter had been returning the compliment. As an experienced seducer, Rivera divined the true nature of the relationship between Tina and Mella. In *Insurrection* he has placed them close together, gazing into each other's eyes. But Rivera seems to have noticed more than that. Just over Mella's shoulder, also gazing at Tina, is the expressionless face and sinister black trilby of the man known as "Enea Sormenti," alias Vittorio Vidali. This intrusion into her personal life was not appreciated by Tina. Her relationship with Mella was highly confidential; he was separated from his wife and daughter, and she was anxious that Xavier Guerrero should not be hurt by hearing rumours of her new affair. Rivera's indiscretion turned Tina against her former lover. She began to criticise his art, not admitting that it offended her but comparing it unfavourably with the work of Orozco. In September she wrote to Edward Weston saying, "I don't at all like his latest work" (that is, in the ministry of education). ". . . Recently Diego has taken to painting details with an exasperating precision. He

leaves nothing to the imagination." These comments mark an abrupt change from Tina's previous admiration for "a great artist."

It was also in September that Rafael Carrillo and Vittorio Vidali returned from Moscow with orders to implement the reorientation of the Mexican party. As far as Vidali was concerned, the immediate problem was Julio Antonio Mella. Mella was not only charismatic, young, handsome and energetic, but he was also a free spirit. He had proposed to organise an invasion of Cuba to overthrow the reactionary ruler General Machado. The Central Committee instructed him to abandon this plan, but in September Mella travelled to Veracruz in strict secrecy to prepare the invasion. The plan eventually had to be abandoned, but when the Mexican Central Committee discovered what Mella had done he was threatened with expulsion from the party. Mella resigned in a fury but later withdrew his resignation. Vidali then accused him of "Trotskyism," a dangerous charge at a time when Stalin was preparing to expel Trotsky from the USSR for "preparing an armed struggle against Soviet power."

Just before Mella left for Veracruz on his revolutionary mission, he wrote to Tina asking her to commit herself to him and she decided that she would have to sort out the situation with regard to Xavier Guerrero. By becoming involved with two members of the Central Committee at the same time, Tina had committed a serious impropriety which she had a duty to denounce. She therefore wrote to Guerrero on September 15, three days before writing to Weston to denigrate the work of Rivera. Having apologised to Guerrero, she had to confess her fault to a member of the Central Committee. Her chosen confessor was her protector, Vittorio Vidali. On Vidali's advice the Central Committee decided not to sanction her, and she was allowed to live openly with her new lover. But from Vidali's point of view, it was becoming imperative to do something about Mella. He was now obstructing Vidali's plans in two ways, by defying Stalinist discipline and by monopolising Tina Modotti. For those unconvinced by the accepted version of Mella's death, the following points are worth consideration.

The only person in Mexico City who knew of Mella's journey to Veracruz to organise the invasion of Cuba was Modotti. Shortly after Mella's departure Modotti confessed the truth about her relationship with Mella to Vittorio Vidali. Shortly after that meeting news of Mella's secret plans reached the Central Committee, and in due course the Cuban government. In the last months of 1928 rumours that General Machado intended to assassinate Mella were circulating in Mexico City.

The source of these rumours was unnamed agents of the Mexican party. On the night he was assassinated, Mella had a meeting with another Cuban exile called José Magriña, who "wanted to warn him about the secret arrival of Cuban government agents in Mexico City." Magriña was later accused of setting up this meeting in order to make it easier for Mella to be followed. Twenty minutes after leaving Magriña, Mella was shot dead in the street outside the apartment he shared with Modotti. A little earlier in the evening Mella had attended a scheduled meeting with Vidali. The gunman who shot Mella fired only twice from point-blank range. Despite the darkness of the street, Modotti, who was walking arm in arm with Mella at the time, was unhurt. After a false start when the Mexican police, following an unconvincing line of enquiry, tried to make it look as though Modotti, "a sexually promiscuous woman," had been an accomplice to the crime, the Mexican government intervened, dismissed the original police investigators and arrested Magriña. Magriña was questioned but released shortly afterwards, and no further arrests were made.

The conclusion of Mella's friends, following Diego Rivera's investigation, was that Mella had been shot by Cuban government agents working with the help of the Mexican police. But none of the Mexican Communists knew the identity or capacities of "Enea Sormenti." And in view of Vidali's subsequent notoriety as a Stalinist assassin who specialised in shooting his victims in the back of the head, it seems entirely possible that Julio Antonio Mella was killed on January 12, 1929, in the street outside Tina Modotti's apartment not by Cuban agents but by his comrade Vittorio Vidali.

What is certain is that within twelve months of Mella's death Tina Modotti, by then one of the most prominent expatriate Communists in Mexico, had been arrested and deported, and that Vittorio Vidali, by skilful use of false identities, was the only foreign Communist to escape the Mexican police dragnet. He slipped onto the same boat as Modotti and accompanied her to Europe, where, with his help, she evaded an attempt by the Italian government to arrest her. They went first to Berlin and then to Moscow, where they lived together.

With the disappearance of Mella, Vidali was free to concentrate on how to get rid of the second unpredictable element on the Central Committee: Diego Rivera. On the face of it, Rivera was a more vulnerable target. He had, after all, been sent home from Moscow in disgrace only six months previously. But he was nonetheless an internationally famous Communist artist. By early 1929 there had been recent exhibitions of his

easel painting in Los Angeles, Cleveland and New York. Ernestine Evans, the wife of a party member who was Tass's New York bureau chief, was at work on *The Frescoes of Diego Rivera,* the first book in English entirely devoted to Rivera's art. Furthermore, Rivera was a protégé of the party's general-secretary, Rafael Carrillo, who was not disturbed by his undisciplined personality and who considered him to be a considerable asset to the party. Notwithstanding these difficulties, Vidali succeeded in having Rivera expelled from the party by September 1929, and as in the case of Mella, personal reasons seem to have played a significant role in the course of events.

There was of course no shortage of political reasons for the expulsion of Diego Rivera. Whether or not the murder of Mella and the humiliation of Tina Modotti had been carried out with the complicity of the Mexican government, there were unequivocal signs of the extent to which the Mexican Communist Party was being marginalised by Plutarco Elías Calles as he pulled the strings of what was nominally Emilio Portes Gil's regime. In March the government declared the Communist Party an illegal organisation. But in April Rivera, instead of showing solidarity with his comrades, neatly altered course and danced several steps away from them by accepting the directorship of the Academy of San Carlos, a government appointment. Just as Rivera had dissociated himself from the muralists' union when the Obregón government started to dismantle his fellow muralists' scaffolds in 1924, so he now once again established separate lines of communication with his patrons in the regime. There was no open break with the party. Rivera continued to attend official functions and to speak. In April he and Siqueiros rode white horses into the plaza of the town of Tizayuca at the head of a Red Aid delegation. On May Day the stetson and great belly bursting through a broad leather belt were photographed by Tina on the march at the head of the delegation from the Union of Technical Workers, Painters and Sculptors. The trim young woman by Rivera's side is Frida Kahlo, the first photograph taken of them together. Shortly after the picture was taken the demonstration was violently attacked by agents provocateurs. Then, on May 15, a peasant leader was murdered in Durango. At the time Rivera blamed Mexican government agents, not knowing that the murder had occurred just after a secret meeting between the doomed and obscure union organiser and Vittorio Vidali. Beneath the surface the gulf between Rivera and the party widened steadily. In June government-inspired agents raided the party's headquarters, and in July Rivera accepted his most prominent official

commission to date: to decorate the main staircase of the historic National Palace in the Zócalo, probably the most prestigious site for a fresco in the whole of Mexico.

Rivera defended himself against critics of his "opportunism" by arguing that he was propagating Communist ideas and increasing the party's influence. At San Carlos he introduced a new curriculum which was both idealistic and brutal. The students suddenly found that they were expected to become industrial apprentices for three years during the day and to pursue their studies at night. That would be followed by five years of advanced day and night study. The only consolation was that in future all decisions made by the professors had to be approved by student vote. Everyone would, of course, be working a seven-day week. The new director's timetable was very different from the one he himself had followed as a student. The unlikely inspiration for this new scheme, according to Rivera, was the training undergone by Leonardo da Vinci in Florence in the fifteenth century. But this was not enough to recommend the new curriculum to the students. Led by the conservative Academy of Architects, the professors of San Carlos began to organise a determined line-by-line campaign against their new director's innovations. At first Rivera, who had the necessary government backing, won easily, but the professors, having nothing else to do, gradually wore the director down; and apart from finding a daily argument tedious, he had several other preoccupations. The first of these was to work out a scheme for his major new mural in the National Palace.

In July 1929, the first of Rivera's sketches was transferred to the north wall of the Palace staircase. He had found a completely new theme which was a response to his disappointment in Moscow and which would dominate much of his best work from here on. On the great staircase of the National Palace in a total space of 176 square metres Rivera, in three separate murals, began to paint an allegory of Mexican history, the official myth of the Mexican people. It was to be a Marxist interpretation of history, a "scientific" portrayal of Mexico's past, starting with Quetzalcóatl, the plumed serpent, representative of the Aztec deities, then moving on to the destruction of the Aztec world, the Spanish Conquest, the colonial era, the taking of national independence from Spain, the U.S. invasion of 1847, the French intervention, the execution of Maximilian, the Porfirian era, the Revolution of 1910 and the contemporary exploitation of the Mexican people. The final panel would depict the armed uprising to come and the figure of the bearded sage Karl Marx, balancing that of the plumed serpent and pointing the inevitable way forward, to the

future! It was hard to see what the Central Committee could find to quarrel with in all that, and in fact Rafael Carrillo found nothing to quarrel with and continued to regard Rivera as a revolutionary painter.

Faced with Rivera's reputation and solid support among an important element of the Central Committee, Vidali might have failed to arrange Rivera's expulsion before he himself was forced to leave the country had he not received help from an unexpected quarter: the artist himself. For it was while he was starting work at the National Palace that Rivera also agreed to adorn the Art Deco conference room of the ministry of health and social welfare with six bouncing nudes. The new sensuality in his painting is evident in this series of frescoes whose theme was, naturally, "Health." The six female figures represented "Life," "Health," "Continence," "Strength," "Purity" and "Knowledge." "Continence" is throttling a serpent which is gliding between her legs. Among the models Rivera used were Cristina Kahlo, younger sister of Frida, and Ione Robinson, a handsome, blonde nineteen-year-old, a U.S. art student who had been sent on a Guggenheim scholarship to work as Rivera's assistant. Cristina was the model for "Life" and "Knowledge"; Ione Robinson was the original of "Purity" and "Strength." Whether or not Rivera seduced Cristina Kahlo at this time, he is known to have started an affair with Robinson, who also accompanied him regularly to work on his scaffold at the National Palace. At the same time Rivera had started a more serious affair with Frida Kahlo, to whom he owed the protective consideration due a younger comrade.

The spectacle of Rivera's sexual recklessness was watched with concern by Tina Modotti, who felt responsible both for Frida, whom she had introduced to Rivera, and to some extent for Ione Robinson, who had been her guest when she first arrived in Mexico. Tina had helped Ione to unpack her cases, and the latter, in a memorable phrase, described how Tina "looked at each dress like a nun who has renounced all worldly possessions." Rivera may even have seduced Robinson in Modotti's apartment, a possibility that outraged another North American comrade named Joseph Freeman, who was himself in love with Ione. Freeman, who was also a Comintern agent, had arrived in Mexico earlier in the year to assist Vidali, his cover being Tass correspondent in Mexico.

Tina Modotti and Ione Robinson soon became confidantes—Tina having shown her the letters which she had received from Mella—and the information Tina extracted from Robinson about Rivera's behaviour enabled her to arouse Freeman's jealousy. This worked so well that Freeman threatened to shoot Rivera, but Tina suggested that a more effective

way for a well-informed man such as a Tass correspondent to put Robin-
son off Rivera would be to tell her that Rivera had gonorrhoea. In any
event, Vidali, who needed an ally motivated to work fast against Rivera,
now had one.

In July 1929, the month when Rivera started work on the walls of the
National Palace and seduced Ione Robinson, the Mexican Communist
Party held its annual conference, scene of the initial battle between the
Stalinists, led by Vidali, and their enemies, who were classified as either
"bourgeois collaborators with a reactionary government" or "Trotsky-
ists." Following the conference Joseph Freeman was appointed to head a
committee investigating Rivera's position vis-à-vis the party. Freeman's
work was made more difficult when Rivera's early work in the National
Palace was publicly attacked by conservatives for showing Communist
tendencies, which was undoubtedly true—Rivera's first panel on the
north wall depicts "the class struggle" in Aztec society. Nonetheless, Free-
man eventually provided Vidali with a report which accused Rivera not of
Trotskyism but of "associating with the minister of agriculture," a seri-
ous offence since the minister was a former revolutionary called Ramón
de Negri. Rivera was also accused of opposing the party line on establish-
ing Communist trade unions, of opposing the party's calls for an armed
peasant uprising and of making unfraternal statements that "he trusted
no one." There was enough in the report for Rivera's name to be added to
the list of those who were to be expelled, a step which was approved by
the Central Committee on September 17. And thanks to the speed at
which Freeman worked, Vidali was able to ensure that the matter was dis-
cussed at a time when Rivera's chief ally, Rafael Carrillo, was absent in
Cuba.

There is a wonderful story about the expulsion of Rivera which
appears in Hayden Herrera's biography of Frida Kahlo. According to this
tale, Rivera expelled himself. Upon arriving at the Central Committee
meeting, he sat down, took out a large pistol, placed it on the table and
said, "I Diego Rivera, general-secretary of the Mexican Communist party,
accuse the painter Diego Rivera of collaborating with the *petit bourgeois*
government of Mexico . . . therefore the painter Diego Rivera should be
expelled by the general-secretary Diego Rivera." Rivera then picked up
the pistol and broke it in two since it was made of clay. There are several
problems with this story, the first being that Rivera never was the general-
secretary of the Mexican Communist Party. Second, he did not, accord-
ing to Bertram Wolfe, attend the meeting at which he was expelled. The
source of the story, a young radical law student, Baltasar Dromundo, was

not a member of the Central Committee either. So it seems that the most likely originator of the story of Diego Rivera expelling himself from the Mexican Communist Party must once again be the fertile imagination of Diego Rivera.

Among the first to rejoice was Tina Modotti, who heard the news the day after the committee meeting and immediately wrote to Edward Weston, exulting in it. "I think his expulsion will do him more harm than it will do to the party," she wrote. "He will be treated as what he is . . . a traitor. Needless to say I too will regard him as one and from now on will limit my contacts with him to our photographic transactions." Tina also emphasised that Rivera had not been asked to stop painting by the party but had been asked to sign a declaration that his official work would not "prevent him from fighting the current reactionary government." This was a characteristically agile and dishonest way for the Central Committee to obscure what had actually happened. It would clearly have been impossible for Rivera to continue painting the walls of the National Palace while openly supporting a party that was calling for an armed insurrection. And his unique contribution to the Revolution was as a painter, not as an orthodox apparatchik.

Tina Modotti has been reproached with ingratitude in withdrawing her friendship from Rivera when he was expelled from the party. But in fact there had been very little friendship or mutual regard between them for over a year, since the time when Rivera had literally plastered her private life all over the walls of the ministry of education. Tina, the high-spirited unconventional girl who had arrived in Mexico in 1923, had long since been replaced by Modotti, an earnest revolutionary increasingly under the influence of Vidali, whose attitude towards Rivera was conditioned by the latter's cavalier treatment of younger comrades such as Frida Kahlo, by Rivera's unreliable response to party discipline and by the personal grudge she bore him. In any event, it seems clear that if Rivera's expulsion from the Mexican Communist Party formed part of a world-wide struggle between Stalinists and their party opponents, its timing and execution were partly a consequence of his tumultuous sex life, and that Tina Modotti played a small but significant role in his downfall.

Joseph Freeman obtained only moderate satisfaction for his efforts. His suggestion of gonorrhoea having failed to discourage Ione Robinson, Vidali arranged for her to be summoned by the Soviet ambassador and warned against continuing to work with Rivera; her decision to ignore this threat was made easier by the fact that she was not actually a party member. Rivera had a more traumatic reaction to the event. He suffered a

nervous breakdown which he claimed was due to "overwork." But his work had been relatively light for most of the year, and his illness was in fact due to the shock of his expulsion. The cause he had embraced seven years earlier, for life, when he returned from his first visit to Tehuantepec knowing that he had both a message for the world and the means to pass it on, had rejected him. Rivera never reconciled himself to his expulsion from the Communist Party, but what seemed at the time to be a personal disaster was, from the point of view of his art, an immense stroke of good fortune. And while recovering from his breakdown he was not alone. On August 21 he had married Frida Kahlo. Tina Modotti, on hearing the news, had a characteristically caustic reaction: "Let's see how it turns out!"

MARRIAGE TO FRIDA

Mexico 1929–1930

I T IS NOT CERTAIN when Rivera and Frida Kahlo first met. She said that she approached him soon after she was able to walk following a serious accident in 1926; he was working on the scaffold at the ministry of education and she asked him for his opinion of her painting. There is a sketch made by him of Frida Kahlo dressed in Tehuana costume and dated 1926 which, if the date is correct, confirms Frida's story. Lupe's early memories of her eventual successor were "very disagreeable." She did not like to see "this so-called youngster drink tequila like a real mari-achi." She also places the meeting at around 1926.

Rivera tended to favour a version in which Frida became obsessed with him four years earlier, when she was aged fifteen. Sometimes Kahlo embroidered this version, claiming to have disrupted his work, stolen his lunch when he was at the top of his scaffold, spied on his meetings with his models and told her friends that she would in due course bear his child, once she had "persuaded him to co-operate." Her school friends regarded the thirty-six-year-old artist as "a pot-bellied, filthy old man." But Frida called him "Fatso" and fell in love with him. Generally, she remembered their initial contact as a meeting between a young artist and a master who offered her immediate encouragement. He remembered her as one among a group, a girl who emerged from among a haze of admirers and imposed herself on his attention. But whenever the meet-ing took place, they only got to know each other properly on his return from Moscow in June 1928, at a party in Tina Modotti's "radical salon." Frida said that Rivera pulled out a revolver and shot a hole in the phono-graph, and that after that her fascination with him overcame her alarm.

Frida Kahlo was twenty years younger than Rivera, born on July 6, 1907, daughter of a German-Jewish father and a Spanish-Mexican mother, in the Casa Azul, a pleasant house in the pleasant suburb of Coyoacán. She was christened Magdalena Carmen Frida, brought up in a conventionally Catholic family home and sent to the German school in Mexico City. There are photographs taken of her at the time wearing a plaid skirt, a neat blouse and a sailor hat. Her mother, Matilda, gave birth to four daughters and never raised a son, although she always said grace before meals. Her father Guillermo, from whom Frida inherited her creativity, was an atheist.

Frida's father was a wanderer and an unlucky man whose health was ruined by an accident he suffered when he was a student. Born in Baden-Baden in 1872, the son of Hungarian-Jewish parents who ran a jewellery shop which also sold photographic equipment, he eventually entered Nuremberg University but never completed his studies after a serious head injury left him an epileptic. His mother died, his father remarried, he could not support the presence of his stepmother, so his father gave him a ticket to Mexico and wished him luck. He arrived penniless, aged nineteen, in 1891, changed his name to Guillermo and, thanks to family contacts, took a job in a jewellery shop. He married, had two daughters, then his wife died in childbirth, so he remarried at the age of twenty-eight, this time to a fellow assistant in the shop.

His second wife, Frida's mother, was Matilda Calderón y González, born in Oaxaca, oldest of the twelve children produced by the union of Isabel González, daughter of a Spanish general, and Antonio Calderón, a Mexican Indian photographer. On his remarriage to Matilda Calderón, Guillermo Kahlo sent his two older daughters to a convent (his first wife, too, had been Catholic), left the jewellery shop and, using his Indian father-in-law's equipment, set himself up as a photographer. In 1904 he received a valuable commission from the Díaz government to travel round Mexico recording the country's architectural heritage as part of the forthcoming centenary celebrations of Mexican independence. That an obscure member of the immigrant German community should have been awarded this contract, involving four years' work, on the basis of talent alone, is surprising, and the decision must have been affected by his wife's Spanish connections in Oaxaca, home state of both her grandfather the general and of Porfirio Díaz. Señor Kahlo's contract was signed by José Ives Limantour, Díaz's *científico* financial genius, the treasury secretary who had balanced the budget. The architectural heritage contract

led to other work; Kahlo also made portraits of Porfirio Díaz and his family, and he was able to build the comfortable Casa Azul.

Guillermo and Matilda proceeded to have four daughters. The birth of the third, Frida, was not registered for a month, and the baby was suckled not by its mother but by an Indian wet-nurse. A year before Frida's birth her mother had given birth to a much-wanted son, but the boy had promptly died. Eleven months later her younger sister Cristina was born, and after that her mother had no more babies.

Although she felt neglected by her mother, Frida Kahlo grew up in a moderately privileged household sheltered from the worst effects of the Revolution, which broke out when she was aged three, lasted till she was aged thirteen and cost over one million lives. Her father was effectively ruined by the fall of the Díaz regime and the turbulence that followed, but he struggled on, scraping a living and earning enough to keep the family together. If her father always spoke Spanish with a strong German accent, she herself was bilingual and in addition learnt to speak and write good English. At the age of six she was partly crippled in her right leg and polio was diagnosed. She was tormented by other children who called her "Pegleg." But her father encouraged her to lead an athletic, tomboyish life, and she eventually appeared to make a good recovery.

When she was aged fifteen, in 1922, her parents sent her to the elite National Preparatory School, where she became one of only thirty-five girls among two thousand pupils. Why her parents took this unusual step is not clear. Rauda Jamis suggests that Guillermo wanted her to escape the religious influence of the German school. Certainly her father, who was proud of her intelligence, wanted her to have the sort of education he had been forced to abandon. Frida told a friend years later that her mother agreed to the move after discovering compromising letters from the gym mistress at the local school.

Frida Kahlo was born with an independent, unconventional nature and this flourished at the Escuela Preparatoria. Her arrival coincided with the period of violent student unrest over Vasconcelos's mural project when her fellow students attacked the walls of the public staircases and courtyards. Kahlo herself became a highly disruptive student who was briefly expelled. In 1923, when she was aged fifteen, her father gave her "a good thrashing" after she had been fighting with her sister Cristina, and she was known for her fierce temper. Despite her occasional claims to have been a precocious atheist, she remained a devout enough Catholic to go on retreat at the age of sixteen, when she described the priest as "very

intelligent and almost a saint" and when she prayed hard for her sister and her boyfriend. Three years later, just before she joined the Communist Party, she sometimes wore a silver cross around her neck.

When she was aged seventeen, trying to earn some extra money, Frida took a job as an apprentice engraver with a friend of her father's who taught her to draw and seduced her. She was also seduced by a female librarian at the ministry of education and shortly afterwards posed for a family photograph taken by her father wearing an elegant gentleman's three-piece suit.

In September 1925 Frida Kahlo suffered terrible injuries in a traffic accident which were to affect her for the rest of her life. In a collision between a bus and a tram she was impaled by an iron handrail that pierced her pelvis, and she suffered multiple injuries including three spinal fractures and eleven fractures of the right leg and a crushed right foot. She started to paint during the long convalescence that followed. She had to withdraw from university, as her father had done, and abandoned her hopes of becoming a doctor. Her father did not have enough money to pay for all the treatment she needed after the accident. Her mother offered a retablo in thanksgiving for her recovery, and a mass.

In the early days of her acquaintance with Diego Rivera, Frida Kahlo was devoted to a former school friend, a brilliant young man called Alejandro Gómez Arias. In 1924 and 1925 Frida was still in love with Arias, who no longer returned her passion, having reproached her with infidelity and promiscuity. In reply she begged for his forgiveness and his love and pleaded with him not to abandon her. Her letters at this period show a girl who was adventurous and reckless, especially when drunk, but who was looking for someone to lean on, someone to whom she could look up. She laments the fact that she has lost her "reputation"; she promises to be good in future; she yearns "to be put into Alejandro's pocket"; she wants to marry him so that she can be "almost made to order" for him. The letters go on for months, far longer than one might expect of a girl aged eighteen writing to her first boyfriend after their love affair had broken up, and they show that the highly visible, independent nature of this girl's character masked a deeply dependent emotional tendency.

As her dependency on Gómez Arias gradually lessened, Frida became a close friend of Tina Modotti and under her influence joined the Young Communist League, a move which placed her among the élite of her generation as far as the politically committed community of Mexico City were concerned. Encouraged by Tina, Frida abandoned the smart, bourgeois clothes that she had favoured and took to wearing the severe uni-

form of a Communist nun, the sort of clothes Rivera showed her wearing in *Insurrection:* plain black skirt, plain red blouse with dark red star. Frida at the age of twenty had shifted her commitment and her dependency to the party; it was a relationship that was to last for much of her life.

It is far from clear why Diego Rivera should have decided one day in 1929, aged forty-two, to marry Frida Kahlo, aged twenty-two. That he should have been attracted to her is less surprising. She was high-spirited, funny, lively and uninhibited. She was a member of the Mexican Communist Party, committed to the same ideals as he was, a member of the same élite circle, and he must have been flattered that such a young woman was taking a serious interest in him. From the start he was impressed by her ability as a painter. But none of this explains why a man who had been married and separated three times already, with three small dependent children living on two continents, should have been tempted to try the experiment once again. Hayden Herrera states that Frida was pregnant at the time of her wedding. But if Rivera knew of this, it would have made their marriage even more surprising. The prospect of fatherhood never bound Rivera closer to women. He had abandoned Angelina during her confinement, and when Angelina's son died he returned to her. He had subsequently abandoned Marevna during her confinement, and again after she had given birth to Marika. He had started an affair with Tina during Lupe's second pregnancy. Rivera was, if anything, repelled by babies and fatherhood and attracted by the lack of them.

But was Frida Kahlo pregnant on her wedding day? The source for this suggestion is a letter to Kenneth Durant, the Tass bureau chief in New York, dated September 30, 1929, and written by Joseph Freeman. Since Freeman was writing two weeks after Rivera's expulsion from the party, since that move had been based on Freeman's report, since Freeman had been spreading malicious rumours that Rivera had gonorrhoea, and had been threatening to shoot Rivera, since Freeman had no direct access to either Rivera or Frida, and since Tina Modotti had also cut her links with Rivera, there seems no reason to believe the story. The tone of Freeman's comment is sneering: "She [Frida] is already, at this early stage in the happy union, pregnant." Strictly speaking, Freeman is not even claiming that Frida was pregnant at the time of her wedding, which had taken place over five weeks before his letter, although that is clearly the implication. But even if Freeman's letter is credible, it seems that no one would have expected the pregnancy to have resulted in a baby. Frida herself was convinced that following her accident and the damage to her pelvis, she would never be able to carry a child to term. In a complete

medical history taken in 1946, Frida stated that she had become pregnant in 1930 during the "first year of her marriage." This pregnancy had ended at three months in an abortion carried out by Dr. J. de Jesús Marín, Lupe's brother, "because of a malformed pelvis." According to the medical history, this was her first pregnancy, and there was no pregnancy in 1929 at the time of her wedding, contrary to the impression Frida gave in a newspaper interview that appeared four weeks before her death. If anything, Rivera would have been prepared to marry Frida Kahlo not because she was pregnant, but because she could never give birth. He had found the ideal wife. She *was* going to have a baby, but the infant was twenty years older than she was, he would tolerate no rival babies, and he already weighed 250 pounds. The wedding photographs show a huge, fat-bellied man dressed like a western sheriff with stetson in hand towering above the brittle, fierce little figure of his bride.

Before the wedding Frida's father, the photographer Guillermo, who had a blunt way of putting things, warned Rivera that his daughter was sick and would always be an invalid, and that furthermore she was "a concealed devil," and he repeated the phrase *un demonio oculto*. Nonetheless, if Rivera persisted in his mad scheme, then Kahlo gave his permission. This was the third time that Rivera had been warned against a woman with whom he was about to become closely associated; it was a ritual he found irresistible. Frida's mother, who was a devout Catholic, was appalled that her fiery daughter was marrying "a fat Communist" twice her age, but her father was less alarmed about the fate of his favourite child. Rivera was regarded as rich and Kahlo knew Frida would always have high medical bills. Shortly after their wedding Rivera paid off the mortgage on the Kahlo family house in Coyoacán, where he had courted Frida, while arranging for her parents to continue living there. From the start everyone expected the marriage to be lively. Rivera had been conducting numerous affairs in the months before the wedding, and was also attracted to Cristina Kahlo. The ceremony, conducted by a prominent *pulque* dealer who happened to be the mayor of Coyoacán, was followed by a rowdy and extended party. Lupe Marín turned up and insulted the bride; one of the revellers remembered that at one time everyone found themselves on Tina Modotti's roof terrace, which was festooned with underwear hanging out to dry; Rivera got drunk, drew his pistol and fired, breaking a man's finger; Frida burst into tears and went home to her parents. Fiesta!

The month after his wedding, having been expelled from the party, Rivera suffered his nervous collapse. He was afflicted with uncertainty as

to what form his painting should now take. And one of the disadvantages of leaving was that you lost all your friends. Frida loyally resigned at the same time, although it cost her a lot to do so, but the attitude of most of Rivera's comrades was summed up by the reactions of Comrade Freeman and Comrade Modotti. Fortunately for Rivera, help was at hand.

§ § §

IN OCTOBER 1929, one month after his expulsion, Rivera received a commission which, in the eyes of his former comrades, was the clearest confirmation of his political treachery but which solved his perplexity about what to paint. He was invited by the U.S. ambassador to Mexico, Dwight W. Morrow, to decorate a loggia in the Palace of Cortés in the town of Cuernavaca. He was to be paid $12,000 for the task. The Cuernavaca mural was to be a gift to the people of the state of Morelos from the people of the United States, and its theme was to be the history of Morelos. This suited Rivera since it fitted well with the anti-colonial themes he had already started to work on in the National Palace. The decoration of the National Palace was a huge project which Rivera was never to finish, even though he struggled with it intermittently for over twenty-three years, whereas with the loggia in the Palace of Cortés at Cuernavaca, Ambassador Morrow had presented him with the perfect site for a fresco: a gallery rather over four metres high, whose paintable length was thirty-two metres, facing east, with its western arches open to the air, built like the exercise gallery of a Renaissance palace, and looking out over the ravines and woods and hills surrounding the town. Cortés had captured the Aztec town of Cuernavaca on his way to attack the capital, and it remained his favourite town and the one where, of all the towns he had taken in the name of the King of Spain, he chose to live.

Rivera started work in Cuernavaca on January 2, 1930, and signed the final panel on September 15. He worked on this fresco with such concentration that he neglected his work on the west wall of the National Palace, where he was under steady attack as "a Communist" from the increasingly confident conservative circles in Mexico City, oblivious to the news of his expulsion. At the same time his former comrades in the party kept up their attack on him for his "opportunism," and in San Carlos the professors attacked him from both sides at once. In April Rivera fought back, answering a crescendo of public criticism with a spirited press release underlining the importance of architecture for all arts students. He left Cuernavaca for a few weeks, alarmed by threats from the architec-

tural students who planned to wreck his work in the National Palace. He
went down to his scaffold wearing crossed cartridge belts and two pistols,
and his assistants again found that their duties included mounting an
armed guard. But although he was able to defend his fresco, he was
unable to defend his position at San Carlos. He had few allies in the
school, and none of his enemies were simultaneously trying to paint two
major frescoes. He was defeated at a council meeting in May and forced
to resign. But he had a powerful consolation in Cuernavaca. The Mor-
rows had lent their house to Rivera and Frida for most of the year, so he
retired there and devoted himself to reforging the history of Morelos.
Cortés's palace was solid evidence of the splendour and triumph of
Spain. By his painting Rivera would show what the cost of the triumph
had been; he would turn a monument to the Spanish victory into a
memorial of the Indian defeat.

The dream Rivera painted in Cuernavaca shows a battle between
armoured Spaniards and the Mexican "Jaguar" knights with their cotton
armour, animal masks and brittle obsidian blades. It is a struggle between
carnival costumes and brute force. It also shows the Spaniards crossing
the town's famous *barranca* by means of a tree trunk, though it is not
made clear that this way in was discovered through the treachery of local
Indians. Once he had shown the city being taken, Rivera turned to its
reduction and forced conversion to Christianity. The Indians are roped
and branded; Cortés counts his gold. Then we see the Indians being
lashed into constructing Cortés's palace—that is, the construction of the
very wall on which the fresco is painted—and being lashed again on a
sugar plantation in the state of Morelos, where the familiar figure of the
leather-booted planter, last seen on the staircase in the ministry of educa-
tion, takes his ease on his porch in his Indian string hammock. The Indi-
ans have lost their gorgeous raiment with their system of beliefs, and
have become animals, beasts of burden. The penultimate panel is entitled
The New Religion and the Holy Inquisition. Dominican and Franciscan friars
accept offerings of precious stones while in the background Indians wear-
ing the Inquisition's sinister dunces' caps dangle from gibbets or burn in
front of the churches. The Aztec pyramids, where their enemies were sac-
rificed alive, have been replaced by the execution pyres of the Holy
Office.

The depiction of the Spanish missionary priests led to the only dis-
agreement between Rivera and his patron. Ambassador Morrow had
been instrumental in organising the *Arreglos,* signed between the Vatican
emissaries and the Mexican government in June 1929, which were sup-

posed to end the *Cristero* uprising. As a result of this treaty, the Mexican hierarchy agreed to reopen the churches and the *Cristero* guerrillas were to be given an amnesty. The Church kept its word; the government did not. Priests who left the guerrilla, obeying their bishops' orders, were promptly executed. Many state governors continued the persecution, burning churches, hunting down priests, and destroying Christian images in private houses. The last thing Morrow wanted, faced as he was with the dissolution of his carefully negotiated treaty, was a further justification for the persecution of the Church on the walls of the palace in Cuernavaca, and he asked Rivera if he could show "at least one kindly priest." Rivera responded in a characteristically ingenious way. He showed Fra Toribio de Benevente, a friend of the Indians, known as "Motolinia" (the One in Rags), but placed him in a context which suggested that the policy of the Church was to teach the Indians gentleness in order to make them easier to exploit. In a series of grisaille beneath the main panels Rivera continued his cynical account of Church activity: Bartolomé de Las Casas protects Indian women and children while a bishop blesses the destruction of their temples. In the final panel Rivera executed one of his most successful and celebrated frescoes: the *peones* have risen; a white-clad figure, Zapata, with sugar-cane cutter in hand, holds the riderless horse of his dead master; beneath the horse lies the body of the rider—the cycle which opened with the jaguar knight astride the fallen conquistador is complete.

To be able to retell the history of the Conquest, and to redefine Mexican identity on the walls of the palace which the conqueror had imposed on his subject people, was, for Rivera, the culmination of everything he had set out to achieve since he had first gazed on the work of Masaccio in the Brancacci Chapel in Florence and seen what the word "fresco" meant in the hands of a master of space, volume, colour and light. In Cuernavaca Rivera achieved his most perfect fusion of fresco and building. Cortés had erected this palace in the conquered town as a symbol of his dominion. But under Rivera's brush, the ghosts of the dead Aztecs of Morelos walk in triumph on the walls of the conquistador's stronghold. In Cuernavaca Rivera discovered the theme that was to mark his work more than any other; he Mexicanised his Communism and detected the key to his own identity as a painter and as a man, and it lay in his treatment of the Mexican Indians. Rivera, whose Indian mother had been "so much taller, so much more beautiful" than his real mother, who did not have to deny the rejection of his mother because he had accepted an Indian mother instead, invented in Cuernavaca a mythological past for

his mythological mother. In the National Palace he had shown the betrayal of the Indians by their god. Quetzalcóatl is abandoning his people, flying away from the Fifth Sun, our life on earth today. Once they were betrayed by Quetzalcóatl, the conquest of the Aztecs became inevitable, and in Cuernavaca Rivera showed what the consequences of that betrayal had been for the people who lived in the town before the gallery was built. Cortés was not the destroyer of the gods, he was merely the person who established that they had departed. The Indians were no longer the pre-Marxist proletariat of Mexico; the Mexican Communist Party which had expelled him was in error, its analysis was inadequate. The Indians were the usurped believers, a dispossessed people. Rivera's alternative analysis was as much nationalist as socialist. And if Rivera's new religion had rejected him, if he had been betrayed, as had the Aztecs, by his God, then he would, by reinventing the Indian past, bring them back to life. He regenerated the Indians with his own creative force; he became therefore not just their immortaliser but the successor to the Aztec kings. For Frida, watching this metamorphosis with interest, the implication was clear. She, daughter of a devout mother and freethinking father, abandoned the uniform of a Communist nun and identified herself as the wife of the reincarnation of an Aztec noble; she adopted the dress of a Tehuana Indian.

It was in Cuernavaca that Frida first assumed her role as an essential accomplice in Rivera's creation of an "ideal" Indian world. The celebrated Tehuana personality which she was to develop in her painting was an invention of her husband's; he bought her native clothing and ornaments, and to please him she wore them. As time passed, this costume became an integral part of her personality, though initially she wore it uneasily, like a woman uncertain of herself in fancy dress. But what started as fancy dress grew into a permanent fantasy. What started as high-spirited complicity—"You have a dog's face," he told her when she was posing for *Insurrection;* "And you have a frog's face," she replied— grew into a deeper, subconscious union. Psychologically they were well matched. Both were children of strong fathers whom they revered. Both their mothers had lost a son and withdrawn their attention thereafter. Both tended to belittle their mother's strong religious beliefs. But whereas Rivera rejected his mother, Frida Kahlo, contrary to the view of her friend Lucienne Bloch, loved her mother and showed it openly. Rivera repeatedly replaced his mother with his wives or mistresses and then rejected the replacement, so revenging himself on the proxy of the mother who had rejected him. And Rivera chose his proxy mothers well,

because they did not retaliate. Bertram Wolfe once had the surreal experience of calling on one of Rivera's former mistresses and finding four of Rivera's other women—Frida, Lupe, Angelina Beloff and a fifth woman, probably Cristina Kahlo—all in the room discussing him in amiable terms, and all agreeing, as mothers will, that he was essentially "a child."

Although Frida Kahlo was psychologically so well matched with her husband, she was never, unlike her three predecessors, Rivera's muse. He painted Frida infrequently, whereas Lupe continued to be an inspiration for his art even after their divorce. He had painted a beautiful portrait of Lupe, in encaustic, in 1926, just before their initial separation, and he used her once again as a model in 1927, just before his departure for Moscow when their relationship was at its lowest ebb. When Lupe realised that, as a muse, Frida would never be her rival, and that Rivera would go on supporting her financially, she made friends with the younger woman, taught Frida to cook the vegetarian food Rivera loved, and made it possible for her brother to act as Frida's doctor. And in 1930, within a year of her wedding, Frida, too, painted Lupe's portrait.

So, redreaming the history of Cuernavaca, Rivera passed the summer of 1930 happily, rising early and going down to Cortés's palace, working all day, returning late at night to dine with Frida, who had earlier brought him his lunch in a basket. The Morrows' villa, called the Casa Mañana, had an extensive walled garden, and Cuernavaca was a pleasant place to spend the first year of a new marriage. In the days of the Aztecs it had been associated with Xochiquetzal, the goddess of love. It was here that the Emperor Maximilian built his summer palace, what his valet called "the pleasure-house" because of the amount of time he spent there with Carlotta. One visitor remembers picking up Rivera at dusk from his scaffold, going to a restaurant, ordering a bottle of tequila and eating and drinking late into the night, night after night, while Rivera invented the most extravagant and magical stories about every subject under the sun. Perhaps it was here that Rivera first divined the intimate relationship that sprang up between the Empress Carlotta and his own uncle Feliciano, alias Coronel Rodríguez. And in Cuernavaca Rivera found time to execute the only nude he ever made of Frida: a pencil drawing of her undressing as she sits on the edge of a bed.

She faces the artist, her back straight, her eyes modestly averted, her arms raised to undo the heavy native bead necklace that is all that is left of her new Indian identity. The lithograph that Rivera made from his original pencil sketch of Frida contains an erotic charge which is increased by the evident inexperience of the model. But there is also something sacrifi-

cial about it, in her resigned, submissive attitude, something almost masochistic, that is leagues away from the mischievous expectation that saturates Modigliani's outstretched nudes. This ominous, slightly menacing note was deepened when Rivera chose to overprint the lithograph of Frida with another print, a self-portrait made at the same time. In the double print the thin, stretched body of the artist's wife emerges through the steady, unsmiling gaze of the great frog face of the artist. Instead of throwing this double print away, Rivera kept it, and it gives us an alarming record of his own view of his initial relationship with his new wife. In portraying Frida nude, he was acquiring her, placing her on a pedestal that would never have a permanent occupant. In 1930, the year when he lived his idyll in Cuernavaca with Frida, Rivera continued his affair with Ione Robinson during his visits to the scaffold in the National Palace in Mexico City, and also found time to enjoy a relationship with a new model whose portrait he made into a rather similar lithograph engraved on the reverse side of the same plate and entitled *Nude of Dolores Olmedo*. It is unlikely that Frida would have been ignorant of these affairs. And she would have been particularly disconcerted by the second lithograph, since Dolores Olmedo really was from Tehuana.

But that was Mexico City. In Cuernavaca, at least, Frida had Rivera to herself, for perhaps the only time in her life, as they worked together to construct their joint imaginary world. And as they revelled in their pleasure house and glorified Zapata, in the hills outside the town the disarmed *Cristeros* were being hunted down by government troops. If one wished to identify the exact moment when Rivera stopped painting history and started painting myth, when his vision became a waking dream, one could say that it was in Cuernavaca when he painted the Spanish priests persecuting the Indians at just the time when, in the pueblos outside the town, *Cristero* peasants, descendants of the Indians, were dying to save the plaster statues of their saints.

NORTH OF THE BORDER

San Francisco, Detroit, New York 1930–1933

I N NOVEMBER 1930, one week after finishing work at Cuernavaca, Diego Rivera went on what he intended to be a brief escapade north of the border. He had been commissioned to execute two frescoes in San Francisco, work which he thought he would be able to carry out during the winter of 1930–31; after which he was contracted to return to Mexico City to complete the frescoes he had started on the main staircase of the National Palace. He had received permission from the president of Mexico, Pascual Ortiz Rubio, to absent himself for the space of a few months.

His visit to San Francisco had been proposed by the sculptor Ralph Stackpole, who had known him briefly in Paris and who had been among the warmest admirers of his work in the ministry of education. Stackpole, himself a San Franciscan, had persuaded William Gerstle, president of the San Francisco Art Commission, to put up $1,500 for Rivera to execute a small fresco of 120 square feet in the city's School of Fine Arts as early as 1926, but there were many obstacles to be overcome before the scheme could be implemented. Preliminary enquiries from Rivera showed that in 1929 the U.S. State Department was determined to deny him a visa. Rivera was indignant, despite his anti-American political record: he had been one of the most active members of the "Hands Off Nicaragua" Committee, which had exhibited the flag of the 47th Company of the U.S. 2nd Marines after its capture by Augusto César Sandino's forces in May 1928. But by 1930, following Ambassador Morrow's commission and his expulsion from the Mexican Communist Party, Rivera had become "a henchman of the Yankee millionaires" in Mexican Communist rhetoric and was therefore *persona grata* north of the border. In September that year Ralph Stackpole persuaded the architects of the new

Pacific Stock Exchange building to commission Rivera to paint several frescoes on the staircase of its Luncheon Club for the sum of $2,500. This was at a time when his oil paintings of Indian flower-sellers were going for $1,500 each, so the fee offered was far from excessive. Nonetheless, the announcement caused a small storm of protest in San Francisco, partly from jealous native artists and partly from those who objected to the city's Stock Exchange being decorated by a known "Communist and Revolutionist," but the directors of the Pacific Stock Exchange were equal to the occasion, and the visit went ahead.

Rivera's first six months in San Francisco, in strong contrast to his Moscow experience, were a professional and personal triumph. The visit which had started under a cloud soon became a series of celebrations of Rivera's presence in the city as people responded to his charm. Rivera in his turn was entranced by San Francisco, which he regarded as one of the most beautiful cities in the world. He had previously only glimpsed the United States from the train which had taken him to the pier in New York on his way to the Soviet Union in 1927. Now he was overwhelmed by the natural splendour and material wealth of California and greatly attracted by the generosity and openness of his hosts. His arrival was marked by a one-man show at the Palace of the Legion of Honor, and there were further exhibitions of his work in Los Angeles and San Diego. Rivera lectured widely in French and Spanish, with interpreters. He slipped into the atmosphere of San Francisco as easily as he had made himself a Muscovite; he had chameleon-like qualities which were invaluable in such situations. Frida was less settled, prickly, uncertain of herself and aggressive; she had much more difficulty in disguising her disapproval of capitalist society in what she termed "Gringolandia." But she was having less fun than Rivera. She was still grieving for the baby she had lost, and she could not get pregnant again. Her English was not as good as she had hoped. And her back was hurting; so was her foot. Whereas wherever her husband went, it was fiesta. During his research for the Stock Exchange mural Rivera met the tennis champion Helen Wills Moody and was so struck by her athletic beauty that he decided to make her the model for the central figure of Californian abundance. Although the tennis player, nicknamed "Little Miss Poker-Face" by the sporting press, had been married for less than a year, she and Rivera started an affair. She drove him around the city in her small green two-seater Cadillac, making him sit in one of the tiny "dicky" seats in the car's boot. This was an extraordinary sight—Rivera, striking enough in normal circumstances, crammed into the space at the back, his huge bulk topped by his huge stetson, the small

car powered by the champ, ascending the impossibly steep streets of the city looking as though it were about to eject the vast passenger whose continued presence defied gravity. Perched beside him on one of these hazardous navigations was the delicate, bird-like figure of Dr. William Valentiner, director of the Detroit Institute of Arts, who attempted to continue a conversation about "balance and harmony in composition" while sitting in a near-horizontal position gazing at the sky. Later Rivera questioned Valentiner closely about all aspects of Detroit's industrial development while the director, who was German, looked across the crowd gathered for tea at Helen Wills Moody's house and thought how enchanting Frida Kahlo looked. The meeting of Rivera and Valentiner was soon to result in one of Rivera's greatest frescoes.

The work Rivera undertook in the Pacific Stock Exchange was fresh, colourful and optimistic. The stockbrokers pass it today as they walk up the staircase for lunch. It shows a massive figure, modelled by Helen Wills Moody, representing the plentiful mother, California, with surrounding gold miners, engineers, fruit, docks and machinery. Above her on the ceiling Rivera added a superb, full-length flying female nude, also modelled by Wills Moody, which is enough to cheer up the gloomiest broker. This fresco is at first sight a triumph of tact, and perfect for the site, both artistically and socially. The Art Deco staircase which it dominates leads from the Grill Room to the principal Dining Room of the Luncheon Club, the inner sanctum, where, before it became illegal, the term "insider trading" took on a more confidential ring. One ascends from the tenth to the eleventh floor between discreetly placed waiters along red, deep-plush carpets, and is eventually faced with a maddening choice of deep-red leather armchairs to find oneself gazing over the bronze balustrade into the enormous blue eyes of the champ, who holds you with a steady gaze. Breaking away from her mesmerising stare, one glances upwards and there she is again. There is no way out except by passing beneath her, past the prehensile figure of the hunched-up gold panner and the discreet little brass wall-plate engraved with the title *Riches of California*. Only a subterranean group of miners, drilling upwards towards the bounteous and sunlit surface of the state, injects a mildly discordant note, suggesting that wealth does not always fall off trees even here.

Rivera completed the Stock Exchange commission—for which he was paid $4,000—by mid-February, then retired for six weeks to the residence of Mrs. Sigmund Stern, who belonged to an influential and wealthy North American clan whose members included the editor of the *Washington Post* and the president of the Metropolitan Museum of Art.

Touched by Mrs. Stern's generosity and attentions, Rivera made a small fresco on a movable panel for her dining-room; it showed her grand-daughter with two other children helping themselves from a bowl of fruit in the Stern garden. Beside them a small, dark-skinned child, a portrait of the gardener's daughter, is also taking fruit. For this work, and for five drawings, Rivera was paid a total of $1,450 by Mrs. Stern.

Among other friends he made in San Francisco were John and Cristina Hastings. John Hastings, later fifteenth Earl of Huntingdon, was an artist and Communist sympathiser who had travelled from Tahiti to study mural painting under Rivera. He soon became an assistant of the man whom he always described as his "master." In San Francisco, Hastings later recalled, "We had to grind colours, wash brushes, plaster walls, enlarge designs, do odd jobs generally, paint skies and unimportant parts of the background, and so came up against difficulties and problems and saw at first hand how they were solved." Hastings's wife, Cristina Cassati, Italian by birth, was immediately attractive to Frida, and possibly the object of one of Frida's first passions following her marriage. Cristina borrowed money from Frida, and her attempt to repay Rivera $250 on May 9, 1931, failed when the cheque bounced. Later, when she was back in Mexico, Frida wrote to Cristina with news of their plans to make an early return to the United States, enclosing a message from Rivera to John Hastings. Inside the envelope she smudged a message to Cristina; a magenta-pink lipstick impression of her lips with six X's and the words "Don't forget me darling, ever." According to Herrera, Frida tended to scatter these pink lipstick kisses pretty widely and without special signifi-cance. But on this occasion the magenta lips had been pressed to a sepa-rate slip of paper which need not have been shown to Hastings.

In San Francisco Frida's public image was that of consort to the great man. Nonetheless, she made quite a spectacular impression in her own right, and Valentiner was not the only person to be entranced by her. When Edward Weston first saw her he wrote in his daybook, "What a contrast with Lupe, she's so slim, she looks like a little doll beside Diego, but she's only a doll in appearance as she is strong and quite lovely. She shows no trace of her father's German blood. Dressed in Indian costume, including sandals, she's a sensation in the streets of San Francisco." And Frida was happy to project this image of herself, even in her painting, which was showing unmistakable signs of her husband's influence.

The first evidence of that influence is in paintings she made even before Cuernavaca. Whereas prior to her marriage she had painted rather two-dimensional portraits of conventionally dressed members of her cir-

cle of family and friends, either with or without allegorical references
such as playing cards, skulls, rocking-horses and alarm clocks, after her
marriage she started to paint Indians. It was as though she had just discov-
ered the existence of thousands of hitherto invisible Mexican people. In
the most unexpected of this new series she painted in January 1931, in San
Francisco, *Indian Woman Nude,* the picture which is the clearest reflection
of Rivera's influence, with the subject, displaying the dark nipples that
Frida favoured, placed against a background of rubbery tropical leaves.
Another picture shows a gringo sitting on a bus; he has blue eyes and a
bow tie and is carrying—the Rivera touch—a bag full of money. Interest-
ingly enough, although Frida was wearing Indian costume at the time
these pictures were painted, she did not wear it in the self-portraits she
completed during the early months of her marriage. She still saw her
Indian costume as "costume" and her inner self as existing independently
of Rivera's trance. It was to be a year before the first self-portrait of Frida
Kahlo "in Tehuana" was made, in April 1931, in San Francisco. It is a dou-
ble portrait, in naïve retablo style, and it depicts her relationship with her
husband in exactly the terms used by Weston in his private journal. She
stands beside the new master of her imagination, small, trusting, her
hand resting on his, her tiny feet, each about the size of one of his big
toes, in their Indian sandals, just touching the ground which supports his
massive boots.

But if Frida's public image in San Francisco was that of consort, it
seems to have been here, too, that she first established an area of personal
autonomy in her marriage. Apart from the ambiguous situation with
Cristina Hastings, a letter to Nickolas Muray suggests that it was in May
1931, the last month of her stay, that she started her first heterosexual
post-marital affair, with the dashing Hungarian photographer whom she
had just met. She was, however, careful—in contrast to her husband,
whose admiration for Helen Wills Moody and many others was blatant—
to keep her infidelity secret. Even in correspondence with close friends
she made only veiled references to her adventure.

Rivera's final mural before leaving San Francisco was his original
commission for the city's School of Fine Arts, and was started in April and
completed in record time by the end of May. It was entitled *The Making of
a Fresco* and was practically without political references. Sited in an art
college, it was intended primarily as an incentive for students. He has
painted men and women at work planning and constructing a city, and
then superimposed the scaffolding and people engaged in making a fresco
of making a city. Rivera has placed himself, seated on one of the planks of

the scaffold, with his back to the room, absorbed in the work to hand, his large bottom drooping in an amiable manner over the edge of the plank. The finished work was not 120 square feet but a total of 658 square feet; but Rivera did it for the original price of $1,500. Incredibly enough, the die-hard opponents of his presence in San Francisco managed to find further grounds for insult in the prominence of the artist's bottom, although if it was a satirical attack, it seems to have chiefly been directed against himself. This fresco was his first attempt to depict a modern industrial process. He signed it "Mayo 31, 1931"; he and Frida then left the United States on the following day.

Rivera returned to Mexico following a long series of increasingly impatient messages from the presidency, which wanted to get his scaffolding off the palace staircase. As soon as he arrived he scrubbed off the work carried out by Ione Robinson in his absence, and was able to complete the west wall by October. Rivera spent just five months in Mexico, but he had no intention of readjusting to the different pace of Mexican life. In keeping his mind focused on the world outside, he was assisted by two visitors. Sergei Eisenstein was in the country, filming *Qué viva México!*, the project he eventually had to abandon after shooting 170,000 feet. A major section of Eisenstein's film was devoted to Posada, and he spent some time with Rivera at the Casa Azul devising a scene based on Rivera's depiction of the Day of the Dead. Eisenstein became so depressed and frustrated by the subsequent collapse of his production's financing, and his consequent failure to record the overwhelming impact of Mexican culture, that he later contemplated suicide. Fortunately, in August, a lucid reinforcement arrived in the shape of Elie Faure.

Faure had kept in intermittent contact with his former disciple ever since Rivera's departure from Europe in 1921, and had been among those friends who had tried to help Angelina and Marevna in the absence of their protector. Faure's earlier attempts to visit Mexico had failed for want of funds, but on the morning of July 24 his train from New York arrived in Mexico City after a four-day journey and Rivera and Frida were at the station to greet him. Faure stayed at the San Angel Inn, opposite the site of the Riveras' new house in San Angel, which was still incomplete, and Rivera took him to see the frescoes at Cuernavaca and introduced him to Dr. Atl. Faure, too, was overwhelmed by Mexico. He described the capital as "one of the most beautiful cities in the world" with its trees and flowers, canals and fountains, and was struck by its freshness and cleanliness. Rivera and his friends, "all Bolsheviks, naturally," had been "so good, so helpful, so intelligent." He described Rivera as "a real brother to him" and

was deeply impressed by the scale and quality of his work, and in a letter to his daughter Faure described him as "a truly great painter." Later, in his *History of Art,* Faure wrote: "One could compare the wealth and vigour of his subjects and symbols to the works of the Italian Renaissance, whose moral values he has however reversed. . . . In his giant frescoes the sap of a people oppressed for 400 years surges up with admirable force in a form which seems to be dictated by the instinctive needs of the masses." Faure departed on August 8 for California, continuing his world tour and having spent nearly all his time with Rivera. After he had gone, Rivera returned to his wall in the Palacio Nacional, then, having put the finishing touches to this, set the project aside until 1935 and left Mexico for over two years.

In San Francisco Rivera had seen a country "hurrying towards the future" and it fascinated him. Before leaving California, he had received a commission from William Valentiner to come to Detroit to decorate the two main walls of the central Garden Court of the city's Institute of Arts. While gathering support for this scheme Valentiner had described Rivera as "perhaps the greatest mural painter living, and certainly one of the few outstanding and original painters on this side of the water." "The one difficulty," Valentiner noted, "which some people present is that he is inclined to Communism . . . [but] I do not see why one should not overlook his political convictions, since he is a great artist." "His prices," Valentiner added, "are exceedingly reasonable." With these reflections Valentiner was, in the Marxist analysis, showing his "bourgeois" preoccupation with money, and his bourgeois belief that politics and art were two different matters, but he was too subtle a man and too skilled a negotiator to allow any vexatious differences of opinion to hinder an important commission. In July, Frances Flynn Paine visited the Riveras in Mexico proposing a retrospective at the Museum of Modern Art, only the second retrospective MoMA had mounted, the first having been devoted to Matisse. In September Mrs. Rockefeller, advised by Frances Flynn Paine, purchased Rivera's Moscow sketches, by now forever entitled *May Day, 1928.* For Rivera, the United States became an enchanted prospect. In his five months in Mexico in 1931, he did little painting apart from twenty-five water-colours and drawings illustrating "the Legend of Popul Vuh," the only development in his preoccupation with the ancient Mexico which surfaced during his visit. On November 13 the ship carrying Rivera, Frida and Frances Flynn Paine docked in Manhattan. He had started on work intended for the MoMA retrospective while the ship was still at sea.

The period of November 1931 to March 1933, which Rivera spent in

New York and Detroit, was a consecration. Before he left California he had written an article entitled "Listen Americans!"

When you say "America" you refer to the territory stretching between the icecaps of the two poles. To hell with your barriers and frontier guards! Listen Americans. Your country is strewn with impossible objects that are neither beautiful nor practical. Many of your houses are filled with bad copies of European ornaments. . . . You have plundered the Old World at great cost and made an America of rags, bottles and old clothes, in place of a New World. . . . Take out your vacuum cleaners and clear away those ornamental excrescences. . . . Proclaim the aesthetic Independence of the American Continent!

He came determined to win acceptance in the United States for his politics as well as his art, and intended to use one to lead his admirers to the other. As always he was prepared to operate on commercial and political fronts at the same time, as he showed by his decision to proceed to Detroit via New York. Valentiner had written to him in April 1931 saying that the trustees of the Detroit Institute of Arts had agreed in principle to his decorating the Garden Court, and in reply Rivera had suggested his "San Francisco price" of $100 a square metre, plus costs and assistants' fees. He had also said that he expected to be back in San Francisco by the autumn. But the MoMA show delayed his plans. For this Rivera offered 143 paintings and, as a novelty, eight frescoes on portable panels; five of these were copies of frescoes he had already made in Mexico City, but three of them covered New York or industrial subjects, the most celebrated being *Frozen Assets,* a picture which attempted to summarise the misery of New York during the Depression and the contrast between the extremes of wealth and poverty that were everywhere visible. This scathing social comment, together with copies of Zapata and his white horse from Cuernavaca and *The Liberation of the Peon* from the ministry of education, was shown to a glittering crowd at the vernissage. The Rockefellers turned out in force, as did the other princely families of Manhattan, the crowd of millionaires and celebrities who patronised modern art: the Goodyears, the Blisses, the Crowninshields, with Georgia O'Keeffe, Edward G. Robinson, Greta Garbo, Hedy Lamarr and Paul Robeson. So Rivera had caricatured the world of East Side capitalism on the walls of Mexico City? Well, here it was in the flesh, and delighted to see him: meet William Paley and Mrs. William Paley, Harry Bull and Mrs. Harry Bull, meet John Hay Whitney and Mr. and Mrs. Henry Luce; the Guggenheims will be along in about ten years. Rivera and Frida were staying in a suite in

the Barbizon Plaza and Abby Aldrich Rockefeller had filled their room with flowers. If Rivera considered the capital of capitalism to be decadent and corrupt, the capitalists did not seem to be particularly bothered about it. And Georgia O'Keeffe took advantage of the occasion to seduce Frida, much to the amusement of Rivera, who had decided to tolerate his wife's homosexual flings.

The vernissage at MoMA was on December 22; meanwhile, in Detroit, Dr. Valentiner was expecting Rivera to arrive in January. That was when he closed the Garden Court and work started on the preparation of the walls. Clifford Wight, Rivera's chief assistant, had written to Dr. Valentiner in November asking for a supply of wood-burned lime to be slaked immediately; a framework of steel bars had been built and set into the wall, these had been wired and plastered, the plants and flower beds had been stripped out, and a movable scaffolding had been erected and installed. But January came and went and still no sign of Rivera.

Back in New York, Rivera was writing, in French, to Jack Hastings, who was still in San Francisco: "In Detroit everything is going badly, the city is bankrupt, all payments for art have been suspended and I have no idea whether the frescoes are going to be done or not. . . . Here two million people a day are visiting my show . . . *mais c'est la crise.*" On January 29 Valentiner, anxious to keep the momentum going, wrote to Rivera saying that he was sorry to hear that he was unwell and that he must have been working too hard, and forwarding Helen Wills Moody's wish "to be remembered" to him. Then, on February 6, Rivera wrote to Mrs. Rockefeller to tell her that "Mr. Weyhe" (probably Carl Zigrosser of the Weyhe Gallery in New York) had just bought all eight of his movable frescoes from the show (which had closed on January 27) but asking if she would mind keeping them a little longer in her garage. Rivera's health improved, but still he lingered in New York. The reason was the opening of *Horse Power,* a ballet, in Philadelphia, with music by Carlos Chavez, conducted by Leopold Stokowski, and devised by Rivera, who had also designed the costumes and sets. The Riveras travelled to the opening night by Pullman with the same first-night crowd who had attended the MoMA triumph on March 31. On April 14 Dr. Valentiner wrote to Rivera begging him to come soon. The situation was becoming "embarrassing": the centre of the museum had been closed for three months, and although he did not want to rush him and realised that he was a great artist, "it would help so much" if he was at least in Detroit. This letter worked and Rivera arrived in the city one week later.

The fact that Rivera delayed in New York for frivolous reasons may

have saved the Detroit project because he thereby avoided any chance of witnessing the events of March 7, 1932, when a hunger march organised by the Communist Party ended in a violent clash at the Ford Motor Company's Rouge plant with four of the strikers being killed. It is difficult to imagine Rivera being able to carry out the frescoes of Detroit if he had been present when this event occurred. His success in New York had led to increased Communist Party attacks. Joseph Freeman, by now back north of the border, had returned to his favourite task: slandering Rivera as an artist. Freeman, writing under a pseudonym, had singled out Rivera for special attention in the North American party periodical *New Masses,* trying to prove that his former comrade had ceased to be a revolutionary painter at the very "moment of his expulsion from the Party." And Rivera was also denounced as "a renegade" in speeches at the John Reed Club. In the event, his arrival in Detroit coincided with the peak of the Depression. In a city with a population of 1,568,662, 311,000 workers had been laid off in the automobile industry alone. Facing annual losses, Ford reduced wages for the surviving workers from $33 to $22 a week; the assembly line was operating at 20 percent of capacity, 15,000 car dealers were put out of business, and corrupt foremen, keen to keep their commissions up, were forcing workers to buy cars with loans they could not hope to repay in return for not laying them off. Against this critical background the city council cut the Institute of Arts budget from $400,000 in 1928 to the impossible sum of $40,000 in 1932. Valentiner himself decided to take eight months' unpaid leave in Europe and prepared to sell his private collection of Rembrandt drawings to fund his expenses. He had had great trouble in finding a sponsor for Rivera's visit. At City Hall there was talk of closing the museum and selling its collection, and there on the platform of the central railway station stood "a foreign artist" being greeted by the Mexican vice-consul and the German-born museum director, an artist who was due to be paid $10,000 to cover a perfectly decent stone wall with Communist paintings.

The man who made the project possible was Edsel Ford, son of Henry Ford, the founder of the company. When the city refused to pay the museum staff's salaries, Edsel Ford agreed to advance the money. Ford also paid for the expensive preparation of the walls, including unforeseen costs of $4,000, and when Rivera asked for a further $5,000 to paint the two end walls as well, Ford stumped up for that too. Since he had personally lost more than $15 million in the previous year, this was more than generous. Furthermore, his original generosity had to be dou-

bled when the sum he initially set aside to pay the artist disappeared in a bank failure and had to be replaced.

When the Riveras arrived in Detroit they were driven from the station to a large building opposite the Institute of Arts called the Wardell Hotel. Rivera discovered that it did not accept Jews, so he claimed that both he and his wife were Jewish, and the hotel, desperate for business, at once agreed to abolish the rule and to reduce the room rate. Rivera then asked to be shown the Institute's collection and was impressed by the extent of Dr. Valentiner's acquisitions. When he came to Brueghel's *Wedding Dance* he fell silent for five minutes, oblivious of the crowd of people gathered around him. Then, turning away from this example of "plunder from the Old World," Rivera, deeply moved, said that he would have his work cut out if he was to paint anything memorable in a museum which had Brueghel hanging on its walls. In the days that followed, Valentiner tried to "explain Detroit" to Rivera. He took the view that the city's incredible energy and success were due firstly to the hostile climate, which meant that only the most resourceful people could live and flourish there, and secondly to the fact that its fortunes were centred on motor cars and the genius of Henry Ford. Shortly afterwards Rivera met Edsel Ford, who was president of the museum's board, and the two men liked each other at once. Ford offered to show Rivera round the Rouge plant and give him any facilities he needed to study the automobile industry. Rivera spent a month in this extraordinary world; it was the first time he had seen factories, machine shops and laboratories on this scale, and he was entranced by Detroit's "marvellous plastic material which years of work could not exhaust . . . [such as] bridges, dams, locomotives, ships, scientific instruments, automobiles and airplanes." Despite the Depression, the Fords had plans to expand, and the previous month they had launched their new V-8 model from Detroit.

During the month Rivera spent in the Rouge plant, happily filling notebooks with sketches and memos, John and Cristina Hastings moved in to share the apartment the Riveras were occupying at the Wardell Hotel. Hastings was once more joining Clifford Wight as one of Rivera's assistants, leaving Frida and the Viscountess to amuse themselves as best they could.

By the end of May Rivera, who had decided that the steel industry was "as beautiful as the early Aztec or Mayan sculptures," was ready to present his preliminary project to Valentiner and Edsel Ford. He had decided to devote both of the large panels prepared for him in the Garden

Court to the Rouge automobile plant in Dearborn, Michigan, birthplace of Henry Ford. Although the one-time three-year-old engine driver did not know how to drive a car, he was fascinated by the process of constructing one. In order to refer to the history of Detroit, Rivera suggested painting all the minor panels available in the court with themes drawn from the natural materials of the region that were used in the manufacture of motor cars. Edsel Ford once again agreed to foot the bill, and the final contract stipulated that Rivera should paint twenty-seven panels for a total of $20,889. The original suggestion had been for a fee of $10,000.

The largest two frescoes Rivera painted in Detroit stand on facing sides of a marble-floored courtyard. From the point of view of harmony between building and subject, these are probably the most difficult frescoes that Rivera ever painted, since the room's stone walls are decorated with stone carvings and resemble the interior of a neo-classical temple. But the entire roof is of clear glass, which does at least provide a splendid light. Here on the north wall, in the first of the two great panels Rivera devised, he showed the manufacture of the 1932 Ford V-8 engine and transmission. There are scenes in the foundry, with molten steel pouring from the blast furnace into moulds; then there are the conveyor belts, the assembly lines and the honing of the newly cast engine block. It is a scene crowded with machinery and figures and bursting with urgent movement. These people are alive and at work. There are brutal faces, reflective faces, all the panorama of the assembly line and the human and mechanical energy required to shape steel into motor cars.

On the opposite south wall Rivera showed the body shop, with stamping press, welders and paint oven, and the final assembly line. And in a grisaille strip which he inserted into the base of the two larger frescoes he showed further details, including the time clock, with workers punching their cards, the snap boxes open at the lunch break, and the pedestrian overpass by the plant's Gate 4. The mechanical details are highly accurate; the frescoes have all the atmosphere of the Rouge plant except the noise, although even that sometimes seeps out through the fire and life of the north wall. Both pictures have a tremendous sense of demand: seconds are ticking, the cars have to be put together, not just because Mr. Ford wants the money but because the customers are waiting. The final assembly line is overlooked by a queue of them surrounded by the innumerable bits and pieces that go into the making of the machine, and the details are picked out in a wealth of colours. Thanks to the glass roof, the light and shadows of the sky chase these colours round the hall all day long. On the north wall there are blocks of blues and

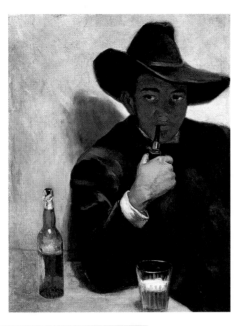

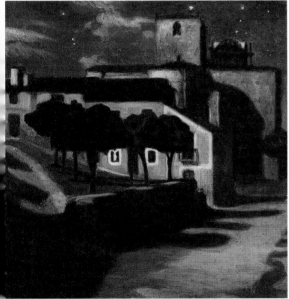

ABOVE: *Self-Portrait,* 1907,
oil on canvas
LEFT: *Night Scene in Avila,* 1907,
oil on canvas
BELOW: *Notre Dame de Paris in
the Rain,* 1909, oil on canvas

LEFT: *Portrait of Adolfo Best Maugard*, 1913, oil on canvas
ABOVE: *Portrait of Angelina Beloff*, 1909, oil on canvas
BELOW: *The Adoration of the Virgin*, 1913, encaustic

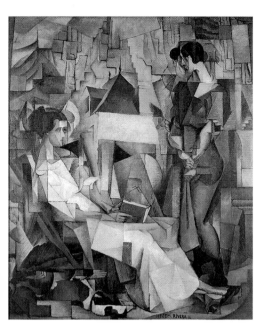

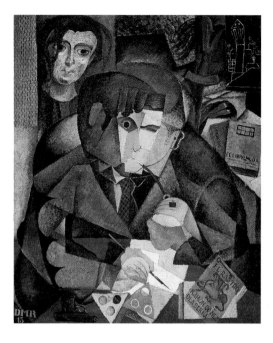

ABOVE: *Portrait of Two Women*, 1914, oil on canvas

RIGHT TOP: *Portrait of Ramón Gómez de la Serna*, 1915, oil on canvas

RIGHT BOTTOM: *Still Life*, 1918, oil on canvas

BELOW: *Zapatista Landscape*, 1915, oil on canvas

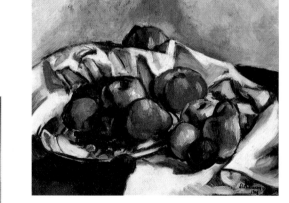

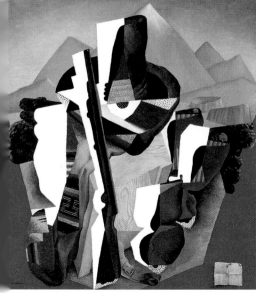

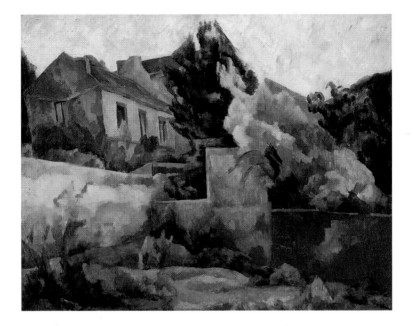

ABOVE: *The Outskirts of Paris,* 1918, oil on canvas
(rediscovered in 1995 in a Parisian attic)
BELOW LEFT: *The Mathematician,* 1918, oil on canvas
BELOW RIGHT: *Bather of Tehuantepec,* 1923, oil on canvas

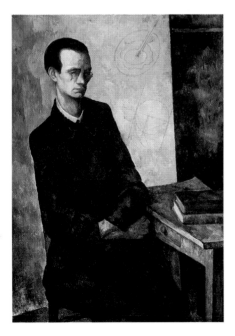

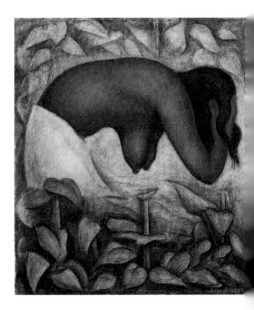

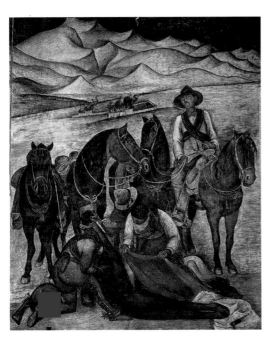

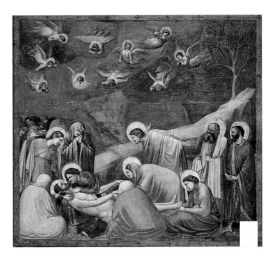

ABOVE LEFT: *Liberation of the Peon,* 1923, fresco,
Ministry of Education
ABOVE RIGHT: *The Laying Out of Christ's Body,*
by Giotto, fresco, Padua
BELOW: *Land and Freedom,* 1923–24, fresco,
Ministry of Education

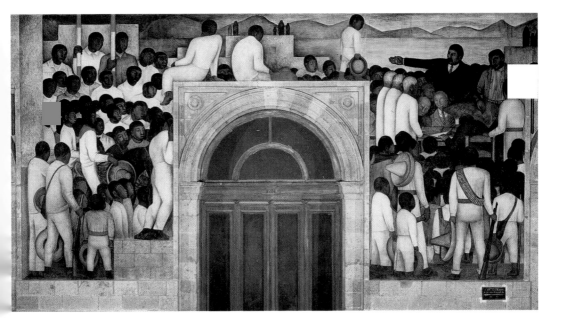

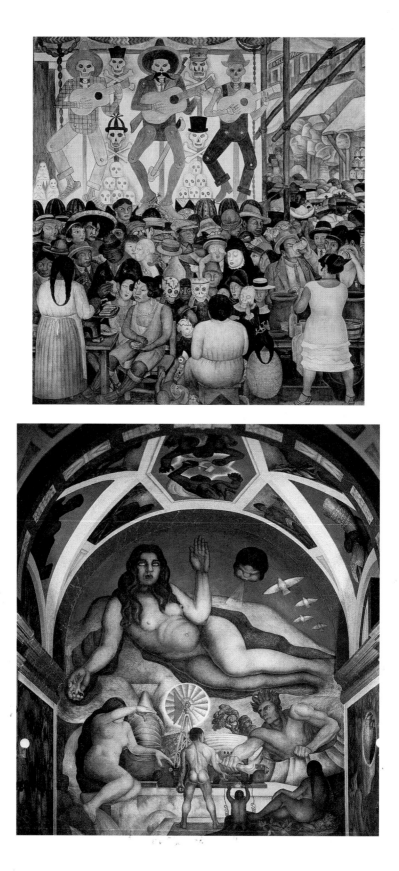

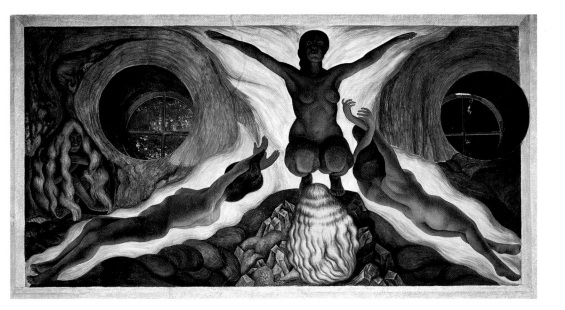

OPPOSITE TOP: *The Day of the Dead,* 1924, fresco, Ministry of Education
OPPOSITE BOTTOM: *The Liberated Earth,* 1926–27, fresco, Chapingo Chapel
ABOVE: *Subterranean Forces,* 1926–27, fresco, Chapingo Chapel
BELOW: *Indian Boy and Indian Woman,* with corn stalks,
1926–27, fresco, Chapingo Chapel

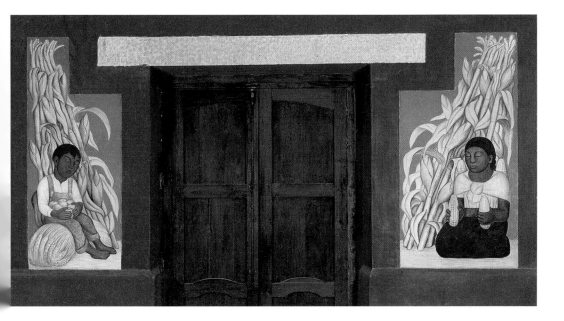

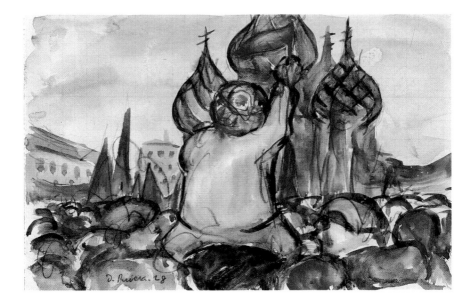

ABOVE: *Moscow Sketchbook, Procession across Red Square*, 1927
BELOW: *Insurrection* (also known as *The Distribution of Arms* or *In the Arsenal*),
1928, fresco, Ministry of Education

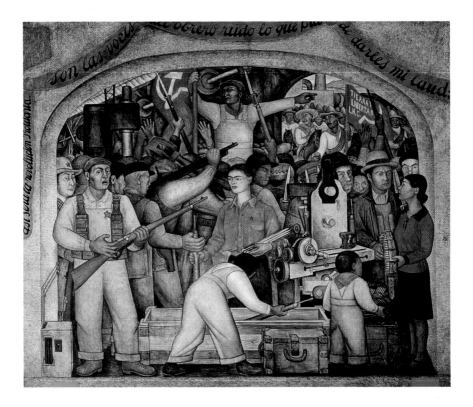

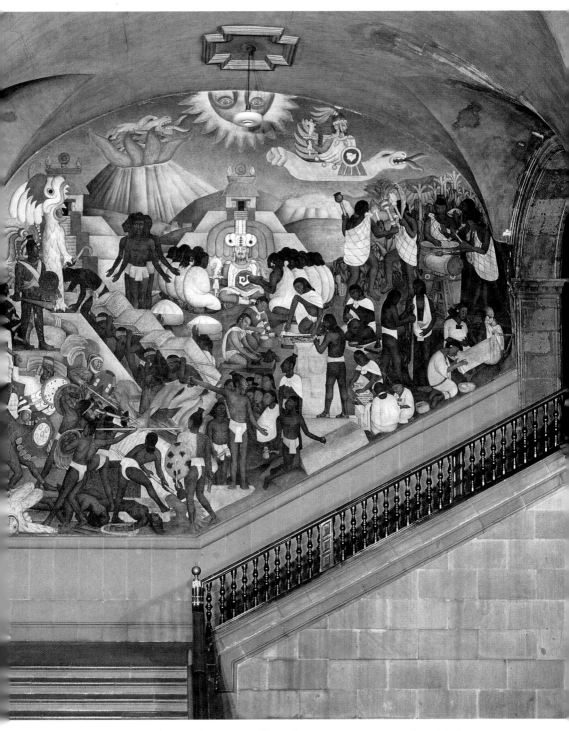

The Aztec World, 1929, fresco, north wall, main staircase, National Palace

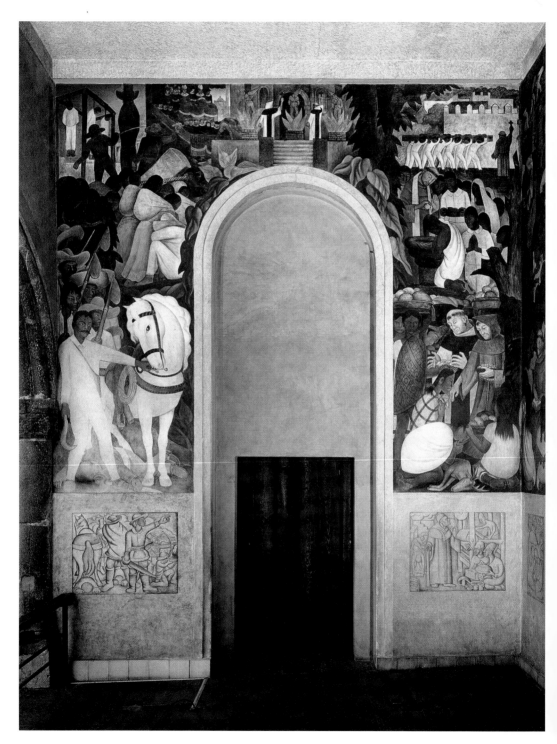

Zapata's Horse, with fallen overseer (left) and the Court of the Holy Office (right), 1930, fresco, Cuernavaca

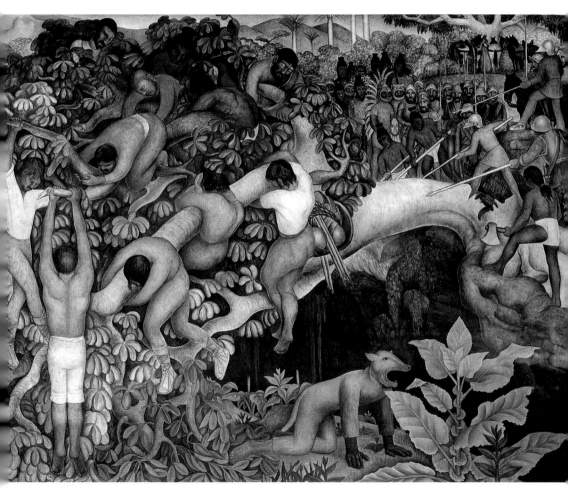

Entering the City, 1930, fresco, Cuernavaca

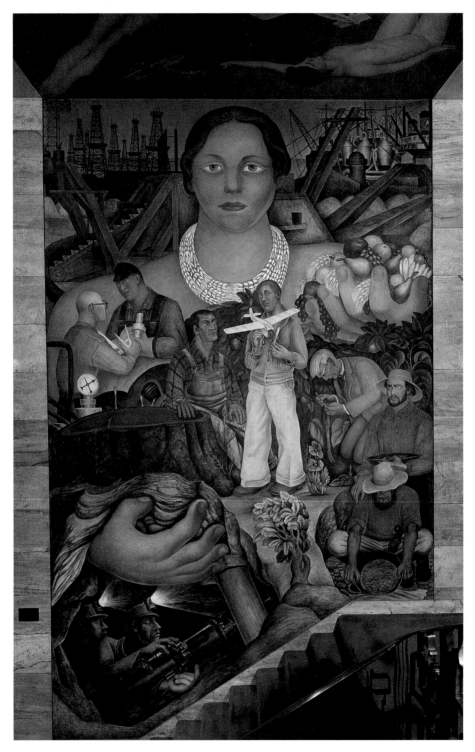

The Allegory of California, 1931, fresco, Pacific Stock Exchange, San Francisco

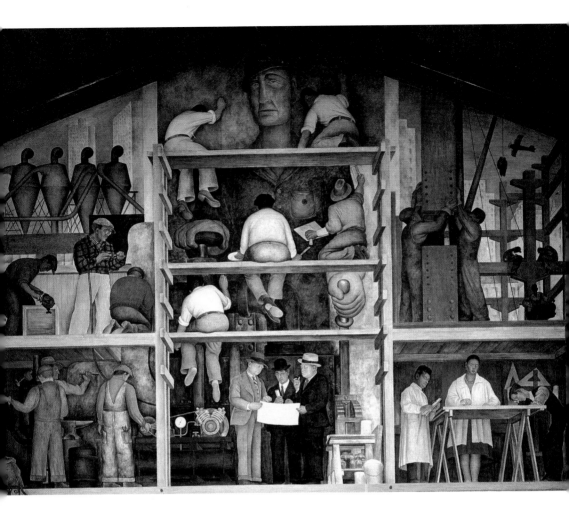

ABOVE: *The Making of a Fresco,* 1931, fresco, San Francisco Art Institute
BELOW: *Henry Ford Hospital,* by Frida Kahlo, 1932, oil on metal

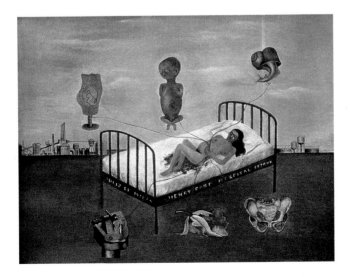

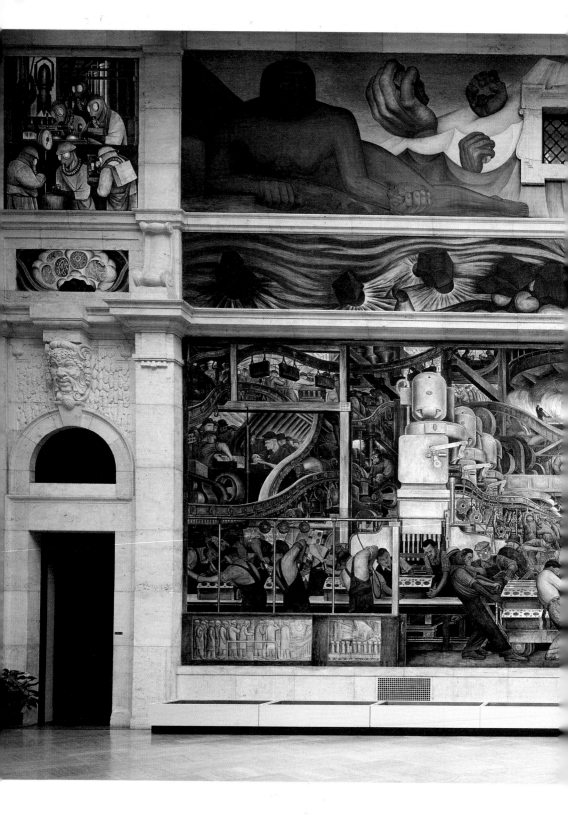

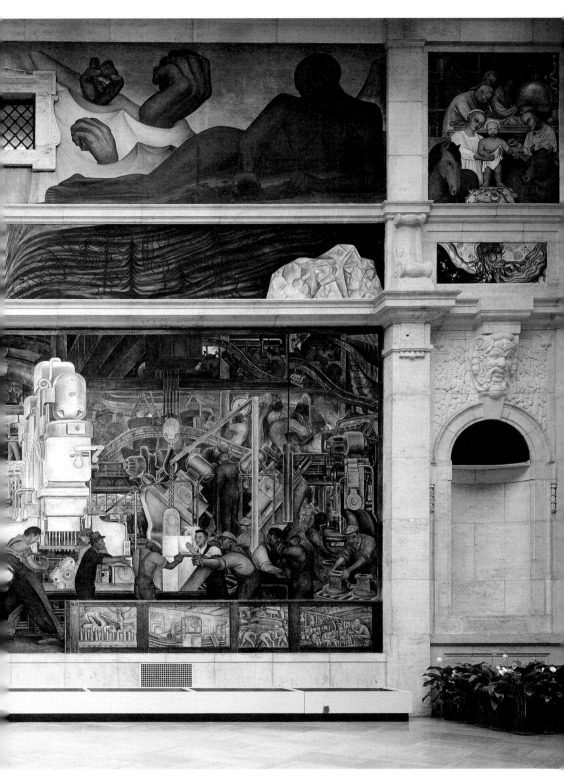

Production of Engine and Transmission of Ford V-8, 1932–33, fresco,
Detroit Institute of Arts, north wall

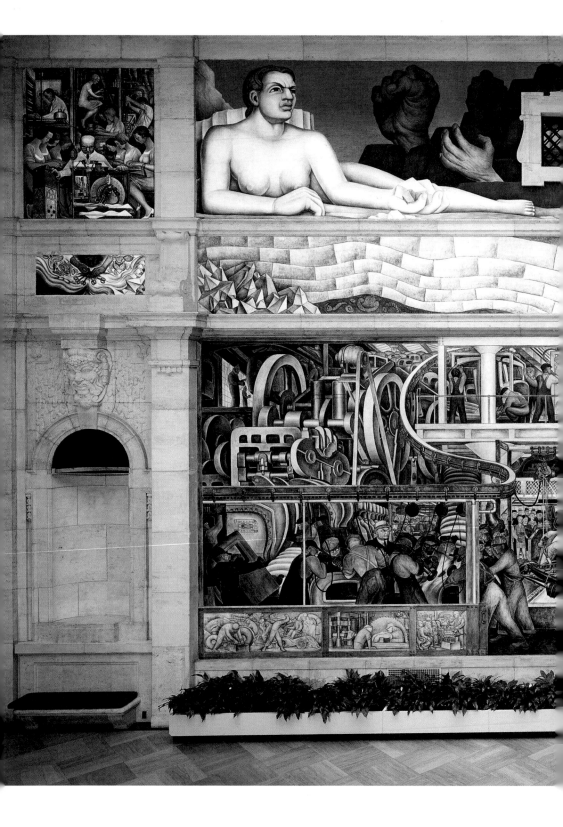

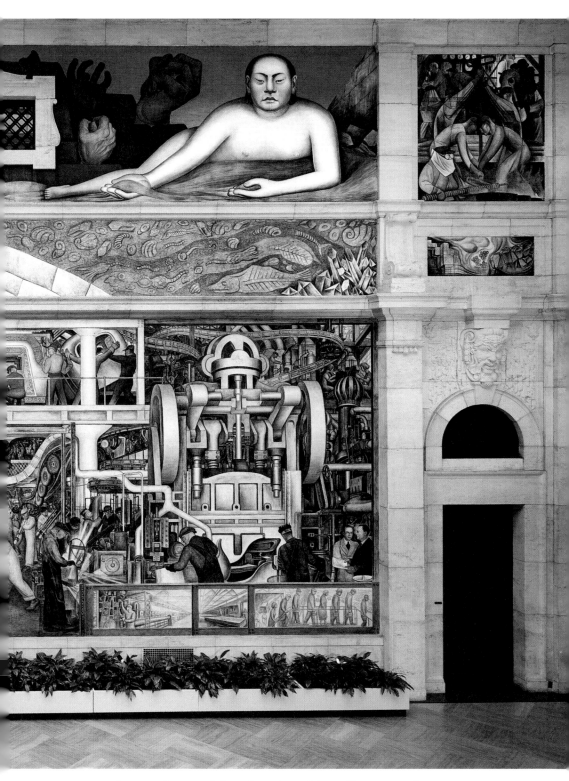

Production of Automobile Body and Final Assembly, 1932–33, fresco,
Detroit Institute of Arts, south wall

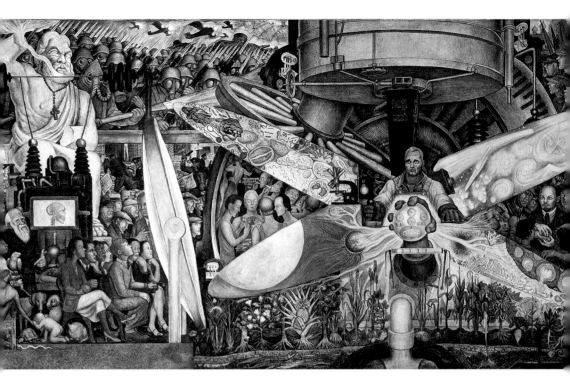

ABOVE: *Man, Controller of the Universe*, 1934, fresco, Palacio de Bellas Artes
OPPOSITE: *Burlesque of Folklore and Politics*, 1936, fresco, Hotel Reforma
BELOW: *Dream of a Sunday Afternoon in the Alameda*, 1948, fresco,
Hotel del Prado

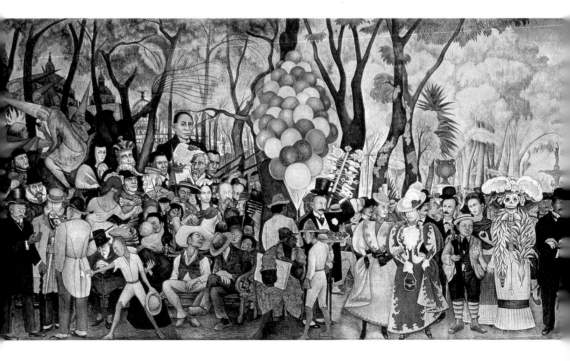

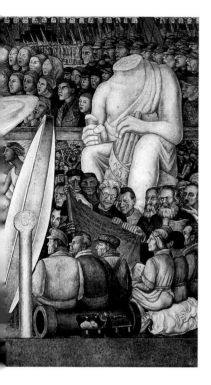

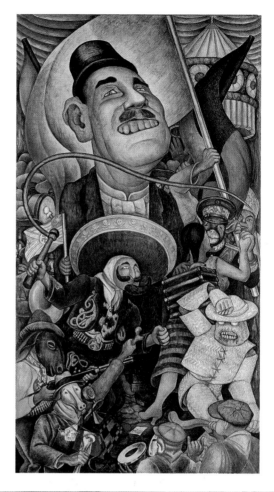

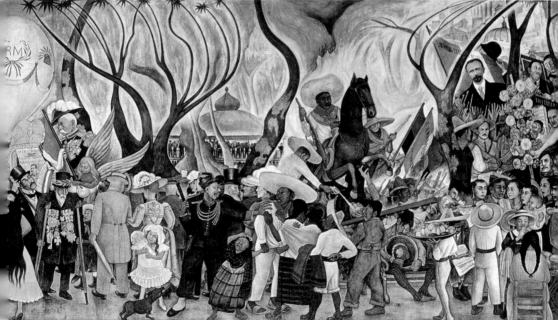

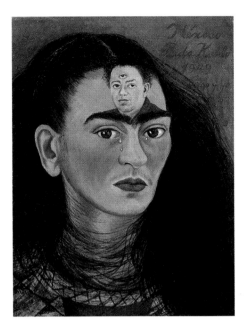

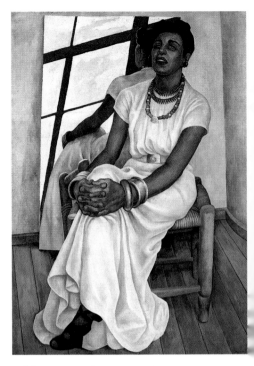

ABOVE LEFT: *Diego and Me,* by Frida Kahlo, 1949, oil on masonite
ABOVE RIGHT: *Portrait of Lupe Marin,* 1938, oil on canvas
BELOW: *The Milliner,* portrait of Henri de Chatillon, 1944, oil on masonite

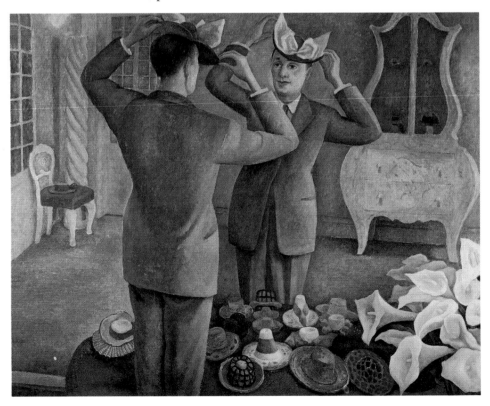

greys, but there is also the orange glare and yellow flashes from the furnaces, and the men masked and hooded, silhouetted with their long rods. The blocks of colour are interrupted by the greeny-yellow skin tones of arms and faces of the men packing sand into mould cores, one of whom turns out to be a portrait of the artist in a bowler hat, a signal of Rivera's desire to identify with the fate of those he was immortalising. There are the strips of greenish khaki overalls worn by some of the men, and the varying colours of the hundreds of metal surfaces, all accurately reflecting the interior light of the fresco; one looks at some of the darker corners of this vast industrial cavern and wonders how they smell, just as one flinches at the heat of the surfaces and dreads the noise of the great galleries. On the south wall the colours give a more composed and finished impression. We are still inside the Rouge plant, but here they are working on cars, not on raw steel. The only fires are from the arcs as metal is stamped or cut with hand-held blades, and there is more light from the world outside which enters through the tall factory windows, which were saving Mr. Ford so much in electricity. The only hint of the Depression that surrounded the Rouge plant is in the paper hat worn by one of the workers on the south wall. It bears the words "We want"; the back of the hat, not shown, carried the word "beer."

Above the two main panels, and in smaller panels on the east and west walls of the Garden Court, Rivera painted twenty-five further frescoes devoted to the state of Michigan, to the raw materials from which cars were made and to a random but enjoyable selection of natural and scientific processes. Two naked women, one holding grain, the other fruit, are wonderfully curved and rounded, their shapes enabling them to squeeze into their rather confining panels, which they fill out in the most satisfying manner. Two magnificently succulent and appetising still lifes illustrating the vegetable cornucopia of Michigan blaze with a Cézannean mix of reds and oranges. Elsewhere geological strata, crustaceans, fossils and a ploughshare alternate with a study of a surgical operation which displays the open wound, the surgeon's gloved hands, the line of instruments and a colourful range of internal organs. The most famous panel, entitled *Vaccination*, shows a blond infant in the hands of a nurse being vaccinated by a doctor, the human group being framed by a horse, a bull and sheep, the animals from which the serum had been drawn. The figures are arranged like the Holy Family, and the child's blond hair resembles a halo, further evidence of Rivera's admiration for Christian symbolism and his talent for recycling it. One of the strongest images is of a human foetus enclosed by the bulb of a plant. The main panels are also

notable for their ingenious composition. In two paintings, each 800 feet square, the artist managed to show the entire production, manufacture and assembly of the engine, transmission and bodywork of a motor car. The pictures show over fifty separate industrial processes in accurate detail, including the lunch break, and must count as the greatest painting ever made of a twentieth-century factory operating at full blast.

Rivera was completely absorbed by his work in Detroit, which he started to paint on July 25, 1932. He generally started work at about midnight, painting the monochrome outlines under incandescent light so that when dawn broke he was ready to work with colours under natural light. A working session could last from eight to sixteen hours, depending on temperature and humidity and the time it took the plaster to dry. In September E. P. Richardson, the museum's assistant director, wrote to the absent Valentiner reporting good progress and adding, "Rivera says he would rather paint two walls than write a letter. . . ." He finished painting nearly eight months later on March 13 the following year, and as he did so a terrific storm broke out in what Valentiner, who had returned from Europe, described as "a frightening manner."

The lobby which formed in Detroit in an attempt to destroy Rivera's frescoes was composed of a rich mixture of patriots, anti-Communists, philistines and bigots. Ten days after Rivera had dismantled his scaffold Valentiner was writing to his opposite number at the Chicago Art Institute, "There is a considerable mass of people here who want the frescoes removed and I am doing all I can to collect opinion from all over the country to help us. . . ." The frescoes had been attacked with one voice by the Catholic Church and the Evangelical Church as being blasphemous and paganistic. To one angry objector, Clyde Burroughs, secretary of the Institute, who was striving to defend the artist, wrote: "If he is a Communist I am sure upon acquaintance you would find him to be a gentle and helpful one." Rumours of the scandalous nature of Rivera's work had started long before the frescoes were shown to the public, and as soon as the doors were open, crowds of people, twenty thousand a day, flooded into the museum to inspect the outrages. Led by the local press, politicians, leaders of women's clubs and assorted lobbyists protested. The frescoes were "anti-American" and "defamatory." They were "an advertising gimmick thought up by Edsel Ford"; they were "an insult to Detroit"; they were "pornographic"; they were "Communistic"; and "they should be whitewashed," according to one city councillor. One of the Protestant leaders, scenting a blasphemy, came down to the museum to interview Valentiner and objected most strongly to the *Vaccination*

panel on the grounds that it was referring to the Nativity. If that was not the case, he wanted to know why the child had a halo round his head. And Rivera, who was standing nearby, did not help matters by replying, "Because all children wear haloes." Rivera's other contribution to the defence of his work was to write a magazine article in which he attacked his critics. He mentioned "the curious spectacle of the local prelates of two religious organisations of European origin—one of which [the Roman Catholic] openly avows allegiance to a foreign potentate, while the other has its roots deep in alien soil—stirring up the people in 'patriotic' defence of an exotic Renaissance patio against what they decry as an 'un-American invasion,' namely the pictorial representation of the basis of their city's existence and the source of its wealth, painted by a direct descendant of aboriginal American stock!" This comment echoed one made by Valentiner, who said that the opposition included "enemies in church and political circles which . . . represented international powers [the Vatican] whose influence was revealed wherever he went. . . ." E. P. Richardson led the counter-attack on behalf of the Institute of Arts, standing on the edge of the fountain in the Garden Court and losing count of the number of times he repeated his discourse explaining that the murals were "monumental realism," a "study of American mechanical genius" and "a remarkable tribute to a purely American development of civilisation." He was a persuasive speaker, although he had actually been chosen for this role because he was one of only two of the museum's senior staff members whose native language was English, a fact which was fortunately never discovered by the opposition.

Public interest, provoked by the controversy, grew and soon developed into widespread enthusiasm; record crowds came to admire Rivera's work. Valentiner claimed that he could never understand how the hostile rumours had started, but one possible clue is to be found in a letter written to him in December 1932, long before the murals were finished, by one of the museum trustees, Albert Kahn, the brilliant but colour-blind architect of Detroit's Fisher Building. Kahn sent Valentiner a copy of a letter he had received from Paul Cret, architect of the Institute of Arts building. Cret was furious that the murals had been commissioned without his knowledge or approval, and even angrier that they were so "out of harmony" with the "international Beaux-Arts style" of the building. And it is possible that Cret's embittered complaints were the seed from which the political opposition grew. The campaign eventually collapsed when Edsel Ford was asked why he had allowed this sacrilege to be perpetrated and replied that it was because he liked the murals. Detroit was in effect

being told to mind its own business, and there was nothing anyone could do about it. Rivera's masterpiece was safe. In the Garden Court in Detroit he had been given one of his most prominent sites by an enlightened patron, and together they had made a triumph out of the opportunity. One aspect of Rivera's achievement that was particularly important, in view of what was to follow, was his political success in making a statement about modern industry that was both true to his own beliefs and acceptable to his millionaire sponsors.

Although Rivera was content with his work in Detroit, it was not an easy time for him and Frida. She had a miscarriage in July 1932 and had to be rushed to the Henry Ford Hospital, where she chose to comfort herself by drawing the foetus she had lost. Since Rivera had the relevant medical references beside him on the scaffold, he defied the doctors' advice and brought them to her in the hospital. The dead male foetus in Frida's drawing bears a distinct resemblance to Diego, and the naked Frida is wearing the Indian bead necklace last seen in Rivera's nude study of her made in Cuernavaca.

The miscarriage in Detroit was the culmination, for Frida, of a long period of anguish and indecision and marked a turning point in her life. She gave a detailed description of her state of mind in a letter to Dr. Leo Eloesser in San Francisco written on May 26, 1932, five weeks after the Riveras' arrival in Detroit. In this letter, to a doctor who was to become one of her most trusted friends, Frida said that she was two months pregnant and had requested an abortion "given the state of my health." (Her only recent complaint at that time was an ulcer on her foot.) Following her request for an abortion the doctor, Dr. Pratt, had given her a mixture of quinine and castor oil, but this had provoked only a light haemorrhage, and Dr. Pratt, who had her entire case history, was now suggesting that she carry the baby to term and then, in view of the old injuries to her pelvis and spine, give birth by Caesarean section. Faced with the decision as to whether to have an abortion or a baby, Frida considered that the first consideration—"and Diego says the same"—was her health. She then asked a series of questions, punctuated with factual assertions.

Would it be more dangerous to have an abortion or give birth? Two years earlier (in 1930) she had had a surgical abortion at three months; now it should be easier since she was only two months pregnant, so why did Dr. Pratt advise her to have the baby? Due to her "heredity" (her father's epilepsy), the baby would probably be unhealthy. Pregnancy would weaken her, and she was not strong. If she gave birth in Detroit, there would be "terrible difficulties" in travelling to Mexico with a new-

born baby. There was no one in her family to take care of her, and "poor little Diego, no matter how much he wants to take care of me, cannot," since he was busy. Diego was not interested in having a child, only in work, "and he is absolutely right." A child would prevent her from travelling with Diego, and that would cause problems. But if Dr. Eloesser agreed with Dr. Pratt that an abortion was dangerous to her health, she would have the baby. Or was Dr. Pratt worried because abortion was illegal? "One false move can take me to the grave," she concluded (followed by a sketch of a little skull and crossbones).

Before Dr. Eloesser had time to reply, Frida had made up her mind: she was going to have the baby. In other words, although the letter was heavily weighted in favour of an abortion due to the threat to her health, indeed to her life, she really wanted to have a child and, despite the danger and her husband's views, she could not bear to give up the chance. But once she had decided to go ahead, she ignored the doctor's instructions and everyone's advice, including Rivera's, and refused to rest in her hotel room. Rivera arranged for a young artist, Lucienne Bloch, to move into the suite with them and stay with Frida during the day, hoping that this would encourage Frida to paint. Instead Frida started to take driving lessons and kept as active as possible. The foreseeable consequence was the miscarriage of July.

Rivera has sometimes been accused, notably by Ella Wolfe, of having put pressure on his wife to prevent her from having a child, but the truth seems to lie elsewhere. Frida was herself convinced that childbirth would kill her: "One false move can take me to the grave." She had no fear of other, more major surgery, but was convinced that an abortion could threaten her life. In other words, it seems that the most enduring consequence of her road accident was psychological. Her memory of the pain she had suffered in her pelvis gave her an overwhelming fear of childbirth and gynaecological surgery. Her trauma was so deep that she even invented a horrific injury that had never taken place. All her life Frida Kahlo claimed that the steel rod that pierced her pelvis had passed right through her body. "The handrail went through me like a sword through a bull. . . . I lost my virginity," she told Raquel Tibol. But her boyfriend at the time, Alejandro Gómez Arias, who helped to pull her from the wreckage, says that this was not true: the handrail entered her body but did not leave it. In his opinion, she invented this sexual wound in order to explain to her family why she was no longer a virgin at the time of the accident. Perhaps she remembered how her father had once broken off contact with an older sister who had eloped. However, the fact that Frida

repeated this story with embellishments for the rest of her life suggests a
less calculating, subconscious explanation. Traumatised by her accident,
desperate both to have and not to have a baby but unable to overcome the
memory of pain, Frida refused an abortion but did what she could to pro-
voke a miscarriage.

In September 1932 Frida received a message that her mother was
dying, and she left the following day for Mexico City by train, taking Luci-
enne Bloch with her. "I adore you, my Diego," she wrote to him while she
was away. "I feel as though I left my child with no one and that you need
me." Rivera felt the same, and during her absence, since there was no
wife to cook him the dishes he loved, he switched to a diet of four
lemons, six oranges and two grapefruit a day, with a litre of vegetable
juice. He lost one hundred pounds, ending up looking very ill and resem-
bling an elderly elephant or a half-inflated barrage balloon. He had to
start wearing the clothes of Clifford Wight, his slim-line English chief
assistant. When Frida returned in October, Rivera met her at the railway
station and she failed to recognise him in his unfamiliar suit; when he
introduced himself she was horrified.

§ § §

WHILE HE WAS STILL WORKING in Detroit, Rivera had opened negoti-
ations with the Rockefeller family for another major project, this time to
decorate the lobby of the new Radio Corporation Arts (RCA) building in
Rockefeller Center in Manhattan. This ambitious scheme was to turn to
calamity within less than two months; it was to lead to one of the biggest
scandals in the history of twentieth-century art and terminate his career
as a muralist in the United States. Yet it started out in the most favourable
way.

Rivera and Frida arrived back in New York after eleven months in
Detroit in March 1933. This time there were to be no delays. Rivera under-
stood that he was dealing directly with hard-headed business people and
the building was falling behind schedule. The situation was very different
from Detroit, where Edsel Ford had been personally interested in art and
there had been Dr. Valentiner to mediate if necessary. Here the artistic
interest was provided by Abby Aldrich Rockefeller, who was not paying
for the fresco directly, and who did not even own the wall. And there was
to be no mediation. In fact, Rivera had to negotiate with the board of the
Todd, Robertson, Todd Engineering Corporation, managers of the Rock-
efeller Center development, who, with Raymond Hood, the architect,

were employed to oversee the project and who were the real power behind the scenes.

At the time of the RCA mural, the Rockefeller dynasty was headed by John D. Rockefeller, Jr., aged fifty-nine, ten years older than Rivera, at the height of his power, his father J.D. Sr. being by then aged ninety-four with only four more years to live. J.D. Jr.'s wife Abby Aldrich was not interested in politics, but she was interested in modern art, and in particular in presenting New York with the world's finest collection of it, and she had been one of the moving forces in endowing the city with MoMA, which had been opened in 1929. The Rockefellers had two sons, at that time old enough to be involved in business, J.D. III and Nelson. Nelson, then aged twenty-five, found his voyages across the family dominions constantly blocked by his older brother and was therefore seeking an area in which he could operate on his own. His mother's art interests provided one such area. The Rockefeller Center development was a huge project in the centre of Manhattan on a twenty-two-acre block of land occupied by rundown housing where all the leases had fallen in between 1928 and 1931. Part of the Rockefeller fortune, which came from the Standard Oil Company, was being steadily invested in property development, but property was a high-risk speculation in New York during the Depression. So many schemes were proposed for the site that J.D. Jr. brought in the Todd group as a partner, to be developers, managers, architects and builders. The Todds had already worked for the Rockefellers on a housing project in the village of North Tarrytown (now Sleepy Hollow), on the banks of the Hudson River, where their management had been criticised by local firms who objected to them accepting tenders above the lowest bid. The Todds were not visionary people. What they were good at was putting up skyscrapers and filling them with tenants. Rockefeller Center was important because of the scale of the construction and the fact that it was going ahead during the Depression. It was a striking act of faith in the capitalist system; it put all the Rockefeller prestige at stake. Sixteen management committees were set up; Nelson sat on seven of them and his older brother on six, but when Nelson showed any signs of taking his own initiatives, the Todds blocked his access to his father.

The fact that the Standard Oil Company was constructing nineteen large and handsome buildings in the centre of Manhattan between Fifth and Sixth Avenues struck Abby Aldrich Rockefeller as an opportunity to commission mural painting and she persuaded her husband to agree. Abby Aldrich was an enthusiastic admirer of Rivera, at that time widely reputed to be the most famous muralist in the world, although Rivera's

name was actually proposed by Nelson as a member of both the Rocke-
feller Center and MoMA boards. The original scheme, controlled care-
fully by the Todds, allowed for sepia murals in the entrance lobby, and
Frank Brangwyn and Josep Maria Sert were eventually engaged to pro-
vide these. Rivera was offered the most prominent position, directly
inside and opposite the main entrance, with a panel sixty-three feet long
by seventeen feet high. He managed to modify the original Todd specifi-
cation considerably, insisting on fresco, not a painting on board, and then
insisting on colour. Rivera communicated with Raymond Hood by writ-
ing in French from Detroit, but sent copies of everything to Nelson,
assuming that he was thereby leapfrogging a level in the hierarchy. He
never seems to have understood that the real power at Rockefeller Center
was the Todd group.

At first all went well. Hood accepted, rather reluctantly, the insistence
on colour, and a subject was agreed. It was to be *Man at the Crossroads
Looking with Hope and High Vision to the Choosing of a New and Better Future*,
a title that was far too long for its own good. It resembled the verbose
prose style of J.D. Jr., whose personal credo is engraved in granite outside
the completed building. This text suggests a close reading of the Ten
Commandments and the Apostles' Creed: number four is "I Believe in the
Dignity of Labour," and number five is "I Believe That Thrift Is Essen-
tial"; number ten is "I Believe That Love Is the Greatest Thing in the
World." God does not appear until number nine. A final preliminary
drawing was agreed with Hood in January 1933, before Rivera had even
viewed the site. When he did so in February, he altered his drawing, mak-
ing it politically explicit, with capitalism on one side as the evil choice and
Marxist socialism on the other as the virtuous one. This was an impudent
move and a colossal risk. It showed bad judgement, but there were rea-
sons to explain this fatal mistake.

Every calculation Rivera made was based on his fixed belief that
Rockefeller Center was run by the Rockefellers. Nelson, who was con-
stantly trying to increase his influence on the project, did nothing to dis-
abuse him. Rivera got on well with young Nelson, but it was his mother,
Abby Aldrich, whom he trusted. He knew her as an intelligent woman
with taste and sensitivity who had frequently asked him about his politi-
cal ideas and discussed his replies, in French. Frida, who spoke to Mrs.
Rockefeller in English, liked her and confided in her. "Concerning
Diego," she wrote to Mrs. Rockefeller from Detroit, "you know that he is
like a child. He is very angry with me. . . . He misses very much your
daughter's baby and he told me that he loves her more than me." On

March 6, 1933, Frida wrote to Mrs. Rockefeller sending her "many kisses" and saying that she would show her her paintings when she arrived. Earlier she had been enthusing over the photographs she had received of the Rockefellers' baby grandchildren. The fact was that the Riveras considered themselves to have become Abby Aldrich's family friends. This was particularly true of Frida, who had lost both a mother and an unborn baby in the previous year, and who was in need of friends. Rivera felt confident that he enjoyed a privileged position and would be able to count on whatever degree of freedom of expression he required.

At the end of March, immediately on arriving in New York, Rivera began to paint at the RCA Building, and in April, Abby Aldrich visited the scaffold and was entranced by the section already completed which showed the Soviet May Day demonstration; this was of course very close to the subject of the book of sketches she had purchased in 1931. The trouble started on April 24, when the *New York World-Telegram* printed a story under the headline "Rivera Paints Scenes of Communist Activity— and John D. Jr. Foots Bill."

Writing in 1992, the critic Carla Stellweg stated that the RCA Building mural was destroyed by Nelson Rockefeller because it had "incensed a public who found it anti-capitalist." But the facts were rather different. The New York press had started hunting for an angle on the next Rivera scandal as soon as he arrived. On April 2 the *New York Times Magazine* carried a piece by Anita Brenner saying, "Rivera has become a cause. . . . In Detroit if words were bullets the walls would by now be plowed beyond recognition. The age of science which he is to forecast and glorify on the main walls of the RCA tower building . . . represents also the emancipation of the artist from his studio . . . [in the future] his function will be serving industry and science as in other days Leonardo and Cellini served the Borgias and their God." In this scenario Rivera was Leonardo and the Rockefellers were the Borgias.

Brenner hinted at another of Rivera's preoccupations, which was how to reconcile his political beliefs with his North American public frescoes. In the Scrovegni Chapel Giotto had placed a scene of Enrico Scrovegni with the Virgin in a prominent position, even though Scrovegni came from a family of notorious moneylenders. And in Detroit it had seemed equally straightforward, Rivera's fascination with the machine and the visual splendour of industrial labour melding with Edsel Ford's love of art and creative role as a hands-on industrialist. And besides, Mr. Ford had been so pleasant; "he had none of the characteristics of an exploiting capitalist," as Rivera confided to Valentiner. "He had the sim-

plicity and directness of a workman in his own factories and was like one of the best of them." Edsel Ford, too, had won a prominent position in the fresco. But there had been those deaths at the gates of the Rouge, and Rivera had not reacted. In November 1932 Siqueiros had been refused permission to stay on in Los Angeles after painting an outspoken attack on "U.S. imperialism and racism." Had he, Rivera, by way of contrast, been no more than Mr. Ford's fig leaf in Detroit, and was he now playing the even more ignominious role of Mr. Rockefeller's barker in New York? Clearly not, as his RCA mural would make clear. There was no question of flattering the princes of Manhattan.

Having overestimated the role of the Rockefeller family, Rivera equally underestimated the role of the architects. He had only once before had to negotiate with an architect, but that had been in San Francisco and there had been no problems. It is clear from the correspondence that the Todd Corporation and J.D. Jr. were in complete agreement on the function of the murals: they were being installed in order to draw the development to the attention of prospective tenants. John R. Todd, president of the Todd Corporation, had earlier travelled to Paris to canvass Matisse and Picasso, but without success. J.D. Jr. had thought those two painters the most valuable "for advertising purposes." He did "not care much" for Rivera, but supposed he would be "a good drawing card" (for tenants). In these circumstances the potential for misunderstanding was considerable, and the story in the *World-Telegram,* even though it went on to describe the result as "a magnificent fresco," was all that was needed to alarm the Todds. Furthermore, it encouraged public interest in the work in progress; the atmosphere at the site became tense as crowds of Rivera's supporters gathered to watch him paint, some of them taking pictures, and the RCA security guards became more aggressive. One of Rivera's assistants was the artist Ben Shahn, and he described what happened next in a radio programme broadcast in 1965.

We were late and we really worked day and night on the thing . . . the other contractors were ahead of us and they were painting the ceiling and splotches of paint hit the fresco. The foreman paid no attention so a Mr. Hood from the architectural firm came over. And I had him on the scaffold to show him that these greasy spots of oil paint that they were painting the ceiling with, when they hit on the fresco spread the oil, you know. And he was very upset. As he looked around he said, "Who's there?" very casually, as he looked down and sort of directed. "Who's that, Trotsky?" And I said, No, Lenin. And then the fun began.

Lenin had not been part of the preliminary cartoon.

The Todds asked Nelson Rockefeller to intervene, and on May 4 he wrote a friendly letter to Rivera saying that the portrait of Lenin "might very easily offend a great many people," that it was in a public building, and that "I am afraid we must ask you to substitute the face of some unknown man where Lenin's face now appears." Shahn recalled that Rivera was very confident that, as in Detroit, he would be able to ride out the storm. After all, he had the older Rockefellers on his side, and only the previous month Nelson Rockefeller had written to him, welcoming him to New York and adding, "We all felt so badly about the discussion which followed the opening to the public of your murals in Detroit." Claiming that the figure of Lenin *had* been present in the original picture, he nonetheless offered to make a radical change, leaving Lenin where he was but removing the scene of the society bridge party on the opposite side and inserting, "in perfect balance with the Lenin portion, a figure of some great American historical leader, such as Lincoln." In other words, he was offering to restore the choice facing man in the fresco to the two paths of a North American or a Soviet model of the future. Capitalism would no longer be shown as simply a form of social evil. Rivera made this offer in a letter to Nelson Rockefeller dated May 6, but he never received a reply. Instead the Todd organisation, increasingly unhappy about the situation, realised that an opportunity had arisen to break the contract with Rivera on the grounds that he had changed the design without consultation. Hugh Robertson, a member of the Todd board, wrote to Rivera on May 9. The letter was not hostile but it had an ominously inflexible tone. The letter implicitly rejected the Lincoln offer, and it made no mention of Lenin. Instead Robertson stated that the preliminary "sketch" had led the managing agents to believe "that your work would be purely imaginative"; there had been no hint that the work would include "any portrait or any subject matter of a controversial nature." This objection, of course, went far beyond the reference to Lenin. It argued that Rivera's mural had to be entirely apolitical. The Todds were looking for a rupture, not a compromise. The letter was delivered by hand by Frances Flynn Paine, Rivera's agent in New York, and when she had to report that it had not had the desired effect, Robertson decided to visit the scaffold in person. Shahn described the scene that followed.

One day [it was May 9] Rivera and I were on the scaffold alone and some people came in. They had changed our scaffolding from a fixed scaffolding to a moveable

one on wheels, and some people came in and put a check on the scaffold and said, "Mr Riviera [*sic*], we'll have to ask you to stop." I don't know who the gentlemen were [they were led by Hugh Robertson, secretary of the Todd Corporation]. And when he said he wouldn't they just called some men over and they just moved our scaffold and so Diego being kind of dramatic . . . That was the end.

Rivera was invited to descend, handed a cheque for the balance of his fee, $14,000, and instructed to stop work. Shahn and Rivera were ushered out of the building without being able to take their tools with them. The news spread quickly, and that evening about three hundred angry people, described in the *Herald Tribune* as "Communists," were dispersed from around the building by mounted police. By then the fresco had been hidden from view behind a large screen. The Todd Corporation put out a statement saying that Rivera "would be permitted to finish the work" when he agreed to make "certain changes in the mural to bring it into closer alignment with the architectural scheme."

In fact, the Todds did everything possible to prevent a settlement from being reached. Nelson Rockefeller played no part in the later negotiations—the Todds dealt directly with his father—but there was the influential critic Walter Pach, a friend of Eli Faure's, who was well known to Mrs. Rockefeller and who tried to intervene. Rivera had asked for his help on the morning of May 10, and Pach tried to get permission from J.D. Jr. for Rivera to finish the fresco and for a limited number of people to be allowed to view it before a decision was made. Dr. Valentiner, who had visited Rivera on the scaffold shortly before it had been wheeled away, had found him in a conciliatory mood. He had apparently realised that he would have to give way, and had even told Valentiner that "he would have been glad to remove the head of Lenin and substitute one of Lincoln." Unfortunately, Rivera's conciliatory impulse was stifled by his fiery New York assistants. The English team of Clifford Wight and John Hastings had moved on to Chicago, where, according to Wight, Hastings and Cristina had employed a university professor to "teach them Marxism." Rivera was now assisted by three hard-line Marxists: Ben Shahn, Lucienne Bloch and Steve Dimitroff. They threatened to go on strike if Rivera gave way on Lenin's head, so causing the artist to hesitate, faced with what had become an impossible dilemma. Once again the Todds acted decisively. An internal Rockefeller memorandum, dated May 12, reads:

Memo for Mr. Nelson—from his Father

The following is the message which Mr. Debevoise and I agreed it was wisest for Mrs. Rockefeller to send to Pach who wrote her yesterday about Rivera:

"Your letters May tenth and eleventh to Mrs. Rockefeller have been referred to the Managing Directors of Rockefeller Center."

Mr. R. Jr. says this is the type of message which Mr. Nelson, Mrs. Rockefeller and he himself should send to anything that needs a reply. . . .

Meanwhile the Todds were doing what they could to make matters worse and to provoke a final rupture. While Pach was trying to reach Mrs. Rockefeller, a Todd official sent a note to Rivera on May 11 telling him to clear his tools and other property out of the building; this was of course two days after they had prevented him from taking them away. Faced with this provocation and the brutal manner in which he had been removed from the scaffold, Rivera lost his head. He had from the start been trying to defend two distinct positions, achieving the mural and protecting his political reputation. With the mural beyond his grasp, he concentrated on his reputation. The affair had become a cause célèbre in the worlds of both art and politics. At a public meeting in New York on May 13 which was widely reported, Rivera proclaimed that he had come to the United States as "a spy," and that at Rockefeller Center, "having won the confidence of my employers, I set out to create a fresco expressing the Communistic theory of life." "This idea seemed to amuse both himself and his audience," wrote the *Herald Tribune*'s reporter, "and both had a good laugh at it."

While J.D. Jr. was being publicly mocked in this way, the Rockefellers were receiving letters of support from all over the country. "I cannot restrain an expression of my admiration for the very courageous and patriotic spirit displayed by you in your recent rejection of the mural. . . . You have given an inspiring example to all good Americans who believe in the superiority of our institutions," the chairman of the National Association of Manufacturers wrote to Mr. Nelson. On May 19 J.D. Jr. finally broke his silence. He said that Rivera was supposed to be working in harmony with Sert and Brangwyn but that he had departed completely from the original plan. "A few days ago he stated that his work was red propaganda," noted Rockefeller, and was there "to further the doctrines of Communism. . . . Nevertheless Señor Rivera was paid in full for his work, although it will never be seen." By this time it was clear that the breach between Rivera and Rockefeller Center was unbridgeable. The Todds' tactics had been a complete success. Worse, because of the public row, Rivera had also lost his next public contract. On May 12 he had received a telegram from Albert Kahn, who had been appointed architect of the

General Motors Building at the Chicago World's Fair, cancelling Rivera's newly agreed commission to decorate that. It began to dawn on Rivera that as a painter of public murals in the United States he was finished. The process had taken less than a week.

In his *post facto* justification of his actions Rivera steadily insisted that the plan to include a portrait of Lenin had been part of the original sketch, but on this point at least it is clear that he was at fault. Bertram Wolfe, who translated his letters into English during the negotiations, later, in private, described this claim as "patently mendacious." The original sketch does contain a half-hidden face, wearing a cap and partly concealed by the body of a soldier, but in the finished mural this face has risen like a full moon, the cap has disappeared, and the great bald dome of Lenin shines out, casting the soldier and other surrounding figures into the shade. It seems clear that Rivera concealed Lenin on purpose in his preliminary design in order to mislead his patrons and to be able to argue that he had not changed the design, a stratagem that has a certain childish charm. In the event, it merely allowed the Todd organisation to argue that the artist had shown bad faith.

Rivera hung on in New York for seven more months. He had risen so high and the fall had been so sudden. From the enchanted meeting in San Francisco to the standing ovation in Detroit, where his political commitment had been in delicate balance with the brutal realities of his patronage, to the ultimate calamity when he had handed a lit match to men who were merely looking for a pretext to blow him off the scaffold, had been a period of only thirty months; hubris had destroyed his anticipated triumph in "Gringolandia." In Detroit his real patron had been Edsel Ford, a lover of his work who was also a genuine force in the company. Henry Ford, the remainder of the company force, was less interested, but he was a robust, self-confident man, regarded as an innovative genius and as one of the founders of North American capitalism; he himself was given to eccentric intellectual speculation and he respected creative talent. Challenged by self-important special interest groups, the Fords could suit themselves. After all, in Detroit Rivera was not painting the product—the cars remained black—whereas that was exactly what he was doing in Manhattan. When Rivera threw an overtly Marxist statement into an equation that already included the "juniority" of Nelson, the highly speculative nature of the Rockefeller Center development and the philistinism and one-track determination of the Todds, the cancellation became almost inevitable. Rivera's failure to analyse the subtle distinctions in the capitalist system was echoed by Frida, who told a New York reporter in

June, "The Rockefellers knew quite well the murals were to depict the revolutionary point of view. . . . They seemed very nice and understanding about it and always very interested, especially Mrs. Rockefeller." By then Nelson Rockefeller had left town for Mexico, where he was intent on buying a large quantity of "folk" art. No doubt Mrs. Rockefeller was mortified by the turn of events, but there is no doubt either that the steel shutter that divided the areas of Rockefeller business from Rockefeller culture descended with its usual, well-oiled speed in the collective Rockefeller mind.

The angrier and more widespread the protests became, the less likely the Rockefellers and their managing agents were to relent. On May 16 there were student demonstrations outside the Rockefeller town houses on West Fifty-fourth Street, and in the Marxist nether regions of Manhattan the protests continued at regular intervals; there was also nationwide newspaper comment, which was pretty evenly divided. Among fellow artists the initial indignation was strong, but it did not last. On May 24 Henri Matisse, passing through New York, was interviewed by the *Herald Tribune* but had little to say to comfort his former friend. "Rivera probably considers himself the greatest painter in the world," said Matisse, "but propaganda has no place in art. Art should rise above politics and the realities of one little epoch. Art is an escape from reality. . . . I do not agree with Mr. Rivera that every art must have its political viewpoint. There was a time for that back in the Middle Ages. Then there were no newspapers [and] images painted on walls were the chief sources of expression and entertainment. Art can afford to rise above that now."

As the year progressed, Rivera became steadily more depressed. He addressed a series of public meetings but began to take refuge in his old habit of storytelling. The Art Students League were fascinated to hear that it was Rivera who had introduced the work of *le Douanier* Rousseau to Picasso, whereas it had in fact been the other way round. In July Rivera mustered sufficient energy to start work on a new series of frescoes for the "New Workers School," a loft near Union Square on a site which Wolfe described as "a crazy ramshackle old building" due to be demolished. Here Rivera made twenty-one paintings on movable panels entitled *Portrait of America*. They started with Colonial America and ended with a portrait of Hitler and were generally considered to be didactic and uninspired, the work of an artist who seemed to have lost his bearings. Thirteen of the frescoes were eventually destroyed by fire in 1969. Rivera finished this series in December, just before he left New York forever. He received no fee for this work and used what was left of the Rockefeller

money to pay for his assistants and materials. Of the $21,000 the Rocke-fellers had paid, $6,300 had gone to Frances Flynn Paine in agent's com-mission, the first time Rivera had to pay an agent for a mural. Rivera had paid a further $8,000 in wages and materials. Despite his decision to spend the balance on making the New Workers School murals and then to donate the paintings to the building's owners, an anti-Stalinist Marxist group led by Bertram Wolfe—who had by now left the party—Rivera was in due course to be accused by the Communist Party of profiteering from his time in Manhattan.

As his artistic assault on the United States petered out in a tumble-down firetrap on the Lower East Side, Rivera's relationship with Frida, now rather bizarrely known as "Carmen," her previously unused second name, deteriorated sharply. Frida told one reporter who asked her at this time how she spent the day, "Make love, take a bath, start again. . . ." This was bravado; she and Rivera had had few sexual encounters since her mis-carriage in July of the previous year. Rivera responded to this situation by starting an affair with one of his New York assistants, Louise Nevelson. Apart from this diversion, it was a discouraging time. Lupe came to stay with Frida and Diego in an apartment they had taken on Thirteenth Street; she was on her way back to Mexico from Paris, which she had been visiting at Rivera's expense. She brought him news of Angelina Beloff and of Marika, the daughter he was never to see again. Lupe said that Marika was "a child who, one can see, has never been happy."

Meanwhile Rivera and Frida were engaged in the first fundamental disagreement of their marriage. It had nothing to do with his repeated infidelities, which his wife generally tolerated without complaint, but with the fact that Frida was increasingly anxious to return to Mexico. She had had almost four years of "Gringolandia" and it was enough. Rivera, on the other hand, had developed an overwhelming aversion to the idea of returning to his native land. His pride would not allow him to go back with his tail between his legs, having been whipped by the Rockefellers. He had invested too much in the hope of building a Pan-American pro-gressive movement, and in turning the greatest industrial democracy in the world towards socialism, to want to limit himself to the national poli-tics of Mexico. The Riveras' quarrels became violent and self-destructive, Rivera going so far as to cut one of his paintings to pieces with a sharp knife; it was a picture of cacti in a Mexican desert, and as he cut it up he shouted, "I don't want to go back to that."

For all his bravado and apparent determination to fight on, some-thing broke in Rivera when the Todd security men wheeled his scaffold

away from the wall in Rockefeller Center. He already knew that Soviet Communism would never allow him the freedom to paint; now he knew that U.S. capitalism was just as inflexible. The path he had mapped out during his conversations with Elie Faure in Paris in 1920 was blocked forever, for him "the second Quattrocento" had come to an end. He no longer believed it was possible to change the world by painting walls in Mexico. Mexico was locked in, Mexico was lost. As Frida put it in a letter to a friend in California, in Mexico "the people . . . always respond with obscenities and dirty tricks, and that is what makes [Diego] most desperate since he has only to arrive and they start attacking him in the newspapers, they have such envy for him they would like to make him disappear as if by enchantment." Indeed it was worse than Frida stated. Even when he was abroad, his enemies in Mexico responded in this way. At the height of the Rockefeller controversy the *Herald Tribune* rather gloatingly reprinted attacks on Rivera appearing in the Mexican press. *Excelsior* had written that because Rivera had accepted a commission from the U.S. ambassador at Cuernavaca, he was "more of a merchant than any Israelite." The writer added, "Rivera is a painter of ugliness" because "nature did not grace him with white skin and blue eyes so he avenges himself by painting hideous types." It was a vivid reminder of everything in Mexico Rivera wanted never to have to deal with again.

Rivera wanted Frida to take the blame for the decision to return, but in the end there was no need to decide. By December his Rockefeller money was spent and he had no further means of support. His last payment of $7,000 from Detroit had reached him in July; now even that was gone. His assistants and other friends such as Aaron Copland and Walter Pach threw a party, had a whip-round and paid for tickets for Rivera and Frida to sail on the SS *Oriente* for Veracruz, via Havana.

Rivera left New York on December 20, at which time negotiations, conducted by Nelson Rockefeller (who had returned from his Mexican trip with twenty-six crates of ceramics and textiles), were under way to transfer the unwanted fresco from the wall of the RCA Building to the nearby Museum of Modern Art. The president of the Todd Corporation, John R. Todd, with characteristic vision, stated in a letter to Nelson that there would be no objection, provided that MoMA paid all removal costs and did not damage the elevator system. Nelson Rockefeller proposed on December 16 that Rockefeller Center should advance the money to the museum and that the museum should raise the sum by charging admission. It was agreed that nothing should be said at this stage to Rivera about this scheme or about the possibility of his being asked "to touch up

and finish the work." These negotiations came to nothing, and on February 10 and 11 of the following year workmen under the orders of the managers of Rockefeller Center pulverised the plaster on which Rivera's fresco had been painted, using axes. The work was done stealthily, at midnight on a Saturday, "so as to cause no inconvenience to tenants." Abby Aldrich Rockefeller later told Dr. Valentiner that the frescoes "would not have been destroyed if the architects had not insisted upon it." A Todd spokesman explained at the time that "structural changes had necessitated the removal of the painting." When his Detroit frescoes had been threatened with destruction, Rivera had written, "If [they] are destroyed I shall be profoundly distressed . . . but tomorrow I shall be busy making others, for I am not merely an 'artist' but a man performing his biological function of producing paintings, just as a tree produces flowers and fruit. . . ." But when he was trying to save his portrait of Lenin in Rockefeller Center, Rivera had written to Nelson Rockefeller, "Rather than mutilate the conception I should prefer its physical destruction in its entirety, but preserving, at least, its integrity." This comment, taken out of context from a letter in which Rivera was in fact trying to negotiate the salvation of the work, was now retrieved by John R. Todd from Hugh Robertson's files, where Nelson Rockefeller's correspondence on the fresco was kept, and widely publicised to justify the act that capped the Todd Corporation's trusteeship of Rivera's work. When Rockefeller Center announced what it had done, the original controversy over the fresco was revived and became even more heated. A private citizen writing to John D. Rockefeller Jr. from Newport, Virginia, summed up the views of Rivera's supporters. "About midnight last Saturday," he wrote, "your family achieved a little measure of immortal fame. . . . As long as the towers of Rockefeller Center stand, they will stand as a grandiose and mocking monument to this piece of vandalism." The men who smashed the wall continued to prevaricate on the subject for many years. In 1942 Hugh Robertson was still denying that "the mural was removed on account of the fact that it portrayed the head of Lenin." And many years later Nelson Rockefeller, reminiscing about the affair, was unable to remember whether the objectionable head in question had been that of Lenin or Trotsky. It made no difference to Rivera either by that time; when he left Manhattan his international career as a revolutionary muralist was over.

PART FOUR

THE LAST DREAM

A BED TOO FAR

Mexico 1934–1936

O N RETURNING TO MEXICO in January 1934, Diego Rivera became ill with anxiety, frustration and disappointment. A letter from Albert Einstein sent from Princeton, New Jersey, expressing "profound admiration" failed to encourage him. His depression reached its lowest point in February when he learnt that the Rockefellers had destroyed his wall; only twelve months earlier he had seen the RCA Building for the first time, he had been on the verge of completing his work in Detroit, he had been "on the roof of his life" without knowing it. Then he had been forced back into the nightmare landscape, as it seemed to him, after all the hope and promise he had found north of the border. He was not alone in this reaction. Evelyn Waugh wrote four years later of "a country where the most buoyant feel crushed by the weight of sheer, hopeless wickedness" and noticed "the sense of doom which lies over the brightest places." Now Rivera was once again trapped in that past which had never burdened the United States, and in that country, his own, where he could be abused for looking Mexican. It was nonetheless reactionary and undemocratic Mexico which continued to offer him the freedom of its walls, whereas in the country dedicated to freedom his work had been censored and obliterated, as Luis Cardoza y Aragón has pointed out.

Rivera remained ill for much of the year, the beginning of a long period of ill health that was to end in 1936 when a doctor traced his problem back to his Detroit diet and ordered him to be "reinflated and not disinflated again under any circumstances." He was, in any case, habitually dejected when he returned to Mexico. "When he arrives . . . he is in a devilish bad humour until he acclimatises himself . . . to this country of craziness," Frida noted. He could be cured by a particularly delicious

duck *mole* or a beautiful stone idol. In 1934, as the months passed, he rec-
onciled himself to his situation by first sketching and then painting Indian
subjects and landscapes; by the end of the year he was even able to paint
new water-colours of cacti in the Mexican desert, the subject of the can-
vas he had attacked with a knife in New York. And he drew further
courage from a visit to Tehuantepec. He began to be absorbed once more
by "the mixture of beauty, grief, oppressed strength and black humour
that seethes and burns in this country."

One of the first drawings Rivera made on his return to Mexico was a
charcoal portrait of Frida's sister, Cristina, who had been deserted by her
husband in 1930 and was looking after her father and her children in the
Kahlo house, the Casa Azul in Coyoacán. Cristina had of course been the
much-admired model for the nude studies in the ministry of health which
Rivera had made in 1929. Rivera now felt strongly attracted to her once
again, and shortly after his return he and his wife's younger sister, who
was also Frida's closest friend, started an affair. Rivera's motives may have
included the desire to punish Frida for leading him back into the trap, the
sticky spider's web of Mexican society—that is what she herself con-
cluded—or it may have been pure self-indulgence; Frida underwent
another abortion at three months in 1934, after which she was advised to
abstain from sexual intercourse for a period of time. More than any other
act, the relationship with Cristina was responsible for the "sadistic" view
of Rivera's relationship with Frida, the notion that there was something
about the marriage that was reminiscent of the little boy in Guanajuato
who once opened a live mouse with a blunt knife to see how it worked.
Hayden Herrera, in her biography *Frida,* suggests that there was no "mal-
ice" in Cristina's betrayal of her sister, although Herrera gives no evi-
dence to clear Cristina of all responsibility. The affair started in 1934 and
continued until at least 1936, and possibly longer. It was discovered by
Frida in the autumn of 1934, and the discovery ended the first phase of the
Riveras' marriage. Once Frida had recovered from the shock, she decided
that she would thenceforward enjoy the same sexual freedom as her hus-
band. He had tolerated her and been amused by her intimacies with other
women, but he was not prepared to accept her adventures with other
men, which drove him into a jealous rage. Paradoxically, Frida's ability to
make her husband jealous whenever she wished did much to keep their
unusual marriage alive in the years to come. But the immediate effect was
less stabilising. Rivera set Cristina up in an apartment on the Calle Floren-
cia in the Zona Rosa, one of the pleasantest and most animated parts of
the city centre; later he bought her a house in Coyoacán. And when

Rivera's sexual infatuation with Cristina continued into 1935, Frida left the new house they had built to share in San Angel and moved into an apartment of her own. In the summer Frida went to New York, a city where she could lead her own life, unthreatened by her husband's pistol. She stayed with the Wolfes, cut her hair short like a boy's, wore fashionable clothes and was altogether a different character from the "Frida Kahlo de Rivera," alias "Carmen," who had managed Diego's correspondence and sat listening quietly to his revolutionary rhetoric on her previous visit eighteen months earlier. Although she continued to see Rivera, she remained unofficially separated from him for most of the year; she made no announcement to her friends since she did not want anyone to know the reason for her decision to leave the house. The fact that Rivera had had an affair with Cristina eventually became widely known in Mexico City but was never published until after his death, and even in his autobiography he remained untypically discreet, referring only to "an affair with [Frida's] best friend."

In April 1934 John and Cristina Hastings visited Rivera, which cheered him up. On their departure he had to ask a friend in the finance ministry to release their paintings and drawings, which had fallen into the clutches of an acquisitive customs official. By November Rivera had reacclimatised himself sufficiently to his homeland to start work on a reconstruction of the pulverised RCA mural on a wall offered to him by the Mexican government on the second floor of the Palacio de Bellas Artes. Rivera executed this work very quickly and succeeded in re-creating something of the spirit of his earlier fresco on a slightly smaller scale. There were a few changes: the title was now *Man, Controller of the Universe;* Lenin naturally stands out as the most prominent figure apart from the central controller, a blond, blue-eyed gringo looking something like a B-21 bomber pilot. And the bridge party, which balances Lenin, representing the evil choice, and which Rivera had offered to abolish in favour of Abraham Lincoln, is back, but this time the card players are joined by a disobliging study of J. D. Rockefeller, Jr.'s head, placed just beneath a magnification of some syphilis bacteria and below a mass of troops moving forward to support the forces of reaction. The picture includes several references to Rivera's own life and previous work. There are the virtuous masses, marching in disciplined ranks, from Moscow; a worker sitting with snap pack on a section of steel pipeline, from Detroit; and portraits of several friends, including Bertram Wolfe, who has been promoted to stand between Trotsky and Marx. A humorous detail is provided by the reference to Charles Darwin, never entirely a figure of scientific authority for

Rivera, who is made to resemble both the X-rayed skull and the bearded ape he stands between. But there are significantly few Mexican references in this picture: just a hairless dog, a parrot and a rubber tree. It is a large piece of Rivera's North American vision transposed, against its will, to Mexico, and that partly explains why in the Palacio it looks so out of place. This picture was never conceived for a Mexican wall or a Mexican public; on the second floor of the Palacio, where it is seen by no one except people who have entered the building to pass the time or look at pictures, it serves to do little except decorate the walls. In its original site *Man at the Crossroads* was raising a Marxist question in a temple of capitalism and might have been expected to evoke a response in the millions of people who entered the Rockefeller complex to work or rest. And there is another problem, to do with the structure of the massive art nouveau edifice conceived during the *Porfiriato*. The galleries on the second floor are divided by pillars, two of which obscure the wall allotted to Rivera. Orozco and Siqueiros, in neighbouring murals, have overcome the problem of the pillars by placing gigantic human figures at the centre of their compositions; the pillars thereby become an irrelevance since they fail to interrupt such grandiose schemes. But Rivera was obliged to reproduce what had been designed for a different site, and the crowd of detail on his wall tends to be lost behind the interruptions.

There are further reasons to suspect that *Man, Controller of the Universe* was destined to be a less successful work than the Detroit murals, even had it remained in Manhattan as *Man at the Crossroads*. In Detroit one of Rivera's assistants, Lucienne Bloch, had asked him why he waited two or three hours after he had been told that the plaster was ready before he came to the scaffold. He replied that "he was making difficulties for himself because if he had too much time, he had a bad habit of making his work too slick. Working under pressure made him paint better. . . ." *Man, Controller of the Universe* was not painted under pressure. It fails not only because of its inappropriate setting but also because it was a reconstruction: it has something of the flat effect of a witty remark which has to be repeated because no one heard it the first time. And yet, there is something about the great blond figure at the lever of his science fiction machine, controlling the universe, that intrigues and draws the crowds back for another look. Despite the deadly struggle taking place in the background, there is a high-spirited, even good-humoured air about it. Perhaps it is the unexpected choice of a gringo to control the universe from a wall in Mexico City; perhaps it is the artist's evident delight in fan-

tastic machinery, or the optimism that forms an essential part of Rivera's simplified vision of the future.

For the following five years Rivera's professional life was dominated by his attempt to make a political comeback. Once he had finished work at the Palacio he returned to the staircase of the National Palace to work on the south wall, where he completed his history of Mexico from the Aztec world, through the period of the Conquest, to the final panel entitled *Mexico Today and Tomorrow*. This was a bold choice of subject because for the first time Rivera decided to portray the reality of Mexican politics under the *Maximato* since the Revolution. The final panel of the staircase in the National Palace shows the Mexican people being exploited by their new rulers; the exploiters wear Mexican costume, and the armed uprising is taking place in the streets outside the Palace itself. By placing the figure of Karl Marx at the top of the picture, pointing the way to a peaceful and socially harmonious future, Rivera carried through his original scheme and insisted on a Marxist interpretation of Mexican history. This was to be his last truly Marxist mural, and Rivera's timing was excellent. After the international furore that had attended the censorship of the Rocke-feller mural the Mexican government could hardly object to the political content of the south wall of the staircase in the National Palace. The government, led by a new president, Lázaro Cárdenas, did not object. But it showed its disapproval in a more effective way. Rivera completed the south wall on November 20, 1935; he was offered no more public walls in Mexico for the following six years, and he was replaced as the most prominent official muralist in Mexico by José Clemente Orozco, who returned in 1934 from seven years' exile in the United States and proceeded to execute much of his finest work in Guadalajara and in public sites, including the Supreme Court, in Mexico City. In an insulting form of compensation, Rivera was appointed "technical director" of a series of public murals commissioned from other artists for the newly completed central food market.

Rivera's only other mural during this period was intended for a private site: the banqueting-hall of the Hotel Reforma, a new development in the Zona Rosa undertaken by the Pani family. The admiration that Alberto Pani, now a politician, had first shown for Rivera when he was ambassador in Paris had not diminished, and he stepped into the breach and attempted to provide Rivera with a site that would be nearly as prominent as the Palacio. The theme agreed for the work, four panels each roughly four metres by two metres, was "Mexican Festivals," since

so many of the hotel's guests were likely to be wealthy tourists. Rivera painted four superb frescoes with the title *A Burlesque of Mexican Folklore and Politics*, but he used the theme to continue his work on the south wall of the National Palace staircase—that is, to attack the corruption and greed of contemporary Mexican politics. In two of the panels Rivera fulfilled the terms of his commission and provided illustrations that, however forceful and striking they might be, were also suitable to decorate a tourist hotel. *The Dance of the Huichilobos* shows Indians in traditional costume dancing in front of a small-town bar; they represent the genuine indigenous culture of Mexico, untouched by tourism. And *The Festival of Huejotzingo* shows what is essentially a battle scene from the War of the French Intervention, a celebrated horseman and *guerrillero*, Agustín Lorenzo, charges some rather laconic-looking French Zouaves. It is one of Rivera's most successful evocations of the archetypal Mexican hero, the mounted gunman at full charge. But in *La dictadura* Rivera showed a street carnival dominated by a gigantic papier-mâché Judas representing corrupt politicians and accompanied by another dancer who was a caricature, the much-hated figure of former President Plutarco Elías Calles, who had ruled the country since 1924; around him dance braided officers, a general who is pilfering fruit from the basket carried by Miss Mexico, mitred bishops, a corrupt radio commentator and an opulent reveller waving a banner composed of the U.S., British, Japanese, Nazi and Italian flags. And in the final panel, *México folklórico y turístico,* Rivera portrayed the corruption of his country's culture by tourism. At the top of the picture a smartly dressed fair-haired woman, *"la clásica turista gringa,"* presides over a superbly composed assembly of carnival masks and costumes. Vacuous pleasure prances side by side with naked greed; at the bottom of the picture a skeletal figure appears with the word "Eternity" written on its skull.

As he finished the last of these frescoes Rivera must have been pleased with their quality; if it was a provocation, it was a splendidly executed one. But the Panis were not happy. They accepted the frescoes, delivered on movable panels in 1936, and paid for them in full. Alberto Pani then arranged for his brother, Arturo, to alter Rivera's work. The U.S. flag was removed and the face of the dancing figure resembling Calles was also changed. To those who accused him of yet again biting the hand that fed him, Rivera could plead a respect for both artistic integrity and his known political views. He therefore objected to the changes and won his case; altering a work of art without removing the signature was ruled to be forgery and Pani was heavily fined. Unfortu-

nately, he still refused to display the frescoes in his hotel, and they were eventually sold to Rivera's Mexican dealer, Alberto Misrachi. All four panels are now displayed in the Palacio de Bellas Artes, but for many years they disappeared from circulation. So ended Rivera's attempts to influence the politics of Mexico by painting walls. The man who had a serious claim to be regarded as the greatest muralist alive was now denied the surfaces he needed in the Soviet Union, the United States and his native land. Supporters of the caudillo, Plutarco Elías Calles, had sprayed acid on his final panel in the National Palace, and in the ministry of education his work had been insulted: the arcades he had decorated were now being used as a dump for scrapped cars.

Throughout 1936 Rivera was once more in poor health. He went into hospital on several occasions with a succession of kidney infections, developed a phobia about going blind and underwent operations on both eyes. On April 25 he wrote to John Hastings, mentioning that he and Frida were in the same hospital. The letter concerned arrangements for an exhibition at the Tate Gallery which Hastings had been trying to arrange and which the gallery had agreed, in March 1935, to hold during the course of 1936. There were financial problems, even though Rivera had offered to help with the costs by painting frescoes to accompany the exhibition and presenting the largest one to the Tate. But negotiations eventually broke down and the exhibition never took place, thanks mainly to the bumbling incompetence of the Tate's director, J. B. Manson, who wrote to Hastings at one point to say, "I must confess finance had not occurred to me." So Rivera lost the chance of finding a new international public, and London lost the chance of being presented with a major work by the world's greatest muralist. In his letter to Hastings Rivera added:

Frieda [sic] is terribly eager to go to London, not within the next year or two but within the next day or two, if that were possible, to see once more her "cuate" Cristina, your wife, of whom she speaks to me constantly, and to see Europe and to travel all over it with her. Naturally, that doesn't mean that we will let them forget us. But, as you know, when they are together Frieda and Cristina will find the most wonderful freaks in the world who will surely please them more than you and I. Frieda has done some magnificent paintings recently; although they get smaller and smaller, they get more and more interesting and intense.

In fact, his relations with Frida were on a dangerous edge, and she had painted almost nothing since her discovery of Rivera's affair with her sister. While in New York in 1935, she had decided to forgive "Cristi" and had

also written Rivera a peace-making letter in which she had said: ". . . All these letters, liaisons with petticoats, lady teachers of 'English,' gypsy models, assistants with 'good intentions' . . . only represent *flirtations,* and at bottom you and I love each other dearly. . . . In the end I love you more than my own skin and though you may not love me in the same way, still you love me quite a lot. . . . I shall always hope that that continues, and with that I am content." In this letter Frida carefully avoids the real wound, treating the affair with Cristina as though it were over, which it was not. She also placed herself in a dangerously vulnerable position since she made it clear that she loved Rivera more than he loved her and that she accepted that. This was a recklessly honest admission for a woman to make when involved with someone as selfish as Rivera. That year Frida painted a portrait of herself in modern clothes, "out of the dream," with short, curly hair, the sort of clothes she wore for her visit to New York. She also painted a horrifying study of the bloody murder of a woman by her lover with a knife, entitled *A Few Small Nips.* Herrera has suggested that in identifying with the victim of this crime, Frida was expressing her anguish over the situation between her husband and her sister, but there could be a more direct explanation. In August, five weeks after writing her love letter to Rivera, Frida wrote to another revolutionary muralist, Ignacio Aguirre, saying: "I wish I could be so pretty for you! I wish I could give you all that you have never had, and even so you wouldn't know how wonderful it is to be able to love you. I will wait all the minutes until I can see you. Wait for me at 6:15 on Wednesday. . . ." Frida was not just passively undergoing her husband's sexual obsession with her sister. She too had fallen in love, and was no doubt considering how this development might be used to activate Rivera's violent jealousy. Arousing Rivera's jealousy would be one way to bring him back, but at the same time she was frightened of his physical violence, either against her or more probably against Ignacio Aguirre. This would explain why the preliminary drawing for *A Few Small Nips* bore the words of a popular song, "My sweetie doesn't love me any more" ("because she gave herself to another bastard, but today I snatched her away, her hour has come"). Although there is no record of Rivera using violence against Frida, he was certainly capable of using it against her (male) lovers. While conducting an apparently sincere love affair with Aguirre, Frida had also been enjoying a fling with the Japanese-American sculptor Isamu Noguchi. Rivera found out about Noguchi and threatened to kill him, at one point chasing him over the roof of the Casa Azul. Frida's hairless dog had run off with one of Noguchi's socks when the sculptor was trying to get dressed in a

hurry. Noguchi was in Mexico on a Guggenheim grant at the time. But Rivera never found out about Ignacio Aguirre. Because of Rivera's unpredictable reactions, Frida always tried to conceal her affairs with men from her husband; this was not always easy, as she was to have affairs with at least eleven men between the summer of 1935 and the autumn of 1940.

Rivera meanwhile was carrying on as usual with as many attractive women as came his way. Despite the pain he was caused by Frida's infidelities it never occurred to him to curb his own. In 1935 he painted a portrait of Frida wearing Indian braids, her face puffy and swollen with tears. Curiously, he chose to execute it in the time-consuming medium of encaustic. At the same time he had painted Cristina on the south wall of the National Palace, placing her in the key position in this huge fresco and showing her in a smart red and black cocktail outfit that he would certainly have paid for himself. There is also a picture of Frida, but standing behind her younger sister, dressed in sombre clothes and, to turn the knife in the wound, partially obscured by portraits of Cristina's two young children, Isolda and Antonio.

Frida's final reaction was both positive and successful. She virtually adopted the children—Isolda said that she lived with Diego and Frida from this period on—thereby making up her quarrel with Cristina even before the situation with Rivera had been resolved. He continued to live on his side of their divided house at San Angel; Frida had her own apartment on the Avenida de los Insurgentes in the centre of town; Cristina also had her own apartment, also paid for by Rivera, not far away on Florencia Street. The Casa Azul, where Cristina's children lived with their grandfather, was neutral family territory at first, while Frida was conducting her affair with Ignacio Aguirre in a different part of the city centre at his apartment on the Puente de Alvarado. Then, when Cristina continued to go to San Angel, Frida started to use the Casa Azul as a meeting place. The situation stabilised, briefly, at some point towards the end of 1935 or in 1936, when Cristina was no longer a problem and there seems to have been an interruption in the succession of Frida's own love affairs.

In a famous passage in his autobiography Rivera wrote, "If I loved a woman, the more I loved her the more I wanted to hurt her. Frida was only the most obvious victim of this disgusting trait." And this admission has been frequently used to characterise its author. In fact, although he was monumentally selfish, there is no record of Rivera behaving in a sadistic manner to Angelina Beloff, Marevna or Guadalupe Marin. His "sadism" seems to have been specific to his relationship with Frida and may have been provoked by her emotional dependency, which developed,

under Rivera's attentions, into masochism. The nude sketch which he made of her in Cuernavaca just after their marriage foreshadows this development. The original aspect of the situation was that Frida managed to be emotionally dependent without being in any way humiliated; Rivera, with his untidiness, his childishness, his uncouth habits, his need to be spoiled, fed, cleaned, comforted, was her "child" who relied on her, as well as being, with his physical size, his rages, his attentiveness, his affection so easily expressed, and his enormous admiration for her painting, a shelter, an encouragement, a comfort, and a distraction from her physical pain. The one thing he could not give her, and which he had never given anyone since he fell in love with Marevna, was sexual fidelity. In the end she decided that what he gave her far outweighed what he took away.

In 1936, shortly before Rivera wrote to John Hastings, Frida had decided to rebuild her life through her painting, and logically she concentrated on what she and Cristina had in common: their parents. At the same time she began to elaborate the joint imaginary world which she and Rivera were to inhabit together. Her parents belonged only to her and Cristina, but to complete the picture by bringing Rivera into it, she presented her parentage à la Rivera, as a Mexican-European family saga.

In *My Grandparents, My Parents and I* Frida placed the head and shoulders of her González grandmother, daughter of the Spanish general, and her Calderón grandfather, with his dark Indian skin, to one side, with her Jewish Kahlo grandparents on the other side. Grandfather Calderón is shown with an un-Indian beard, which suggests that he was mestizo, not Indian after all. Below them, linked by a blood-red cord, are her parents on their wedding day. Frida then turns this into a ninefold portrait by showing herself three times at the foot of the picture, once as a naked infant, unwounded and complete, standing within the security of the garden court of the Casa Azul, the beloved house of her childhood and adulthood where she was born and where she would die. She also appears as a foetus projected onto her mother's wedding dress, and again as a fertilised human egg under attack from a sperm. The painting is on tin in the naïve retablo style, and there is no pain in it, no monsters weighing three hundred pounds or competitive sisters in sight.

Even in Detroit, four years earlier, Frida had painted her own birth as a trauma, with her mother apparently dead, à la Señora Rivera. She also made a little pencil sketch of herself, naked on a bed, dreaming. The dominant face in her dream is Rivera's. In the years to come she was to paint her Indian wet-nurse, like Rivera's; her father as a hero, like his; sin-

ister carnival artefacts, such as he painted (and using the ones in his studio, because they made her think of him); and dead children, like their dead siblings. It was not just when she was in Tehuana costume that Frida took her place in Rivera's dream. As time passed she modified that imaginary world and made it hers; she began to invent a common past and a shared childhood. And as this world grew it was not just her imagination but her whole personality that began to identify with his, developing a potentially suffocating closeness. The day would come when she would write, "Diego = Me."

Whereas Frida made her feelings for Rivera one of the most important sources of inspiration for her painting, she seldom inspired his major artistic preoccupations, which were centred outside his personal life. Deprived of his frescoes, Rivera resumed easel painting on a greater scale than before and so earned considerably more money. His commercial career as a painter of the picturesque for the wealthy tourist market had started with his association with Frances Toor's prestigious, glossy magazine, *Mexican Folkways,* in 1927. He now produced an increasing amount of "ethnic" work: Indian market scenes, flower pictures, and children in native costume, related in style to the Tehuana subjects he had originally placed in a political context. Even in 1929 Rivera had been able to sell oil paintings for $750 through a dealer in Los Angeles who showed potential clients black and white photographs. He had fallen out with his New York dealer, Frances Flynn Paine, after the Rockefeller débâcle; the bone of contention had been some incautious remarks she had made about him being "the great-grandson of the Marquise de la Navarro" in the 1930 MoMA catalogue. But this hardly amounted to a setback. In Mexico his portraits were in steady demand and had the advantage of enabling him to negotiate his own fee and retain two-thirds of it, instead of selling the picture at a fixed rate to Alberto Misrachi, his Mexican dealer. The high income was essential since, apart from San Angel and the Casa Azul, there were Cristina and Frida's separate apartments to pay for. Frida always said that she refused to take money from any man, but in fact she had no independent resources and still regarded her infrequent paintings as more of a private pastime than a profession. Then there were Lupe and the children to support, and regular appeals for assistance from Paris, where Marevna was struggling to establish herself as a Constructivist painter while bringing up Marika. Marevna's health was poor and Marika spent long periods living on the grounds of the Psychiatric Hospital now called St. Anne's. Marika rarely went to school but was learning to dance, and first appeared on the stage at the age of five. Once Marika had learnt

to write, Marevna encouraged her to make the appeals for help. One letter, written in French, read:

Cher papa Diego, I've been thinking. Perhaps for you its easier to send me some drawings or a picture of Indian life. I have a landscape of yours which Maman gave me and I asked Carpentier to sell it but he said nobody wanted to buy a landscape you had done in France so that's why I ask you to send me a picture as soon as possible so I can get some money and go to the country. I hope I am not asking for something impossible.

Your Marika

The surviving correspondence provides no reply, but on another occasion a request for 500 francs brought a response of 1,500 francs.

In 1937 Marevna sent Rivera a striking photograph of Marika, by then aged seventeen. His daughter was at that time on the threshold of a successful international career as a dancer and actress. Although he made no direct response to this gift, Rivera passed the picture to Bertram Wolfe so that it could be published in Wolfe's forthcoming biography. But it seems possible that Rivera was sufficiently moved by this image of the daughter he had not seen since she was aged one to use Marika's picture as his model for a fresco (on a movable panel) showing his daughter as a Tehuana Indian girl, standing in a forest with a young boy—himself—kneeling before her and offering her a bouquet of lilies. Rivera never referred to this (possibly unfinished) fresco during his lifetime; he neither exhibited it nor listed it among his works.

As for Angelina, she was very much closer. In 1935 she had decided to leave Paris and, unable to rid herself of her obsession with the past, move to Mexico. Rivera saw her once, at a concert, but did not recognise her. The only time they are known to have met was when she went to the scaffold where he was working in the Hotel Reforma in 1936 to ask him to sign some sketches he had given her when they were living in Paris so that she might sell them. She died in Mexico City in 1969, aged ninety and unknown.

A SURREALIST DEATHTRAP

Mexico, San Francisco 1936–1940

ONE DAY, in the summer of 1936, Rivera was sipping coffee in the Café Tacuba just off the Zócalo when *pistoleros* entered the long room and opened fire on a man drinking at the next table. The victim was a politician known as Deputy Altamirano, and when the incident was over Rivera studied the body slumped against the brightly coloured tiles of the café wall with close attention, his "eager, protruding eyes drinking in, memorising, fixing forever each detail." Two days later he had completed a picture which was rather different from his usual society portrait. Entitled *The Assassination of Manlio Fabio Altamirano,* and executed in tempera on tin, like a nineteenth-century retablo, it showed the still-warm body, formally dressed in suit, stiff collar and Windsor-knotted tie, with bullet holes in the temple, beside the nose, in the neatly buttoned waistcoat and in one insufficiently bulletproof hand. The actor Edward G. Robinson snapped it up as soon as he saw it. Sometime afterwards Rivera himself was the target of a similar attack. *Pistoleros* approached his table in the Restaurant Acapulco intending to pick a quarrel but were driven away by Frida, who fearlessly leapt in front of her husband, accusing them of cowardice, and making such a scene that the gunmen lost the initiative and fled. The dramatic incidents seem to have reinvigorated Rivera, who was already in better health after his eye operation. With the completion of the Hotel Reforma murals he had realised that he would be offered no more walls in Mexico for the foreseeable future; negotiations with the Tate Gallery in London were getting nowhere and he felt deprived of his "biological function." His solution was to resume his active political career, and so, on the eve of his fiftieth birthday, in September 1936, he

joined the International Communist League (ICL), affiliated to Trotsky's embryonic Fourth International.

Rivera's political comeback was acknowledged by his former comrade and fellow muralist David Alfaro Siqueiros, still a pillar of the Mexican Communist Party, who publicly condemned Rivera as an artist and as a revolutionary, describing him as a cynical political opportunist of limited imagination and technique. At a political rally in Mexico City the two muralists appeared on the same platform and drew their revolvers, which they waved in the air as they attacked each other verbally. Then they opened fire simultaneously, knocking knobs of plaster off the ceiling, and the audience started to leave. This politico-aesthetic clash was hailed in the Mexican press as a superb performance of "Stalinismo versus Bolshevismo Leninista." So the stage was set for Rivera's final tragicomic political production. It was to have a cast of hundreds, a semi-tropical background, a rhetorical script that covered the big issues, a dramatic plot, and it was eventually to acquire a title: *The Death of Trotsky.*

The life of Lev Davidovich Bronstein, known as Trotsky, since he had been exiled from the USSR by Stalin in February 1929 had been one of increasing isolation and danger. In Moscow Stalin initiated a process of ritual humiliation. First Trotsky's allies, such as Bukharin and Zinoviev, were expelled from the Politburo or the party. His daughter, Zinaida, unable to take the constant psychological pressure, committed suicide in Berlin; his grandson disappeared. His younger son, Sergei, was interned in the Soviet Union and never seen again. At first Trotsky took refuge on the island of Prinkipo, under the protection of the Turkish government. Then, in 1933, he moved secretly to France. In Moscow the screw was tightened; in August 1936 the Moscow Trials began and Zinoviev, with others, was executed. Meanwhile Trotsky, whose presence in France had been denounced in the press, was expelled by the French government and moved to Oslo. In 1936 he had sanctioned the movement for the founding of a Fourth International to challenge the Stalinist Comintern. In September he was interned by the Norwegian authorities on trumped-up charges, and in New York a "Committee for the Defense of Leon Trotsky" was set up by disaffected members of the Communist Party and its former sympathisers.

No one knew the hopelessness of his predicament better than Trotsky, who was regarded as a hostile, one-man nation-state by the directors of the Soviet Union; Stalin in particular had developed an obsession about him. "I know I am condemned," he said once. "Stalin is enthroned in Moscow with more power and resources at his disposal than any of the

Tsars. I am alone with a few friends and almost no resources, against a powerful killing-machine. . . . So what can I do?" He who had once been the commander of an army of five million men, and who had used the enormous power at his disposal with complete ruthlessness when he judged it necessary, knew that he was doomed to become the victim of the lethal organisation which he himself had helped to construct. He summarised his own predicament as a fugitive by saying that he inhabited "a planet without a visa." All he could do was read and write, and wait for his killers. The only unpredictable aspect of his impending fate was its association in the event with the genial, blandly smiling, monstrously imaginative and exotic figure of Diego Rivera.

Meanwhile Mexico had, in 1934, with the election of Lázaro Cárdenas, at last acquired a president who was energetic and competent and determined to implement many of the promises of the Mexican Revolution. Cárdenas, who had been nominated by Plutarco Elías Calles, and who was apparently just another of the henchmen of the *"Jefe Máximo de la Revolución,"* as Calles was by then called, was in fact set on restoring the power of the presidency. During his six-year term Cárdenas distributed forty-nine million acres of land among one-third of the population—two and a half times as much as had been distributed in the previous twenty years. About 50 percent of the fertile area of Mexico was thereby given over to village co-operatives and devoted to a mixture of cash crops and subsistence farming. In 1935 Cárdenas took the necessary steps to settle the *Cristero* revolt, thus bringing to an end the slaughter that had lasted for twenty-five years and cost one million Mexican lives out of a population of fifteen million. When Calles protested against the programme of land reform, Cárdenas exiled him, so ending the *Jefe Máximo's* fifteen-year reign. Cárdenas then nationalised the foreign oil companies after they had defied a succession of decisions by Mexican courts.

So Rivera was faced with the opposite situation to the one existing during his previous political intervention. This time the established government was not neo-Porfirian but radically reformist. His political adversaries were carrying out exactly the programme of popular education and land reform he himself had been advocating in his paintings since 1923. Nothing daunted, Rivera threw himself into the struggle with what threatened to be an elusive opponent, and was almost immediately presented with an opportunity to play a national role. In November he received a cable from Anita Brenner in New York, who was a member of Trotsky's Defense Committee, drawing attention to the fact that Leon Trotsky was facing expulsion from Norway and asking Rivera to inter-

vene on his behalf with President Cárdenas. To Rivera's surprise Cárde-
nas agreed to give Trotsky asylum, and so it was that Trotsky and his wife
Natalia arrived in the port of Veracruz on January 9, 1937. They disem-
barked looking rather elegant, Trotsky in a tweed suit and plus fours,
Natalia in chic black outfit including pillbox hat, tight mid-length skirt,
black silk stockings and high heels. Rivera was once again ill with kidney
trouble, so Frida travelled to Veracruz to greet them and escort them
to their new refuge, the Casa Azul in Coyoacán. Natalia had a very
favourable first impression. It was "a low, blue house," she wrote to a
friend, "a patio filled with plants, cool rooms, collections of pre-
Columbian art, countless paintings." On Trotsky's first night in Mexico,
Rivera rose from his sickbed and went back to San Angel to fetch a
Thompson machine-gun to guard his guest.

Despite this martial gesture, it is probable that at first Rivera had little
idea of the danger he was now facing. For all his posturing, revolver in
hand, at meetings with Siqueiros, Rivera was not a man of action.
Siqueiros, an inferior painter, was a genuine gunman. He had fought in
the Mexican Revolution, he would fight again in the Spanish Civil War,
and he was proud to be a Stalinist. But Rivera became a "Trotskyist"
because he was looking for a platform on the revolutionary left that was
outside the Communist Party yet substantial enough to support him. He
had been anti-Stalinist since his experience in Moscow. The acid test for
members of the Communist Party in 1937 was whether or not they
defended the 1936 Moscow Trials. Rivera joined the Trotskyite ICL in Sep-
tember 1936, the month following the first Moscow Trial. When he found
himself entertaining and guarding Trotsky, he was identified by the Mexi-
can Communists as an arch "Trotskyite," a term of abuse they had been
heaping on his head since he was expelled from the party, and for the first
time he happily accepted this label. But there is no evidence that Rivera
realised that in following this course he was risking his life.

In fact, the early days in Mexico were a time of hope. Relations
between Rivera and Trotsky were at first excellent. The latter was
immensely touched by the warmth and generosity of his welcome,
which made such a contrast with his recent experience in Turkey, France
and Norway, and he considered that it was entirely due to Rivera's inter-
vention that he had been allowed to enter Mexico. The Casa Azul was
turned upside down to ensure the comfort and safety of the Trotskys, and
Lupe Marin's brother became Trotsky's doctor. Cristina was moved out
into a neighbouring house which Rivera purchased for her; the Casa
Azul's exterior windows were filled in and Rivera even bought the adjoin-

ing house and garden to secure them both from attack. Police were sta-
tioned outside during the day, and private security guards took over at
night. A brick wall was erected on the pavement outside the front door. An
illusion of security was created. Stalin and his killers seemed so far away.

At first, as the Trotskys got used to the pleasures of Mexico, the time
passed in touring and socialising. Trotsky, who retained his physical
vigour, was immediately attracted to Cristina Kahlo. When he discovered
where she lived he tried to organise an emergency drill for sudden exits in
the case of attack. Trotsky's idea was that he should climb over the gar-
den wall of the Casa Azul and run to Cristina's house, and that it would
be necessary to practise this quite frequently. But the scheme was vetoed
by his secretary and the guards who were omnipresent. "Who are all
these people?" asked Guillermo Kahlo, faced with an invasion of unfamil-
iar foreigners, "Who is Trotsky?" He was then moved out to live with
another daughter, out of harm's way, having failed to deliver an impor-
tant message to his distinguished visitor, which was to warn him to avoid
getting involved with politics. Soon after arriving, Trotsky resumed dic-
tating his revised life of Lenin. He also started work on the deposition he
was to make to the international inquiry he had asked to be set up to con-
sider the allegations made against him at the Moscow Trials.

The Joint Commission of Inquiry into the Moscow Trials started to
hold its hearings in April in the Casa Azul; it had eleven members and was
chaired by the North American philosopher John Dewey. The proceed-
ings were dominated by Trotsky, who mounted a tour de force despite
having to speak and answer all questions in English. He had collected a
wealth of detailed evidence to rebut the charges brought against him and
his older son, Leon Sedov, by witnesses who had been tortured or intimi-
dated for months into perjuring themselves. The proceedings attracted
wide publicity, particularly in the United States, where Dewey's participa-
tion was fiercely criticised, but they were also followed in Europe and in
Spain, where anti-Stalinists were defying the authority of the Spanish
Communist Party. Trotsky was delighted by the success of the Dewey
Commission in drawing attention to his predicament, but this very suc-
cess was one of the factors which led Stalin and Beria to intensify their
worldwide persecution of the Trotskyist movement. In January Trotsky's
son Sedov, who was living in France, had narrowly escaped a meeting
with a Soviet secret service team in Mulhouse. At the end of April a secret
Comintern meeting was called to organise the next phase of the struggle.
It was also in 1937 that Stalin decided that the time had come to liquidate
Trotsky himself. On the advice of Beria he summoned the deputy head of

the foreign section of the secret service, generally known as the GPU—although it had recently been renamed the NKVD—a man called Sergei Spiegelglass, and instructed him to arrange this. But the only public sign of the escalation of the struggle between the Communists and the non-Stalinist revolutionary left was in Spain, in Barcelona, where, at the height of the war against Franco, open fighting broke out between Communist troops and the "Trotskyist," or anti-Stalinist, POUM. In Mexico the Communist Party used the Dewey Commission hearings to redouble its attacks on Rivera; these were usually published in *El Machete*, the paper he had founded.

On the run, Trotsky was a very much less repulsive character than he had been in his days of glory. With his powerful intellect, wide culture, wit, charm, and ability to make other people feel that he was genuinely interested in their opinions, he had a gift for attracting sympathy and loyalty that has survived the fifty years since his death. Trotsky was captivated by Rivera's frescoes. He said that Rivera was the greatest interpreter of the October Revolution, and that "these magnificent frescoes" had penetrated the "epic of work, oppression and insurrection" and revealed "the hidden springs of the social revolution." In response Rivera deferred to Trotsky's political analysis and followed the leader's line. "History would prove," wrote Rivera at this time, "that between Adolf Hitler and Joseph Stalin there was absolutely nothing to choose."

At this time, Trotsky, rejuvenated by his performance before the Dewey Commission and exhilarated by the splendour of Mexico, allowed himself to be drawn into an affair with his hostess, Frida Kahlo. He had taken to riding horses very fast over the rough country outside the town of Taxco, and the entanglement with Frida was perhaps the first sign that the intoxicating quality of Mexican life had begun to affect his judgement. The affair started in Mexico City with Trotsky, encouraged by the young woman's flirtatiousness, slipping notes to Frida in books he was lending her, sometimes under Rivera's nose. It was conducted in Cristina's house round the corner from the Casa Azul, for which Trotsky had found a use at last. Since Rivera spent most of the time working in San Angel it was not difficult to conceal what was happening from him, and Trotsky may have been encouraged by the impression the Riveras gave of leading actively separate lives. Nonetheless, for a man in Trotsky's vulnerable position, with an international reputation for moral strength and rational judgement, it was a potentially self-destructive act. But it was the result of an unequal struggle.

Trotsky, overwhelmed by sexual passion, fell in love. But Frida's

motives were more complicated. If she was flattered by the idea and intrigued by "el Viejo," as she called him (the Old Man, although he was, at fifty-seven, only seven years older than Rivera), she was also delighted to get another opportunity to repay her husband for his affair with her sister. The fact that she met "Little Goatee," another of her nicknames for the leader of the Fourth International, in Cristina's flat on the Calle Aguayo, which had been paid for by Rivera, and that Cristina became *her* confidante, was a handsome revenge for Frida. But she was also trying to recover from a period of unhappiness, and Trotsky was a useful distraction. Frida may have suffered another miscarriage in 1935—a lithograph she made entitled *Frida and the Miscarriage* bears that date; and in 1937 she painted two oils, one of a dead child and the other of herself on an empty child's bed with a dead-looking porcelain doll seated beside her. She had also undergone four surgical operations, one to remove her appendix and three on her right foot, since her abortion in 1934. It may be that in 1937 she was simply feeling better and ready for an adventure, no doubt aware that where her husband was concerned she had some catching up to do. What is certain is that, however much she enjoyed humiliating Rivera by secretly making love to his idol and political mentor, she did not take her affair with Trotsky very seriously. It lasted for a few months, but rumours soon reached his entourage and Trotsky's wife Natalia became deeply depressed. Fearing that if Rivera or the Mexican Communist Party learnt what was going on there would be a major scandal, several of Trotsky's closest collaborators persuaded Frida to break off the affair. It was over by July 15, 1937, and in the event Rivera suspected nothing for over a year. Shortly after ending her affair, Frida wrote to Ella Wolfe enclosing a love letter she had received from Trotsky which she wanted Mrs. Wolfe to see "because it was so beautiful," and adding, "I am really tired of the old man." She had chosen as her confidante the wife of her husband's biographer. Frida then started an affair with Trotsky's French secretary, Jean van Heijenoort, who had been instrumental in persuading her to break with Trotsky.

Meanwhile, outside Mexico, the GPU was concentrating on the job in hand. In July 1937 Andrés Nin, the Spanish POUM leader, had been arrested, tortured and murdered in Madrid by a GPU team. And in September, in Barcelona, Trotsky's former Norwegian secretary was murdered by Soviet agents. Then a former Soviet intelligence chief who had changed sides to support Trotsky was found dead in Lausanne. For Trotsky, watching events helplessly from Mexico and no longer distracted by Frida, the fear returned. It seemed as though the GPU were capable of

reaching anywhere in the world and killing, however well hidden their quarry might be. In December he was briefly encouraged by the Dewey Commission's report, which cleared both him and Sedov of all the accusations that had been made against them, but the relief was short-lived. He was working in his study in the Casa Azul in February 1938 when Rivera came in to tell him that Leon Sedov had died in a private clinic in Paris following a routine appendix operation. The clinic was directed by a Russian who had been in contact with the GPU, so Trotsky concluded that his older son, too, had been murdered. Two weeks later the third Moscow Trial opened, at the end of which Bukharin was among those who were executed.

As a member of the uninfluential International Communist League, Rivera had relatively little scope to play any significant part in Mexican politics. He had no walls to paint, and it was a condition of Trotsky's residence that he take no part in national politics. The group's approval of Cárdenas's decision to expropriate the assets of foreign oil companies in March 1938 passed unnoticed among the massive demonstrations of support the president's move excited. But in the spring of 1938 an unexpected opportunity arose for Trotsky and Rivera to take a novel political initiative, with the arrival in Mexico of the Parisian poet and surrealist intellectual André Breton.

Breton and his wife Jacqueline arrived in April with nowhere to live, the French Embassy having failed to make arrangements despite offering to sponsor their tour. When he heard of their plight Rivera arranged for them to stay with Lupe Marin. Lupe and Rivera had recently resumed something like their old friendship, and since 1937 Rivera had once again started to sketch and paint his former wife. There is a photograph of Rivera sitting holding hands with Lupe, under Frida's somewhat bemused gaze, taken shortly after the Bretons' arrival. Later the Bretons moved into the San Angel house where Rivera and Frida were then living together, and the Riveras encouraged the Bretons and the Trotskys to travel with them around Mexico. André Breton, who had joined and then left the French Communist Party, counted himself a disciple of Trotsky and regarded Mexico as a country "destined to become the Surrealistic place par excellence."

Breton was delighted by the work of Posada, which he linked with death, sadism and the unconscious. He also became increasingly interested in the paintings of Frida Kahlo. Breton only spent seven months in Mexico and he may have formed a rather romantic view of it. "Red land, virgin land, soaked with the most generous blood, land where man's life

is priceless, yet ready . . . to consume itself in a flowering of desire and danger!" he wrote later. "At least there is one country left in the world where the wind of liberation has not died. . . . The armed man is still here, in his splendid tatters, ready to rise suddenly once more from oblivion." The armed man rising suddenly from oblivion was Trotsky's nightmare of Mexico rather than his dream of it, but perhaps the subject did not arise on their travels. In any event, Trotsky, Breton and Rivera spent enough time together to collaborate on a joint manifesto, published in the autumn issue of the *Partisan Review* as the "Manifesto for an Independent Revolutionary Art," signed by Rivera and Breton but written by Trotsky.

Many of the discussions which preceded the writing of this took place on a journey the three couples made to the little town of Pátzcuaro in Michoacán State, which was the region Frida's part-Indian grandfather had come from. They might have been discouraged to learn that it was also the town in which a Spanish bishop once failed to construct Thomas More's "Utopia." There were several comical moments on this journey. Trotsky did not speak Spanish, so he and Breton conversed in French. Frida did not speak French, so she and Jacqueline conversed in English. Natalia did not speak English and was not expected to contribute to the construction of a political aesthetic, so she remained silent. Rivera could follow the conversation in French or English but apparently declined to contribute in any language. When Frida got bored—and she was quickly bored by André Breton—she would light a cigarette. Trotsky, who did not approve of women smoking, would rebuke her, and once Frida was rebuked she and Jacqueline could leave the room.

There were also many points of creative disagreement in Pátzcuaro. Trotsky revered "the Novel"; Breton loathed it. Trotsky greatly admired Céline's *Voyage au bout de la nuit;* Breton had written that it was equivalent to "holding a pen and dipping it in filth." When Trotsky directed Breton to write a first draft of the joint manifesto, Breton became incapable of writing a word. "I felt suddenly deprived of my powers . . . under your scrutiny," he explained later. Trotsky thereupon flew into a rage and there was a violent quarrel. There had been an earlier argument when Trotsky was shocked to discover Breton stealing retablos from village churches. Eventually Breton produced a manuscript written in green ink and Trotsky got to work on it, employing his habitual and highly original method of prose composition. He erected a large pin-board to which he attached the manuscript and scraps of his own work, together with relevant news cuttings or other extracts. He would then move these passages

around the board until they could be assembled in the appropriate order. It was an early version of the "cut and paste" methods offered by modern word processors, but watching Trotsky at work with his pin-board, composing prose, was more like watching a staff officer planning a military attack.

Breton was greatly stimulated by his visit to Mexico and amazed to find a country which illustrated his ideas so vividly without once having been exposed to them. On his return he wrote to Rivera:

Diego, my very dear friend,

In Mexico everything related to artistic creation is not adulterated as it is over here. That is easy to judge just by your work, by the world that you alone have created. . . . You have the advantage over all of us of being part of a popular tradition that, as far as I know, remains alive only in your country. You possess that innate sense of poetry . . . for whose lost secret we are desperately searching in Europe. But it will always be your secret. To realise that, one has only to see you stroke a Tarascan idol, or smile with that incomparably grave smile of yours at the extraordinary and opulent display of a street market. It is clear that you are linked, through thousand-year roots, to the spiritual resources of your land, for you and for me the dearest land in the world.

Breton had a profound admiration for Rivera and was one of the first to notice the fantastical rather than the political aspects of his work, and Breton was to give a considerable boost to Frida Kahlo's career as a painter. Before he left he offered to organise an exhibition in Paris for her. But as far as the relationship between surrealism and Mexico went, the influence was entirely one-way. A brief series of paintings Rivera executed of desert-plant roots in female form, which have been described as "a rather forced attempt to inject surrealism into his vision of Mexico," were in fact made near Taxco to pass the time while Trotsky was digging up cacti to add to his collection, were painted the year before Breton arrived, and had nothing to do with the surrealist movement. As for Frida, whose work Breton described as "a spontaneous outpouring of our own questioning spirit," she later famously said, "I never knew I was a Surrealist until André Breton came to Mexico and told me I was."

Meanwhile, in what might be termed the sub-real world of the GPU, events moved predictably forward. In July 1938, four days after Rivera and his guests reached Pátzcuaro and paced the many-coloured galleries and patios, diverted by the noise coming from twenty cages full of mocking-birds, Rudolf Klément, Trotsky's French secretary who was living in

Paris, was invited to dinner in an apartment on the Boulevard St-Michel by a GPU secret agent, stabbed to death and decapitated. The headless body was then jammed into a suitcase and thrown into the Seine. In Spain the pitiless settling of accounts between the Communist Party and the POUM continued. Wherever they were found in Barcelona or Madrid, anti-Stalinists were arrested and frequently executed after being tortured in GPU jails.

By this time it was obvious to everyone close to Trotsky that the danger was increasing. Rivera's response was to go on the attack. At a press conference he called in September, he publicly denounced Mexican officials or private citizens whom he suspected of being Communists, and declared that they represented a danger to a man who was an official guest and under the protection of the Mexican state. In October Rivera joined the editorial board of *Clave: Tribuna Libre,* a newly launched Marxist and anti-Stalinist magazine, and in November he delivered a paper at the congress of the General Confederation of Workers Union in which he denounced the Communist reign of terror in Spain. In September the Munich Agreement had been signed, and a few days later Trotsky made a public statement predicting a Nazi-Soviet pact. Just before Munich, at a conference of Trotsky supporters in Périgny, France, the Fourth International had been officially proclaimed. And it was just after this proclamation, in the autumn of 1938, that Trotsky's already grave situation was complicated by Rivera's discovery of el Viejo's affair with Frida.

In October Frida had left Mexico on a six-month journey to New York and Paris, and Rivera made his discovery just after her departure. The source is unknown but may have been Cristina Kahlo, who had been in her sister's confidence and who was still not resigned to the ending of her own affair with Rivera. When he realised what had been going on, Rivera decided to say nothing publicly, but he also decided to break his links with Trotsky. He accordingly manufactured a "political disagreement" which apparently baffled el Viejo, who refused to connect the problem with his one-year-old fling with Rivera's wife. The first sign of trouble came on November 2, the Day of the Dead, when Rivera presented Trotsky with a large sugar skull bearing the name of Stalin. Trotsky was upset by this insulting and malicious joke and ordered the skull to be destroyed lest it upset his wife. The quarrel then developed as Rivera wrote a letter to André Breton containing disrespectful references to Trotsky, which he asked one of Trotsky's secretaries to type out. When Trotsky, as was inevitable, saw this letter, which had been left with his own correspondence for him to sign, he became very angry and decided to leave the

Casa Azul. Rivera in return decided to leave the Fourth International. But it was some months before another house could be prepared to receive el Viejo and his ramshackle circus of advisers, bodyguards and starry-eyed research assistants. The expense involved in moving from the Casa Azul put an unprecedented strain on Trotsky's resources. Correspondence between Trotsky's North American guards on duty in Coyoacán and their employers in New York gives a clear picture of the desperate state of the "security operation" his followers were able to mount for their leader once Rivera's patronage was withdrawn.

"Dear Comrade Hank," writes "Irish" O'Brien on January 14, 1939, "Here it is the middle of January and no money yet received for the guard fund." There follows a long tale of woe. No torches in working order; a shortage of guns; Comrade Lillian has been forced to borrow from the food allowance after waiting three months without a gun. The five guards are a month behind in paying their board bill; there is no money to pay for light bulbs; they are in debt to Diego for the purchase of another gun; the Ford is in the garage for repairs to its brakes and they have no money to pay the bill to get it out. Early in March Comrade Hank eventually replied, sending $50 ($150 had been requested) and adding, "I am tired of your constant appeals for funds. . . . Come to your senses. . . . Vote yourselves a wage cut. . . . We cannot afford to have an emergency each week; no one will believe us when a real emergency arises." The five guards then sent a dignified and wounded reply, asking where their extravagance lay. "Could it be in money for toilet seats? Or typhoid inoculations? Or medicine?" The guards ask the committee to consider the specific points raised in letters from the chief guard, Irish O'Brien, and "refrain from arbitrarily berating him . . . for wilful extravagance." At the same time the guards were trying to get Trotsky into the new house, a "ruined bourgeois folly" only a few hundred yards from the Casa Azul, which needed electricity, water, floors, a shower, locks and higher walls, as well as a new door and a hut for the Mexican police stationed outside. The builder's estimate was $500. "Irish" pointed out the impossibility of approaching Diego for a loan. "You must not forget that it is not only a material question, but also a political and personal one for LD [Trotsky]. To stay in the present house is a very, very difficult situation. . . . A stop in the working for the new house would be terribly bad." Trotsky meanwhile, alarmed by the quarrel with Rivera and realising how much this would weaken his position in Mexico, wrote an urgent appeal to Frida in New York on January 12, 1939. "Why should Diego be a secretary?" Trotsky wrote. "He is a revolutionary multiplied by a great artist and it is even [sic] this "multipli-

cation" which makes him absolutely unfit for routine work in the Party . . . I believe that your help is essential in this crisis. Diego's break with us . . . would mean the moral death of Diego himself." But it was all to no avail. Trotsky's plight had no more power to move Frida than it had to move her husband. She received the letter in Paris, from where, absorbed by her own preoccupations, she failed to reply.

In Moscow, following a purge in 1938, Spiegelglass had been replaced by Pavel Soudoplatov, and the latter was now summoned by Stalin and put in charge of all NKVD (GPU) operations to eliminate Trotsky. Stalin told Soudoplatov that "apart from Trotsky there is no significant political figure left in the Trotskyist movement"; that Trotsky was dividing and confusing the Comintern; that it was essential to eliminate him before the outbreak of the inevitable world war between the imperialists and the Soviet Union; and that Spiegelglass had been insufficiently energetic in carrying out this mission. Soudoplatov, according to his own account, clearly understood that if he failed to eliminate Trotsky he faced the same fate as Spiegelglass; furthermore, he was himself an experienced and competent GPU assassin. He eventually entitled the chapter in his memoirs in which he described his first killing, carried out with an exploding box of chocolates in a restaurant in Rotterdam in 1938, "A Start in Life." Naturally, he was entirely in favour of the liquidation of Trotsky. "For us," recalled Soudoplatov in 1994, "the enemies of the State were our personal enemies."

At the Casa Azul another member of the entourage, Comrade Charles Curtiss, was in charge of negotiations with Rivera. On January 20, 1939, Rivera had told Curtiss that "the differences [with Trotsky] were personal." On March 11 Curtiss reported that Diego claimed that Trotsky had "read his mail, which was a typical act of the GPU"; that if Trotsky continued to "bother" him, he would "make public the entire issue which up to now he had considered it his duty to keep quiet"; and that Trotsky had attacked him and his position on art. "Diego stated that Trotsky was attacking those who had saved his life." By referring to "the entire issue," Rivera was playing his trump card, and effectively blackmailing Trotsky. It was not simply a question of reading letters but of the scandal that would be caused if Rivera revealed the human frailty shown by Trotsky in having an affair with Frida, so betraying Natalia and his host Rivera. As Trotsky realised the lengths to which Rivera was prepared to take his retaliation, it slowly dawned on him that in trespassing in the Rivera-Kahlo marriage he had blundered into an emotional minefield. The move to the new house was eventually accomplished in April 1939. Trotsky left

with colours flying. Referring to Rivera he wrote: "He has the full right to make one more political mistake instead of one good painting." But at the same time, Trotsky realised the extent of his loss. He had often said that he "could convince people of socialism by the ones and fives, but Rivera, with his paintings, could influence them by the scores and hundreds." When he moved out of the Casa Azul, Trotsky left behind a beautiful full-length self-portrait which Frida had dedicated and presented to him at the end of their affair. And by the time Frida returned from Paris, Rivera had resigned from the Fourth International, the break was complete, and Trotsky was locked into his new fortress, another villa in the same neighbourhood, where he lived behind a system of armour-plated, communicating doors.

Despite the breach with Trotsky, Rivera continued to attack the Mexican Communist Party. Following Trotsky's prophetic analysis, the Nazi-Soviet pact was announced in August 1939, and in December Rivera and Trotsky both offered to testify before the U.S. Congress's Dies Committee on Un-American Activities, arguing that the policy of the Mexican Communist Party was hostile to Mexico and therefore to the interests of the American continent. In the event, neither attended the Committee's hearings, but Rivera had private meetings instead with officials from the U.S. Embassy and made essentially the same allegations to them that he had previously made publicly to the foreign press about the covert manoeuvres of Communists in Mexico, including naming dozens of people he accused of being GPU agents. Rivera also claimed that three hundred of the fifty thousand Spanish Communists admitted to Mexico as political refugees after their defeat in the Spanish Civil War were GPU agents who were conducting a campaign of murder and terrorism in Mexico and who were intending to infiltrate the United States. State Department officials were sceptical of Rivera's claims and wary of his credibility. A Department of State internal memo read: "In view of Rivera's known tendency towards exaggeration, if not even fabrication, many of his statements should, I think, be accepted with considerable reserve." This was something of an irony since for once Rivera's information was highly accurate. As Soudoplatov has since confirmed, the Spanish Communist refugees were precisely the group the NKVD/GPU were using to infiltrate their agents, and the agents were indeed working to infiltrate the United States. And in particular, it was among the Spanish refugees that two of the three teams plotting to kill Trotsky were to be found.

Among the fifty thousand "Spanish" Communists authorised to enter

Mexico from Spain in April 1939 was Tina Modotti, who did so under an assumed name, and her companion Vittorio Vidali, now known as "Sormenti." In Spain, Vidali, there known as "Carlos Contreras," had distinguished himself at the head of the Republican Fifth Regiment. He was by now an experienced GPU agent who, having been appointed a political commissar in Madrid, had personally executed hundreds of working-class prisoners who were suspected, on flimsy evidence, of being "Fifth Columnists." He may also have been one of four Communists who assisted the GPU field officer Alexander Orlov to kidnap, torture and murder Andrés Nin, leader of the Trotskyist POUM. In Mexico the Spanish refugees were to become "the sea" in which the GPU "fish"—like Vidali—could swim. In due course Tina and Vidali were among those named by Rivera as being Soviet agents in Mexico, an allegation that was certainly correct. Nevertheless, it was a sign of the failure of Rivera's political idealism that the young girl who fifteen years earlier had inspired some of his greatest frescoes, and whom he had depicted in 1928 on the walls of the ministry of education handing out guns to insurgents— something Tina had actually done for Italian volunteers in Madrid in 1936—should have become one of those who were plotting against him in 1938, and whom he was therefore prepared to denounce to the Mexican government, the U.S. consul and the capitalist press.

Liberated by Frida's lengthy absence, and liberated from the obligation to entertain the Trotskys, Rivera now abandoned his political activities. He resigned from the editorial board of *Clave* in January 1939 and was thenceforth free to concentrate on his work and his social life, hoping wherever possible to combine them. The *Partisan Review* manifesto had not ignited an artistic revolution, but Rivera retained enough interest in surrealism to paint a curious *Portrait of a Lady in White,* showing a seated bride surrounded by spider webs with a prominent white sugar skull in place of the conventional bouquet in her lap. He used the same wedding dress as a prop for a straightforward bridal portrait in 1949. He also took a paternal interest in a young Mexican actress with the impossibly appropriate name of Dolores Del Rio, whose semi-nude portrait he had painted in 1938. She was to become one of his and Frida's closest friends. Rivera also developed an obsession with the large black North American erotic dancer Modelle Boss, who posed for a series of nudes in both oil and water-colour which must rank among Rivera's most unusual pictures. By the end of the series, twelve in all, Rivera's fixation on the subject had transformed the dancer's hands, arranged above her head, into a scorpion's pincers. The studies of Boss may have been the world's first

attempt at erotic surrealistic painting and were perhaps André Breton's sole contribution to Mexican culture.

In April 1939 Frida returned from a successful six-month trip to New York and Paris to find that her marriage was over. During her absence she is known to have had an affair in New York with her gallery owner, Julien Levy, and in Paris—where she was drinking a bottle of cognac a day—with André Breton's wife, Jacqueline, among others. She only came back to Mexico because a long-standing love affair with the photographer Nickolas Muray had ended. Once home she fell briefly in love with a Spanish refugee, Ricardo Arias Vinas. The strain of all these love affairs, coupled with Rivera's continuing resentment over the liaison with Trotsky and his own hectic daily philandering, caused the Riveras to separate, and six months after Frida's return they were divorced. But their separation had little effect on their friendship. Frida continued to use her side of the house at San Angel when she wished, although the communicating door was now kept permanently locked. But she based herself in the Casa Azul, where Rivera visited her, her father, his children, her sister, his nephew and niece, and the Kahlo collection of small black monkeys and hairless dogs, at will. She felt free to welcome Nelson Rockefeller on his visit to Mexico City in 1939, presumably hoping to sell him some pictures, although there is no record of Rivera agreeing to meet this particular guest.* After her separation from Rivera, Frida made a series of ten oil paintings, starting with a lesbian study, *Two Nudes in a Forest,* and moving on to a superb double self-portrait showing herself bleeding to death and including other self-portraits expressing agony, torture and desperation, which ended with *Cropped Hair,* a study in self-mutilation. Throughout the entire length of her life with Rivera, this was the period when Frida Kahlo struggled most vigorously to escape the clutches of "the common imagination" and to establish a complete interior life of her own. The effort it cost her is visible in these paintings, which were among her finest to date.

Rivera, meanwhile, was enjoying a relatively tranquil interlude attending to his steady stream of young North American lady visitors, for whom a tête-à-tête with Mexico's most celebrated artist had become an essential part of the tourist experience. In August the Mexican section of

*Rockefeller's visit followed the nationalisation of the Mexican oil industry. As a director of Standard Oil with a known interest in Mexican art, he was thought to be well placed to intervene. His offer of a major show of Mexican art at MoMA as part of a diplomatic settlement was not taken up.

the Fourth International denounced him for supporting the Conservative candidate, Juan Andreu Almazán, in the election to choose a successor to President Cárdenas, but he remained serene. In the spring of 1940 the Paramount Pictures movie star Paulette Goddard visited Mexico City. Goddard, known as "Sugar," was married to Charlie Chaplin, had just finished shooting *The Great Dictator*, and was the star of *Modern Times*. She had a warm, lively personality, agreed to pose for Rivera and had an affair with him. One Saturday morning Rivera was at work in his studio on a double portrait of Goddard and a young Indian model when the news reached him that in the course of the previous night Trotsky's bedroom in his new house just round the corner from the Casa Azul had been riddled with 173 machine-gun bullets.

§ § §

BY THE END OF 1939 Soudoplatov, working patiently in Moscow, had succeeded in infiltrating three separate teams of assassins into Mexico, and on the night of May 24, 1940, one of his agents, who had befriended one of Trotsky's American bodyguards, managed to introduce a commando of twenty men dressed in Mexican police and army uniforms into the heavily guarded house where Trotsky was living. They opened fire on Trotsky's bedroom and the adjoining room where his grandson slept. The boy was slightly injured, but Trotsky and his wife, who had taken refuge under the bed, survived unharmed. The attack would have been clearly audible from the Casa Azul. Among the Communist refugees from Spain named by Rivera, and suspected of being one of those who took part in the attack, was Vittorio Vidali, although the likelihood is that if Vidali had been a member of the commando, the attempt would not have been such a shambles. He was questioned by Mexican police but released without being charged. Vidali is more likely to have been involved in the subsequent murder of the twenty-three-year-old U.S. guard, Robert Sheldon Harte, who was tricked into admitting the gang through the gates of Trotsky's villa, and was abducted and subsequently dispatched because he had recognised one of them.

In Moscow Soudoplatov, according to his memoirs, analysed the attack, which had been led by the fresco artist David Alfaro Siqueiros, and concluded that it had failed because none of the group were experienced killers or trained in searching a house. By June 18 the Mexican police had established Siqueiros's involvement and linked the attack to the GPU. On hearing the news, Rivera immediately went into hiding, once again aban-

doning work on the portrait of Paulette Goddard and the Indian girl, which was destined to remain unfinished. He later claimed that he was suspected by the police of taking part in the attempted murder, but the idea of a GPU commando recruiting Diego Rivera in 1940 was clearly absurd and in reality he was frightened of becoming the victim of a similar attack. When news of Siqueiros's arrest reached the house in San Angel, Rivera was inside with the young Hungarian painter Irene Bohus, with whom he was having an affair. Watching from the hotel opposite was Paulette Goddard, awaiting her turn to pose. With admirable generosity the two women combined to smuggle the panic-stricken Rivera out of the house. Even after routine police questioning, Rivera remained in hiding. He had certainly done enough to justify being listed as an enemy of the Mexican Communist Party, and had been denounced at the April Congress as a man who merited "punitive action" being taken against him. Capitalising on his contacts with the U.S. Embassy, Rivera requested assistance in getting a border-crossing card, and disclosed that he was hiding in the house of his lawyer. Wolfe claimed that Rivera flew to California on a scheduled flight from Mexico City, but the journey was more complicated than that. The U.S. consulate contacted the immigration office in Brownsville, Texas, and misled the local FBI "Red Squad" as to the details of Rivera's travel plans. Rivera then flew to Brownsville with Paulette Goddard, and after being briefly questioned by immigration officials was given a visa good for one year. By the time Soudoplatov's second agent, the trained hand-to-hand killer Ramón Mercader, alias "Jacson Mornard," the "sweet, generous, charming and inoffensive" lover of a trusting young Trotskyite American militant, had talked his way into Trotsky's study and buried his mountaineer's ice pick in Trotsky's skull on August 20, Rivera was safely on a scaffold at the Golden Gate International Exposition in San Francisco, once again painting a fresco. The United States had become his refuge from the Mexican Communist Party.

Rivera played no part in either of the assassination attempts carried out against Trotsky in the summer of 1940, nor was he seriously suspected of any involvement, despite his claims to the contrary, which can be explained by his subsequent ambition to rejoin the Communist Party. But he contributed indirectly to the success of the GPU operation. So long as Trotsky was under Rivera's roof he was, in a sense, officially protected and assimilated into the Mexican nation. Rivera was one of the most celebrated figures in the country, and any harm that befell Trotsky while he was a guest of Rivera would have directly reflected on the honour of Mexico. It was more difficult for Soudoplatov's assassins to dis-

guise their true identity when attacking the Casa Azul, and they were under strict orders to avoid linking the operation with Moscow. Once the two men fell out, Trotsky resumed his habitual status of an isolated and vulnerable exile and his fate was sealed. But Rivera also suffered as a result of his connection with Trotsky. His discovery of Frida Kahlo's affair with el Viejo wrecked Rivera's own position within the Fourth International and terminated his coherent political career. When Trotsky made his forlorn appeal for Frida's intervention in January 1939, he had written: "Diego's break with us . . . would mean the moral death of Diego himself. Apart from the Fourth International and its sympathisers I doubt whether he would be able to find a milieu of understanding and sympathy not only as an artist but as a revolutionary and as a person." In predicting Rivera's political future, this was prophetic. But it is clear that Trotsky never acquired any insight into the real reasons for the rupture with Rivera.

Rivera's break with Trotsky was personal. They had no political disagreements. In an interview Rivera gave to a U.S. news agency reporter on April 14, 1939, only a week after Trotsky had left the Casa Azul, he described Trotsky as "a great man for whom . . . I continue having the greatest admiration and respect." And in a letter written a month earlier, on March 19, to his first biographer, Bertram Wolfe, who had also become a Trotskyist, Rivera defended Trotsky's politics and his public reputation at some length. "The man of the October Revolution" (that is, Trotsky) "has to be respected by everybody who is not a lackey of the assassin, master of Russia" (that is, Stalin), wrote Rivera. He went on to say that he had cut off "all personal relationship with Trotsky and for this reason" had resigned from the Fourth International, and continued:

In spite of every profound personal difference I consider Trotsky as the very centre of the organisation and feel that his work and personality are tremendously important to it. Therefore I do not wish to start any discussion with him. His statements concerning me being entirely inadmissible to me, I have rejected them and withdrawn from the organization, considering my own collaboration entirely insignificant and practically nil compared to that of which Trotsky is capable. Nevertheless I have sufficient revolutionary courage to recognise the value of his revolutionary accomplishments and to hold for him the respect which is the essential duty of the real revolutionist.

Wolfe was of course well placed to appreciate the depth of Rivera and Trotsky's "personal difference."

In the same letter Rivera, who was very angry about the portrait Wolfe had drawn in *Diego Rivera: His Life and Times,* which had not yet been published, refused to publicise the book. He had been expecting "the first Marxian biography of a painter." Instead, he claimed, his biographer had been "more influenced by Freud than by Marx." In particular, he noted that Wolfe had broken his "word of revolutionary honour" in failing to reproduce Rivera's small fresco, made in 1933, "showing Trotsky and his followers with the flag of the Fourth International"; in other words, Wolfe had failed to reproduce Rivera's study of Trotsky in heroic pose. "You have committed not only a treacherous and vile action towards me, but a lie as a biographer, and that is even worse. . . . You are in a very bad position, dear boy," Rivera concluded this letter, which he had written in English.

And Wolfe was not the only one. Rivera, a national figure, felt deeply humiliated by his wife's affair with the man who was both his mentor and his protégé. There is a photograph taken in the summer of 1938, during André Breton's visit, shortly before Rivera made his discovery, which shows all the principal characters involved in the Trotskyist-surrealist offensive on the future of the world. They are lined up as though posing for a fresco. They include Rivera, Frida, Trotsky, Natalia and Jean van Heijenoort, four of whom, aware of the situation, gaze ahead. Rivera, the odd man out, stands slightly behind Frida, looking sideways and down.

The break between Rivera and Trotsky, and the subsequent fate of Trotsky, is the story of what happened to the principal people in that photograph after Rivera joined the subgroup of those who knew what had been going on. The Mexicans have a concept termed *chingada,* a word whose many meanings have been considered and explained by Octavio Paz. *Chingar* is a verb not casually used in public which generally means "to screw up." It is a word which has different meanings in different Hispanophone countries. In Spain it can mean "to get pissed." In Mexico it has other, more violent meanings. It can involve making a fool of someone. "It contains the idea of aggression"; it denotes "the emergence from oneself to penetrate another by force." The man "who commits it never does so with the consent of the *chingada,*" the one it is done to. "The person who suffers the action is passive, inert and open. . . . The word has sexual connotations but it is not a synonym for the sexual act: one may *chingar* a woman without actually possessing her." When people become excited on national occasions they may shout, *"Viva México, hijos de la chingada!"* (Long live Mexico, children of the *chingada*!). And Paz adds, "To the Mexican there are only two possibilities in life: either he inflicts

the actions implied by *chingar* on others, or else he suffers them himself at the hands of others."

When Rivera seduced Frida's sister, Frida was the *chingada*. When Frida seduced Trotsky, Rivera felt as though the tables had been turned. He was angry with his wife, but he also respected her because she had been as hard as he was, for once at least. Frida had taken her revenge by using Trotsky and abandoning him, *"Soy mucho cansado del Viejo"* (I am really tired of the old man). So Trotsky, too, had been *chingado*. Rivera restored his own self-esteem by abandoning Trotsky again; publicly he was still esteemed, but privately he was insulted and rejected with contempt. Trotsky was *chingado* a second time. And then he was *chingado* a third time; penetrated by the GPU, forever, by force.

Rivera's return to painting in San Francisco in 1940 had originally been suggested by Timothy Pflueger, the architect who ten years earlier had arranged for him to paint the stairway of the Luncheon Club of the Pacific Stock Exchange. This time he was invited to take part in the Golden Gate International Exposition and engaged to execute ten panels mounted on movable steel frames, the theme being simply "Pan-American Unity." He worked in public on an island in San Francisco Bay, and thousands of visitors filed past his scaffold during the summer of 1940 while he was completing the work. When he heard the news of the death of Trotsky, Rivera took the precaution of employing an armed guard to stand beside the scaffold, later explaining that he feared reprisals from Trotskyists who suspected him of being involved. And to a San Francisco reporter who came to interview him he gave the impression that he was not displeased about the death of "the old man." This was an understatement. Rivera was relishing the consequences of the quarrel he had initiated, and the bloody *chingada* that had concluded the Trotsky story. And the armed guard was intended to protect him from Stalinists not from Trotskyists. In a letter to a friend in New York, Rivera had earlier complained that his letters were being opened and money stolen from his correspondence; it was the work of "the GPU, both Mexican and U.S. sections," he explained. And in his San Francisco mural Stalin appears as a hooded assassin. Trotsky does not appear at all. The man who had so recently been his mentor was, quite simply, painted out of the picture.

Frida Kahlo, on the other hand, was seriously suspected of complicity in Trotsky's death, since in Paris she had met his assassin, Ramón Mercader. Her house was searched and wrecked by the Mexican police, and she was arrested and roughly questioned for two days. Her Mexican doctors were at that time recommending spinal surgery, so she telephoned

Rivera, who arranged for her to leave the country and join him in San Francisco as soon as possible. For Frida and Rivera, Trotsky's death proved to be a means of reconciliation. But not immediately. Rivera was still heavily involved with Paulette Goddard. He was also living with Irene Bohus; the affair only ended when the artist's mother discovered what was going on. Meanwhile, to distract Frida, who had entered hospital in San Francisco, Rivera introduced her to an attractive young art dealer, Heinz Berggruen, with whom she promptly started an affair. At the same time her doctor, Leo Eloesser, cancelled the surgery, put her on an alcohol-free diet and advised Frida and Rivera to remarry. And this they did in San Francisco, on December 8, 1940, the groom's fifty-fourth birthday. Heinz Berggruen, his usefulness at an end, was dismissed, but from New York Nickolas Muray was summoned to take the wedding pictures. For the ceremony Frida was back in her Tehuana costume which she had put aside for much of their two-year separation. In Muray's engagement photograph Rivera is still clutching the gas mask he often wore on the scaffold. A rueful Heinz Berggruen, looking at the wedding pictures, described Rivera as "a huge animal."

With their remarriage the Riveras closed the surrealistic period in their lives, and they probably wasted little time in thinking of the old Marxist whose life had briefly divided them, and whose emblematic death, in the surrealistic land, had been the occasion of their reunion. Trotskyism was relinquished with surrealism; Stalin had been right. Without Trotsky, there was no Trotskyism. Neither Frida nor Rivera ever expressed any regret for what had happened as they resumed their life together and the struggle for control of their common imagination.

THE LORD OF MICTLAN

Mexico 1941–1957

I
N 1942 Diego Rivera, who had spent so much of his life painting the walls of other people's buildings, decided that he would construct one of his own. He would build a house like the Aztecs had built and it would be his residence, his studio, his museum and his tomb. It seemed a fitting project for a man who was both a fresco painter and the reincarnation of an Aztec deity: he would erect many walls; he would retire within them accompanied by his enormous collection of Aztec idols; he would inter himself while he was still alive. There would be no model for this final project, the monumental folly of a genius; he would invent it from his artist's imagination but it would bear a certain resemblance to the heart of the Great Temple of Tenochtitlán. He would dwell there with his images, of Tezcatlipoca, the god of fate, ruler of the night; of Cihuacóatl, the serpent woman, goddess of sacrifice. He would be accompanied by Tlazoltéotl, the eater of filth, the sin-eater, the goddess of confessions and patroness of midwives, who would discipline the shade of his midwife mother should that be necessary, and he would honour Xochiquetzal, "Precious Flower," the patroness of harlots; he would honour Xochiquetzal many times, and together they would await the arrival of the god of death, the Lord of Mictlan.

Ever since his return to Mexico in 1921 Rivera had been fascinated by pre-Columbian art and had spent every penny he could scrape together to purchase it. By 1942 he had a collection of sixty thousand stone pieces and he needed somewhere to put them. His former wife Lupe Marin had once become so exasperated by the lack of money to pay for food that she had taken one of his idols, smashed it and served it to him for his supper, saying that if he was going to spend the housekeeping budget on pieces of

stone, he could eat them. But Rivera found the same inspiration in pre-Columbian art that Picasso had found in African art. He persisted with his collection and eventually spent what remained of his fortune on the walls to house it, and still never managed to complete the building.

Nonetheless, he succeeded in constructing one of the strangest sights in Mexico. Having chosen a plot on a volcanic lava plain on the edge of Mexico City, he cultivated it, and from this black and stony level grew walls and floors and doorways and carvings so fantastic that they form the maddest artist's studio ever made. The inspiration for the building at Anahuacalli was a pre-Columbian temple, not on the scale of the Great Temple of the Mexica but nonetheless the size of a respectable Christian basilica and worthy of the private residence of an Aztec king. The immense energy which Rivera had once dedicated to covering miles of wall with fresco was here turned towards the construction of the walls themselves. His fascination with the relationship between art and architecture, his belief that the two were forever linked, even his fantasy self-portrait on the walls of the education ministry of the artist as architect, were here brought to life. The result is both frightening and imposing. The monstrous imagination sensed by Elie Faure on the banks of the Dordogne in 1920 had finally produced a worthy dwelling place.

The principal entrance is through a stone-pillared gateway over a stone bridge across a moat whose black waters are choked with lilies. The gateway leads to a vast stone courtyard to one side of which there is a construction which, were this an Aztec temple, would have been a sacrificial altar. Entering the courtyard today, one has no sense that its designer intended its modern use as a picnic table. Inside the house high granite walls are pierced by narrow corridors with high arched roofs, giving the impression that the passageways have been cut from the living rock. Walking down them, one has the feeling that the rock might heal itself and close up again. There is a subterranean air about most of the interior which persists even on the upper floors. The windows are for the most part absent, or replaced by stone slits filled not with glass but with opaque onyx sheets, so that even the daylight is filtered through stone. Inside this house, inside his head, the artist became an Aztec.

One maze of corridors leads from the first hallway to the lowest point in the house, where, at the level of a cellar, an "offering chamber" is let into the floor; at the centre of this there is a small pool. There were offering chambers in the Great Temple as well, small compartments hollowed out of the stone, in which the "offerings," usually the bones of human sacrificial victims, were concealed. In Diego's temple the stone ceilings

above these passageways lead eventually to the higher floors and are dec-
orated with serpent's heads and bodies, picked out in lighter-coloured
stone against the darker stone background. Then, on the first floor, there
is a transformation. In a building where there were no windows at all,
there is suddenly a glass sheet as large as one side of the building, stretch-
ing from floor to ceiling and letting the north light into the one large
room in the house, the studio. While Rivera was building Anahuacalli, he
and Frida used it as a regular retreat, so naturally there had to be some-
where for him to work. The studio at Anahuacalli was the only room he
ever owned whose walls were large enough to carry the cartoons of even
the largest of his frescoes. But by the time the studio at Anahuacalli was
ready for occupation, his mural work was diminishing and the walls of
this temple remained undecorated, except in his imagination.

Above the studio level, reached by a long, narrow stairway, the levels
again succeed each other, each containing small rooms crammed with
the small stone idols of Rivera's collection, today the temple's only resi-
dents, until the stairs lead out onto the roof terrace with its incredible
view over the valley of Mexico. Immediately below the terrace one sees
the stone-flagged court and its sacrificial altar; around that the trees of
the garden enclosed by the same black stone walls; and far out the encir-
cling hills, then mountains, of the valley. These are the peaks and volca-
noes that for hundreds of years protected the Mexica from their enemies,
and which protected them still in Rivera's reimagined world. As Rivera
constructed Anahuacalli he also set to work on a new series of murals
showing pre-Columbian Indian civilisations on the walls of the National
Palace. So Anahuacalli became more than a monument to his powers of
fantasy and organisation; it became the artist's subconscious, hewn in
stone.

In the galleries on the first floor of the National Palace, Rivera
achieved his last great series of frescoes and his final attempt to reconcile
his Mexican nationalism and his international socialism. In San Francisco
in 1940, on returning to fresco after a break of four years, he had adopted
a more light-hearted, almost apolitical approach to political art with *Pan-
American Unity*. The colours and many of the details are superb, and the
Californian fresco reflects the artist's delight in being once again in San
Francisco; it lifts the spirits to be in the same room as those colours. Yet
there is something unconvincing about the political ideas expressed.
Rivera said at the time that he was hoping to create "a real American
art . . . the blending of the art of the Indian, the Mexican, the Eskimo
with the kind of urge that makes the machines . . . From the South

comes the Plumed Serpent, from the North the conveyor belt." So in one panel the vast carved head of the plumed serpent rests on the edge of an outdoor swimming pool beneath the arched, flying shape of Helen Crienkovich, the American Athletic Association Union's indoor diving champion of 1939. This is amusing, and *Pan-American Unity* is outstanding illustration—it would have made a wonderful story-board for a Hollywood feature cartoon—but it does not move us. Looking at the plumed serpent in this northern rational setting, one has the feeling that the creature has no place in California, outside of the zoo. The fresco is good-humoured to the point of flippancy. In one panel Netzahualcoyotl, the Aztec poet-king, is inventing a flying machine with the assistance of a bald eagle and fruit bat. In another there is a study of the abstract artist Mona Hoffman's cat. In the central position of the central panel one finds the personification of Pan-American unity, Rivera himself, seated in intimate conversation with Paulette Goddard, who is holding "the Tree of Life and Love." Beside them, looking the other way, stands Frida Kahlo, in superb Tehuana battle dress, whose remarriage to Rivera ended the artist's relationship with Goddard. The adjoining panel has been described as an "allusion to the world conflicts of the time." It shows scenes from the film *The Great Dictator,* with Charlie Chaplin and Jack Oakie as "Benzini Napaloni, Dictator of Bacteria." Behind Chaplin, in sinister grisaille, like stills from a black and white newsreel, stand Hitler, Mussolini and Stalin—the latter, brandishing a dagger and an ice pick, is draped with the letters *GPU.* . . . This certainly is political comment, and a deadly insult to Stalin which would have been noted by the Comintern, but the original inspiration for even this panel is likely to have been its proximity to the image of Paulette Goddard and the fact that Chaplin, whose portrait appears four times, was still married to her. It is typical of Rivera's sly humour to show the international celebrity husband in one panel, addressing his worldwide audience, while in the adjoining panel Mrs. Chaplin, his beautiful young wife, gazes deeply into the eyes of Rivera. *The Great Dictator* caused deep offence to the pro-German lobby in the United States, and when the Golden Gate International Exhibition closed *Pan-American Unity* was not displayed as intended at City College, or bought up by Walt Disney, but was put into storage, where it remained for the rest of Rivera's life.

If it is difficult to be convinced by the high seriousness of Rivera's approach to the theme of "Pan-American unity," one should remember that it was painted in public, as part of an "Art in Action" show, and that it was the work of an artist who enjoyed being an entertainer. One should

also remember the number of times Rivera had by then been forced to modify his political stance. Starting as a revolutionary artist on his return from Paris in 1921, he became, under Vasconcelos's influence, a Mexican revolutionary and anti-reactionary liberal. Then he became a revolutionary Communist and anti-fascist. Then, on his expulsion from the Communist Party, he was an ex-Communist, anti-fascist revolutionary muralist without a wall. Then he became a Trotskyist, anti-Communist anti-fascist, until he discovered that Trotsky had had an affair with his wife, whereupon he became an independent, semi-retired, revolutionary, anti-Communist anti-fascist. He then became a Pan-American, Internationalist, anti–Nazi-Soviet pact revolutionary artist who wished to pay homage to the ex–Ziegfeld girl Paulette Goddard. No doubt *Pan-American Unity* reflects some of this ideological complexity and confusion.

In the corridor of the National Palace, by contrast, Rivera was working on a subject which had always been close to his heart. He had finished with the dream of the future; now he started to dream the past. In a series of eleven panels, round two sides of the open first-floor gallery of the great central courtyard, he set out to reconstruct the four civilisations of ancient Mexico. He deployed the innocent eye of Gauguin to depict an idealised, mythical Arcadia, an Indian paradise, in which peaceful, industrious people harvest rubber, cocoa and the maguey cactus. The most successful of this series of frescoes is perhaps the large panel painted in 1945 which shows the vast panorama of the valley of Mexico and the Aztec capital of Tenochtitlán just before the Spanish Conquest. We know it is just before the Conquest because a beautiful young woman in the Tlatelolco market, whose leg is so seductively tattooed, is being offered a severed male arm, and the arm is that of a European. Rivera brought the series to an end after nine years, in 1951, by once again depicting the Spanish Conquest, showing Arcadia turned into an Indian Hades marked by slavery, branding, the lash and the gibbet, and presided over by Cortés, who has by now become "a hunchbacked, syphilitic, microcephalic imbecile." Rivera justified this historical distortion by referring to the recent discovery of some human bones in the nave of the Church of the Temple of Jesús which were unconvincingly attributed to the captain of the conquistadors. Rivera's critics pointed out that by reducing Cortés to the level of a cretin he was implicitly reducing his defeated foes, the Indian Emperors Montezuma and Cuauhtémoc, to an even lower level. But this was a quibble as far as Rivera was concerned. He was content, having defiled Cortés's palace in Cuernavaca, to have extended his record of the Conquest into the very citadel from which it had been directed, and once

again to have transformed a building which glorified the Spanish victory into a monument to Indian suffering.

In the National Palace gallery Rivera was also expressing his own sense of mixed race. Rivera was never tempted by the early "Revolutionary racism" which preached that "the purer the racial (Indian) origins" of an artist, "the greater the purity of his work." Instead, unlike others of similar descent, Rivera delighted to boast of his mixed blood, and one way of doing this was by creating a romantic myth of Mexico's Aztec past. Rivera's National Palace paintings were a contribution to a debate in Mexico that started in 1861 with a celebrated speech before the Mexican Congress by the writer Ignacio Ramírez, in which he said:

Whence do we come? Where are we going? This is the double problem whose solution individuals and societies must seek. . . . If we insist on being pure Aztecs we will end in the triumph of a single race, adorning the Temple of Mars with the skulls of the other race. . . . If we insist on being Spaniards we will plunge into the abyss of the re-Conquest. . . . But we come from the town of Dolores, we descend from Hidalgo. Like our fathers we were born struggling for freedom. And like Hidalgo, fighting for the holy cause, we shall disappear from this earth.

Rivera's decision to champion the theory, developed by Vasconcelos, that Mexico's true identity lay in the mestizos, who were destined to become the dominant race of the future, meant that he frequently had to put up with crude racial abuse. In Detroit he noted that Dr. Valentiner, his patron, was accused by the president of the Marygrove College for Girls of having soiled public walls with the work of "an outside, half-breed, Mexican Bolshevist." Rivera's replies could be appropriately colourful. In 1952 he made a speech in Mexico City in which he said that he had once witnessed an experiment in which "a distinguished Soviet scientist produced a pure white child from the ninth generation of crossings between Negroes and Mongols." He did not say whether this had been undertaken with the assistance of a time machine. In the same speech he mentioned in passing that his own great-grandmother had been Chinese.

In fact, Rivera had no Chinese blood, but he was, like so many other Mexicans, neither Aztec nor Spaniard but Mexican, *"hijo de la chingada!"* The *chingada* in this case, says Paz, is the mythical Mother, violated by the Conquest, and the Mexican is the offspring of this violation who curses his Spanish father for his crime and his Aztec mother for having been violated. Rivera's glorification of the Aztec Arcadia was his personal attempt

to exorcise this curse and to close Mexico's unending debate about its national identity.

Rivera's homage to Mexico's lost Indian culture was not only intended to revalorise the Indians, the despised component of the national identity, but was also inspired by his own need to reconcile his account of the Indian experience of the Revolution and the reality of that experience. The Revolution had offered the Indians a temporal religion of socialist materialism, but the Indians did not want a temporal religion; they had always believed in eternity. When the Aztecs were overwhelmed by the conquistadors they were forcibly converted to Christianity, but they continued to worship their old gods secretly, often, in Anita Brenner's famous phrase, hiding their "idols behind altars." The *Cristeros*, in rejecting the Revolution, were trying to erect altars behind the new idols.

But Rivera did not need to sympathise with the *Cristero* revolt to acknowledge that the Indian attitude to the Mexican Revolution was far more ambivalent than he had originally portrayed it. When he came back to Mexico in 1921, one of his first models was a young Indian girl called Luz Jiménez. She appears in his first mural in the Escuela Prepatoria, and he used her as a model for the next twenty years. Luz had lived the Revolution that Rivera appropriated for his own fictional autobiography. Her hometown in Morelos had been liberated by Zapata while he was quietly writing letters to Angelina and sketching the volcanoes outside Amecameca. Luz's story has been related by Frances Karttunen. She was a child when the Zapatistas rode into the Plaza of Milpa Alta and shot down the federal soldiers who were breakfasting there. Luz hid behind one of the stone columns of the arcade to escape the bullets. The Zapatistas occupied the town, and the people found that they were bandits, rapists and murderers. Then the Carranzistas came to drive the Zapatistas out, and the townspeople discovered that they behaved in exactly the same way. The Carranzistas shot all the men in the town, including Luz's father, and when the Revolution ended, Luz was living in Mexico City, a young woman who had once hoped to be a schoolteacher, with an incomplete education, no home and no future. So she became a domestic servant and life model and met Rivera.

Under the *Porfiriato,* Luz had received a free education in a government school; her family could never have afforded to pay for her to be educated, and the worst thing she can remember happening was her parents being threatened with prison if they did not send her to school every morning in clean clothes. After the Revolution she posed for Jean Charlot,

Edward Weston and Tina Modotti as well as Rivera, and among the Inter-
nationalists she was generally known as "Anita Brenner's cook." Even
today she tends to be identified in photo captions as "a servant" or even as
"a Tehuana," which she was not. In Rivera's oil paintings she appears as
The Flower Seller (1926) or *Indian Spinning* (1936). The Revolution had
destroyed Luz's chance of becoming a schoolteacher but in one of his
first great murals, on the ground floor of the ministry of education,
Rivera painted her as *The Rural Schoolteacher,* sitting on the ground, in a
field, teaching children to read, guarded by a Zapatista revolutionary on a
horse. Luz Jiménez was an intelligent woman who was prepared to speak
her mind, and Rivera was a gregarious portrait painter who let his models
walk around and liked to hear them talk. Throughout Rivera's life Mexico
was governed by the same sort of people, none of them Indians. Luz
Jiménez vividly remembered Díaz's education inspectors coming to her
Indian town and saying, "We are going to turn out children who will
become teachers or priests or lawyers. . . . When they grow to be young
people the girls who have gone to school will not have to become ser-
vants—grinding corn, kneading dough. . . ." In Díaz's day, it was assumed
that being educated meant abandoning an Indian identity and forgetting
the Nahuatl language and customs; Luz had to wear shoes and a skirt to
go to school. After the Revolution, Indian dress and customs were glori-
fied, not least by Rivera, but the Indians occupied more or less the same
place in society as they had always occupied. The post-revolutionary lead-
ers of Mexico have all been criollo; in fact, the last president of Mexico
who is known to have been part Indian was Porfirio Díaz, the historic
oppressor.

As he built Anahuacalli and painted the walls of the National Palace
and dressed his German-Jewish wife in Tehuana clothes, Rivera was resist-
ing the racial hierarchy of Mexico and remaining true to the vision which
had inspired him when he first set eyes on the bathers of Tehuantepec.

§ § §

WHEN HE WAS NOT WORKING on the walls of the National Palace,
Rivera divided his time between his temple in Anahuacalli; Frida's house
in Coyoacán, where he had a bedroom on the ground floor which he sel-
dom occupied; and the house in San Angel, where he did his portrait
painting. There could hardly be a stronger contrast between two houses,
two temperaments, than the domain of Diego at Anahuacalli and the
domain of Frida in the Casa Azul. On a sunny day Anahuacalli remains a

stone sepulchre, whereas the Casa Azul is always a house of light. Frida lined the kitchen with blue and yellow tiles. There are white walls and high, white-beamed ceilings, and yellow-painted cane furniture and superb glazed terracotta pots. And all through the house the colours she chose seem to suck the light in and magnify it before throwing it back, so that the rooms glow, even in a winter gloom. Here Rivera lingered over Frida's vegetarian meals and spun tall stories to Gladys March about his days as a student cannibal.

Ella Wolfe, in August 1994, recalled visiting the Riveras in the Casa Azul on one of the occasions when Rivera was in residence. "Nobody had a stranger household than the Riveras," she said. "There were monkeys jumping through the window at lunchtime. They just jumped up on the table, took some food and left. And there were seven hairless Xólotl dogs named after the members of the Politburo. That was fun because they answered to their names. Rivera could be very nice or very difficult. We were lucky because with us he was always very nice. He spent much of the time telling us stories, wonderful stories. There was something hypnotic about him. Even when you knew he was fantasising, you listened." Raquel Tibol was present when one of the hairless dogs urinated on a water-colour Rivera had just finished. Rivera seized a machete and chased the dog round the house. But when it was cornered, the animal begged silently for mercy. So Rivera picked it up instead of killing it, saying, "Lord Xólotl, you are the best art critic I know." Rivera and Frida's relationship was frequently high-spirited. At a lunch party in 1941, Frida, tired of Rivera's obsession with his latest model, possibly his favorite model, Nieves Orozco, or another Indian model, Modesta Martínez, complained about "her huge, ugly breasts." Herrera has recounted that when Rivera objected that they were "not that huge," Frida replied, "That's because you always see them when she's lying down." The New York muralist Michelle Stuart, who worked with Rivera in 1953 on a theatre mural on the Avenida de los Insurgentes in Mexico City, remembers the packs of wild dogs that ran in the streets outside the Casa Azul at night. She also recalls that even in old age Rivera retained his power to charm. "I was a student and when we were introduced he took my hand and he kissed my hand. He looked like a big frog, and everything he did was intended to prove he was larger than life. When he kissed my hand it was a statement, about women and about him. Well, I *was* good-looking. But if he was like that with a student one can just imagine how he behaved with women who mattered, like collectors' wives."

High spirits also marked Rivera's life in San Angel. In 1947 a truck

driver, steering a lorry round the bend outside Rivera's house, came under pistol fire, and on November 29 a warrant was issued for Rivera's arrest. In his defence Rivera explained that he had merely opened fire because he was convinced that the truck driver was about to knock him down. "Who has not fired a shot into the air to celebrate the New Year?" he asked. "Who has not fired a shot during thirty or more years for the sheer joy of it, even without the blessing of constitutional law? Who has not fired a shot *just to get a waiter's attention?*"

The San Angel house is just opposite the San Angel Inn, one of the best restaurants in Mexico City, where Rivera was able to entertain his models. His appetite for the company of beautiful women was never sated. After the film actresses Dolores Del Rio and Paulette Goddard, there was Linda Christian and the film actress María Félix, whom he painted and seduced in 1948. His relationships with his numerous models, and with the subjects of many of his portraits, were the subject of frequent speculation in the Mexican press well into his old age. María Félix, Dolores Del Rio and Pita Amor became the lovers of both Rivera and Frida.

Rivera's relations with other women were by now supposedly a matter of indifference to Frida. According to Rivera, Frida had insisted before their remarriage that they should not resume sexual relations, but there are several references to sexual passages with Rivera in the diary she kept for the last ten years of her life. In fact, their sexual relationship continued, fed by their sexual compatibility which was androgynous. Frida once proudly claimed that "the sensitivity of Rivera's marvellous breasts" would have seduced even the ferocious female warriors of Lesbos. And he said that he loved women so much that he sometimes thought he must be a lesbian. She painted him in 1949 as a gigantic female baby, stretched out in her lap with round thighs, a swollen belly and plump breasts. At the same time she accentuated her own masculine characteristics, willed on her during childhood by the fact that she succeeded a stillborn brother. She frequently dressed as a boy, and in adult life took care to comb her little black moustache and became a voracious lover of both men and women.

The manuscript of Frida's diary shows that when she crossed something out she did so very thoroughly, as though fearing that somebody else might read it. The only other person likely to read it was her husband. There are frequent passionate references to him in the diary, and there are also references to her interest in other women. There are no references to her interest in other men, although she is known to have had a

love affair with at least one other man at this time.* One is left with the
impression that Frida was keeping the diary knowing that Rivera was
reading it and in order to reassure him of her devotion, which implies that
he was still sufficiently interested in her to be jealous. She would some-
times arouse this jealousy by taunting him, in public, about Trotsky.
Clearly the curious mixture of neglect and obsession that characterised
Rivera's feelings for his wife during their first marriage continued into
their second. Publicly, Rivera continued to play the monstrous role which
became him so well, as the inspirer of much of the suffering which his
wife transformed into art. As the years passed, Frida's dependence on her
idol and tormentor increased. The Casa Azul became a shrine to Frida's
suffering, and Rivera's childhood interest in medicine found adult expres-
sion in his marriage to a chronic invalid who took a perverse pride in her
status as a professional patient. On their bookshelves, between the cook-
books, books of Mexican history, works by Elie Faure, J. H. Duveen's
Secrets of an Art Dealer, La Carreta by B. Traven, and classics by Balzac,
Maupassant and Tolstoy, stand well-worn copies of *Ramsbotham's System
of Obstetrics* and *Winckel's Textbook of Midwifery.* Rivera owned a collec-
tion of several hundred retablos whose primitive style was an influence
on Frida's painting, and these were displayed on the walls of the house.
The little pictures on beaten tin, made in thanks for miraculous cures or
interventions and painted by anonymous artists who worked outside
churches, show the mundane incidents of Mexican magical life. There are
scenes of armed men attacking an isolated hacienda, a woman praying at
night by a lake and seeing a vision, and a sick child in bed while his sister
kneels by a table lit by candles and gives thanks to the Virgin of
Guadalupe for "a cure without an operation." These pictures depict a
saga of suffering and release that encouraged Frida as she mounted the
stairs to her bedroom, where the photographs of an alternative college of
saints—Engels, Lenin, Stalin and Mao—were displayed around the bed.

 As Frida's health deteriorated, Rivera was asked to display qualities he
did not possess, such as patience and self-sacrifice. Instead he sometimes
neglected her. Then he would feel guilty and hurry home to amuse her
with tales of his adventures with other women. Her dependency on him
ensured a devotion on her part to which he in his turn became addicted.
Otherwise he would never have stayed with a woman who cost him so

*He was a Spanish refugee from Barcelona, also a painter, and when he died recently his
papers were found to include hundreds of letters from Frida, as well as drawings and paintings
she had made for him over the years.

much time and who so frequently interfered with his work. We can assume that she sapped his energies because in her diary she wrote of how she never wanted his energies to be sapped. In her correspondence Frida frequently complained about Rivera's infidelities, but as frequently stated that he had every right to his freedom. It seems therefore that their mutual sexual liberation in reality caused her profound unhappiness, but that it was an unhappiness whose source she was constantly forcing herself to deny. Instead she blamed her unhappiness on her ill health, and thereby made her ill health an essential cover for her unhappiness. She became dependent on it. What she was saying was "If I wasn't so ill, I would be better loved." A typical letter to Dr. Eloesser, written in December 1940, just after her remarriage, starts by asserting how well their new relationship is going, continues by regretting Rivera's enduring interest in other women, and immediately switches to the question of her health. "This thing of feeling such a wreck from head to toe sometimes upsets my brain," she wrote. To comfort her Leo Eloesser sent her a human foetus in a jar of formaldehyde, knowing that she would cherish it, and she kept it by her bed. It stood among her collection of dolls, and Rivera was expected to keep an eye on these "babies" while she was away. When she was at home, which was most of the time, Rivera became her baby and she became his mother, bathing him regularly and even filling the tub with rubber ducks. So he kept his marital vow, and provided her with a child. At bathtime her dolls came to life. A relationship of such comprehensiveness and intensity was probably impossible for either of them to duplicate. Certainly Frida was the only woman who managed to pierce Rivera's elephant-hide balloon of egotism.

"I can say at least," he wrote in 1946 to "Dr. Nilson" (the New York surgeon's name was actually Philip Wilson),

that her life is of more value to me, much more than my own. She crystallises in herself, in one human being, possessing artistic genius, everything that there is in the world, that interests me, that I love, and that gives any sense to me of why I live and struggle. So you see the sort of mental inhibition that cuts me short, in trying to express to you the debt I owe you.

Kahlo put the same feeling, more briefly, in a poem in her diary. "Diego my child, . . . Diego my mother, Diego my father, . . . Diego = me."

In his autobiography Rivera referred to Frida's anguish during their two-year separation and claimed that she sublimated this anguish in her painting, practically attributing the credit for her achievement to his own

bad behaviour. In reality, he had a deep admiration for her skill. There is a photograph taken in 1943 of Frida sitting, painting a self-portrait, her face showing the tentative disapproval of an artist who is wondering why the picture is not quite right, while behind her chair Rivera stands, oblivious of the camera, lost in wonder, intently watching the movements of her brush, like the little boy who in his imagination once stood at the door of Posada's workshop.

In the last fourteen years of her life Frida continued to draw on that common imagination which she had once, in 1932, depicted as a battle-ground with her picture *Self-Portrait on the Border Line Between Mexico and the United States*. There, in Detroit, she had shown herself in a long pink ball gown standing in front of two landscapes, the industrial artefacts of the United States—the contemporary furniture of her husband's imagi-nation—to one side, and the magical artefacts of Aztec Mexico to the other. She is holding a Mexican flag which is pointing towards the skull and stones of the Aztecs, and she made sure that that was where their joint future lay. It was in 1940 that she painted Rivera as her monstrous female baby, sitting on her lap while she sat on the lap of their mythical giant stone Indian wet-nurse. In 1943 she painted a Tehuana self-portrait with a miniature portrait of Rivera set in her forehead. It is the picture he was watching her paint in the photograph, which was taken before his own face was added. A mirror behind the easel would have reflected his face looking down over her shoulder.

The fusion she yearned for became more complete with *Diego and Frida 1929–1944*, a very small oil on wood, in an ornate seashell frame, showing a single face that is split down the middle between the left side of his face and the right side of hers. This was his birthday present, and it is noticeable how much softer and feminine his face looks, and how much harder and masculine hers. In 1949, three years after she had undergone an unsuccessful operation* in New York for a spinal fusion, and at a time when Rivera had told her that he intended to marry María Félix, she painted *Diego and I*. Once more his face appears imprinted on her fore-head; it is her culminating tribute to their common imagination, Diego has become her Third Eye, her painter's eye. But this time there are tears running down her cheeks. Her long black hair is loose and twisted round her throat like wire. The overdose she took after finishing this painting brought him to heel. Rivera's second attempt to divorce Frida was clearly

*Despite Rivera's expression of gratitude to "Dr. Nilson," the operation had not been a success.

a bid to escape an intimacy which he was beginning to find as suffocating as it was addictive.

Judging from his appearance, Rivera's health, too, began to deteriorate between 1944 and 1949. The change is first visible in 1945, when he was working on a grisaille panel at the National Palace, beneath *The Great City of Tenochtitlán*. At fifty-eight Rivera started to age fast, and within a year he had the appearance of a worn-out old man. The relentless struggle for love and possession which he waged with Frida in the years after their remarriage contributed to this. Whereas Rivera dominated the adult life of Frida for twenty-six years—from 1929, when she was twenty-one—she entered the foreground of his life when he was already a "made man" with more than half his best work complete. Her art grew through their relationship and was partly the consequence of it. She was, as she herself said, painting her private reality. But Rivera was trying to paint abstract ideas; his art was independent of their relationship, formed by earlier experience, and was frequently challenged by the demands she made on his time and energy. So what sustained her during their second marriage threatened him. And as his creative powers diminished, his relationship with Frida started to enclose him too. The fact that he should have tried to make his final escape in the company of one of her lovers doomed the attempt from the start. Even in their infidelity they were chained together.

Release came with her death in 1954. Frida Kahlo died, probably from an overdose of painkillers after leaving a suicide note in her diary, alone except for her servants in the Casa Azul, the house where she had been born, exactly one week after her forty-seventh birthday. Since the failed spinal operation of 1946 the pain she suffered in her back and legs had steadily increased. In 1951 she developed gangrene in her right foot and spent most of the year in hospital. In 1953 her right leg was amputated, and after that, according to her friends, she more or less gave up. For some time she battled to carry on painting, and on one occasion summoned enough energy to fly into a rage and threaten to send her amputated leg to Dolores Del Rio. Perhaps it was of that incident Rivera was thinking when he wrote: "Following the loss of her leg, Frida became deeply depressed. She no longer even wanted to hear me tell her of my love affairs. . . . She had lost her will to live."

In her last years Frida became a fervent Stalinist. One of her diary drawings was entitled *Marxism Will Give Health to the Sick,* and showed a saintly Karl Marx reaching down from the sky to heal her. And the painting she left on her easel was an unfinished portrait of Stalin. After her

death Rivera wrote: "July 13th, 1954, was the most tragic day of my life. I had lost my beloved Frida forever. Too late I realised that the most wonderful part of my life had been my love for Frida." When her ashes emerged from the crematorium oven, Rivera took some in his hand and ate them. He was free, but he painted no more frescoes. As far as his work was concerned, his own life too had all but ended.

Two months after the death of Frida Kahlo the Mexican Communist Party readmitted Diego Rivera on his fifth application—thirteen years after he had first reapplied (Frida had been readmitted in 1949). Stalin had died a year earlier, in 1953, and Beria had been overthrown, an event which led Rivera, as idiosyncratic as ever, to toast "the return of the Trotskyists to power in the Soviet Union."

Rivera's first application to rejoin the Communist Party was made in February 1941, four months *before* the ending of the Nazi-Soviet pact, and a month after he had finished *Pan-American Unity*, in which he depicted Stalin as a hooded assassin. It is a characteristic Riveran paradox that over the following years, when so many artists and writers were being murdered by the Communist Party or stampeding out of it, he was struggling to rejoin it, and being refused. But his rediscovered Communism was one of the great bonds he had with Frida in their last years together. He was readmitted after he had turned her public funeral into an unauthorised Communist Party demonstration by spreading the hammer and sickle over her coffin while it was being escorted by representatives of the state of Mexico. One further reason for Rivera's wish to be reconciled to the party was his Mexican need for a spiritual home. For much of his life Rivera's god was Lenin, and between 1923 and 1929, and 1941 and his death in 1957, he identified Leninism with the Soviet Communist Party. Lenin was not, of course, his only god. As a child he had been a Catholic, and in 1956, without in any way renouncing Leninism, he startled a large audience of journalists by proclaiming, *"Soy Católico!"* (I am a Catholic!). At other times Rivera saw himself as a follower of Quetzalcóatl, the plumed serpent, the god who had abandoned the Aztecs and who would one day return. Rivera had the Catholic need to pass his sins to a confessor, if only he had been able to discover what his sins were. Lacking confession, Rivera lacked redemption.

In 1953 Rivera had undertaken his last fresco, for a new hospital in Mexico City, the Hospital de la Raza, on the subject of "The People's Demand for Better Health." One half of the decorated wall shows the activities of a modern hospital; the other shows Aztec medical advisers at work. An Indian woman giving birth is assisted by two midwives, both

modelled by his twenty-five-year-old daughter Ruth. The newborn baby
bears a striking resemblance to the infant Rivera. The fresco is dominated
by a glorious silver, black, red and gold depiction of Tlazoltéotl, the sin-
eater, who had the power to provoke lust and to favour indecent loves, as
well as the power to forgive. In the absence of Tlazoltéotl, Rivera's sus-
tained attempts to re-enter the Communist Party and his regained inter-
est in Catholicism were signs that he was still in search of a church. Jean
Charlot once heard Rivera at a public meeting say, "I thank God I'm an
atheist," a comment which perfectly summarised his lifelong ambiva-
lence towards religion.

Certainly Rivera's born-again Communism seems to have had little
to do with any belated grasp of practical politics. Tina Modotti had died
in 1942 in mysterious circumstances. She collapsed in Mexico City in a
taxi, after a normal dinner with friends, aged forty-six. Questioned by
police, her companion, Vittorio Vidali, who had dined with her, claimed
that she had been suffering from a heart condition for some time; for this
he was the only witness, and it is a mystery why anyone believed him.
Vidali was growing tired of Tina by that time, and she knew far too much
about his political operations both in Spain and in Mexico. Furthermore,
she was showing increasing signs of disaffection with Stalinism. She had
said sometime before that she hated Vidali "with all her soul," but that
she was forced "to follow him till death." It seems entirely possible that
Vidali "eliminated" her, although when Rivera suggested this, on hearing
of how Tina had died, he was roundly abused by the Communists he was
trying to rejoin.

At the end of his life Rivera continued to paint oils and water-colours.
The year after Frida died he finished sixteen paintings, and in 1956 he com-
pleted fifty-six. Rivera painted because he had to, but also to make money,
which he lacked to the end of his life. He was capable of undertaking two
commissions for a self-portrait and sending two respected customers
practically the same picture if time was short. He had been too poor in
1948 to pay for all the medical treatment Frida needed, and in October
1957, one month before his death, he wrote to an official in the ministry of
finance asking for help with the printing costs of his daughter Ruth's
architectural thesis but offering to pay for the paper himself.

In November 1954, the year of Frida's death, Rivera presented both
Anahuacalli and the Casa Azul to the Mexican nation. Then he attended
the Day of the Dead celebrations in Mexico City. In earlier years he had
travelled by night to join in the celebrations in Pátzcuaro, the town where
he had once entertained Trotsky and André Breton. Now he announced

his plans for his own funeral, saying that he wanted to be cremated and to have his ashes added to the pot which contained Frida's. He had bought the heavy clay pot some years before her death, and when it was full he asked for it to be placed in the burial chamber in the centre of Anahuacalli.

Twelve months after the death of Frida, Rivera married his art dealer, Emma Hurtado, at her gallery, the Galería Diego Rivera in Mexico City. In 1952 he had been told that he had a cancer of the penis, a condition which he learnt with some satisfaction was most unusual. His Mexican specialist advised amputation, but Rivera, in a manner that recalls his accounts of his grandfather's death on "the field of honour," refused the cure as being worse than the condition. The cancer recurred in 1955, whereupon he flew to Moscow with his new wife to receive the latest revolutionary "cobalt" treatment from Dr. Funkin and his team of mainly female Soviet surgeons, as a result of which he was restored to the pink of health. On his return to Mexico Rivera fell in love with Dolores Olmedo, and, leaving Emma, he went to stay with Dolores in her villa in Acapulco. Dolores Olmedo, who is said to have been the favourite of several of the presidents of Mexico, had been a friend of Frida's and became her executrix; she was also the principal collector of Rivera's easel paintings. Rivera was therefore in the unusual position of being married to his dealer while living with his dealer's principal customer. One of the early bonds between Dolores Olmedo and Rivera, at the time of their original liaison in 1930, when she first posed for him, was that she came from a poor family in Tehuantepec. By the end of Rivera's life she had become one of the richest women in Mexico, and he made a sumptuous portrait of her in 1955; this time she was posing in bare feet and a Tehuana dress with a basket of fruit; but unlike his other Tehuana maidens, she wore solid gold jewelry round her neck and her wrists, and her toenails were painted red. Rivera rebaptised the Acapulco house "Ehecatlcalli" (House of the Wind God)—it had formerly been called the "Quinta Brisa" (Villa Breeze)—and filled it with mosaics and stone carvings. Among the figures represented is that of a toad-frog (Rivera) who is offering a lollipop to a mermaid (his hostess).

In September 1957 Rivera, aged seventy, suffered a stroke and lost the use of his right arm, but he continued to attempt to paint. The Lord of Mictlan came for him on November 24, as he lay on his three-quarter-size bed in the little room beside his San Angel studio. He rang the bell, and when Emma asked him if he wanted her to raise the steel bed on its adjustable frame, he replied, "On the contrary, lower it." Those were his last words before his heart failed. His wish to be buried in his personal

temple at Anahuacalli, placed in the "offering chamber" and surrounded by his little stone men, was ignored. Instead the Mexican political establishment which he had so often ridiculed took its final revenge by giving him a state funeral and interring him in the national "Rotunda of Illustrious Men."

In the last decade of his life Rivera took increasing pleasure in his skills as a storyteller. He devoted his inventive power to his autobiography, reliving his life as a fable, rather as he had relived the Aztec past as a fable in the National Palace. *My Art, My Life* is the biographical equivalent of the magical realism school of fiction. Sometimes there are rational explanations for his inventions. Why did Rivera claim to have led a student strike at San Carlos when he was in fact a docile and hardworking young painter? Because Siqueiros actually did lead a student strike there ten years later. Why did Rivera invent his non-existent revolutionary experience in 1911? Because his rivals, Orozco and Siqueiros, both lived through the Revolution, and the latter fought in it with distinction. Why did Rivera claim to have known Posada? Because Orozco did know Posada. Why did Rivera pre-date his Cézannean influence by ten years, to 1909? Because Siqueiros saw Cézanne for the first time in 1919. And why did Rivera always claim to have spent seventeen months in Italy, studying fresco? To emphasise the seriousness of his "vigil"? Or perhaps because he did not want to account to the Mexican government for the 2,000 gold pesos he had spent in four months.

His daughter Guadalupe once explained her father's fictions by saying, "My father was a storyteller and he invented new episodes of his past every day." No doubt this was true; nonetheless, the real journey made by the industrious young state bursar of the *Porfiriato,* the boy whose father was ruined, whose mother was impossible, but who had genius, is far more extraordinary than the legend of "the infant socialist and atheist" who held the same opinions all his life.

In 1947, ten years before his death, at a time when his creative powers seemed to be draining away, Rivera started work on a great fresco which was also his most splendid myth. He called it *Dream of a Sunday Afternoon in the Alameda,* and it was his personal response to Ramírez's question: "Whence do we come? Where are we going?" In the centre of it he placed the figure of the child Diego trustingly holding the hand of "la Calavera Caterina," Posada's skeletal caricature of the figure of Death; the child Diego knows he can trust Caterina because she will accompany him throughout his life. The boy has a toad climbing out of one pocket; a

snake emerges from another. Behind him stands Frida, with a protective hand on his shoulder. The picture displayed the pageant of Mexican history through the eyes of a child, but it was also his painted autobiography and showed the world the child had entered and expected to live through. These were the marvels the little boy had glimpsed when he peered so many years before into the waters of the fountain in the courtyard of his childhood in Guanajuato. The painting is notable for the fantastic complexity of its composition and its soft, bright colours. The *Dream* is fifteen metres long and nearly five metres high, and once again picks out the main characters in the events from the Conquest to the 1910 Revolution. But this time Rivera has found a new way of retelling the story; there is humour in this picture as well as social justice. Rivera was one of the century's finest portrait painters, and in the *Dream* the Alameda, the park outside the doors of the Hotel del Prado for which the mural was commissioned, is crowded with over 150 figures, each of them significant either in history or in Rivera's own life. Cortés is again a bold warrior, though his hands are covered with blood. The luminous face of Sor Juana, the seventeenth-century poet and advocate of women's education who was forbidden by the Church to publish her work, gazes down on a small pickpocket who is removing a silk handkerchief from the coat-tails of a wealthy Porfirian patron of the arts. Joy and misery are intertwined. A young woman dandles a blond child; below them the same woman, alone in old age, holds her face in despair. Old men sit dozing on a park bench, dreaming of past glory. The beautiful Carlotta stands dutifully beside her betrayed husband, the Emperor Maximilian, and from the shadows behind the marble shoulder of Carlotta peers the face of the dashing Coronel Rodríguez, uncle of the boy Diego and mythical lover of the Empress. Doña Carmen de Díaz advances in silk and feathers and pearls and lace, ready to buy Rivera's pictures on the day the Revolution that was to drive her into exile broke out; and near her in a yellow dress and ungathered hair is the insolent figure of "la Revoltosa," the singer and prostitute Chiutlahua, with her hands on her hips staring down a policeman. And near her on crutches, wearing a frock coat and top hat, is another real-life character from Diego's childhood in the Alameda, General "Lobo" Guerrero, a hero of the War of Intervention, who was by then known as "General Medals." Another policeman drives an Indian family out of the park; above them Zapata's horse rears over a barricade, bringing liberation; and the story ends with modern Mexico, dominated by skyscrapers, a venal, sallow-faced priest in tinted spectacles, corrupt

millionaires and a corrupt president. When the picture was complete, a furious row broke out over one detail—a small historical text, dating from the nineteenth century, bearing the words "God does not exist." The fresco was destined for the dining-room of the new Hotel del Prado, but the archbishop of Mexico refused to bless the building until the blasphemy was removed. "Why doesn't he bless the building and curse my fresco?" enquired Rivera. But the painting was nonetheless concealed for nine years, until, with death approaching, the artist agreed to make the alteration.

Rivera was a man who tried in his work to make sense of his existence and who failed to make that sense. Before Elie Faure died in 1937, he sent Rivera a message of farewell. "Hurrah for the success of your action!" wrote Faure. "The artistic glory of a Matisse or even of a Picasso does not count alongside the human passions which you arouse, and there is not at this hour of the world's course another painter who can say as much. . . . My dear old Diego, I embrace you tenderly." But there was no development at the end of Rivera's life; instead there was regression, to Stalinism and to compromised ideals which he himself had seen through as a young man. There was no personal resolution or synthesis, no selection from experience, leading to a developed personal statement. To the question, what was his life all about? Rivera could only reply with a resounding silence and point to the magnificent spectacle of his final dream. His life had no more coherence or meaning than his last great fresco. But it had the complexity and imagination and colour and passion of that picture. His life started in a dream by a fountain in a small town in Mexico, in a world that was shortly afterwards swept away forever, and in his last years he painted his life as a dream, a magnificent dream fifteen yards long and five yards high, in which he fused the significant events in his own and his country's past.

In 1921 Rivera returned to his native land to become a revolutionary painter in a revolution that had already been betrayed. In a time of collectivism and communal *dictats* he was condemned to assert an individual genius. In Mexico the message of life, of order, of hope is generally submerged by the morbid stone force of Indian culture, the culture of the dead. The irony of Rivera's life was to choose to return to his country bearing the message of order and hope, and to reinterpret it in terms of the Indian culture which would inevitably be fatal for the message. In his frescoes in the ministry of education, Rivera started by painting the corrupt past, the heroic present and the idyllic future. He ended in the Hotel

Reforma, the Hotel del Prado and the galleries of the National Palace by painting the corrupt present and the idyllic past, with no reference to the future. But in abandoning the role of propagandist and assuming that of the myth-maker, Diego Rivera turned a political failure into a magnificent artistic success. In his art he succeeded in turning the nightmare of history into vision, and in endowing his people with a national myth.

APPENDIXES

A NOTE ON SOURCES

SELECT BIBLIOGRAPHY

INDEX

APPENDIX 1: CHRONOLOGY

1861	Imposition of the puppet "Emperor of Mexico," Maximilian of Habsburg, by Napoleon III of France.
1867	Defeat of French forces by Mexican liberals led by the Indian lawyer Benito Juárez. Execution of Maximilian.
1876	General Porfirio Díaz seizes power with the slogan "No Presidential re-election." He remains in power for the next thirty-five years and is fraudulently re-elected seven times, a period known as "the Porfiriato."
1886	**December 8, birth of the twins Diego María Rivera and Carlos María Rivera in Guanajuato in central Mexico, a silver-mining town.**
1888	**Death of Carlos María Rivera.**
1889	**Diego Rivera begins to draw, aged two.**
1891	**Birth of a sister, María.**
1893	**Rivera family move to Mexico City and live in reduced circumstances.**
1898	**Diego Rivera, aged eleven, starts to attend the national school of art, the Academy of San Carlos.**
1905	**Rivera passes out of San Carlos and is awarded a bursary to study in Europe by Teodoro Dehesa, a stalwart member of the Díaz regime and the governor of Veracruz State.**
1906–7	Violent political protests against the Díaz regime repressed by massacres.
1907	**In January, Diego Rivera leaves Mexico and settles in Madrid to continue his studies. He is aged twenty, over six feet tall and weighs as much as 300 pounds.**
1909	**In March, Rivera completes his studies and moves to Paris. After a few weeks he sets out on a tour of northern Europe, visiting Bruges, Holland and London. He meets Angelina Beloff, a Russian-Jewish art student from St. Petersburg.**
1910	**Rivera and Angelina Beloff live together in Paris and visit Brittany. In October Rivera returns to Mexico to take part in the centenary celebrations of the Mexican Revolution.**
1910	An attempt to overthrow the Díaz regime, led by the liberal Francisco Madero, is thwarted. Madero flees to the United States just before the start of the official celebrations.

November 20, armed uprisings break out in northern Mexico. In Mexico City, on the same day, Rivera's one-man show is opened by Doña Carmelita Díaz, the president's wife, who buys six of his paintings. The Mexican State buys seven more.

1911 The armed uprisings spread all over Mexico. Díaz is forced into exile in May.

1911 **In April, Rivera returns to Paris, having taken no part in the insurrection. He and Angelina Beloff, now regarded as his wife, settle in Montparnasse. They travel to Catalonia, Toledo and Madrid, and Rivera starts to exhibit in Paris. The Madero administration renews Rivera's grant.**

1912 **Rivera spends the summer in Spain, the autumn in Paris and the winter in Toledo, which reminds him of Guanajuato. He comes under the influence of El Greco's painting.**

1913 In January, death in Mexico City of the engraver and cartoonist José Guadalupe Posada. The Madero regime is overthrown by the treacherous General Victoriano Huerta, and eight years of violent unrest ensue.
 Rivera returns to Montparnasse and starts to paint in the Cubist manner, which he maintains for four years.

1914 In April U.S. Marines occupy Veracruz; they remain for eight months. In August, in Europe, outbreak of the Great War.
 Rivera meets and becomes friends with Picasso. He has his first one-man show in Paris and a scandal erupts when the gallery owner attacks him in the catalogue to the show. In July Rivera sets out on a walking tour of Majorca. The Mexican government stops paying his grant. He spends the winter in Madrid.

1915 **In March, Rivera and Angelina return to Paris and become part of the impoverished wartime community of Montparnasse.**

1916 **Rivera quarrels with Picasso. In August Angelina gives birth to Rivera's son, Diego, and the painter simultaneously starts an affair with the Russian artist Marevna Vorobev. In New York Rivera's work is exhibited at the Modern Gallery with paintings by Cézanne, van Gogh, Picasso and Braque.**
 In Mexico Pancho Villa crosses the U.S. border to attack the town of Columbus, New Mexico, provoking a nine-month punitive expedition into northern Mexico by U.S. cavalry. The most violent phase of the Mexican Revolution, which caused the death of one million people, ends in December.

1917 **Rivera becomes involved in a public controversy about the nature of Cubism. He quarrels with his dealer and with leading Cubists and is befriended by the art historian and critic Elie Faure. He starts to paint in the manner of Cézanne. In October his son dies at the age of fourteen months.**
 In Russia, outbreak of the October Revolution.

1918 In Mexico the revolutionary government under Carranza sets about the reconstruction of the country.

Rivera attempts to break off his affair with Marevna, and with Angelina leaves Montparnasse for a more bourgeois district of Paris. Under the influence of Elie Faure, Rivera starts to take a close interest in the techniques and purposes of the Italian Renaissance masters.

1919 In Mexico the guerrilla leader Emiliano Zapata is shot dead by government troops.

In November Marevna gives birth to Rivera's daughter Marika. The Mexican government contacts Rivera and invites him to return home to take part in a national programme of mural painting.

1920 In Paris, Rivera is torn between Angelina and Marevna. Impoverished, he undertakes a first series of commissioned portraits. In December, with a grant from the Mexican government, he sets out on a short tour of Italy to study fresco painting.

In Mexico President Carranza is overthrown and murdered by supporters of General Obregón.

1921 In April Rivera returns from Italy and in July he abandons Angelina, and Marevna and Marika, and returns to settle in Mexico after an absence of fourteen years. Shortly after Rivera's return, his father dies.

The new minister of education, José Vasconcelos, initiates a national programme of popular education which is to include the decoration of public buildings with mural art.

1922 Rivera starts work on his first mural in the National Preparatory School. He marries Guadalupe Marin. Together with other painters, including José Clemente Orozco and David Alfaro Siqueiros, he founds the revolutionary Union of Technical Workers, Painters and Sculptors, and joins the Mexican Communist Party (MCP).

1923 Rivera starts work on his second official commission, to undertake a vast series of murals in the ministry of education. He quickly seizes control of this project and destroys some of the work of his colleagues.

1924 In July, resignation of Vasconcelos as minister of education. The national mural programme is cancelled. In December, election as president of the skilful, corrupt, reactionary Plutarco Elías Calles. Outbreak of the *Cristero* insurrection in response to religious persecution.

Rivera is the only muralist to continue working, despite conservative protests, under the new regime. Guadalupe Marin gives birth to his daughter Lupe. He begins work on a new commission at Chapingo.

1925 Rivera resigns from the Mexican Communist Party.

1926 At Chapingo Rivera uses a new model, the photographer Tina Modotti. In July he is readmitted to the MCP.

1927 The government intensifies the repression of the *Cristero* rebellion and the persecution of the Church.

Rivera, who has started an affair with Tina Modotti, is injured when he falls from his scaffold. His daughter Ruth is born. In August he separates from his wife Guadalupe and sets out for the Soviet Union to take part in the anniversary of the October Revolution.

1928 After becoming involved in anti-Soviet politics, Rivera is asked to leave
 Moscow.
 In Mexico, election of President Obregón, followed by his assassination by
 a *Cristero* militant.

1929 The Mexican Communist Party is proscribed as an illegal organisation. A
 prominent Cuban Communist, Julio Antonio Mella, is assassinated in Mex-
 ico City.
 Rivera helps to prevent Tina Modotti from being framed by the Mexican
 police for Mella's murder. He is appointed director of the Academy of San
 Carlos. He starts to dissociate himself from the MCP's anti-government
 line and begins work on a new official commission to decorate the walls of
 the National Palace. In August he marries a young Communist militant,
 Frida Kahlo, and in September he is expelled from the MCP. In December
 he goes to Cuernavaca to undertake a commission from the U.S. ambas-
 sador, Dwight Morrow, to paint frescoes at the Palace of Cortés.

1930 Calles, now known as "el Jefe Máximo de la Revolución," brings land
 reform to a halt and imposes conservative policies through a series of pup-
 pet presidents.
 Rivera resigns from San Carlos. In November, after finishing the murals at
 Cuernavaca, he leaves Mexico to work in San Francisco.

1931 Rivera completes two major murals at the Pacific Stock Exchange and the
 San Francisco Arts Institute. In June he is summoned back to Mexico to
 continue his work at the National Palace. He is briefly reunited with Elie
 Faure and meets Sergei Eisenstein, who finds Rivera's art an inspiration for
 his film *Qué Viva México!* Rivera commissions a new house and studio from
 the architect Juan O'Gorman in the suburb of San Angel, then travels
 to New York for a one-man retrospective at MoMA, which is a popular
 success.

1932 Rivera arrives in Detroit to start work on a series of frescoes inspired by
 Henry Ford's Rouge automobile plant and commissioned by the Institute
 of Arts. In July, Frida Kahlo suffers a miscarriage.

1933 In March, the Detroit murals are inaugurated despite fierce criticism from
 local churchmen and nationalists. Eighty-six thousand people visit the
 Garden Court in the first two weeks. Rivera moves to New York to com-
 mence a mural in the lobby of the RCA Building in the unfinished Rocke-
 feller Center. In May the architects remove his scaffold after discovering
 that his incomplete fresco includes a portrait of Lenin. In the resulting
 furore a further commission from General Motors to paint at the Chicago
 World's Fair is cancelled. In December, angry and humiliated, Rivera
 returns to Mexico.

1934 Election of Mexico's greatest president, Lázaro Cárdenas.
 Rivera suffers from ill-health. In February the management of Rockefeller
 Center pulverises his mural. Rivera starts work on a reproduction in the
 Palace of Fine Arts in Mexico City, and has an affair with his sister-in-law,
 Cristina Kahlo.

1935 Cárdenas breaks the backstage power of Plutarco Calles, his former men-
 tor, and launches a vast programme of land reform.
 **Frida Kahlo leaves Rivera and goes to New York. She returns to him at the
 end of the year to resume, by mutual agreement, an "open" marriage.**

1936 Calles is forced into exile. The *Cristero* rebellion enters its final phase.
 **Rivera undertakes a new mural commission for the Hotel Reforma, but the
 panels are never installed, owing to disrespectful references to living politi-
 cians. Deprived of mural commissions, Rivera resumes his political career.
 He joins the Fourth International and persuades President Cárdenas to
 grant refuge to Trotsky, who is the quarry of a (Soviet) GPU manhunt.**

1937 **In January Trotsky and his wife Natalia take up residence at the Casa Azul,
 the Rivera-Kahlo house in the suburb of Coyoacán, which is turned into a
 fortified stronghold. Trotsky and Frida Kahlo have a brief affair.**
 In March a Joint Commission of Inquiry into the Moscow Trials, under the
 chairmanship of the philosopher John Dewey, starts public hearings at
 the Casa Azul. In December the Dewey Commission clears Trotsky of the
 accusations Stalin has brought against him.

1938 Cárdenas nationalises the British and U.S. oil companies and restores the
 right of Mexican priests to say Mass in church.
 **Trotsky and Rivera, with the surrealist writer André Breton, travel round
 Mexico together and produce a "Manifesto for a Free Revolutionary Art."
 Frida Kahlo sets out on an extended visit to New York and Paris, where her
 paintings are being exhibited for the first time.**

1939 **Rivera, having found out about his wife's affair with Trotsky, quarrels with
 the latter, who moves out of the Casa Azul. Rivera breaks with the Fourth
 International and divorces Kahlo. But he continues to defend his former
 mentor in public and denounces the Mexican Communists who are plot-
 ting to kill him. Lacking any mural commissions, Rivera concentrates on
 painting portraits and Indian themes.**

1940 **In May a gang led by the fresco painter and Communist Party gunman
 David Alfaro Siqueiros fires 173 machine-gun bullets into Trotsky's bed-
 room but fails to hit him. Rivera flees to San Francisco and starts work on a
 mural for City College. In August, after Trotsky has been assassinated by a
 GPU professional killer, Frida Kahlo is roughly questioned by Mexican
 police. She joins Rivera in San Francisco and they remarry.**

1941 **Rivera finishes his work in San Francisco and returns to Mexico, where he
 unsuccessfully applies to rejoin the Communist Party.**

1942 **He starts on a new series of frescoes in the upper corridors of the great
 courtyard of the National Palace. Rivera also starts to build a monumental
 new residence at Anahuacalli, inspired by an Aztec temple.**

1945 **Both Rivera and Kahlo suffer repeated periods of ill-health. With Rivera's
 encouragement his wife's paintings become more and more accomplished
 and celebrated.**

1947 **Rivera starts on a vast autobiographical fresco, *Dream of a Sunday Afternoon
 in the Alameda*, commissioned by the Hotel del Prado.**

1948 The Alameda mural is completed but hidden from public view after the archbishop of Mexico City objects to the inclusion of the words "God does not exist."

1949 Frida Kahlo is readmitted to the Mexican Communist Party. Rivera's third application for readmission is rejected.

1950 Kahlo, whose health has been steadily deteriorating for many years, spends most of the year in hospital. Rivera continues to campaign for Soviet causes and supports the anti-nuclear Stockholm Peace Conference.

1951 He completes his work at the National Palace after twenty-nine years. He starts to plan a further series of frescoes for the higher galleries, which will never be executed.

1952 Continuing his campaign for readmission to the MCP, he paints a movable fresco entitled *The Nightmare of War and Dream of Peace*, which shows Stalin and Mao Tse Tung in heroic and pacific pose. The Mexican government refuses to exhibit it and two people are shot by police in subsequent public protests. Rivera's fourth application to rejoin the MCP is rejected.

1953 Frida Kahlo's right leg is amputated. Rivera sends "War and Peace" mural to the People's Republic of China, where it disappears.

1954 In July Rivera and Kahlo demonstrate against CIA subversion in Guatemala. So the last photograph taken of them together, like the first photograph of them taken in 1929, is at a Communist Party rally. In July Kahlo dies, probably by suicide. Rivera turns her public funeral into a Communist demonstration, and in September his fifth application for readmission to the MCP is accepted.

1955 Rivera marries his dealer, Emma Hurtado, and travels to Moscow to undergo treatment for cancer.

1956 He travels home via Budapest and East Berlin. In Mexico he goes to live with an old friend, Dolores Olmedo, and agrees to remove the offensive words from the Alameda fresco. As it is unveiled he surprises onlookers by saying "I am a Catholic." A national tribute is paid to him on his seventieth birthday.

1957 On November 24 Diego Rivera dies in bed, in a small room off his studio in San Angel. His last wish, for his ashes to be mingled with those of Frida Kahlo and installed in his private temple, is overruled, and he is buried in the National Rotunda of Illustrious Men.

APPENDIX 2:

MAJOR MURAL PAINTINGS

1922–23	*Creation* (encaustic and gold leaf)
	National Preparatory School, Mexico City
1923–28	*Labours and Festivals of the Mexican People* and *The Mexican Revolution* (fresco)
	The Ministry of Education, Mexico City
1924–26	*Song to the Liberated Land* (fresco)
	Chapel of the University of Chapingo, State of Mexico
1929	*Health and Life* (fresco)
	Ministry of Health, Mexico City
1929–35	*History of Mexico* (fresco)
	Staircase of the National Palace, Mexico City
1930	*History of the State of Morelos* (fresco)
	Palace of Cortés, Cuernavaca, State of Morelos
1931	*Allegory of California* (fresco)
	Pacific Stock Exchange, San Francisco, California
1931	*The Making of a Fresco* (fresco)
	San Francisco Art Institute, San Francisco, California
1932–33	*Detroit Industry* (fresco)
	The Institute of Arts, Detroit, Michigan
1933	*Man at the Crossroads* (fresco)
	RCA Building, Rockefeller Center, New York City
1933	*Portrait of America* (fresco)
	New Workers School, New York City
1934	*Man, Controller of the Universe* (fresco)
	Palace of Fine Arts, Mexico City
1936	*Burlesque of Mexican Folklore & Politics* (fresco)
	Hotel Reforma, Mexico City
1940	*Pan-American Unity* (fresco)
	City College, San Francisco, California
1942–51	*Prehispanic & Colonial Mexico* (fresco)
	Corridor of the National Palace, Mexico City
1947–48	*Dream of a Sunday Afternoon in the Alameda* (fresco)
	Hotel del Prado, Mexico City

A NOTE ON SOURCES

The only full-length life of Diego Rivera previously published was written by the artist's friend and one-time comrade Bertram Wolfe in 1939. After Rivera's death Wolfe felt compelled to revise this book, which, he realised, was flawed by its reliance on Rivera's word. Thirty-five years ago Wolfe published his second version, which he entitled *The Fabulous Life of Diego Rivera* in wry acknowledgement of his continuing failure to escape from "the labyrinth of fables" which Rivera had constructed out of the facts of his own life. Nonetheless, Wolfe produced an elegant and vivid portrait which remains a valuable source of information about those few key episodes in Rivera's life which the author shared.

Another flawed but important source is Rivera's autobiography, *My Art, My Life*, dictated to Gladys March, which contains many stories even more fantastic than the tales Rivera related to Wolfe. Not all of these stories are untrue. There would surely have been little point in inventing the account of the vision of the sun dancing which Rivera experienced in the company of the hard-line Communist artist and would-be assassin David Siqueiros as the two sailed from Hamburg to Veracruz in 1928. Conversely, there is no particular reason to believe Rivera's claim that as a student in Mexico City in 1906 he regularly indulged in cannibalism in the university hospital morgue. Rivera's autobiography has to be decoded and submitted to chronological investigation, but even in its original state it is a useful record of the face Rivera wished to present to the world, and contains valuable admissions about such matters as his relationships with his first and third wives, Angelina Beloff and Frida Kahlo.

The most scholarly account of Rivera's life to date has been produced by the art historian Ramón Favela, who has published two monographs on the eleven-year period from 1907 to 1917. In addition, Hayden Herrera's two books about Frida Kahlo, *Frida* and *Frida Kahlo: The Paintings,* contain a wealth of information about the twenty-four years Rivera lived with Kahlo; but for the biographer of Rivera their interest is limited by the fact that by the time he met Frida much of his major work had been accomplished and his character had long since been formed. The role he played in her relatively short life was far more important than the role she played in his. Since Herrera's books appeared, one of her sources, *The Diary of Frida Kahlo,* has been published, and it is now possible to re-evaluate the rather grim picture she painted of Frida Kahlo's husband.

Many of Rivera's private papers are in the archive of the Dolores Olmedo Foundation in Xochimilco, Mexico, which is closed. But in 1993 his daughter, Guadalupe Rivera Marin, and his grandson, Juan Coronel Rivera, edited a collection of personal memoirs, private letters and photographs which was published in Mexico under the title *Encuentros con Diego Rivera;* this is the only significant personal source material to appear since the artist's death.

I have undertaken research for this biography in Spain, France, Belgium, England, Italy and the United States, and in Mexico have visited Guanajuato, Cuernavaca, Amecameca and the sites of all Rivera's major frescoes in and around Mexico City. I have also found biographic material in the Museo Casa Diego Rivera in Guanajuato, as well as in the Museo Estudio Diego Rivera at San Angel; the Museo Diego Rivera at Anahuacalli; the Museo Frida Kahlo and the Museo Leon Trotsky at Coyoacán; the Museo Nacional de Arte, the Museo de Arte Moderno, the Museo Mural de la Alameda, the Museo Nacional de la Revolución and the CENIDIAP in Mexico City; and the Fototeca del Instituto Nacional de Antropología e Historia in Pachuca.

In the United States, at the Hoover Institution on War, Revolution and Peace in Palo Alto, California, I was able to read the extensive collection of Bertram Wolfe's papers, which includes many original documents from Rivera's life. The Hoover Institution's collections of Trotsky and Hansen papers were also helpful. The Detroit Institute of Arts allowed me access to its archives, which include correspondence and internal records relating to Rivera's work in Detroit. In Washington the Library of Congress holds a collection of published and unpublished material about Diego Rivera, and in the National Archives (in the General Records of the Department of State, 1940–44), I consulted a number of documents relating to information about the activities of the Mexican Communist Party which Rivera supplied to the U.S. consul in Mexico City, the State Department's evaluation of this information, and the conflict between the State Department and the Federal Bureau of Investigation over the question of Rivera's admission to the United States. The Harry Ransom Humanities Research Center at the University of Texas at Austin allowed me to consult the Huntingdon Papers, the Carlton Lake Collections and the Mary Hutchinson Papers, which cover episodes relating to Rivera's time in Paris, San Francisco, New York City and Detroit. The Rockefeller Archive Center in Sleepy Hollow, New York, gave me access to several collections of family and business papers covering Rivera's work in Rockefeller Center, and further information on this episode was made available by the librarian of the Museum of Modern Art.

Other sources include those in the Select Bibliography.

SELECT BIBLIOGRAPHY

Agustín V. Casasola. Centre National de la Photographie, Paris, 1992.

Apollinaire, Guillaume. *Chroniques d'art, 1902–18*. Paris, 1960.

———. *Le Flâneur des deux rives*. Paris, 1920.

Arquin, Florence. *Diego Rivera: The Shaping of an Artist*. New York, 1971.

Boyd, Alastair. *The Essence of Catalonia*. London, 1988.

Brenner, Anita. *Idols Behind Altars*. New York, 1929.

———. *The Wind That Swept Mexico*. New York, 1943.

Brenner, Leah. *The Boyhood of Diego Rivera*. New York, 1964.

Burckhardt, Jacob. *Civilization of the Renaissance in Italy*. Basel, 1860.

Bynner, Witter. *Journey with Genius*. New York, 1953.

Callcott, W. H. *Liberalism in Mexico, 1857–1929*. New York, 1965.

Carmichael, E., and C. Sayer. *The Skeleton at the Feast*. London, 1991.

Carrillo, Rafael A. *Posada and Mexican Engraving*. Mexico, 1980.

Carswell, John. *Lives and Letters: 1906–57*. London, 1978.

Catlin, Stanton Loomis. "Some Sources and Uses of Pre-Columbian Art in the Frescoes of Diego Rivera." New York, 1964.

Charlot, Jean. *The Mexican Mural Renaissance*. Austin, Tex., 1962.

Chase, William, with Dana Reed. "The Strange Case of Diego Rivera and the U.S. State Department." Research note, 1993.

"Chroniques d'une conquête." *Ethnies* 14 (Paris, 1993).

Clark, Kenneth. *The Nude*. London, 1956.

Constantine, Mildred. *Tina Modotti: A Fragile Life*. London, 1993.

Courtois, Martine, and J.-P. Morel. *Elie Faure*. Paris, 1989.

Crespelle, J.-P. *La Vie quotidienne à Montmartre, 1905–30*. Paris, 1976.

———. *Vlaminck: Fauve de la peinture*. Paris, 1958.

Daix, Pierre. *Picasso*. New York, 1991.

Debroise, Olivier. "Hotel Bristol, Tverskaya 39." *Curare* 5 (Mexico, 1995).

Desanges, Paul. *Elie Faure*. Geneva, 1963.

Deutscher, Isaac. *Trotsky: The Prophet Armed*. London, 1954.

Díaz, Bernal. *The Conquest of New Spain*. Translated by J. M. Cohen. London, 1963.

Dictionnaire Picasso. Edited by Pierre Daix. Paris, 1995.

Diego Rivera: A Retrospective. Detroit Institute of Arts. New York, 1986.

Diego Rivera: Catálogo general de obra de caballete. Mexico, 1989.

Diego Rivera: Catálogo general de obra mural. Mexico, 1988.

Diego Rivera: Los frescos en la SEP. Edited by L. Cardoza y Aragón. Mexico, 1980.

Diego Rivera: Frida Kahlo. Edited by Christina Burrus. Martigny, 1998.

Diego Rivera: Mural Painting. Edited by Antonio Rodríguez. Mexico, 1991.

Diego Rivera: Pintura de caballete y dibujos. Edited by Oliver Debroise. Mexico, 1986.

Diego Rivera and the Revolution. Mexic-Arte (Austin, Texas, 1993).

Dormann, Geneviève. *La Gourmandise de G. Apollinaire.* Paris, 1994.

Downs, L. "The Rouge in 1932." Unpublished memorandum, archives Detroit Institute of Arts.

Drot, J.-M. *Les Heures chaudes de Montparnasse.* Paris, 1995.

Dugrand, A. *Trotsky in Mexico: 1937–40.* Paris, 1992.

Ehrenburg, Ilya. *People and Life: 1891–1941.* London, 1961.

Ellis, Havelock. *The Soul of Spain.* London, 1908.

Engelhardt, Julia. *Mexico: A Political Chronology.* London, 1987.

Faure, Elie. "Diego Rivera." *The Modern Monthly* (New York, 1934).

———. *Histoire de l'art.* Vols. I–VII. Paris, 1909–37.

———. *Les Constructeurs.* Paris, 1914.

———. *Oeuvres complètes.* Vol. III. Paris, 1964.

Favela, Ramón. "Jean Cocteau: An Unpublished Portrait by Diego Rivera." Library catalogue of University of Texas at Austin, no. 12, 1979.

———. *Diego Rivera: The Cubist Years.* Phoenix, Ariz., 1984.

———. *El joven e inquieto Diego María Rivera.* Mexico, 1991.

Freedland, S. "Diego Rivera in Detroit." Unpublished memorandum, archives Detroit Institute of Arts.

Fuentes, Carlos. *The Buried Mirror.* London, 1992.

———. *A New Time for Mexico.* London, 1997.

Furet, François. *Le Passé d'une illusion.* Paris, 1995.

Galtier-Boissière, Jean. *Mémoires d'un Parisien.* Paris, 1963.

Giotto, Masaccio, Raphael. Editions Hazan. Paris, 1994.

Gombrich, E. H. *The Story of Art.* London, 1987.

González, Stella M. *History of Mexico.* Mexico, 1993.

Greene, Graham. *The Lawless Roads.* London, 1939.

Guzmán, Martín Luis. *La sombra del caudillo.* Mexico, 1929.

———. "The Ineluctable Death of Venustiano Carranza." Translated by Keith Botsford. Boston, 1994.

Hale, C. A. *The Transformation of Liberalism in Late 19th Century Mexico.* New York, 1989.

Hall, L. B. *Alvaro Obregón: Power and Revolution in Mexico, 1911–1920.* New York, 1979.

Harr, J. E. *The Rockefeller Century.* New York, 1988.

Herrera, Hayden. *Frida.* New York, 1983.

———. *Frida Kahlo: The Paintings.* London, 1991.

Heyden, Doris. *The Great Temple and the Aztec Gods.* Mexico, 1984.

Honour, Hugh. *The New Golden Land.* London, 1976.

———, and John Fleming. *A World History of Art.* London, 1982.

Hooks, Margaret. *Tina Modotti: Photographer and Revolutionary.* London, 1993.

Jamis, Rauda. *Frida Kahlo.* Paris, 1985.

Kahlo, Frida. *The Diary of Frida Kahlo*. Edited by S. M. Lowe. London, 1995.

Karcher, Eva. *Otto Dix*. Paris, 1990.

Karttunen, Frances. "Doña Luz Jiménez." Unpublished paper, Linguistics Research Center, University of Texas at Austin.

Klüver, Billy, and Julie Martin. *Kiki's Paris: 1900–30*. New York, 1989.

Lawrence, D. H. *Etruscan Places*. London, 1932.

Lemaître, A. J. *Florence et la Renaissance*. Paris, 1992.

Le Livre de Paris, 1900. Paris, 1994.

Lorenzetti, Piero della Francesca, Mantegna. Editions Hazan. Paris, 1995.

Marevna. *A Life in Two Worlds*. London, 1962.

———. *Life with the Painters of La Ruche*. London, 1972.

Max Jacob et Picasso. Réunion des Musées Nationaux. Paris, 1994.

Mendoza, Eduardo. *City of Marvels*. London, 1988.

Mexico: The Day of the Dead. Edited by Chloe Sayer. London, 1990.

Mexico: Entre espoir et damnation. Edited by V. de Tapia. Paris, 1992.

Mexico Through Foreign Eyes. Edited by C. Naggar and F. Ritchin. New York, 1993.

1893: L'Europe des peintres. Edited by Françoise Cachin. Paris, 1993.

1910: Paris inonde. Direction du Patrimoine. Paris, 1995.

Modotti, Tina. *Lettres à Edward Weston: 1922–31*. Paris, 1995.

Newton, Eric. *European Painting and Sculpture*. London, 1941.

Parisot, Christian. *Amedeo Modigliani: 1884–1920*. Paris, 1996.

Paz, Octavio. *Le Signe et le grimoire*. Paris, 1993.

———. *The Labyrinth of Solitude*. New York, 1961.

Penrose, Roland. *Picasso*. London, 1958.

Picasso, Pablo. *Oeuvres*. Vols. I and II. Cologne, 1995.

Picasso Photographe: 1901–16. Réunion des Musées Nationaux. Paris, 1994.

Poniatowska, Elena. *Cher Diego, Quiela t'embrasse*. Paris, 1993.

———, and Carla Stellweg. *Frida Kahlo: The Camera Seduced*. London, 1992.

Posada: Messenger of Mortality. Edited by Julian Rothenstein. London, 1989.

Pourcher, Yves. *Les Jours de la guerre*. Paris, 1994.

Richardson, John. *A Life of Picasso*. Vol. I, 1881–1906. London, 1991.

———. *A Life of Picasso*. Vol. II, 1907–17. London, 1996.

Rivera, Diego. "Dynamic Detroit." *Creative Art*, April 1933.

———, with Gladys March. *My Art, My Life*. New York, 1960.

Rivera Marin, Guadalupe, and Juan Coronel Rivera. *Encuentros con Diego Rivera*. Mexico, 1993.

Rochfort, Desmond. *The Murals of Diego Rivera*. London, 1987.

———. *Mexican Muralists*. New York, 1994.

Rose, June. *Modigliani: The Pure Bohemian*. London, 1990.

Soudoplatov, Pavel. *Missions spéciales*. Paris, 1994.

Soustelle, Jacques. *La Vie quotidienne des Aztèques*. Paris, 1955.

South of the Border: Mexico in the American Imagination, 1914–47. Washington, D.C., 1993.

Sterne, M. "The Museum Director and the Artist." Draft cap. for biography of William Valentiner, archives Detroit Institute of Arts.

Teatro Juárez: 1908–93. Guanajuato, 1993.

Thomas, Hugh. *The Conquest of Mexico*. London, 1993.

Tibol, Raquel. *Frida Kahlo: An Open Life.* New York, 1983.

Traven, B. *The Carreta.* London, 1981.

Turner, John Kenneth. *Barbarous Mexico.* Austin, Tex., 1990.

Vasari, Giorgio. *Lives of the Artists.* Translated by G. Bull. London, 1965.

Vollard, Ambroise. *Souvenirs d'un marchand de tableaux.* Paris, 1937.

Werner, A. "The Contradictory Señor Rivera." London, 1960.

Wolfe, Bertram. *Diego Rivera.* New York, 1939.

———. "Diego Rivera on Trial." *The Modern Monthly* 8 (New York, 1934).

———. *The Fabulous Life of Diego Rivera.* New York, 1963.

Wolfe, Tom. *The Painted Word.* New York, 1975.

INDEX

PERMISSIONS
ACKNOWLEDGEMENTS

Grateful acknowledgement is made to the following for permission to reprint previously published and unpublished material:

Dover Publications: Excerpts from *My Art, My Life: An Autobiography* by Diego Rivera (with Gladys March). Copyright © 1991 Dover Publications, New York.

Mrs. Marika Rivera Phillips: Excerpts from an undated letter to her father, Diego Rivera.

Señor Juan Coronel Rivera: Excerpts from two letters written by Diego Rivera, dated September 10, 1910, and March 19, 1939. Used by permission of Señor Juan Coronel Rivera, on behalf of the Estate of Diego Rivera.

Rockefeller Archive Center: Excerpt from "Memo for Mr. Nelson—from his Father" (205.11a), dated May 12, 1933 (Collection RAC; Record group 1112C, Box 94, Folder 707, Correspondence Walter Pach).

ILLUSTRATION CREDITS

Note: Copyright to all works of art by Diego Rivera is licensed on behalf of the Estate of Diego Rivera by VAGA, New York. Copyright to works of art by Frida Kahlo is licensed on behalf of the Estate of Frida Kahlo by VAGA, New York. Reproduction rights in the work of Diego Rivera and Frida Kahlo are granted by INBA on behalf of the people of Mexico.

Black-and-white insert following page 114

Town of Guanajuato: Photo © by A. Briquet.
Wedding of Rivera's parents; the twins: Courtesy of the Museo Diego Rivera, Guanajuato.

Díaz as young general: Photo © Patrick Lorette, Photographie Giraudon. Courtesy of the Musée Royal de l'Armée et d'Histoire Militaire, Brussels.
Engraving of gunman and rider: Photo © Javier Hinojosa, Collection of Hemeroteca Nacional.
Díaz, father of his people: Collection of Juan Coronel Rivera.
At Academy of San Carlos: Courtesy of UNAM, Mexico City.

"Dr. Atl": Courtesy of CENIDIAP.
Identity card photos: Courtesy of Juan Coronel Rivera. Reproduced by Bob Schalkwijk.
Portrait of Diego Rivera (Modigliani): Courtesy of Monsieur Jean-Louis Faure.

Rivera in Paris: Courtesy of CENIDIAP.
Marevna's arrival in Paris: Collection of Mrs. Marika Rivera Phillips.
Foujita on way to Paris: Archives Artistiques / Madame Sylvie Buisson, Paris.

Portrait of Rivera (Foujita): Collection of Lupe Rivera.
Modigliani with Basler: Archives Legales Amedeo Modigliani / Monsieur Christian Parisot, Paris.
Apollinaire: Courtesy of Corbis-Bettmann.

Picasso with *Seated Man:* Courtesy of Réunion des Musées Nationaux, Paris.
Picasso's sketch: Collection of John Richardson.

Rivera, Modigliani and Ehrenburg; Rivera with Marika: Courtesy of Mrs. Marika Rivera Phillips.

The Operation: Courtesy of SEP, Mexico. Photo by Bob Schalkwijk.
Guadalupe Marin: Collection of Juan Coronel Rivera.
Tina Modotti: © 1981 Center for Creative Photography, Arizona Board of Regents Collection, Center for Creative Photography, the University of Arizona.

Chapingo Chapel: Courtesy of the University of Chapingo. Photo by Bob Schalkwijk.

Banquet of the Rich and *Banquet of the Poor:* Courtesy of SEP, Mexico. Photo by Bob Schalkwijk.

"The Wise Men": The Estate of Diego Rivera. Photos by Bob Schalkwijk.
Portrait of artist as architect: Courtesy of SEP, Mexico. Photo by Bob Schalkwijk.

Nude of Frida: Collection of Dolores Olmedo Patino.
Nude of Dolores Olmedo: Collection of Dolores Olmedo Patino. Photo by Bob Schalkwijk.

Arrival of Diego and Frida in San Francisco: Photo © by Manuel Alvarez Bravo, from his collection.

Frozen Assets: Collection of Dolores Olmedo Patino. Photo by Bob Schalkwijk.

Portrait of Frida by her father: Collection of Christina Burrus.
Frida and Cristina Kahlo: Courtesy of CENIDIAP.

Self-portrait by Frida Kahlo: Collection of María Rodríguez de Reyero.

Rivera with Kahlo and her family: Collection of Juan Coronel Rivera. Reproduced by Bob Schalkwijk.

Frida greeting Trotsky: Courtesy of UPI/Corbis-Bettmann.
Pan-American Unity: Courtesy of the City College of San Francisco.

Rivera with Paulette Goddard: Courtesy of AP/Wide World Photos.
Rivera and Kahlo's second marriage: Courtesy of George Eastman House, Rochester, N.Y. Photo by Nickolas Muray.

Rivera and Kahlo in her studio: Courtesy of Archive Photos.

Rivera and daughter at Anahuacalli: Collection of Juan Coronel Rivera.
House and mausoleum: Photo by Jorge Ramírez.

Rivera towards end of career as muralist: Collection of Rafael Coronel. Photo by Guillermo Zamora.
Demonstration against CIA: Courtesy of CENIDIAP.

Rivera and Emma Hurtado: Collection of Juan Coronel Rivera. Reproduced by Bob Schalkwijk.

Rivera painting interior: Photo by Hector García. Reproduced by Bob Schalkwijk.

Last pictures of Rivera at work in his studio: Courtesy of CENIDIAP.

Colour insert following page 242

Self-Portrait: Collection of Dolores Olmedo Patino. Courtesy of the Detroit Institute of Arts. Photo by Dirk Bakker.
Night Scene in Avila: Collection of Dolores Olmedo Patino. Photo by Bob Schalkwijk.
Notre Dame de Paris in the Rain: Courtesy of the Detroit Institute of Arts. Photo by Dirk Bakker.

Portrait of Adolfo Best Maugard: Museo Nacional de Arte, Mexico City. Courtesy of the Detroit Institute of Arts. Photo by Dirk Bakker.
Portrait of Angelina Beloff: Collection of the State of Veracruz. Photo by Bob Schalkwijk.
The Adoration of the Virgin: Collection of María Rodríguez de Reyero.

Portrait of Two Women: Courtesy of the Arkansas Arts Center.
Portrait of Ramón Gómez de la Serna: Courtesy of the Arango Collection.
Still Life: Collection of the State of Veracruz. Photo by Bob Schalkwijk.
Zapatista Landscape: Museo Nacional de Arte, Mexico City. Photo © The Detroit Institute of Arts.

The Outskirts of Paris: Courtesy of Monsieur François-Nicolas d'Epoisse.
The Mathematician: Collection of Dolores Olmedo Patino.
Bather of Tehuantepec: Museo Diego Rivera, Guanajuato. Photo © 1998 The Detroit Institute of Arts.

Liberation of the Peon: Courtesy of SEP, Mexico. Photo by Bob Schalkwijk.
The Laying Out of Christ's Body: Padua, Scrovegni Chapel. Alinari-Giraudon, Paris.
Land and Freedom: Courtesy of SEP, Mexico. Photo by Bob Schalkwijk.

The Day of the Dead and *The Liberated Earth:* Courtesy of SEP, Mexico. Photo by Bob Schalkwijk.

Subterranean Forces and *Indian Boy and Indian Woman:* Courtesy of University of Chapingo. Photos by Bob Schalkwijk.

Moscow Sketchbook: Photo © 1998 The Museum of Modern Art, New York.
Insurrection: Courtesy of SEP, Mexico. Photo by Bob Schalkwijk.

The Aztec World: Courtesy of the Palacio Nacional, Mexico. Photo by Bob Schalkwijk.

Zapata's Horse and *Entering the City:* Palace of Cortez, Cuernavaca. Photos by Bob Schalkwijk.

The Allegory of California: Pacific Stock Exchange, San Francisco. Courtesy of the Detroit Institute of Arts. Photo by Dirk Bakker.

The Making of a Fresco: Courtesy of the San Francisco Art Institute. Photo by David Wakely.
Henry Ford Hospital: Collection of Dolores Olmedo Patino.

Production of Engine and Transmission of Ford V-8 and *Production of Automobile Body and Final Assembly:* Gift of Edsel B. Ford. Photo © 1998 The Detroit Institute of Arts.

Man, Controller of the Universe and *Burlesque of Folklore and Politics:* Courtesy of the Palacio de Bellas Artes, Mexico City. Photos by Bob Schalkwijk.
Dream of a Sunday Afternoon in the Alameda: Courtesy of the Museo del Alameda. Photo by Bob Schalkwijk.

Diego and Me: The Estate of Frida Kahlo. Private collection.
Portrait of Lupe Marin: Museo de Arte Moderno, Mexico City.
The Milliner: Courtesy of the Detroit Institute of Arts. Private collection. Photo by Dirk Bakker.

A NOTE ON THE TYPE

This book was set in Monotype Dante, a typeface designed by
Giovanni Mardersteig (1892–1977). Conceived as a private type
for the Officina Bodoni in Verona, Italy, Dante was originally
cut only for hand composition by Charles Malin, the famous
Parisian punch cutter, between 1946 and 1952. Its first use was
in an edition of Boccaccio's *Trattatello in Laude di Dante* that
appeared in 1954. The Monotype Corporation's version of Dante
followed in 1957. Although modeled on the Aldine type
used for Pietro Cardinal Bembo's treatise *De Aetna* in 1495,
Dante is a thoroughly modern interpretation of the venerable face.

Composed by North Market Street Graphics,
Lancaster, Pennsylvania

Printed and bound by Quebecor Printing,
Martinsburg, West Virginia

Designed by Iris Weinstein

DATE			